Four Ways of Hearing Video Game Music

The Oxford Music / Media Series
Daniel Goldmark, Series Editor

Tuning In: American Narrative Television Music
Ron Rodman

Special Sound: The Creation and Legacy of the BBC Radiophonic Workshop
Louis Niebur

Seeing through Music: Gender and Modernism in Classic Hollywood Film Scores
Peter Franklin

An Eye for Music: Popular Music and the Audiovisual Surreal
John Richardson

Playing Along: Digital Games, YouTube, and Virtual Performance
Kiri Miller

Sounding the Gallery: Video and the Rise of Art—Music
Holly Rogers

Composing for the Red Screen: Prokofiev and Soviet Film
Kevin Bartig

Saying It with Songs: Popular Music and the Coming of Sound to Hollywood Cinema
Katherine Spring

We'll Meet Again: Musical Design in the Films of Stanley Kubrick
Kate McQuiston

Occult Aesthetics: Synchronization in Sound Film
K. J. Donnelly

Sound Play: Video Games and the Musical Imagination
William Cheng

Sounding American: Hollywood, Opera, and Jazz
Jennifer Fleeger

Mismatched Women: The Siren's Song through the Machine
Jennifer Fleeger

*Robert Altman's Soundtracks: Film, Music, and Sound from M*A*S*H to A Prairie Home Companion*
Gayle Sherwood Magee

Back to the Fifties: Nostalgia, Hollywood Film, and Popular Music of the Seventies and Eighties
Michael D. Dwyer

The Early Film Music of Dmitry Shostakovich
Joan Titus

Making Music in Selznick's Hollywood
Nathan Platte

Hearing Haneke: The Sound Tracks of a Radical Auteur
Elsie Walker

Unlimited Replays: Video Games and Classical Music
William Gibbons

Hollywood Harmony: Musical Wonder and the Sound of Cinema
Frank Lehman

French Musical Culture and the Coming of Sound Cinema
Hannah Lewis

Theories of the Soundtrack
James Buhler

Through the Looking Glass: John Cage and Avant—Garde Film
Richard H. Brown

Sound Design Is the New Score: Theory, Aesthetics, and Erotics of the Integrated Soundtrack
Danijela Kulezic—Wilson

Rock Star/ Movie Star: Power and Performance in Cinematic Rock Stardom
Landon Palmer

The Presence of the Past: Temporal Experience and the New Hollywood Soundtrack
Daniel Bishop

Metafilm Music in Jean—Luc Godard's Cinema
Michael Baumgartner

Acoustic Profiles: A Sound Ecology of the Cinema
Randolph Jordan

Four Ways of Hearing Video Game Music
Michiel Kamp

Four Ways of Hearing Video Game Music

MICHIEL KAMP

OXFORD
UNIVERSITY PRESS

Oxford University Press is a department of the University of Oxford. It furthers
the University's objective of excellence in research, scholarship, and education
by publishing worldwide. Oxford is a registered trade mark of Oxford University
Press in the UK and certain other countries.

Published in the United States of America by Oxford University Press
198 Madison Avenue, New York, NY 10016, United States of America.

© Oxford University Press 2024

All rights reserved. No part of this publication may be reproduced, stored in
a retrieval system, or transmitted, in any form or by any means, without the
prior permission in writing of Oxford University Press, or as expressly permitted
by law, by license, or under terms agreed with the appropriate reproduction
rights organization. Inquiries concerning reproduction outside the scope of the
above should be sent to the Rights Department, Oxford University Press, at the
address above.

You must not circulate this work in any other form
and you must impose this same condition on any acquirer.

Library of Congress Cataloging-in-Publication Data
Names: Kamp, Michiel, author.
Title: Four ways of hearing video game music / Michiel Kamp.
Other titles: 4 ways of hearing video game music
Description: New York : Oxford University Press, 2024. |
Series: Oxford music/media series | Includes bibliographical references and index.
Identifiers: LCCN 2023043237 (print) | LCCN 2023043238 (ebook) |
ISBN 9780197651223 (paperback) | ISBN 9780197651216 (hardback) |
ISBN 9780197651247 (epub)
Subjects: LCSH: Video game music—History and criticism. |
Video game music—Philosophy and aesthetics. | Video game music—Analysis, appreciation.
Classification: LCC ML3540.7 .K35 2024 (print) | LCC ML3540.7 (ebook) |
DDC 781.5/4—dc23/eng/20230914
LC record available at https://lccn.loc.gov/2023043237
LC ebook record available at https://lccn.loc.gov/2023043238

DOI: 10.1093/oso/9780197651216.001.0001

Paperback printed by Marquis Book Printing, Canada
Hardback printed by Bridgeport National Bindery, Inc., United States of America

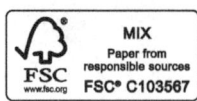

Contents

Acknowledgments ix
About the Companion Website xi

Introduction: Towards a Phenomenology of Video Game Music 1
 Poietic and Aesthesic Approaches 3
 Game Design Strategies and Gameplay Tactics 6
 Ways of Hearing 9
 Phenomenology as an Approach to Video Game Music 17
 Whose Phenomenology? 25

1. Background Music 29
 Case Study: *StarCraft* 32
 Background Music as Ground 37
 Background Music as Mood or Atmosphere 42
 Background Music as Affordance 51
 Background Music as Equipment 57
 Conclusions 65

2. Aesthetic Music 66
 Case Study: *Minecraft* 68
 Having an Aesthetic Experience 71
 Nostalgic Hearing 75
 Hearing Beauty in Virtual Nature 82
 Authored Musical Moments 94
 Aesthetic Listening as Interpretation 100
 Conclusions 107

3. Ludic Music 110
 Affect, or 'Doing This Really Fast Is Fun' 113
 Case Study: *Proteus* 117
 Inward Dancing and Embodied Listening 124
 Music Games, Synaesthesia, and Glee 129
 Musical Movement and Emotional Context 137
 Conclusions 141

viii CONTENTS

4. Semiotic Music — 143
 - Case Study: *Left 4 Dead* — 144
 - Musical Signs — 149
 - Musical Symbols — 152
 - Musical Signals and Anticipation — 158
 - Broken and Unestablished Signs — 164
 - Conclusions — 170

Conclusion — 173
 - Hearing Video Game Music in Context — 174
 - Other Ways of Hearing — 176
 - A Final Word on Hermeneutics — 180

Notes — 183
Bibliography — 193
Index — 207

Acknowledgments

Video game music scholarship has experienced a remarkable boom over the past decade or so, a period that coincides with the writing of this book. When I first started thinking about this topic academically during my master's degree in 2008, it was not so much as a lover of video game music, but of video games. As a musicology student, I wondered not what made the scores of Koji Kondo or Nobuo Uematsu great, but why I had never thought seriously about the music of the games that I loved—*StarCraft, Civilization, Grand Theft Auto*—in the way that I had about music in films and in my MP3 library. This might explain why this book is often written from a somewhat personal perspective, solipsistic even, from the inside out, rather than from the outside in, from the rich culture of video game music and its scholarship. But this means all the more that the ideas in this book are strongly influenced by those in my immediate social circles, all the friends, family, and colleagues with whom I played and discussed video games and their music.

I am profoundly indebted to the guidance and wisdom of Isabella van Elferen, my master's thesis supervisor, and Nicholas Cook, who supervised the PhD dissertation that this book grew out of. My PhD examiners at various stages, too—Ian Cross, Julio d'Escrivan, Benjamin Walton, Monique Ingalls, and K. E. Goldschmitt—gave much-needed direction and advice that shaped this work. As the field of game music studies grew over the decade that this book was put together, so did the number of colleagues whose feedback and comments at conferences were vital to my thinking. I would particularly like to thank my close friends and colleagues in the Ludomusicology Research Group with whom I've argued, laughed, and stressed about ludomusicological matters over the years: Andra Ivănescu, Melanie Fritsch, Tim Summers, and Mark Sweeney. My colleagues in Utrecht have been a great source of support and inspiration as well, as have the many graduate and undergraduate students that have let me develop this research. Two case studies from Chapter 2 and 4 have appeared in different guises in the edited collection *Music in the Role-Playing Game: Heroes and Harmonies* (2019) and suggestions from my co-author Mark Sweeney and editors William Gibbons and Steven Reale have helped shape the new approaches taken to these case

studies in this book. I am also grateful to series editor Daniel Goldmark and OUP senior editor Norm Hirschy for their interest in my work and patience with my progress. Then there are all those friends that have kindly read drafts or discussed ideas, or that I've stayed up late to play games with: Matthias Grein, Nahal Khabbazbashi, Ross Cole, Natasa Mavronicola, Teresa Segura Garcia, Kyle Sutherland-Cash, Dhiren Mistry, Krit Sitathani, Matt Cooper, Daisy Hessenberger, Mare Venerus, Pablo Aran Terol, Floris Schuiling, and #bumba members Hans Ploegmakers, Robin van Groesen, Jaap Feenstra, Luke Crooymans, Eelco Kingma, Wouter van der Heijden, Paul van Eekelen, and Rick Worms. Finally, I cannot thank enough my parents and my sister for their love and support.

About the Companion Website

www.oup.com/us/fourwaysofhearingvideogamemusic

This book features a companion website that provides material that cannot be made available in a book, namely several gameplay recordings of the book's case studies and a few colour images. The reader is encouraged to consult this resource in conjunction with the chapters. Examples available online are indicated in the text with Oxford's symbol ⏵.

Introduction

Towards a Phenomenology of Video Game Music

As an experiment, let us for a moment consider the opening moments of *Hades* (2020) not as a game, but as a film, perhaps some form of modern animation. *Hades*, like earlier games by developer Supergiant Games such as *Bastion*, throws the player *in media res*.[1] After the briefest of voice-overs from the narrator over the titles accompanied by a low string drone on D (0'09" in **Video I.1** ▶) follows an establishing shot of the gates to Tartarus, where Zagreus, the son of Hades, drops into frame (0'27"). The drone resolves with a rising fourth to an ostinato pattern on G that continues as Zagreus rushes off into Tartarus, destroying the architecture with this sword as he comments, 'To hell with this place.' Cinematographically, something unconventional happens, as the high-angle establishing shot is not followed by closeups of the action when Zagreus sets off, but instead the camera rigidly tracks his movements from the same angle in a manner uncommon in films. It has certain qualities of the rigid tricycle shots from *The Shining* (1980), but the manner in which Zagreus' destructive process is tracked is also reminiscent of the corridor fight scene from *Oldboy* (2003), whose camera underlines Oh Dae-su's—and through association Zagreus'—unrelenting desire for freedom. Darren Korb's music underscores Zagreus' determination not just through the resolution to G that sets him on his path, but also through the prominent syncopated percussion and lack of harmonic deviations that set a firm beat, somewhat of a heartbeat, that leads Zagreus through the various chambers of Tartarus until he stumbles upon a potential ally, Athena (1'34"), and a moment's respite. The ostinato fulfils several functions that theorists of film music both old and new have proposed. It both 'illustrates on-screen action' and 'lends audible structure' to the narrative, as James Wierzbicki (2009, 6) would put it, just as it 'underlines psychological refinements' of the main character, in the words of Aaron Copland (2004, 107). But at the same time, the faintly audible bouzouki or bağlama ornamentations (e.g. 1'02") function to create 'a more convincing atmosphere of time and place' (Copland

2004, 107) through its cultural connotations with *Hades*' setting in ancient Greek myth.

But consider now a second recording of the same opening sequence of *Hades*, **Video I.2** ⊙. We are met with the same establishing shot of the Tartarus gate, again with Zagreus dropping into view. But this time, Zagreus turns around for a second to look back at the gate. The camera rigidly follows his frantic, searching movements as he explores the room he landed in. He runs and stands amongst the cloaked, ghostlike denizens of Tartarus, while the ostinato lingers on G to await his next decisions. The lack of harmonic development signifies Zagreus' indecisiveness, or perhaps the audience that does not know what will come next. At the same time, the bouzouki's melodic fragments more clearly limn not only the location, but Zagreus' exploration of that location as well. But when Zagreus takes a swing at the unsuspecting and unflinching ghosts only for them to vanish in a puff of smoke—'Out of my way,' he commands (1'19")—the music does not follow suit. Why does it linger?

My two analyses of *Hades* and the questions that they raised show that while film music theory can say a lot about video game music, it is ultimately unable to account not just for the dimension of interactivity that games introduce, but for the kind of hearing that this dimension affords too. In the vein of audiovisual experiments such as Sandra Marshall and Annabel Cohen's (1988), or what Michel Chion calls 'forced marriage' (1994, 188), we may substitute the same soundtrack with different images to elicit different meanings from the music. In the first video, the same ostinato seemed to underscore the player's avatar's determination, in the second one his indecision. But this is what an audience might glean, looking over the player's shoulder; what do I hear as a player? What is it like to hear music when I am performing actions in a goal-oriented, rule-bound medium such as a video game? Do I hear the musical 'underscoring' in *Hades* as a suggestion of what actions to perform? I could, for instance, take the continuous ostinato as a sign to move on to the next room and start my journey. Or do I reflect on the music's relationship to my actions and to the game's visuals and narrative? My lingering (or my avatar Zagreus' lingering; in video game parlance, player and avatar are often [con]fused) might have brought into focus the melodic fragments of the bouzouki and their orientalizing *couleur locale*. Or, again, do I decide to play along to the music? As I speed off in the first recording, I can hear the unrelenting syncopated beat as an invitation to run along with the cue, gleefully smashing up the ancient stonework of Tartarus. Or, finally, do I actually

pay attention to the music at all? It could after all be no more than 'elevator music,' the repetitive ostinato having nothing worthwhile to add to whatever I decide to do, be it lingering or rushing off to the next room. *Hades* is, after all, a so-called roguelike game—a genre that has the player (or rather their avatar, of course) die over and over again and start from the same location in order to progress ever so slightly further into the game's story—not unlike Zagreus' 'mate' Sisyphus, whom he encounters again and again in the bowels of Tartarus. In these games even more so than in other game genres, we may encounter the same cues over and over again. What significance could they hold after the umpteenth time?

The questions that I want to answer in this book are in this vein. Simply put: 'what is it like to hear video game music?' When considering a question like this, it is always useful to ask 'why?' and 'who wants to know?' When I ask you what something it is like, I usually do so because I have no (easy) way of finding out for myself. It could be that you have different physiological features ('what is it like to be seven-foot tall?'; 'what is it like to have synaesthesia?'), or have a different life history ('what is it like to have grown up in Japan?'; 'what is it like to be a veteran from the Iraq war?'). But why would I want to hear your description of what it is like to play a video game and hear the music, when I can find out for myself? Academic interest in descriptions of experience—phenomenology in its various incarnations—can come from another kind of inaccessibility, namely a theoretical one. Just as the formalist film-studies approach with which I began distorts the experience of playing video games, so I want to argue that current musicological theories may direct us to the wrong questions, and can misconstrue what it is like to be playing a video game. To start with, we may briefly survey the history of the field of video game music studies and distinguish the approaches that have been taken in terms of what I will call 'poietic' and 'aesthesic' scholarship, terms borrowed from semiotician Jean-Jacques Nattiez (1990). This will both introduce some common terminology that will return throughout this book's case studies and arguments and allow me to position my approach more clearly.

Poietic and Aesthesic Approaches

Although video game music had sporadically been the topic of scholarly debate in the 1980s and 1990s, Zach Whalen's 'Play along—an approach to

video game music' (2004) can be said to be the first major piece of research on video game music. It explores the functions of music in three video games, *Super Mario Bros.* (1985), *The Legend of Zelda: Ocarina of Time* (1998), and *Silent Hill* (1999). In more ways than one, Whalen's research laid the groundwork for future research. First, he identified the distinction between safety- and danger-state music—music that changes according to the presence of enemies or other challenges to the player—that has been pervasive in video games, going back all the way to *Pac-Man* (1980). The possibility for musical cues to change according to states in a game is one of the medium's most characteristic features and will play a central role throughout my descriptions. Second, his choices of case studies formed somewhat of an initial canon for research, with subsequent scholarship returning to *Silent Hill* as an example of horror music and diegesis in games (Whalen 2007; Ekman and Lankoski 2009; Summers 2016b; Cheng 2013; Roberts 2014; Donnelly 2016); to *Ocarina of Time* for its musical implementation and strong thematicity (Collins 2008; Medina-Gray 2014; Summers 2021; Brame 2011); and to *Super Mario Bros.* for its role in video game nostalgia and intertextuality (Collins 2008; Summers 2016b; Schartmann 2015).

The first book-length study, Karen Collins' Game Sound (2008), not only expands on Whalen's game-music functions, but also introduces a host of different approaches on the topic that had not been extensively taken before: a history of styles and technology, compositional approaches, and processes of implementation. One concept in particular stands out: 'dynamic music,' or music whose structure is variable in some way. It can react either to changes in the game environment, which Collins terms 'adaptive music,' or directly to the player's actions, which she terms 'interactive music' (2008, 139). Dynamic music is closely related to Whalen's 'state music,' and it prompts a variety of avenues for enquiry. The composition of dynamic music, for instance, brings with it a number of different problems to do with the music anticipating or reacting to state changes in the game. At a very basic level, video game music, like film music, consists of a series of cues—short pieces of music that are written for a particular location or sequence in a game, such as a level or map, or an important plot event. The problem is that in many video games, unlike in films, the length of these sequences depends on the player's actions, which is why cues usually loop in a variety of ways: either directly and continuously (such as in *Tetris* [1989]), or by gradually fading in and out at randomized intervals (such as in *World of Warcraft* [2004]). In dynamic soundtracks, certain events can prompt a transition from one cue into another. This can be

done through simple crossfading (such as in *Ocarina of Time*), or a complicated transitional section, which 'waits' until a certain point in the music has been reached—usually the end of a measure or short section. For increased variety, a combination of short loops (sometimes called 'cells') can be used that transition into other loops. Winifred Phillips calls this common method of composing dynamic music 'horizontal re-sequencing' (2014, 188). The other common method considers music in terms of vertical 'stems' instead of horizontal cells, layers of instrument groups (usually playing loops as well) that can gradually fade in and out depending on states in the game. This technique, which Phillips calls 'vertical layering' (2014, 193), has been used to great effect in the horror game *Dead Space* (2008).

These discussions of musical implementation and functions are easily framed in terms of questions about composition and implementation, or what I would like to call 'poietic problems.' But we can also ask what such issues mean for the way in which players hear video game music—for what the music means to them—which is an 'aesthesic problem.' Aesthesic scholarship of video game music has taken two general directions in recent years: hermeneutics and ethnography. Hermeneutic approaches treat video games as art(efacts) to be interpreted. Andra Ivănescu's (2019) studies of popular music and nostalgia in games and William Gibbons' (2014) study of silence in *Shadow of the Colossus* (2005) are prime examples of this approach. In the traveling sequences of *Shadow of the Colossus*, the use of silence instead of wall-to-wall dynamic state music creates a sense of solitude that shapes the player's experience of the game's narrative (Gibbons 2014, 128–29). By contrast, ethnographies of video game music take as their object of study not individual games, but communities of players, and consider how music has shaped their relationship to the game. Joanna Demers' (2006) study of *Dance Dance Revolution* (1998) and Kiri Miller's (2012) study of *Guitar Hero* (2005) and *Rock Band* (2007), for instance, ask in what way players play and 'play with' music games, and how this interaction can be called musical. While the methodology differs, the line between hermeneutics and ethnography is particularly blurred in video game music studies, with both Miller and William Cheng (2014) slipping in and out of interpretations of their own experiences and their analyses of the experiences of others.

While the aforementioned studies all focus on experiences with specific games, a number of studies have appeared that propose aesthesic theories for video game music in general. Many of these involve questions of 'immersion' and the many interpretations of this concept. We find psychological

explanations in the ideas of Rod Munday and Isabella van Elferen, who propose that music can act as a 'wall of sound' (Munday 2007, 57) or 'private bubbles of musical virtuality' (van Elferen 2011, 32). Munday, again, and Tim Summers (2016b, 60) discuss the semiotic aspects of immersion, arguing that music co-constructs the fictional game world through semiotic connotations, effectively 'texturing' the game, creating depth and context through references to other media.

Game Design Strategies and Gameplay Tactics

Despite the central role afforded to the concept in theories of video game music, immersion is a somewhat problematic term in video game studies, as shown by these different explanations of the concept. Katie Salen and Eric Zimmerman have pointed out the 'immersive fallacy,' the idea that 'the pleasure of a media experience lies in its ability to sensually transport the participant into an illusory, simulated reality' (2003, 31) and that therefore the ultimate goal of a game is to immerse the player. Moreover, '[a]ccording to the immersive fallacy, this reality is so complete that ideally the frame falls away so that the player truly believes that he or she is part of an imaginary world' (Salen and Zimmerman 2003, 31). There are two related problems with the fallacious conception of immersion that Salen and Zimmerman identify. The first is that there are many examples of games that do not construct imaginary worlds, such as *Tetris*, but are still 'engrossing.' From this it follows, secondly, that the term 'immersion' creates somewhat of a black box for an understanding of player enjoyment and experience in video games. To be immersed in something is merely to say that something matters to me: I am immersed in my studies, just as I am immersed in a newspaper, just as I am immersed in a video game. We can think of the concept, then, as a theoretical tool for game designers and producers: the question 'how can music be used to immerse players?' is a poietic one, not an aesthesic one.

We can think of the relationship between poietic and aesthesic qualities of a game—between designers' ideas about musical functions and immersion and players' experiences—in terms of Michel de Certeau's (1984) distinction between 'strategies' and 'tactics.' The practices of everyday life, such as walking through town or buying products in the supermarket, are 'hidden' underneath the more explicit systems they inhabit. Avoiding the martial

and militaristic connotations of strategies and tactics, de Certeau uses these concepts to describe these practices. A strategy is reserved for those in a position of power, with a clearly defined subject and what de Certeau calls a 'proper' place in society. Tactics, on the other hand, are reserved for those in an 'underdog' position (de Certeau 1984, 36–37). Those who cannot act on their own terms must react to the outside forces that are imposed on them. In consumer culture, this means that there are the companies that are able to clearly define their position on the market among their competitors through business strategies. Then there are the consumers, who can only react to the products that the companies make available to them, for example by buying the one and not the other. Anahid Kassabian's (2013) concept of ubiquitous listening, which has gained popularity in the last decade, can be understood in a de Certeauian manner as an attempt to describe listening tactics in the face of musical ubiquity. Her construal of Starbucks customers as audiences, for instance, describes a particular way of consumers orienting themselves to music in places that they do not have control over. Video game players have a lot in common with consumers. The materials with which they create their experiences, on which they base their decisions, belong to the game's creators. The areas that they visit in the game world and the musical cues that they hear are predetermined by strategies on how to create successful games in terms of rules and goals. Like consumers, they can only react to the objects that they encounter in the game. The designers' choices, then, are strategies. Their means are clearly discernible in the form of the game's resources, in the case of music, the individual cues.

One of the characteristics of strategies according to de Certeau is a 'triumph of place over time' (de Certeau 1984, 36). So while the player potentially hears the soundtrack of a game as a continuous musical event, or as a series of musical gestures that comment on their actions, the designers who implement the music have a different understanding of it. They can *see* it as a series of separate musical cues that can loop, dynamically interweave, and transition into one another based on triggers in the game's code. This understanding of music as a (spatial) object is in many ways comparable to the traditional 'musicological' understanding of music as a score on paper, which comes from music analysis. The difference in video games is that these objects become file names in hierarchical filing systems, rather than notes on bar lines, in digital audio workstations and middleware programs such as Wise or FMOD (see Figure I.1 on the companion website ▶).

With this in mind, we can define gameplay in terms of player experience. In *Understanding Video Games* (2008, 37–39), Simon Egenfeldt-Nielsen, Jonas Heide Smith, and Susana Pajares Tosca propose a division between 'game mechanics' and 'game dynamics.' A game's mechanics are the rules of a game, which are invisible to the player, while the dynamics are the way a game actually plays. This division is very much like Jesper Juul's division between a game's rules and its gameplay (2005, 83–91). The rules are obviously the mechanics, and the gameplay is defined almost exactly the same as game dynamics, as 'the way the game is actually played' (2005, 83). Furthermore, gameplay is a 'consequence of the game rules and the dispositions of the game players' (2005, 88). For example, the rules or mechanics of *Hades* allow me to run to the next room once all its enemies have been cleared. Whether this means that I speed through the first room to get to the next one as I did in the first recording, or I take my time exploring it, is a matter of gameplay or game dynamics. Both these divisions are very similar to de Certeau's strategies (which would be the rules) and tactics (the gameplay). They are not identical, however. Part of the definition of tactics is that they are taken for granted, they are ordinary. There is no mapping out of everyday behaviour, whereas gameplay allows for players to discuss strategies with each other, to plan on how to overcome a game's challenges—they even discuss the music in these terms, as I will show in Chapter 1. We can ask, however, if the particular ways in which we play a game in relation to its music are made explicit as well. But what amounts to a 'tactical experience' of music?

If a game's designers and composers can be said to hear the music 'visually,' in terms of cells and strategies to immerse players, how do players hear it differently? Van Elferen distinguishes two ways in which music immerses players in video games: through the narrative functions that it shares with film music, and through ludic functions that work through the 'intensification of gameplay.'[2] Narrative, or 'cinematic,' game music can be found in cutscenes, but also during gameplay sequences, where it can serve to emotionally affect players. Ludic music, on the other hand, guides the player's actions, providing auditory clues that help them attain goals and progress through a game. While van Elferen refers to narrative and ludic music as immersive functions, they can also be construed as ways of hearing. Narratively, players can hear 'sudden stingers' in horror games as scary, and drones that 'speed up as the action increases' as 'nerve-racking'; ludically, players can hear a sudden stop in the music as a sign that all enemies have been defeated and that 'she or he can advance' (van Elferen 2011, 33).

The distinction between narrative and ludic music draws upon Juul's (2005) conception of video games as 'half-real'—having real rules presented through a fictional world. As a set of rules, video games are like sports and board games; as a narrative medium, they are related to artefacts in other audiovisual media such as films, music videos, and television programmes. Juul argues that a game's narrative elements cue the player into the game's rules, and that '[e]ven though fiction and rules are formally separable, the player's experience of the game is shaped by both' (2005, 177). In other words, players' experience of rules is a manner of 'seeing—or hearing—in' fiction. For Ian Bogost, this rules-fiction structure allows for a very special kind of representation in video games, whereby games can represent systems in the real world. For instance, '[u]nder the shiny, credible graphics of *SimCity* towns is an abstract simulation of urban development, based largely on Jay Forrester's concept of urban dynamics' (Bogost 2007, 239). We can ask, then, how the jazzy soundtrack of *SimCity 2000* (1993) fits into this rhetoric. For instance, are players to associate the upbeat jazzy sounds with the soundtracks from metropolitan sitcoms from the early 1990s: *Seinfeld*'s (1989) slap-bass bumpers and *Frasier*'s 'Tossed Salads and Scrambled Eggs' (1993)? Or are we to hear the improvisatory trumpet lines against the predictable chord progression in the rhythm section as conforming to our playing around in the simulation system of the game, as Summers argues (2016b, 106)? While the former is clearly an instance of narrative music in van Elferen's terms, in the latter interpretation, it is related to the rules of the game: we can potentially hear the rules system reflected in the musical soundtrack. The distinction between rules and fiction in video games is an important one, and I will return to it on a number of occasions throughout my arguments. However, their close connection and inseparability in the player's experience suggests that in order to understand the way that we hear music in video games, a different approach might prove more useful.

Ways of Hearing

The question of whether we hear fiction and rules in game music, or whether we hear rules *through* fiction, points to the possibility of different ways of hearing the same 'piece' of game music. The aim of this book is to provide a categorization and description of the different ways in which we hear and listen to music in video games. Instead of starting out with categories derived

from functions—strategic-poietic concepts—I want to move towards an aesthesically derived categorization. The starting question should therefore be 'what do we hear *in* music?' in various different situations. This question, of course, raises the issue of who 'we' are, and I will address this problem from time to time in my argument by referring to various sources of academic, critical (in game journalism), and popular (on internet forums) discourses surrounding music in games. However, I will for the most part rely on my own experiences as suggesting how people might engage with the music in video games.

That said, the crux of my argument lies in the fact that 'we' do hear different things in the same music in different situations. This has become generally accepted, especially in various musicological writings of the last few decades. Audiovisual studies of music (e.g. Gorbman 1987) point out that as the images accompanying music change, so does our perception of the piece of music, and vice-versa. Nicholas Cook adds to this the idea that 'intermedia relationships are not static but may change from moment to moment, and that they are not simply intrinsic to "the IMM [instance of multimedia] itself," so to speak, but may depend also upon the orientation of the recipient' (1998, 113). Music sociology, too, stresses the importance of a context to determine how music is 'used' (i.e. heard) in different ways (DeNora 2000). Ola Stockfelt (1997) has argued for 'adequate modes of listening' that depend on the situation in which musicking occurs, which led Kassabian (2013) to develop her concept of ubiquitous listening. Both musical hermeneutics and phenomenology, however, even when they argue for hearing over 'reading' music, tend to focus on attentive listening where it does not matter so much when and where we hear the music. In a video game the listening situation is vitally important for our understanding of how music is heard, and not just the situation in which we play a video game. Unlike other audiovisual media—particularly the cinematic film experience—there are a number of different situations in which we play video games, heavily dependent on the technological platform: the classic penny arcade, the living room console, the office PC, and the portable handheld gaming device whose ecology became more complicated with the rise of smartphones and tablets as gaming devices in the 2010s. Still, it can be said that the locations where people play games are nowhere near as diverse as locations where one encounters music, or as porous: you are either playing a game or you are not, while it is more difficult to say you are either listening to music or you are not, based on the

situation you are in. (This will form a main point of my argument on background music in Chapter 1.) But when playing a game, we do not always find ourselves in the same gameplay situation when we hear the same piece of music. A stinger chord or a transition between cues may always happen at the same time we are performing a specific action, but then again it might not, depending on the way the music has been implemented, and this again could change our perception of the music.

The importance of listening situations—for instance where we play a video game, or when, while playing a game, we hear music—and the way they are disregarded by traditional phenomenologies and hermeneutics of music point towards the problem of *significance*, which will become a central theme in my descriptions of music. Significance is that what matters to us, which we experience as meaningful, and which we pay attention to in any project that we might undertake, be it academic research, or playing a video game. This is different from that what 'affects' or 'influences' us. For example, in Susan McClary's arguments in *Feminine Endings* (1991, 128), the hair colour of the persons in front of her in the concert hall in which she might have heard Beethoven's Ninth was insignificant, whereas the violence that she heard—and perhaps 'saw' in the score—in the recapitulation of the first movement of the Ninth *was* significant. One could say, however, that the balding grey hair of the row of men in front of her signifies the patriarchal culture that resorts to such violence as that in the Ninth, influencing McClary's arguments. But that is a significance that I as a reader am finding in her argument. What is significant to someone is not an effect of the psychological, sociological, ideological, or even neuro-physical processes that lead them to say or think certain things: it is something constituted by what they say or think, what is central to their lived experience. In identifying my categories of hearing, I want to ask not *what* is significant in music in video games or *why* it is significant, but *in what ways* can video game music become significant to players.

From those things in the music that hold our interest, that have significance, it follows that there are parts of the music that do not. This brings up questions surrounding the phenomenon of background music. As it has been traditionally discussed (e.g. Hamilton 2007; N. Cook 1990), background music, for which Muzak is often cited as a metonym, is music that is heard as insignificant. But does this mean that it is not consciously perceived, or not attended to at any point? Returning to my initial question,

we hear significant phenomena (e.g. melodies, patriarchal society, game rules) *in* music against a background of musical insignificance. A melody against accompaniment is the clearest example, but there are also sections of music that are more significant than others. Cook quotes the composer John White:

> As far as I'm concerned many people listen to a lot of classical music just from phrase to phrase, waiting for the really good bit to come up, more or less switching off after the 18th Variation of Rachmaninov's *Paganini Variations*, until the exciting bit towards the end comes up. (1990, 65–66)

Of course, in the case of Muzak, the music as a whole can be heard as insignificant, a background against which significant non-musical activities can take place.

With background music, or musical insignificance, we have our first way or category of hearing. But how can we categorize difference in the ways music becomes significant to us? A good place to start is Milena Droumeva's (2011) overview of game sound in general (not just music), which assembles different categories of listening from soundscape theory (Truax 2001), film sound (Chion 1994), and an earlier study of video game sound (Tuuri, Mustonen, and Pirhonen 2007).

In her overview of listening positions (**see** Table I.1), Droumeva locates the musical score of a video game exclusively in the attentional background, but throughout her article she alludes to other positions music might take: she mentions musical 'earcons'—which occupy a middle ground according to the table—and musical *flow*, such as 'the temporal flow of the landscape' and 'a highly melodic, musically semantic flow' as found in older, fantasy-themed games such as *Super Mario Bros.* (2011, 138). Droumeva is unclear as to what the attentional position towards this kind of musical flow would be, and the question is what the difference between a middle ground and a background, or even a foreground, really is in experience—a question I will return to in Chapter 1. Moreover, in a second table, Droumeva suggests a number of different listening *modes* rather than attentional positions, one of which is explicitly dedicated to music: what she calls the 'nostalgic listening' mode is '[a]n analytical, culturally-critical type of listening that has emerged over time in experienced players who look for iconic game music themes through platforms and generations of a particular game (some notable examples here being the *Final Fantasy, Super Mario, Zelda* and *Mega*

Table I.1 Droumeva's listening positions and game functions (2011, 139)

Attentional Position	Game Functions	Listening Position	Examples from Gameplay	Reference Frames
Foreground	Action-oriented functions	Analytical listening (Truax 2001); listening-in-search (Truax 2001); semantic Listening (Chion 1994); causal listening (Chion 1994); functional, semantic, and critical modes of listening (Tuuri, Mutsonen, and Pirhonen 2007)	Alerts: notifications, warnings, confirmation and rejection Interface sounds	Trans-diegetic
Mid-ground	Orienting functions, identifying functions	Media listening (Truax 2001); navigational listening (Grimshaw and Schott 2007); causal and empathetic modes of listening (Tuuri, Mutsonen, and Pirhonen 2007)	Contextual sound effects; auditory icons; earcons	Diegetic
Background	Atmospheric functions, control-related functions	Background listening (Truax 2001); reduced listening (Chion 1994); reflexive and connotative modes of listening (Tuuri, Mutsonen, and Pirhonen 2007)	Musical score; environmental soundscape	Extra-diegetic

Man series)' (2011, 145). Droumeva's use of the word 'analytical' suggests a more active engagement with this type of music.

A good way to start dealing with the problems that arise from Droumeva's categorization is to note the difference between hearing and listening—terms that I have up to now used more or less interchangeably, but between

which I will distinguish from now on. By listening I mean a kind of active searching for or paying attention to sounds, while hearing is experiencing or encountering sounds. So for instance, nostalgic *listening* is an act that involves attempting to *hear* music as relating to one's past experiences. But we can hear sounds without having listened for them as well: a sudden noise in a quiet room, or music playing in the background when a conversation falls silent, for instance. Then, once we have heard a sound, we can attend to it actively by listening. I find this ordinary language distinction between hearing and listening more useful than creating different listening modes or listening levels. I realize that this does leave out the traditionally important category of 'inattentive' or 'background' listening, but I will come back to these psychological 'modes' in a round-about way when discussing background music more in-depth in the first chapter. For now, I will discuss ways of *hearing* music, thereby meaning ways of encountering it, rather than attending to or searching for it.

The category of background music is an archetypal example of music in video games, film, and other audiovisual media. It is that kind of music that you do not listen to, or attend to, or actively engage with; perhaps it is even that kind of music that you do not *hear*. Droumeva seems to suggest that all the music in video games is background music, but this is an oversimplification. We can distil four useful starting points for ways of musical hearing in video games from Droumeva's categorization and from musical functions identified by other authors mentioned earlier, such as van Elferen and Summers. I will call these background music, semiotic music, ludic music, and aesthetic music. By referring to these categories as types of 'music,' I might seem to suggest that there is something different in the musical structure as it was composed, recorded, and implemented in the game, and that different musical cues in games can be labelled as one or the other. However, as I argued above, the way we engage with music is highly dependent on the situation in which we encounter it, and the interactive nature of video games means the same fragment of recorded music will be played back when different things are happening in the game. This means there can be ludic musical moments or background musical moments, for instance, depending on what I am doing as a player at the time, and I will call these instances of 'ludic music' and 'background music,' respectively. In other words, these are aesthesic musical categories, in that they are 'created' through a way of hearing the music, not through a way of musical composition. An example

of aesthesic background music would be John White's account of the nineteenth *Paganini Variation* at a concert, whereas Muzak's especially composed and recorded 'Stimulus Progression' programmes, or the world music that Anahid Kassabian (2013) finds in Starbucks cafés, are instances of poietic background music.

So whereas background music is heard as insignificant, music can attain significance to the player in the following three ways. Semiotic music is the kind of music that provides the player with information about gameplay states or events: the sudden appearance of an enemy that is foreshadowed by a change in the tone of the music, or a victory fanfare that signals the successful completion of a level. This music has an explicit signifying function—like the transdiegetic foreground sound in Table 1—that warrants the player's attention, even if it is just for a moment. In fact, as I shall argue in Chapter 4, the briefness of semiotic significance raises the question whether the music really matters to us at all in this way of hearing. Ludic music, as discussed in Chapter 3, invites a more continuous attention or active engagement with musical features. While I am of course borrowing this term from van Elferen, as mentioned above, I mean something slightly different: when I hear ludically, I hear myself as playing *to* the music or *along with* the music, such as running to the beat or following a crescendo up a mountain. Finally, Chapter 2 discusses aesthetic music—not to be confused with Nattiez's concept of 'aesthesic'—which has an 'autonomous' quality to it. This means that when we hear aesthetically, we experience an isolated musical moment. To characterize our engagement with aesthetic music, I want to draw upon classic (Kantian) philosophical accounts of aesthetic experiences that refer to their arresting qualities (we halt our actions to enjoy the moment), but ignore their normative implications. This means that Droumeva's nostalgic listening could be a form of engaging with aesthetic music, but so could a sweeping orchestral score that has us stop playing a game for a moment to admire its virtual landscapes. In this book, I want to offer a phenomenological account of each of these four musical categories, to tease out what makes them different from one another, and how they relate to hearing music in other contexts.

If developers' poietic engagements with music represent a 'triumph of place over time,' as I initially argued in terms of de Certeau's distinction between strategies and tactics, we might say that players' engagements with music are the reverse, an engagement with music as a temporal phenomenon.

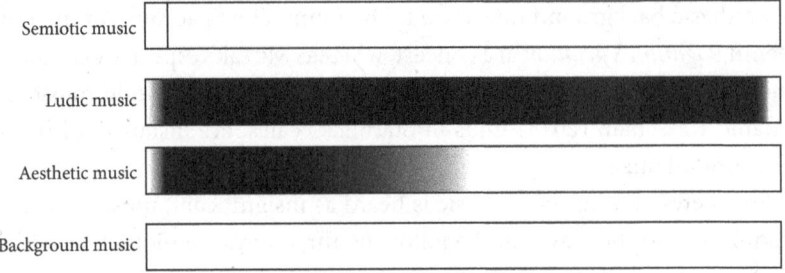

Figure I.2 The temporality of musical significance in video games

A preliminary distinction among the four categories can therefore be in terms of the temporality of their significance: when and for how long does music become significant to us in a video game? Semiotic music only requires an instant of attention of us: the moment I hear something significant in the music, I have learned all I need to know, and can continue my gameplay pursuits. Ludic music has more continuous significance, as I hear myself playing along to musical duration: melodies, beats, and sections, for instance. Aesthetic music, through its arresting features, has an indeterminate period of significance to us: we can think of it as a kind of 'trailing off' of significance, away from the game we are playing. Background music, finally, of course has no moment of significance to us at all. These distinctions in temporal significance can be shown graphically as in Figure I.2, in which a musical event of significance to the player is represented by a black bar, and the duration of its significance by the length of the bar.

While this is a good way to initially understand and distinguish the different ways of hearing, when discussed more in-depth, these accounts of their temporality will ultimately prove to be phenomenologically insufficient. Paraphrasing Edmund Husserl, Alfred Schutz, and Henri Bergson, the temporality of significance and the significance of temporality in our hearing are two different things.[3] Music, according to the phenomenologists, presents its own time, as I will explain below in more detail, but there are various ways of experiencing or inhabiting that time. Therefore, temporality will return on numerous occasions in each chapter: the infinitesimal minuteness of semiotic hearing, the timelessness and trailing off of aesthetic moments, the continuous 'leaning into' of ludic hearing, and even the temporal pervasiveness of background music are all essential characteristics, as I will argue.

The four categories are also interdependent in various other ways. For instance, as will become clear in the final chapter, we can think of semiotic music as embodying a kind of musical insignificance similar to that of background music. And we can talk of aesthetic and ludic music as sharing similar characteristics as well, since reflecting on music and having the sense of playing along to it are very similar experiences. For these reasons, each chapter will require at least some understanding of the other chapters. The chapter order is to some extent arbitrary, although it seems prudent to start with background music as the most pervasive and yet difficult to grasp of the ways of hearing. Semiotic music is the way of hearing that has perhaps been discussed the most extensively in theories of video game music, and that has been seen as the most idiosyncratic to the medium, but my discussion of this phenomenon actually depends the most heavily on the other three categories. Therefore, the book will end rather than start with this way of hearing.

Phenomenology as an Approach to Video Game Music

As I mentioned, I want to elucidate each of these ways of hearing by means of phenomenological description. As an approach that explicitly suspends interpretation, theorization, and explanation in favour of description as much as possible, it is an ideal way of gaining a better understanding of what it is uniquely like to play a video game and hear its music. Calls for phenomenological approaches have often expressed some sort of resistance to theory, or a resistance to the naturalization of theory. Founder of phenomenology Edmund Husserl's rallying cry 'back to the things themselves' (2001b, 168) was aimed at naturalism and its passive acceptance of the scientific worldview and the scientific method as a way of accessing it. Analogously, in music, Thomas Clifton's (1983) phenomenological critique of music theory was aimed at its passive acceptance not only as transparent description, but as the primary way of describing music. In taking a phenomenological approach to music in video games, then, what tendencies am I resisting? First of all, there is the tendency to confuse poietic and aesthesic perspectives, to analyse the way the music is composed or implemented instead of how it is encountered while playing. Then there is the tendency to analyse cues of video game music as autonomous pieces, or in relation to

a broad understanding of the game's narrative or genre, instead of in relation to moment-to-moment player encounters and decisions. Finally, phenomenology will be my starting point in order to resist my own theoretical tendencies, and to describe in as much detail as possible my experiences of encountering music in video games before attempting to explain them, generalize them in a theoretical framework, or even interpret them.

As 'pure description' of things as they appear to us, phenomenology works in two ways: by 'bracketing out' our assumptions about the existence of things in the world—also called the *épochè* or transcendental or eidetic reduction—and by 'eidetic variation,' which involves working out what features are essential to the phenomenon we experience, by imaginatively or (in certain approaches) physically considering variations of it. According to Clifton 'one of the most important distinctions between ordinary description and phenomenological description is that the latter describes those aspects of experience which are given in the experience, but which are not reducible to a single experience' (1983, 9). Thus, phenomenology starts with a description of experience, and then—without resorting to explanations of that experience—works through a series of considerations of similar experiences in order to find out what is essential to the particular object of experience under consideration, or what is essential to that particular way of experiencing it. This also reveals one of the fundamental tenets of phenomenology, namely that every experience is an experience of *something*—a structure called intentionality. Experienced 'somethings' are noema—of which my four categories of music are examples—and ways of experiencing are noetic 'acts'—which are ways of hearing in my case. Anything can be noematic content in phenomenological description: a musical cue or a melody, but also the visualization of a musical cue in a DAW or the recollection of a melody, and the latter two are considered different phenomena from the former two.

It is important not to confuse phenomenological description with interpretation of, or reflection on, experiences. These, as I will argue in Chapter 2, are the consequences of a particular noetic act, namely aesthetic hearing. In his introduction to *The Phenomenology of Perception*, Maurice Merleau-Ponty admits to the problematic qualities of phenomenology, though, when he suggests that '[t]he eidetic reduction is the commitment to make the world appear such as it is prior to every return to ourselves; it is the attempt to match reflection to the unreflective life of consciousness' (2012, lxxx). In

other words, phenomenology often necessarily involves what amounts to reflection, even if as it tries to minimize it. Hubert Dreyfus and Sean Kelly offer as a humorous example the attempt to elicit a first-person description of Jean-Paul Sartre trying to catch a streetcar:

> [T]he [researcher] can put a microphone on Sartre running to catch the streetcar and let him report as he runs. If he pants, 'I'm straining every muscle to catch the thing,' he has to be told to be more careful and only report what he directly finds in his experience prior to reflection. Finally, like a Beckett character speaking in the impersonal first person, he simply gasps—'getting closer, getting closer.' (2007, 47)

But as Merleau-Ponty suggested, phenomenological reduction asks us to go along with it, to pretend that we have unrestricted access to its phenomena, in order to arrive at a more complete understanding of its objects of studies.

Music scholars who have explicitly placed themselves in the phenomenological tradition include Alfred Schutz, Don Ihde, David Lewin, Thomas Clifton, and Tiger Roholt. But music has been an object of phenomenological investigation since it was first established as a philosophical discipline by Edmund Husserl (1991), figuring explicitly in his description of time consciousness. A melody serves as an example of how the perception of a temporal object involves more than just the perception of a series of instantaneous presents. We grasp a melody as a melody rather than just a meaningless series of notes because we understand each note in the melody in terms of the preceding notes and the possible future notes that we anticipate. Thus, any present 'moment' consists of a past in 'retention' and a future in 'protention.'[4] The importance of time and Husserl's example of time consciousness have been picked up and elaborated on by subsequent phenomenologists of music. Schutz, for instance, argues that '[a]ll musical experience occurs in the flux of inner time,' rather than in what we might call 'clock time' (1976, 46). He does make a side note that '[t]he listener may partake in the flux or "bring it to a standstill."' Although Schutz does not elaborate on this comment, we can identify the possibility of different ways of hearing in it that are close to my distinction between ludic and aesthetic music: 'partaking in the flux' as moving to music, and 'bringing it to a standstill' as reflecting on it aesthetically. How this figures into experiencing video game music I will describe in Chapter 3 and Chapter 2, respectively.

We find a similarly detailed approach in Lewin's (1986) phenomenology of music, proposed as a method for music theory and analysis. His 'p-model' also builds on Husserl's example, expanding it to consider how we hear harmonic context in terms of different 'percepts,' which Brian Kane (2011, 31) compares to Husserl's noetic acts, or ways of hearing. Like other phenomenological approaches to music at the time, such as Clifton's or Lawrence Ferrara's (1984), Lewin's model serves as a tool for music analysis, and their embrace of phenomenology was an attempt to circumvent the perceived prejudices of 'traditional analysis' (see also Miraglia 1998). The aim of my project is similar, but I am engaging with a different body of music analysis, namely audiovisual analysis. What is interesting about Lewin's approach, however, is that he ultimately comes to reject the p-model's universal validity in the same essay in which he proposes it. He argues that '[m]aking fresh music as a mode of musical perception—this link is missing in the perceptual theories we have so far considered' (Lewin 1986, 381) and follows this with a reference to Harold Bloom's ekphrastic assertion that 'the meaning of a poem can only be a poem, but *another poem, a poem not itself*' (1973, 70). In other words, music analysis is always a creative act. Lewin's 'performative turn,' to quote Nicholas Cook (2002, 96), suggests a commitment not only to what I call aesthetic hearing in terms of reflection, but also to ludic hearing in terms of playing along and playing with (as will become clear in Chapter 3), or as Lewin suggests, 'making fresh music.' Moreover, he implies that the two are, or at least should be, essentially related.

Kane suggests that instead of turning to Bloom's literary criticism, Lewin could have turned to the post-Husserlian phenomenology of Martin Heidegger and Merleau-Ponty. This is exactly what Thomas Clifton does in *Music as Heard* when he moves from a discussion of musical space and time (engaging with music analysis in a manner much like Lewin's) to the musical essences of 'play' and 'feeling.' Judy Lochhead argues that Clifton's conception of these essences amounts to 'a hermeneutics not a description of listening experience (in other words, the discussion is Heideggerian not Husserlian in tone)' (1986, 363). In 'feeling' as a musical essence, we find a particularly existential account of music listening, albeit an incomplete one. For something to be heard as music, Clifton argues, we always already have to take a positive stance toward it:

> A raw sound event is experienced as such when an involuntary proximity of sounds is felt as closing in—a condition we wish to be free of by fleeing

from it, putting it at a distance. This can be done literally or figuratively; even ignoring a sound event is fleeing from it, in a sense. On the other hand, music is experienced as such when a voluntary proximity of sounds is felt as opening toward: a condition *toward* which we use our freedom to effect the closure between ourselves and music. (1983, 279)

In other words, music always demands from us an emotional stance towards it, even if it is merely positive or negative. This has consequences for our understanding of background music, which I will describe in more detail in the first chapter.

What Lochhead calls hermeneutics and Kane calls post-Husserlian phenomenology is what Don Ihde calls a 'second phenomenology' (2007, 18), and this is where I will locate my categorization and investigation of the different ways of hearing music. Ihde suggests that the main difference between Husserlian 'first phenomenology' and a Heideggerian approach is an active description of intentional objects versus a '"letting be" of the phenomena to "show themselves from themselves"' (2007, 19). So while first phenomenology reveals the richness of experience that might once have been covered up by theoretical 'jumping to conclusions,' second phenomenology reveals the fundamental embeddedness of experience in history and culture that might have been covered up by a first phenomenology. For instance, a first phenomenology of the opening chord of The Beatles' 'A Hard Day's Night' might reveal its timbral complexities beyond its immediate harmonic functions and the notes of which it is composed, by listening to the song intently and bringing out the particularities of *that* chord, played on *those* instruments and recorded in *that* manner. A second phenomenology is sensitive to the fact that the timbral complexities of the chord were covered up in the first place by our musical vocabulary and ways of engaging with 'A Hard Day's Night.' It attempts to understand the song in terms of these constraints, which have their own historical and cultural dimension.

Ihde's is a phenomenology of sounds, and his first phenomenology reveals to us the richness of hearing that has been covered up by visually biased or 'oculocentrist' thinking. While keeping the 'weakness' of the auditory dimension in mind—the fact that we almost always hear sounds as sounds of things first—he considers the spatiality of the auditory field and its focus, fringe, and horizon, and the 'timefulness of sound' and our ability to focus on different points of Husserl's temporal present—focusing on protention, for instance, when we are anticipating a click-like signal (2007, 93). Throughout, Ihde

here and there remarks on the particularities of hearing music, attributing to it generally a 'broad focus that extends throughout the temporal span' (94) and a 'full immersion' into an auditory field in hearing 'Beethoven's Ninth Symphony in an acoustically excellent auditorium' (76). I will follow a similar trajectory from first to second phenomenology in many of my case studies, and they will show the possibility of ways of attending to music spatially and temporally other than 'broad focus' and 'full immersion.'

Continuing his description of the auditory field, for Ihde, second phenomenology is what happens at the perceptual 'horizon' of experience. Ihde gives the visual example of attending to a clock:

> It sits over there on the shelf behind me, not now appearing within my gaze. But as I turn my head the clock's presence comes into the field and I am not surprised. I have expected the 'invisible' to become 'visible,' for in the sedimented beliefs that I have, I selectly 'know' that just as the field transcends the thing, so the World transcends my opening to it. (2007, 107)

Similarly, I am interested in the appearance of music at our experiential horizon in a video game, and my ways of hearing can be considered as ways of appearing—only my horizon is temporal rather than spatial. As Ihde's example shows, the particular épochè in which we consider music to appear to us on a horizon raises the question of expectation, and where these expectations come from. This is Ihde's and Heidegger's 'world,' or Husserl's 'life-world.' Our relation to this world not only determines which things at our horizon are expected and which are unexpected, but what things *are* at our horizon. That the clock has any significance as a thing to Ihde is contingent on his armchair-phenomenologizing way of being in the world. So too does musical significance depend on our being in the 'game world,' a subset of the world. But it also depends on our experiences of music in the broader world—the conventions of film scores, of background music in public spaces, of the concert hall—what van Elferen would call a kind of musical 'literacy' (2016).

Following on from Heideggerian hermeneutics and Ihde's second phenomenology, I want to consider my approach as a 'letting be' of video game music in gameplay, and in the broader context of gaming. This means that

I will often start with detailed autobiographical or autoethnographic accounts of my experiences in games that I will analyse after the fact, rather than taking the active approach of phenomenological reduction while playing. In this regard, the approach to *Hades* with which I began can be seen as such an active approach, a Husserlian 'first phenomenology.' My two recordings can be considered as a kind of transcendental reduction of the phenomenon of musical accompaniment through 'gameplay variation.' In the first recording, I rushed to the next room without stopping while slashing at the destructible scenery with my sword; in the second recording, I moved around the room and stopped irregularly. What this variation revealed was the inability of the ostinato to impart specific meanings onto my actions; rather, it seemed to work the other way around. Moreover, this reduction showed the inability of the music to accompany specific actions of mine, such as slashing at the denizens of Tartarus (1'15" in **Video I.2**) with the same temporal synchronization as film music. But this active approach 'covers over' the particular ways of being in the game world that the two recordings represent: the first recording represents the confident movements of an experienced player, the second the hesitance of someone who is new to *Hades*, and both hear the music in different ways. Moreover, I was deliberately acting out these two characters to emphasize the difference between video game music and music in other audiovisual media, which again changed my stance towards the music—I was more play-acting than playing the game. For these reasons, to get at a more accurate phenomenology of different ways of hearing music, I feel it is important to describe my original experiences with video game music in as much detail as possible. This means that although it might seem that some of my case studies border on the anecdotal, they each play a crucial role in uncovering distinctions in the ways we hear video game music. As a consequence, the four chapters in this book start out with accounts of my experiences in games that exemplify the four ways of hearing—background, aesthetic, ludic, and semiotic music—before further developing them through discussions of related theories and other video game examples.

A 'letting be' or second phenomenology of the opening moments of *Hades*, then, would involve imaginative or eidetic variation rather than gameplay variation, which is essentially a form of what Summers and others have dubbed 'analytical play' (2016b, 34–36) and not phenomenological

description. Eidetic reduction could reveal how certain qualities of the ostinato are experienced in relation to my gameplay intentions or 'project,' be it rushing destructively to the next room, or taking my time to explore the first. Focusing on the first recording, the constant syncopated rhythm and lack of harmonic development seemed to underscore or accompany my grim determination to get underway. By imagining the ostinato as sounding or appearing different, it is possible to work out the way in which this 'grim determination' is an essential quality of this particular experienced ostinato pattern. For instance, I can imagine it having more of a straight rhythm, with the bass drum falling on the third beat instead of the eighth note before it. But while this may have taken away some of the cue's orientalist qualities, the relentless propulsion of the repeating rhythm could still have reflected my playing. Only when I imagine it as significantly faster or slower does the cue potentially lose this attribute. But the manner in which a different attitude in the second recording revealed different qualities of the same ostinato reveals that ways of playing need to be taken into account in order to understand the meaning of game music. A true 'letting be' of the ostinato in experience would then have to go one step further and take recourse to different ways of hearing in *Hades*. Did I really hear the ostinato's determinateness or lingering qualities, and did I play in response to those in the two recordings? Or did I perform my actions regardless of the ostinato's presence, instead moving the controls because this of my 'ludoliteracy,' my knowledge of the video game conventions of roguelikes and titles by Supergiant Games? Did I hear the ostinato at all? And what is the difference between these ways of hearing? These questions form the starting point of this book.

The two central manoeuvres of phenomenology can most simply be put as 'stay with experience' (the épochè) and 'look closer' (eidetic variation). This is why it can most productively be applied to widely shared, but not thoroughly understood, phenomena such as art, technology, and even existence and being themselves. In the more specific case of music, it can and has been employed to gain a better understanding of phenomena such as groove (Roholt 2014). Its contribution to broader academic debates is then to provide both nuance and conceptual clarity and to bridge gaps between the technical language of theory and concepts that seem closer to everyday experience of music. For example, Elizabeth Medina-Gray (2014, 31–32), in her analysis of modularity in game composition, makes a distinction between

musical and non-musical choices. Pressing a button in *Guitar Hero* to play a note or phrase is a musical choice, based on rhythmic timing; rushing through the first room to get to the next in *Hades* seems like a non-musical choice, based on the game's objectives. In both instances, the music responds to our actions, but the qualitative difference between the ways in which we hear that musical response can be described phenomenologically. A cursory glance would suggest that in the case of *Guitar Hero*, we are firmly in what Schutz calls the 'inner time' (1951, 88) of the song, whereas in the case of *Hades*, this temporal experience is at the very least a function of musical and non-musical expectations. However, looking closer at the music in *Hades*, we may ask about the inner time of the ostinato or the drone that preceded it (0'10"-0'27" in **Video I.1**). Jonathan Kramer might suggest that both can be seen as a form of 'vertical music' (1988, 375) that has no clear directionality to it. But then the rising-fourth resolution from the drone lends a clear harmonic directionality to the ostinato, one that I can hear as 'carrying forward' in my rush to the next room. In music from the classical concert-hall tradition, drones can be heard as anticipatory (cf. the opening drone to *Also Sprach Zarathustra*), and ostinatos can be heard as a 'setting underway' of a piece (cf. the string ostinato in Schubert's Eighth symphony). While it is undoubtedly the case that the anticipation created by the drone and the 'setting-underway' of the ostinato are also soundtrack conventions (think of the use of *Zarathustra* in *2001: A Space Odyssey* [1968], or the ostinatos in *The Dark Knight* [2008]) and thus in part non-musical, they are clearly conventions that go back even further to, for instance, bagpipe playing and dance rhythms. Moreover, to suggest that a 'setting underway' or Zagreus' (and as a player, my) 'determination' are inessential attributes to the ostinato is a misconstrual of my experience, of the phenomenon in question. Is 'rushing to the next room' in *Hades* then a completely non-musical choice, if soundtrack conventions are so closely intertwined with video game and audiovisual narrative conventions? It is these questions that a phenomenological approach uncovers.

Whose Phenomenology?

One issue with the applied-phenomenology approach that this book takes is it that it ultimately operates on the gambit that the subjective experiences

under investigation are shared. Throughout my discussions so far, even in the abstract to this book, the word 'we' often surfaces: but who is this 'we' and how can I speak for the experiences of others? Many of the objects of classical phenomenological investigations are assumed to be universally shared: Husserl's investigation of time, Heidegger's investigation of being and existence, Merleau-Ponty's of perception. But even in those studies, philosophers sometimes proceed from everyday experiences that might be common, but certainly not universal. Husserl's phenomenology of time experience proceeds from hearing a melody, which presumes the ability to hear music. Heidegger's analysis of being in the world starts with a phenomenology of mood, which makes certain assumptions about what it is to have a mood. Merleau-Ponty often relies on pathological phenomena such as phantom limb to make his points, but even when discussing colour perception he is taking recourse to certain assumptions about 'normal vision.'

At the heart of this problem of positionality in phenomenology lies Husserl's concept of the 'natural attitude.' As Dermot Moran (2013, 106) argues, Husserl developed this context in order to show the limits of scientific approaches to the world and their claim to objectivity, and how those approaches are always predicated on a natural, 'naïve' attitude and its assumptions. Phenomenology's task would be to describe this natural attitude. But whereas a scientific worldview can count on mathematics, empirical experiments, and the scientific method to argue that phenomena are shared between different perspectives, what is to say that my natural attitude is your natural attitude? This critique of phenomenology returns time and time again. Discussing the 'New Phenomenology' of Hermann Schmitz, for instance, who speaks of a 'felt-body' as the basis of perception, Friedlind Riedel (2020, 24–25) asks whose this felt body is. For his concept to work, Schmitz needs to rely on a 'normal' felt-body that excludes 'the infantile, the impaired, the animal, the psychotic,' rendering those somehow 'primitive' and unable to access a normative way of experiencing the world that underlies Schmitz's ideas. We may ask the same questions of someone like Merleau-Ponty or Heidegger, even before considering how some of the latter's fascist ideas influenced his phenomenology of 'being in the world.'

Sara Ahmed (2006, 3) suggests that it might be worth attending first to the positions and objects that orient phenomenologies, remarking that it is not surprising that many begin with tables as case studies: after all, that is what

many phenomenologists find themselves sitting at, phenomenologizing from. She elaborates:

> [W]hat is 'present' or near to us is not casual: we do not acquire our orientations just because we find things here or there. Rather certain objects are available to us because of lines that we have already taken: our 'life courses' follow a certain sequence, which is also a matter of following a direction or of 'being directed' in a certain way. (2006, 21)

Following Ahmed, I might then briefly turn to my own life course that has me taking as starting points the various case studies in this book; the games that are my 'tables.' Work on the PhD project that led to this book began more than a decade ago in the United Kingdom and continued in the Netherlands. The various autoethnographic accounts that my case studies proceed from belie this as well: listening to music while reading, walking while wearing headphones, attending concerts will all reveal the everyday life of a PhD student in the United Kingdom, where the research for this book was started in the early 2010s, and the everyday life of a lecturer in Utrecht, where it continued throughout the decade.

But we may follow the life course that orients the phenomenologies in this book even further back: my background is primarily in PC games, having grown up in an environment where this was the dominant gaming platform, and this presents a certain bias in case studies. My particular orientation also explains the lack of engagement in this book with some of the political and ethical issues that play in the world of video games, and in video game music by extension. A number of case studies that I spend much time on are of games by developers and composers that have been engaged in controversy in the past decades. In doing so, it might be argued that the book exemplifies the same tone-deafness that was found in many responses in the video game community to these controversies in line with the #GamerGate event (see e.g. Mortensen 2018). I do spend some time in my discussion of *The Elder Scrolls V: Skyrim* (2011) in Chapter 2 on how controversy around its composer influences the experience of an author in the game, but similar issues surrounding Blizzard as a company do not feature in my case studies of *StarCraft* or *Diablo III*. This is partly due to the focus of this book, which is not so much on the games, but on ways of hearing, much as tables are not the focus of Husserl's phenomenology. But it is also due to the fact

that the experiences that those case studies start were had years ago, before these controversies came to light. A more sustained phenomenology of how one hears game music in the light of moral disagreement with its creators deserves a study of its own, although I will briefly return to the issue in my conclusion.

1
Background Music

A solitary late-night shopper wheels her cart down the soup aisle of a nearby supermarket; she finds the repeating pattern of the colored labels vaguely relaxing as she glides by. (Clinical monitoring of her eye-blink rate would show that she has entered the first stage of hypnoid trance.) She wonders, as she does every time she traverses this aisle, why there are so many different brands of soup and who buys them all. She remembers, suddenly, that she has been wanting for a long time to try some chunky chicken noodle. The music drifting down from speakers embedded in the ceiling hardly registers on her consciousness. (Fink 2005, 2)

Before answering the question 'how do we listen to video game music?,' one should begin by asking, '*Do* we actually listen to video game music, and if so, when?' Of course, anyone steeped in gaming culture will be able to hum the theme to *Super Mario Bros.* (1985), but they might have picked it up when their little brother took the controller and played some of the game, giving them time to sit back and enjoy the sights and sounds of the game. Or they might have heard it in one of the many YouTube video performances on the most outlandish instruments, or even by a full symphony orchestra at a *Video Games Live* concert. In between avoiding pits, picking up coins, jumping on goombas (the game's mushroom-like enemies), and making it to the end of a level within the time limit, is there really a moment during which the player can divert their attention away from all this to the music? Or is it somehow possible to both play and listen at the same time?

I want to start my account of musical listening in video games at its boundaries, at those moments where we do not listen to whatever music there is. The above example from Robert Fink's *Repeating Ourselves* (2005) conveys one such boundary experience—specifically engineered background music that does not attract our attention, but still affects us somehow. This is just

one of many situations in modern everyday life where we encounter music in this, usually acousmatic, way: in films, on the television, in video games, in restaurants and shops, and in the workplace.[1] Sometimes we even engineer such situations ourselves, such as turning on the radio to help us study or creating a playlist for a morning run. In all these cases we are doing something else (or our attention is directed at something else) while music is playing, but this does not mean that our experience of the music is the same in each: the simple fact that we choose radically different music when reading a book and while going for a run suggests that more is going on.

Still, there is a sense in which we do not have full conscious access to what background music does to us when it is playing. Whenever we turn our attention to it, we could say that by definition it ceases to be background music. Moreover, multiple writers have attributed hypnotic qualities to it. Fink, building on examples like the quote above, argues that hearing minimal music works in similar ways to the (television) advertising that developed in the 1960s, slowly and unconsciously changing our perceptions, rather than explicitly having us follow a musical development:

> [Through] gradual shifts in perceptual structure, aided by repetition—pulse pattern minimalism is, in effect, a 'low-involvement' style of music. Beethoven, on the other hand, exemplifies an older and more familiar high-involvement style, where the listener is invited to participate consciously in a staged dramatic conflict of musical ideas. (2005, 157)

Similarly, Ruth Herbert considers everyday music listening as a form of 'trancing' (2011), and Paul Allen Anderson speaks of a 'kind of music-induced trance' that 'undergirds the automatism of much cognitive labor as well as those dull but otherwise energized hours on the treadmill' (Anderson 2015, 819). In film music scholarship, there is Claudia Gorbman's influential idea of 'unheard melodies' (1987), which explains the hypnotic workings of background music through the suture theory developed by Didier Anzieu and Guy Rosolato, among others. This psychoanalytic approach traces the workings of (background) music back to the 'sonorous envelope' of the mother's womb, closely related to Freud's death drive. Empirical psychological studies of background music tend to focus on the 'effects on behaviour' and 'influence' of music (e.g. Milliman 1986; Yalch and Spangenberg 2000; Dobbs, Furnham, and McClelland 2011). In his aesthetics of music, analytic philosopher Andy Hamilton goes as far as to attempt a philosophical

argument why Muzak (a common metonym for all background music) is not music, saying that it 'has no aesthetic aim, it is not meant to be listened to but to elicit a subliminal, Pavlovian reaction' (2007, 54), much like a drug would.[2] There are also studies of background music that attribute more agency to the listener. Tia DeNora (2000, 99), for instance, argues that music should be seen as a resource rather than a force over which listeners have greater or lesser control depending on the situation. Rather than a drug, music becomes a tool or a device for mood management and identity construction, and the issue of its deployment (who gets to decide which music is played where) is ultimately a political one (DeNora 2000, 162–63; see also Kassabian 2013).

Whether considered positive or negative, drug or tool, both characterizations consider background music as a black box. This, combined with the paradox of 'turning one's attention to background music,' prompts the question whether a phenomenological approach to background music is at all possible. Is that not an attempt to gaze over the horizon of consciousness? And do we really need to do this, or do we merely need to flesh out and describe individual situations of background music—ways in which the music shapes our experiential horizon? Video games form an interesting case study of background music, because they offer many different situations, different ways for music to be in the background. Firstly, there are multiple degrees to which the music can be composed and implemented to accompany and synchronize with the player's actions: a particular dynamic musical cue can be programmed to match a certain situation occurring in a game, such as picking up a power-up or fighting enemies (both are instances that we shall see occurring many times over the course of this book); it can play throughout a longer section of gameplay, such as a level or area; or it can play throughout an entire gameplay episode, such as the Nintendo Game Boy version of *Tetris* (1989), in which the player picks one of three cues that play until the player fails and has to start over.[3] Alternatively, the player can choose music from their own libraries or streaming services to play during a game, a feature implemented in the Microsoft Xbox 360 console in the 2000s, but afforded more generally by specific volume settings for music in most games. Secondly, music's role in video games bridges the gap between background music in our daily lives (music while exercising, in restaurants, etc.) and in film and television, because we are often interacting with a narrative that the music was designed to be a part of. These idiosyncrasies of video game background music make it potentially easier to characterize in terms of its 'shaping of horizons'—after all, we have overlapping, but slightly

different, situations in which music occurs in other parts of life to compare our experiences to.

Even though there exist no sustained phenomenologies of background music, one can find remarks on what it is like for music to be in the background of experience in writers as diverse as Don Ihde, Roger Scruton, Robert Fink, and Brian Eno. Eno, for instance, suggests that '[m]ost music chooses its own position' and that 'Muzak [here again metonymical for background music] wants to be back there' (quoted in Grant 1982). What is it like for music to 'want to be back there?' In this chapter I want to distinguish four different phenomenological approaches to background music. The first considers ways of describing music *just* on the horizon or fringes of our attention, as the aforementioned writers do. Borrowing from the *gestalt* psychologists, I will call this a musical 'ground.' The second approach compares music on the one hand to phenomenological accounts of moods, as something that we are always 'in,' that retreats from our attention in order to form the basis on which we come to perceive what is significant in our environment. On the other hand, this approach considers background music to the concept of atmosphere, which, although related to moods, are more part of a spatial environment or situation. The third approach builds on this idea of significance by considering background music in terms of a psychological theory of action-based perception, James Gibson's ecological approach. I ask what role background music plays in constructing the actions a video game environment affords to us. The final approach asks how, unlike moods or affordances, we can feel that we could attend to background music at any time, and that it would still function as background music. Here, I move on from the comparison with moods to considering music as 'equipment'— a tool for mood management. A case study of background music in the *StarCraft* series will serve as an example of each of these four approaches, and as a guiding line through the chapter. Along the way, I will be making comparisons to other video games, and to hearing music in film and other aspects of life.

Case Study: *StarCraft*

Blizzard's *StarCraft* series is arguably the most successful and popular real-time strategy game series (RTS) in the history of the genre. The original game *StarCraft* and its expansion pack *Brood War* were both released in

1998, with its sequel *StarCraft II: Wings of Liberty* (2010) and its expansions *Heart of the Swarm* (2013) and *Legacy of the Void* (2015) following over a decade later. Both games and their expansions have a similar set-up, with a single player campaign in which the player takes control of the armies of three alien factions—Terran, Protoss, and Zerg—engaged in an interstellar war. The source of the games' enduring popularity, however, has been the multiplayer mode. Particularly in South Korea the game grew to be almost a national sport: in 2005, the finals of the SKY Pro League *Brood War* tournament attracted 120,000 spectators, and the esport has its own professional players as well, living off sponsorships and tournament money. While part of *StarCraft*'s success in Korea can be attributed to circumstances outside the game—the rise of cyber cafés or 'PC Bangs' and the popularity of similarly deep strategic board games such as Go, for instance (Ashcraft 2010; Rossignol 2008)—some aspects specific to the games and their mechanics have been pointed out as well, namely their impeccable balance. At the end of this chapter I hope to show that these aspects seep all the way down to the way we experience *StarCraft*'s musical soundtrack. For now, however, I will start with descriptions of 'the game itself,' and 'the music itself' (in effect the game soundtrack's musical cues) in order to make the problematic of describing music-as-background clearer.

An important factor in RTS games—perhaps *the* most important factor to its players, if we are to go by online forum discourse surrounding *SC* and similar games—is balance. In games in general, achieving a good balance means providing the player with multiple viable choices that lead to progress, with no one strategy's outcomes significantly outweighing the others (Rollings and Adams 2003, 235–38); in game-theory terminology, balancing means ensuring there are no dominant strategies. In multiplayer games, imbalance can favour not only certain strategies over others, but one side over the other as well, which is why sides are often designed to be symmetrical. In chess, for instance, both players start with the same pieces, aligned in the same way on the board. The only element of asymmetry is that white goes first, which is enough to have huge effects on the strategic choices that chess players have. Many early RTS games, such as *Dune 2* (1992) and *Warcraft: Orcs & Humans* (1994), have similar symmetrical set-ups to avoid imbalance. *StarCraft*, however, was one of the first RTSs that successfully employed asymmetry between sides (in this case the three factions) without significantly unbalancing the game.[4] While balance is what ensured the game's longevity, asymmetry was its initial draw, as widely recognized in critical reception and paratextual

material: the first bullet point on the back of *SC*'s original box advertised 'three unique alien species,' meaning the player 'must devise totally unique strategies to master the specialized units, abilities, and technologies of each,' while Gamespot's review praised the game's 'personality' in terms of the 'notably different experience' the three factions provide, and the 'balance despite great diversity' (Dulin 1998). It is therefore no surprise that the source of the game's most enduring debates and discussions is the issue of balance. The question whether a faction or a unit is more powerful than the others—'overpowered' or 'OP'—is vital to the game's longevity.

If, following Jesper Juul's (2005) dichotomy, asymmetry is to be found in *StarCraft*'s rules, it is emphasized in its fiction. The Terrans are not the basic human space marines in a hostile and alien universe that the player is to identify with, but are instead 'othered' with stereotypical southern United States attributes: these Terrans speak in heavy southern accents and use slang words, they smoke cigar stubs in their space-suit helmets, and their suits and low-tech-looking vehicles are adorned with graffiti and trophies. At least as suggestively, they do not belong to a 'galactic republic' or a 'united federation of planets,' but to a Terran Confederacy. If the Terrans represent the trigger-happy, tough-talking marines from James Cameron's *Aliens* (1986) taken to a clichéd extreme, the Zerg are a more faithful replication of the film's aliens. The Zerg units are not built or trained but hatch from eggs, and the sounds with which they acknowledge the player's commands range from guttural, inhuman growls to a squishy salivating expectoration and the sound of scuttling insects. Finally, the Protoss represent a highly technologically and evolutionary advanced alien species, like giant 'little greys' with telepathic abilities and crystalline weapons and vehicles. The factions' distinctions are also presented through the music, with each faction having a separate soundtrack. In *SC1*, this consists of short cues to be played during mission briefings before the main gameplay and during victory screens afterwards, and four five-minute-long cues to be played randomly during a match. *SC2* has a similar set-up, although the game makes more frequent use of cutscenes during single-player missions that are accompanied by specific musical material.

In the cues the factions are differentiated musically in a number of ways. While in *SC1* the instrumentation is all electronically produced, with a heavy reliance on synth-pad textures underlying the cues, the use of harmony and specific synth instruments differs for each faction and sometimes between each cue. The Terran cues are carried by electric/synth guitars playing broken chord/alternate picking accompaniments, sometimes alternating

with distorted power-chord patterns, and with fast synth-solo-like pentatonic scales in the foreground. The heavy or industrial metal influences are rounded out by a (synthetic) drum kit. The Zerg cues on the other hand have numerous distortion, phaser, flanger, and chorus effects added to their instruments, which, combined with the 'acoustic distortion' or altered timbre of prepared piano sounds, imbue the music with a sense of foreboding. The Protoss timbres have more woodwind-like qualities to them on the one hand—complete with wordless female soprano vocals—and on the other hand are achieved through more traditional orchestral instruments and their idiomatic musical effects and phrases, such as harp arpeggios and melancholic oboe solos.

Even more important differentiators between the groups of cues for each species are rhythm, beat, and tempo (perhaps because the predominance of synthesizers tends to reduce the variety in timbre). Terran cues in particular feature many musical passages with a strong, up-tempo beat, driven by the aforementioned rock or metal percussion. These sections tend to break down into slower, often half-tempo sections that then build back up into another up-tempo metal section. The ebb and flow in tempo between sections is less drastic in the Protoss and Zerg cues, but it is still there. The beats and rhythms in the Zerg cues are generally more syncopated than the Terrans'—reminiscent of 1990s electronic dance music artists such as Aphex Twin and the Prodigy—and they fade in and out more gradually, their transitions blurred by sweeping synth-pads and counter-rhythms. In rhythmic terms the cues might even be described as eerie, with some of the more percussive background sounds falling just in between beats at seemingly random moments to destabilize them. Finally, the Protoss cues are generally a lot slower than the others. Their pace, usually between 60 and 90 bpm, is reminiscent of a funeral march, complete with muffled timpani that appear sporadically on the beat to emphasize the methodical, march-like quality. It is relatively easy to read connotations for each faction into the cues: the metal-loving, rough-but-determined Terran space truckers; the strange and creepy Zerg; the spiritual, mournful, and serious Protoss.

The above description may seem like a neutral attempt to put into language what is there in the music to be heard. There are, however, already some signs of an unconventional musicological approach: my descriptions of timbre in each of the factions are stretching the musical lexicon (or at least my vocabulary) almost to the breaking point, and I have to resort to references to sound production (phaser and flanger effects) and even some impromptu

onomasiology ('acoustic' distortion) as 'aesthesic descriptors' (Tagg 2012). But even more fundamentally, I am talking about musical *cues* here, which can be extracted from the files on the game disc and have been uploaded to YouTube by numerous users. There, titled and accompanied by one or multiple images, they can be accessed at will by someone who searches for instance for 'StarCraft music' or 'Zerg theme,' played back over and over again, scrubbed through, commented on, downloaded (with the right software), and shared. These material features of the cues were essential to my analyses, as they afforded tapping along to determine the tempo, navigating to certain sections to compare timbres, and gauging from the time indicator how long faster and slower sections were. Perhaps most importantly, they allowed for quick access, without having to boot up the game on a PC that has it installed and starting a mission. My 'neutral descriptions' would not have been possible, or at least would have been very difficult, without an active reception history of *StarCraft*'s music that has had players upload the game's music files to YouTube. So while they may seem neutral, they presuppose an access to a kind of listening that has certain material prerequisites.

So how do we listen to this music while playing *StarCraft*? As I have mentioned, some of the musical cues are only heard in the game's menus. The remaining twenty minutes or so of music are heard during single-player missions and multiplayer matches. Although many people's first encounter with the music might have been during the single-player campaign, the vast majority of players over the game's lifespan have many more hours invested in multiplayer matches, and I will begin by focusing on hearing music in a multiplayer match. Regardless of which faction the player picks, in multiplayer, they start out in the same way. With only a main building and some resource-gathering units, players quickly have to build up a base and an army before their opponent does. This constitutes the first few minutes of a game, after which the players start attacking each other, and the action gets more intense. While the tactical choices the player makes in the first few minutes are significant and partially rely on knowledge of what the opponent is doing, it usually involves the carrying out of a preconceived strategy, rather than moment-to-moment creative thinking and problem solving. The most intense moments happen during battles, which, in addition to tactical decision-making, involve quick responses and keyboard and mouse agility (some professional players have been known to perform over two hundred actions per minute). A phenomenology of background music in *StarCraft*, then, must take into account all these aspects of visuals, sounds, and gameplay.

Background Music as Ground

The first phenomenological approach I want to take considers background music as the 'ground' against which we perceive a 'figure,' as for instance Joseph Lanza does in his introduction of *Elevator Music* (2004, 3). The terms 'figure' and 'ground' are borrowed from *gestalt* psychology, in which they form essential components of perception (Koffka 1935, 177). They hold that any figure with a definite shape depends on a ground to provide the shape's contour. While *gestalt* psychology's focus is mainly visual, considering the shapes and contours of flat, two-tone images (such as Rubin's famous vase, see Figure 1.1), we can think of such relationships in hearing as well: the sound of a voice has a sharp contour against a ground of chatter in a café; the sound of a car passing by—a vague contour by virtue of its welling-up and fading-out—is heard against a ground of traffic noise. A typical musical relationship of this kind would be melody against accompaniment.[5] The figure-ground relationship has been taken up in the phenomenology of perception by Maurice Merleau-Ponty, who talks more generally about a 'perceptual something' that is 'always in the middle of some other thing, it always

Figure 1.1 Rubin vase

belongs to a "field"' (2012, 4). Similarly Don Ihde (2007, 74–75), in his phenomenology of sound, speaks of a relation of 'focus' to 'fringe' in our 'field' of auditory perception.[6]

Our field of normal, everyday auditory perception is intimately linked with our environment: sounds are emanated by objects around us—they indicate a direction in which we can turn to discern their source. Unlike the visual field, the auditory field does not lie in front of us but surrounds us fully. In musical concert-hall listening, Ihde argues that the music fills the auditory field to such an extent that we become 'immersed' (2007, 75–76). In the figure-ground relationship of *gestalt* psychology, the contour is part of a figure (Koffka 1935, 81). When we see Rubin's vase, the border between colours becomes its contour, and when we see the faces, the contour will belong to them. So we can say that when we hear music as fully filling our auditory field, it has no contours of its own. This non-directionality of musical sounds is a common feature of acousmatic music as well, particularly in audiovisual media. In a film or video game, nondiegetic music points us in no particular direction to look for its source,[7] and this contourlessness is what allows it to function so effectively as a ground—it becomes an auditory equivalent of negative space. But directionlessness and contourlessness are not the only aspects required for auditory phenomena to form a perceptual ground. Relative loudness is another: the appearance of a single, loud sound can draw my attention, and the continuous presence of loud sound(s) can make it impossible for me to attend to softer sounds. This is what Ihde calls sound's 'penetrating' qualities (2007, 81–82). Finally, auditory grounds have a continuity to them. We do not consider them to be interrupted by sounds but having a continuous presence throughout.

Taking these qualities into account, we can now consider the musical soundtrack of *StarCraft* as an auditory ground during a match. Starting out in a building stage (as shown in **Video 1.1** ▶), the player is confronted with only sporadic sounds, mostly voices: workers acknowledging orders and harvesting resources, reports of buildings completing, and the odd warning that enemy scouts are attacking the player's buildings or harvesters. On the other hand, when engaging an opposing army (see **Video 1.2** ▶), the music is completely drowned out by the sounds of battle: units shouting order confirmations, the cries of soldiers dying, vehicles exploding, and the almost continuous sounds of gunfire. Even though most of the game's sounds are quite centrally located in the stereo mix, they gain a directionality towards the on-screen visual effects they accompany. The music, on the

other hand, surrounds the totality of diegetic and interface sounds: wherever in the auditory space I turn my attention, I hear music through the noises of gunfire and units. It has this continuity not only spatially, but temporally as well: when the battle ceases and its sounds die out, I hear the music as having been there all along. If there is ever a recurring moment during an *SC* match, however, where the music is not part of a distant, virtually inaudible background, it would be during a building stage, either leading up to, or just after, battle situations. This is echoed in a post by a *StarCraft II* player on the TeamLiquid.net forums, reacting to hearing the Terran music cues uploaded on YouTube: 'When listening to that . . . all I can hear in my head is: "SCV READY!" "IN THE REAR WITH THE GEAR" "WHAT."'[8] These are sounds made by the Terran resource-gathering unit, the only unit the Terran player has available to them in the first moments of a match.

There is, however, a particular kind of reduction we have to perform in considering background music in video games as a ground. It is similar to what Michel Chion calls 'reduced listening' (1994, 30), a term derived from Pierre Schaeffer (1966), in that we pay attention to the sounds themselves. However, reduced listening for Chion is careful description of a single sound, divorced from its environment, which requires one to 'listen many times over, and because of this, the sound must be fixed, recorded' (1994, 30). Of course, the sounds in *StarCraft* have been recorded, but my description of them was in their 'new' sonic environment, during gameplay. For this reason, my previous description was more akin to what Steven Feld would call doing 'acoustemology' (2012, xxvii) or what R. Murray Schafer (1980) would call a soundscape study.[9] In *Sound Unseen*, Brian Kane (2014, 9–10) places Chion and Schaeffer's reduced listening in the phenomenological tradition of Husserl, connecting it explicitly to the transcendental reduction. He sees Schafer's project, on the other hand, as a 'counter-reduction' (2014, 152), a deliberate response to Schaeffer to reconnect and re-place sounds in their spatial environments. Both modes of listening, however, require a deliberate reduction, or at least a deliberate kind of attention to sounds or their environments. As such, a description of this kind of listening cannot not answer how music that dominates a soundscape—such as the cue that plays during the building stages of a *StarCraft* match or the short cues that loop throughout *Tetris*' gameplay—can be in the attentional background, how it can be background music. Even if we admit to including the music's relationships to visual occurrences in these descriptions, such as the sounds of gunfire directing us towards (or sounding like they 'belong to') muzzle

flashes on the battlefield, this still leaves the dimension of interactivity. When playing a game, we do not naturally take up a reduced listening attitude; we do not listen to the game's soundscape, taking in each and every sound and weighing it against the others; we are trying to win a match. So we need a different kind of phenomenological reduction from an acoustemological one to describe background music during gameplay.

The next step from a reduction to a soundscape would be to include the relation of my actions to the music in my description of *StarCraft*. Especially during the building stages of a match, when executing pre-planned actions, there is an almost rhythmical aspect to my motions, which need to be executed as smoothly and efficiently as possible. For example, once a unit has been produced, I need to give it orders and start building the next one immediately in order not to fall behind on my opponent. At the same time, my attention is focused ahead of me in time, on the opponent and on the battles to come, and away from my current actions. Consider the similarities of this kind of attention to entrainment to a musical rhythm: when we make music, we do not think of playing or singing a rhythm as 'this note . . . and then this note . . . and now this note and then quickly that one' (although we might learn it in that way) but more as a whole, a temporal *gestalt* within which the notes we play fall, or ought to fall. Similarly, actions during a building stage— placing buildings, training units—are most effectively performed when they fall within certain moments, as a background against which the match is played out. However, the rhythms of the musical cues do not synchronize in experience with the rhythm of our mouse clicks and movements—even the more pronounced and steady rhythms of the Terran cues. The cues do not 'help' players in the same way as music on a personal stereo helps you run. Whereas the runner can entrain their individual footsteps to the beats of the music (an example of ludic listening; see Chapter 3),[10] if the *StarCraft* player matches their actions to the music, it must happen on a more 'abstract' level: not to the level of individual beats, or even to general tempos of sections, but to an overall kind of 'mood' that the music sets.[11] This also means that while we could consider my movements as rhythmical in phenomenological reduction, I do not hear or experience them as such while playing—certainly not in light of the music. Clearly, merely relating a description of my actions to a description of the musical soundscape offers no satisfactory insights into the phenomenon of background music.

A final limitation of this first kind of reduction involves the problems with considering music as a ground in an intermodal relationship. While

we can say that the sounds of gunfire drown out the sounds of the music, we could not say that the bright muzzle flashes obscure the sounds of the music (a scenario that is easily testable by turning down the sound effects in *StarCraft*'s menus, leaving only the music). Nor could we say that my frantic actions during battle, ordering units to retreat and attack, push the music into a perceptual ground: in phenomenological description, I can attend to both. A musical ground seems to only make sense as part of an auditory, monomodal *gestalt*, not a multimodal one. Music can of course still form a *back*-ground in a multimodal context, but this demands a different kind of description.

Briefly turning to non-interactive audiovisual media, Nicholas Cook's multimedia model (1998, 70) describes the relationship between music and image (or other media) in terms of how a metaphor works. It requires a certain 'enabling similarity' (1998, 86) between its two terms, on the basis of which a new, emergent meaning is constructed. Cook's model is aimed at analysis that advocates a departure from the naturalistic attitude towards an Instance of MultiMedia (IMM), in which one medium forms a foreground against the background of another. One can do this, for instance, by 'listen[ing] to or look[ing] at each contributory medium on its own,' or through an 'inversion of the relationship' (1998, 134–35). While this can offer us a better understanding of the IMM as whole, it does not necessarily help us better understand the 'natural' relationship in which music is a background.[12] Supplementing the metaphor model with Gorbman's concept of semiotic 'anchorage' (1987, 34) makes up for this deliberate lack of hierarchies. Borrowing from semiotician Roland Barthes, Gorbman suggests that background music 'wards off the displeasure' of the image's potential ambiguity, which Barthes characterized as 'the terror of uncertain signs' (1987, 34).[13] Barthes originally introduced this term to explain captions for magazine photographs: they counter the ambiguity of the visual signifiers in the picture by 'anchoring' their signifieds (Barthes and Heath 1977, 38–39). Gorbman (1987, 40) argues that music in films can do the same thing. It can for instance help to situate a scene in a certain historical period, or to depict a newly introduced character as evil. In the case of video game music, we can conceive of our (inter)actions as an additional mode (or in Cook's terms 'medium') whose meaning music 'anchors' like a term in a metaphor. But while playing a match of *StarCraft*, we are not interpreting the meaning of the game's visuals: we are trying to best our enemies. As Cook stresses, these are models for analysis that attempt to understand the object *beyond* the 'natural

attitude' in which music forms a background, whereas here I am trying to describe this natural attitude. What the conception of background music as a gestaltist ground suggests, then, is that in the natural attitude towards a *StarCraft* match there is no such thing as 'multimodal' perception; we are not moved by the game to interpret our actions in terms of the music, or vice versa. In experience, the background music is just there, unrelated to what we are doing.

This seems like an unsatisfactory conclusion given the vast differences among the different factions' cues in *StarCraft*. How can we not hear these differences while we are playing? In the next section I will move from considering music as a ground to which we can attend in phenomenological reduction to an account of music as (setting a) mood. Before moving on, though, there are two preliminary conclusions we can draw about the background music in *StarCraft* from this first investigation. First, it shows that *StarCraft*'s background music is quite robust. The intensity of action of the game's multiplayer matches and the dense soundscape that follows its contours are crucial to its musical soundtrack being free to go through any number of drastic shifts in tempo and beat without drawing attention to itself. In a sense, the music is able to push and pull at me without bringing about the necessity of following it (which, if heard as such, would be a case of ludic hearing; see Chapter 3), because I am effectively operating in other tempos, in other directions that the game requires. Even if this does not completely support Eno's point that background music 'wants to be back there,' at least *StarCraft*'s music is *allowed* to be 'back there.' Secondly, as a ground, the music is continuous and contourless—even in the densest battle moments we assume it is there—and it fills our auditory field. It is not music that is 'over there,' somewhere in the diegesis, or even somewhere in the room where our PC sits, but surrounds us completely. This means that even though I might not fully attend to the music, I am what Thomas Clifton calls 'in music' (1983, 281–82). With these 'grounding' qualities of background hearing in mind, we can now start asking what is different in our experience when we find ourselves in a musical background in a video game.

Background Music as Mood or Atmosphere

The conclusion of the previous section, that hearing music as a background is a way of being-in-music, suggests much more than being surrounded

by music spatially when we attend to a video game's soundscape. I am surrounded by music temporally as well, in the sense that when my attention drifts towards the music, I hear it as having been there all along. And my engagement with the music can involve more than just passive listening. Researching Heidegger for this chapter, to give an example, I had *The Essential Leonard Cohen* (2002) playing in the background. Trying to concentrate, the music insisted itself upon my consciousness whenever a song in a new style came on: the almost comically synthetic synthesizers of 'The Tower of Song,' or the eerily familiar-sounding introductory bars to 'I'm Your Man' that made me wonder who killed Laura Palmer again. At other times I only became aware of myself singing along to 'Hallelujah' several seconds after I joined in with the track. I only noticed the played-to-death track (to which I might have been singing along as well) 'So Long Marianne' when I tried to read a particularly difficult passage: less than half a sentence into the section my attention drifted towards Cohen's voice and I found myself unable to concentrate on Heidegger's dense prose. My background hearing involved a continuous back-and-forth between attending and not attending to the music, involving singing along and the intrusion of sung words upon read words. We can say that during those moments of attention, it was more than that music was already there in the environment, I was already bodily (at least vocally) engaged with the music—I was already 'in music,' in Clifton's terms.

We can compare the relative prominence of Leonard Cohen's music in the soundscape of my apartment to the relative prominence of the music at the beginning of a *StarCraft* match: non-musical sounds occur only sporadically. The same goes for *Tetris*, where the presence of the music vastly outweighs the staccato sounds of blocks being spun, moved, and dropped. Besides *Tetris*, a large variety of games feature music that is relatively uninterrupted by other sounds during a gameplay session. Often these are puzzle or strategy games that give the player a substantial or indefinite amount of time to think and decide upon their next action. Whereas *StarCraft* and *Tetris* have the hectic pressure of real-time gameplay, turn-based games like the *Civilization* series (see Chapters 2 and 4), *Final Fantasy* (1987), or *Slay the Spire* (2017) provide long periods where music almost exclusively occupies the soundscape. And we may include other genres where the player is given ample time to think and strategize as well, from adventure games like *The Secret of Monkey Island* (1990) and *Disco Elysium* (2019) to simulations like *SimCity 2000* (1993).

Consider a typical gameplay sequence from *Slay the Spire* as an example (**Video 1.3** ▶). In this turn-based, roguelike deck-building game, the

player first picks a character for their run in the menus, after which the menu music fades into the cue for Act 1 (0′12″). Clark Aboud's up-tempo orchestral cue plays during most of the player's run through the game's first act, whether they are fighting enemies, picking reward cards, or exploring unknown locations. The cue only dynamically fades out briefly when the player character encounters a rest site (3′04″) and sometimes makes way for other specific room cues such as during a more difficult elite fight (3′35″), but is otherwise continuously present. It does share its soundscape with frequent sound effects varying from enemy growls and cries to shuffling cards, but these are all relatively short, lending even more soundscape prominence to the ostinato patterns and legato melodies of the Act 1 cue. The start of the player's run coincides with the start of the cue, beginning like many pieces of music with eight bars of its accompanying pattern (0′12″). By the time I have selected the boons offered by the whale-like Neow, the main melody has already started (0′22″). This G-minor melody follows a symmetrical question-answer pattern, moving to the dominant before coming back to the tonic, after which it repeats with melodic and instrumental variations, all in eight-bar patterns. Apart from the initial synchronization of the cue's introduction with the introduction of my run by Neow (albeit loosely—I can linger in front of the whale for as long as I want), none of these musical qualities seem to directly comment on my actions. The cue is prominent in the soundscape, and its melodies strike a balance between repetition and variation that could invite the curious ear to follow their development. Yet in my decision-making—picking the right cards to best my enemies—these qualities did not draw my attention at all.

We could say that in all these cases of background music dominating a soundscape, be it in a game like *Slay the Spire* or when having Leonard Cohen on while reading, the music effected what Rod Munday calls 'cognitive immersion,' in which 'music functions as a "wall of sound" which serves to prevent potentially distracting sounds from entering into the ... situation' (2007, 57). After all, there was no immediate 'enabling similarity' between the songs of Leonard Cohen and *Being and Time* at any one moment of my reading it. And any possible enabling similarity between my run in *Slay the Spire* and the symmetrical melodies and ostinato accompaniment was lost on me in the moments of playing cards and picking rewards. But we can ask the same of a *StarCraft* match: at which particular moment would we hear an enabling similarity? As I said, the players start out in virtually the same manner and go through similar motions and actions building up their base and armies. For

Cook, the most common form of enabling similarity is kinesonic, a congruence between music and another medium in terms of movement, or what he calls an 'iconicity of process' (N. Cook 1998, 79; see also Kamp 2020). Yet the musical cues are completely different in rhythm and tempo among the three factions: the up-tempo, straight, and heavy beats of the Terrans; the eerie waves of breakbeats of the Zerg; and the slow, mournful funeral marches of the Protoss. And the cue the player hears first when starting a match is random as well. The musical soundtrack being completely nondynamic, there is no way in which either the tempos or fluctuations in intensity of the musical cues match up to those in the matches. To continue the analogy to running while listening to music from the previous section, one could say that while music remains continuously significant to the runner—at least for as long as they match their tempo to the beat—the significance of *StarCraft*'s music is not so easy to pin down to specific moments while playing, and certainly not as straightforward as following a beat. Beyond matching the faction I am playing as, any musical occurrences such as development, breaks, or melodies happen in spite of my actions, and the rigorous demands of competitive gameplay mean that any relationship between what is happening in the game and what the music is doing on that level are coincidental at best. Any significance the music has during a match depends on my ability to attend to it while performing other actions. Then, however, the question becomes: why would I shift my attention to the music, or why would the music draw my attention?

I suggested earlier that if I played *to* the music in a *StarCraft* match in any way, it would have to be to a general 'mood'—not during any one moment or period of time. The same goes for my engagement with the music in *Slay the Spire*. I was not playing to the flowing orchestral melodies, nor even to the larger symmetrical structure of the cue. After the initial moment of starting my run coinciding with the start of the cue, any kind of relationship could only exist on a much broader timescale. In the case of listening to *The Essential Leonard Cohen* too, the most significant moment was when I put the music on. It was a form of 'mood management,' to make sure that I was 'in the mood' to read. The idea of using music to manage, entrain, modulate, or, more negatively put, manipulate one's mood or that of others has been around for a long time, going back to Plato's *Republic* (Frith 2002; DeNora 2000). Goethe considered that the goal of setting a poem to music is to 'put the listener into the mood that the poem establishes' (quoted in N. Cook 1998, 107). More recently, Muzak lost its illustrious brand name in favour

of its new parent company's name Mood Media (Anderson 2015, 812), underscoring the relationship between background music and mood once more. From this it follows that it would be prudent to consider background music in terms of 'setting a mood'—or in other words, to consider the relationship of being-in-music to being-in-a-mood. What I want to answer here is not so much how music puts us in a certain mood, a question that has been asked in many an empirical study (e.g. Mitterschiffthaler et al. 2007; Juslin and Sloboda 2010; Chanda and Levitin 2013), but what it is like to be in a certain mood. In other words, what is a mood, phenomenologically?

Ihde argues that 'in phenomenology every "mood" reveals something about the quality of an appearance. In a state of boredom the visual "world" lacks its normal sense of involvement "with me," whereas in a state of ecstasy the "whole world" leaps out "toward me" in its beauty and awesomeness' (2007, 40). But Ihde's use of the word 'world' suggests that moods are much more all-encompassing than revealing the quality of individual appearances. Matthew Ratcliffe refers to Heidegger to argue the difference between moods and emotions:

> Moods constitute the various different ways in which we are able to experience things as mattering. Hence they are presupposed by intentionally directed emotions. Take fear, for example. Heidegger claims that the experience of being afraid of something presupposes an appreciation on our part of distinctive kinds of possibility; 'different possibilities of Being emerge in fearing' (1962, 181). In order to be afraid, one must already find oneself in the world in such a way that being in danger or under threat are possibilities... According to Heidegger, mood determines the space of possible kinds of concern. (Ratcliffe 2009, 355–56)

Things matter to us and are significant to us, on the basis of a mood, and in this relationship moods retreat to the background. While we are in a mood, we are not concerned with the 'qualities' of this mood, the qualities that it imparts on our 'world'—in that mood, they seem like a natural part of the world. It is only because of the temporary nature of moods that we come to see that the world is not really like this, that it can be different. A good example of this is being 'blinded with rage.' We only come to recognize that we were in a certain mood on the basis of another mood. As Heidegger says, 'when we master a mood, we do so by way of a counter-mood; we are never free of moods' (1962, 175). Ratcliffe gives the example of depression as a

mood that is deep to the extent that it is all-pervasive: '[o]ne cannot see outside it' (2009, 360).

Background music has similar qualities to the 'self-concealing' and 'world-disclosing' natures of moods.[14] When we turn to music in a *StarCraft* match in a Heideggerean manner, one that 'lets it be' an existential background like a mood (see my introduction), we find very little of significance. For instance, I hear *StarCraft*'s music as temporally static, or in a way, timeless. While the cue that is playing has certainly progressed in time, from one section to another, I do not hear it as having progressed when I turn my attention to it during a match. This might seem phenomenologically incorrect, given (for instance) Ihde's argument about the temporality of auditory events:

> When I listen to auditory events there seems to be no way in which I can escape the sense of a 'coming into being' and a 'passing from being' in the modulated motions of sound. Here temporality is not a matter of 'subjectivity' but a matter of the way the phenomenon presents itself. I cannot 'fix' the note nor make it 'come to stand' before me, and there is an objective-like recalcitrance to its 'motion.' (2007, 94)

However, the appearance of temporality is a direct consequence of Ihde's phenomenological reduction. The opposite, timelessness, occurs when attending phenomenologically to a stationary object:

> If I look at the calendar on the wall, it stands out as motionless and mute, and in relation to it I detect only a massive nowness. Its appearance neither dramatically comes into presence nor passes from it in its motionless state. If I want to take note of its 'temporality' I must already make a reflective turn to noetic phenomena: it is my consciousness that is aware of the passing of time before this object. (2007, 94)

We can say that something similar to the calendar happens in background music. The static continuity of the music as a background phenomenon (its 'massive nowness') is lost when we attempt a phenomenological reduction, and its temporality is revealed. But its temporality is only revealed in the musical details: the notes, melodic phrases, and sections of the music that 'come into being' and pass from being. In the background hearing attitude of a *StarCraft* match, the temporality of musical details has no significance.

The insignificance of musical detail in backgrounds is echoed by Aaron Ridley. For Ridley, musical understanding, or musical listening, requires the listener to be aware of passages of music 'that take up time without being meant to be especially noteworthy or striking' so that 'high-interest material stands out more clearly by contrast' (2004, 37). This echoes the gestaltist conception of figure and ground, and, for Ridley, it happens both in time and in musical space:

> To the extent that one hears background material as background, I would suggest, one hears it as at least potentially replaceable by other material that would do the job (of being a background) equally well. In almost every piano sonata, for instance, where Mozart used the straight Alberti bass he could just as effectively have used one of its variants . . . Part of what it is to be an efficient background, after all, is to be unobtrusive in the relevant context; and unobtrusiveness is clearly best secured by lack of individuality. To be sure, one might *notice* if one patch of unobtrusive background were substituted for another in a very familiar piece. But to the extent that it really is background, one could have little reason other than pure habit for objecting to the change. (2004, 38)

While Ridley is talking about attentive, concert-hall listening in which only the musical sounds have significance, we can consider the musical soundtrack of *StarCraft* to have similar features as a background, which come down to a lack of individuality. This is achieved at least in part by the nondynamic nature of the soundtrack: we could find any passage from a particular faction's cues accompanying any moment in a match. The same goes for the Act 1 cue from *Slay the Spire*. Although the cue is rich with melodies that would in another listening context be in the foreground, the fact that they can occur at any moment during a run allows them to recede to the background.

I want to be careful, however, in making absolute statements about what can and cannot be background music in a video game. The music in both *StarCraft* and *Slay the Spire*, regardless of their nondynamic nature, can absolutely draw the attention of the player at any point for whatever reason (and become more like the ways of hearing described in the next chapters). At the same time, dynamic soundtracks, or dynamic transitions more specifically, do not necessarily attract attention. To some degree, this is afforded by the aesthetic of 'smoothness' that Elizabeth Medina-Gray (2019) identifies in video game music. Musical smoothness, as opposed to disjunction, is about

how well two cues or 'modules' fit together in terms of five aspects: meter, timbre, pitch, volume, and abruptness (2019, para. 18). Often this poietic 'backgrounding' of the music is achieved in combination with a dense soundscape in which music retreats in favour of dialogue and sound effects. In one of the early combat set-pieces of *God of War* (2018), the music obeys this combination of game-musical and film-musical rules in order to 'underscore' the action as unobtrusively as possible. And the soundtrack has to work harder in *God of War* more than in most games to follow these rules, because the game's camera rigidly follows the protagonist Kratos without any cuts between levels, gameplay sequences, or cutscenes—in effect operating like a one-take film. After Kratos is thrown off a cliff by the mysterious Stranger at the start of **Video 1.4** ⏵, creating one of several lulls in the fight, the music falls away temporarily before sneaking back in as Kratos makes his way back up, almost inaudibly. The string drones and muffled drums are even obscured by the falling rocks from the cliff (0′00″–0′15″). The manner in which the strings accentuate the Stranger's monologue then creates a smooth transition to the final combat sequence of the fight: the sudden tremolo stinger as the Stranger lunges across the gap (0′39″) creates harmonic and melodic tension that is resolved by the syncopated string ostinato that starts off the combat module (0′43″). Although the start of the combat module has a degree of abruptness, or disjunction in Medina-Gray's terms, this is smoothed out by its harmonic preparation and the increase in volume effected by the stinger. At the same time this transition underscores the Stranger's words 'Let's finish this.'

Medina-Gray stresses that not all smooth transitions are designed as background music, but that not all disjunctive transitions necessarily draw the player's attention either (2019, para. 14). In my example of a *Slay the Spire* run, waking up one of the game's elite enemies triggers a sudden transition to a cue that not only interrupts the Act 1 cue mid-measure (3′35″ in **Video 1.3** ⏵), but that is also drastically different in terms of meter, tempo, and pitch material, shifting to B minor and a march tempo. This musical disjunction was lost on me as an experienced player, however, as I knew the creature would be waking up after playing my Strike+ card and would be more dangerous than my previous opponents. In Ridley's words, these moments in *God of War* and *Slay the Spire*, irrespective of how smooth or disjunctive they are, have a lack of individuality to them. Following Ihde, the lack of significance and individuality of these musical transitions can be described as a lack of temporal significance as well, pointing to the temporality of moods.

Although upon analysis or attentive listening, the music during the fight in *God of War* is clearly carefully synchronized with its narrative development, when heard as background music it just portrays the overall mood of the encounter. The more disjunctive and less dynamic music during a run in *Slay the Spire* portrays the overall mood of that run, or at least of Act 1.

One issue with the idea of background music as mood is that moods are essentially personal phenomena, while background music is experienced as external to our selves: however inconspicuous, it is something that exists out there in the world. Whose mood is the music in *God of War*, *Slay the Spire* portraying? That of the player's avatar? And how can we understand mood in a game without a specific avatar, like *StarCraft*? This is why we may turn to the phenomenon of atmosphere to better characterize this aspect of background music. Atmosphere has become more prominent in contemporary aesthetics thanks to the work of Gernot Böhme, who, building on the New Phenomenology of Hermann Schmitz, has argued for the centrality of this concept to practices such as music and architecture. He explicitly connects atmospheres to moods, describing them as 'spatial carriers of moods' (2017a, 20). A certain room can for instance have a cozy, an exciting, or a creepy atmosphere depending on its lighting, its wallpaper, or the music that is playing there. One might imagine the usefulness of this concept purely by considering that room as a virtual room in a video game: a dank cave in a game can have a creepy atmosphere thanks to its lighting, or the music's low-pitched dissonant harmonies. Indeed, Gregor Herzfeld (2013) argues for the close relationship between games and atmosphere because 'games have a very intense relation to space,' discussing a number of case studies from *Pac-Man* (1980) to *Gran Turismo* (1997) and *Half-Life* (1998). But whereas mood might be an imperfect phenomenological characterization because of its personal nature, atmosphere brings with it certain issues of its own. Significantly, atmospheres reveal or announce themselves through their spatiality. As Böhme suggests (2017b, 73), while we are always surrounded by atmospheres, they become most apparent when we move from one atmosphere to another, like from a cheerful forest to a dank cave. In this regard, they share many commonalities with Julianne Grasso's 'affective zones' (2020) in video games and the ways transitions between musical cues figure into these. For instance, *Slay the Spire*'s musical soundtrack is at least partially connected to its different acts that can be seen as zones, spaces that the player progresses through when climbing the game's eponymous spire. But this means that first of all, we may wonder to what extent music in games

that do not prominently feature spatial movement can be better considered as atmosphere rather than mood. Certainly, there is spatiality to an abstract game like *Tetris*, but how does its soundtrack figure into this? Even in a representational game like *StarCraft* that very clearly features spaces and spatial decision-making in its gameplay, we may wonder to what extent the Terran, Zerg, and Protoss cues are related to that spatiality. Secondly, an important component of atmospheres is the fact that they announce themselves, which makes the idea of background music as atmosphere problematic. This 'announcement' might be better seen as a moment of semiotic hearing (the music makes me recognize that I am in a dank cave, or on the first level of *Slay the Spire*) or aesthetic hearing (I appreciate the dankness of the cave or the level and how music features into this).

As conceptions of background music, mood and atmosphere each have their own merits and drawbacks. Atmosphere does justice to the fact that background music is a semi-objective part of the world around us,[15] but mood does justice to the fact that background music is both self-concealing and world-disclosing, or in our case 'game-world-disclosing.' But in order to ask in what way mood music discloses or 'colours' that world, we have to step out of the mood the music has put us in. There are two ways in which we can do this. The first is to take a third-person approach to music and talk about it in terms of its effects. The second is to consider the way in which the mood-like nature of a mood is normally revealed to us, which, much like with atmosphere, happens when our mood changes. While the first method might seem to require suspending the phenomenological method, there are ways around it, as I will argue in the next section when considering musical affordances. I adopt the second approach in the final section of this chapter, when discussing the music of *StarCraft* in the game's larger context as an esport.

Background Music as Affordance

Towards the end of my discussion of background music as ground, I argued that our normal, everyday listening does not weigh sounds against each other in a soundscape divorced from its source. What we hear and how we listen are determined by our goals and intentions, and our relation to our environment (Gaver 1993). Upon hearing the sound of a car when trying to cross a street, we do not stop to admire the slow crescendo, but identify it as approaching

us, gauging its direction and its speed. When pouring tea, we hear a small change in timbre in the sound because it indicates the filling of the mug, not merely because it pleases us. In the previous section, I argued that background music is comparable to a mood, in that it retreats from our attention to disclose our environment (the game world in the case of video games) in different ways. For instance, the busy commuter will attend to the soundscape of a city differently than the leisurely shopper. Similarly, our attention to a video game soundscape depends on our mood and attitude towards it. In an empirical study of sound in *WarCraft III* (2002)—another, very similar real-time strategy game by *StarCraft*'s developers—Kristine Jørgensen (2008) found that playing the game with the sound off increased players' reaction times and decreased awareness of off-screen events, especially when multitasking. The significance of certain sound effects thus gets more important as more multitasking is required, which tends to coincide with the most intense battle situations. What increases during these moments then is not just the density of sounds, but also their significance. This again explains why we hear the music in *StarCraft* as background music, but the question remains how we can conceive of the music as (playing a part in) 'disclosing' the game world of *StarCraft*. If my comparison between music and mood is apt, background music is at least partially responsible for a way in which we have a particular pre-reflective understanding of the video game world. What is needed, then, is an explanation of how it functions as such.

Phenomenology is a good way to approach musical experience because it provides the tools for describing with a high degree of precision *what* we hear when we play a video game. However, it does not answer questions about *why* we hear music in one situation, and not in another, and why music means or indicates what it does and not something else. As Ihde (2007, 29) stresses (following Husserl), phenomenology remains purely descriptive, unwilling to adopt any explanations or theories that do not follow from what is given to consciousness. Thus, phenomenological description allows me to say that when there is a sudden, disjunctive change in the music of *Slay the Spire*, my attention is drawn to it first, and subsequently to visual and auditory cues in the virtual environment that could have caused this change (a case of semiotic hearing; see Chapter 4). It cannot however answer why it is that my attention is drawn to the musical change, and what happens subsequently. To explain my actions rather than describe them, I will have to temporarily 'step out of' the époché. The above description does however suggest a close relation between musical perception and action, which naturally follows from

the fact that the video game is an interactive medium. The psychological approach to perception that I will adopt here must then incorporate (inter)action in a way that complements a phenomenology of video game music.

One such theory that considers perception in terms of interaction with an environment is James Gibson's ecological approach. Gibson's theories were developed in the mid-twentieth century and are most extensively laid out in his 1979 book *The Ecological Approach to Visual Perception*. At the basis of the approach is the idea that the perceptual systems of animals, including humans, evolve in tandem with their environment in order to pick up the information that is most important for their survival. Gibson's work was influenced by the pragmatist philosophy of William James and the *gestalt* psychologists and ran counter to the predominant ideas on perception from cognitive psychology at the time, which focused on discovering the mental processes and systems that process sensory information from the outside world as if it provided a 'kaleidoscopic inflow of sensations' (Gibson 1966, 5).[16] Gibson argued that organisms do not need to 'decode' a complex array of data. Rather, their sensory systems resonate with their environment and have developed in such a way to pick up that information that they require. This resonance follows from an evolutionary process of mutual tuning, in which the environment shapes organisms to perceive and react to it—to fit inside their 'niches'—just as organisms shape the environment in turn.

This means that we too have evolved to perceive our surroundings in terms of the actions that they afford us. The term 'affordance' coined by Gibson therefore becomes a central concept in this theory. Affordances are always relational properties, in that they are dependent on the one hand on the physiology and interests of the animal, and on the other hand on the makeup of objects in the environment. Eric Clarke (2005, 37–38) gives the example of a termite, to which a wooden chair affords eating; to a person of a certain build, it affords sitting. Affordances can be good (fire affords warmth) or bad (fire also affords burning), and they are gleaned through aspects of the environment that remain invariant in perception under change of time or locomotion. Gibson's entire idea of an environment is built upon these relational properties. For instance, an obstacle is an 'animal sized object that affords collision and possible injury,' which is nested in a larger environmental affordance he terms a 'path,' which 'affords locomotion from one place to another, between the terrain features that prevent locomotion' (Gibson 1979, 36). This also means that environments do not consist of physical entities like atoms or galaxies, but of surfaces like the ground and objects like trees

and rocks (Gibson 1979, 9). Temporally, the scale of an environment is tuned in relation to the life of an animal as well, and thus an environment contains events, cycles, and changes like falling rocks and rippling waves, but not the erosion of mountains. Thus, in an ecological approach, the environment is a relatively stable, permanent ground (borrowing this term from *gestalt* psychology) against which events and processes can take place. Because it is possible for environments to change (e.g. due to weather and seasons), Gibson speaks of environmental stability as persistence rather than permanence.

In the study of video game music and sound, the concept of affordances has been applied by Julianne Grasso (2020), Mark Grimshaw (2008), Erick Verran (2021), and me (2014; 2021b), particularly in order to describe the way players are invited to interact with a dynamic soundtrack. As an interactive medium, video games lend themselves particularly well to a Gibsonian approach. Virtual worlds have affordances built into them by their designers, and through verisimilitude, generic conventions, or sheer audiovisual ostentatiousness these can announce themselves to players. In a skateboarding game like *Tony Hawk's Pro Skater*, rails and park benches afford grinding; in an assassination game like *Assassin's Creed*, victims afford stabbing, emphasized through a visual interface prompt that indicates the button players are invited to press. Verran builds upon Gibson's term niche to suggest that unlike the natural environment, game environments are 'inside-out niches' that players do not necessarily fit into, but that are shaped to fit players' generic expectations 'through the development team's finite number of beta-tested challenges, obtainables, and pathed landforms' (2021, 41). While game environments are undoubtedly designed or 'authored'—see my discussion of authored moments in Chapter 2—to fit player expectations, this, like other generic conventions, can also be said to be a Gibsonian process of mutual tuning, with video game affordances shaping player expectations and vice-versa. As Grasso suggests, '"learning" in virtual environments is linked to affordances for interaction' (2020, 43).

Where Verran considers the 'total affordance' of games as a 'playability' and the way sound and silence figure into this, Grimshaw, Grasso, and I consider the sonic and musical affordances of specific games and game genres. Grimshaw's *Acoustic Ecology of the First-Person Shooter* (2008) is a landmark study that considers the importance of sound (diegetic and nondiegetic interface sounds) in FPS games from a Gibsonian perspective, and I have argued how nondiegetic dynamic background music can structure these affordances. Through the way in which cues stop and start, transform and

transition into one another in response to player interactions, they shape what players interpret as signs of safety or danger, hazard or help; in other words, they shape what the game world affords. This occurs not only diegetically but 'supra-diegetically' as well. 'Danger state' music in the first-person shooter *Unreal* (1998) structures situations in which diegetic sounds afford turning towards an enemy and shooting it (Kamp 2014, 242). But by continuing to play or stopping when a player's avatar dies in a platform game like *Super Mario Bros.* (1985) or *Super Meat Boy* (2008), music can also structure the affordance of 'death' in a game, not for the diegetic avatar in the game world, but for the player in the arcade hall or in the living room (Kamp 2016). For Grasso, as for me, musical affordances are very much tied up with the 'physical' affordances for interaction in a game space 'that do not necessarily rely on sound' (2020, 46). Learning the workings of a game world and its mechanics for interaction then always leads to an understanding of these intermedial, intermodal affordances and the way music plays into them.

The concept of affordances has become thoroughly interdisciplinary. As a psychologist, Gibson was concerned primarily with an empirically testable, third-person account of perception, but the ways in which his ideas have been taken up in sociology and musicology raise the phenomenological question what it is like to experience an affordance. Working in the psychological tradition of William James, Gibson thought his ecological approach should ultimately be empirical in nature, and phenomenological description was no more than 'a good starting point for identifying significant psychological phenomena that warrant more detailed analysis' (Heft 2001, 114). Nevertheless, many of Gibson's own examples of invariants and affordances are much like phenomenological descriptions, and there are striking similarities between the observations of some later ecological psychologists and phenomenologists like Ihde.[17] Philosophers Hubert Dreyfus and Sean Kelly see an affordance as a kind of knowledge we have about the world that is not a belief. Rather, it is a kind of pre-reflexive, immediate 'sense' we have of objects in the environment that is lost in reflection. The best way Dreyfus and Kelly have of expressing our experience of these affordances is in terms of 'an experienced tension in the situation that my body is immediately drawn to reduce':

> Consider the example of walking along the wall at a museum and having your attention caught by an enormous picture just to your right. At first one is simply overwhelmed by its size, perhaps confused about how to respond.

Quickly, though, one feels oneself pushed to step away from the wall in order to get the painting into view. One does not decide to step away, as if it were a pure and spontaneous act of the will. Rather, one responds immediately to a felt demand of the situation; one is moved to retreat from the picture as if it were repelling one. As one steps back, and the painting comes into better view, the tension that was created by being too close to it is reduced. In such a situation the painting itself leads you to stand at an appropriate distance for seeing it. (2007, 52)

I will go one step further than this and argue that in our acting 'appropriately' to this situation, we would not experience 'tension' at all: we merely stand where we are supposed to stand. Only when something 'breaks down' in experience does the affective tension reveal itself (a phenomenon I shall return to in the last chapter). This is also why Grasso distinguishes environmental affordances from 'affective zones' in her account of video game music. Having our attention drawn to a sound's affective qualities is different from 'being affected by' a sound. As David Huron (2006) would say, we are always affected by sounds through their activation of our brains' 'fast-track' response. A 'working' affordance therefore does not carry any affective or emotional qualities with it.[18] It is merely there as part of the environment, orientating us towards it in a certain way without us realizing. In Dreyfus and Kelly's own words, '[a] central feature of affordances is that they present themselves only when you're not looking for them' (2007, 52).

Dreyfus and Kelly admit that their phenomenological take on the concept is at odds with Gibson's, who explicitly argued that affordances are objective relationships in the environment, not just categories of experience. Video games offer a unique understanding of affordances in that they can be said to feature objective affordances as well as phenomenal affordances. Objective affordances are 'hard-coded' into a game by its developers: park benches in *Tony Hawk's Pro Skater* afford grinding, but similar benches in *Grand Theft Auto* have not been designed that way. Phenomenal affordances are the ways in which players attune differently to games based on those objective affordances, naturally seeking out park benches to grind on in *THPS*, while avoiding them in their cars in *GTA*. Nondiegetic background music in games usually relates to the latter: it helps attune players to the objective affordance structure of games. I have gone into more detail about how music achieves this elsewhere (Kamp 2014; 2016; 2021b), but to summarize, background music primarily constructs and structures affordances through its (lack of)

dynamic transitions. In games with dynamic transitions between 'safety' and 'danger state' cues, new situations arise when the game's code prompts a new musical cue or module, which in turn affords new ways of interacting. In *God of War*, the transition into the combat module (0′43″ in **Video 1.4** ▶) helps attune the player to a change in the game's affordances for interaction: from watching a cutscene and being ready for possible button prompts to actively using the controller to move around and look for openings in the Stranger's defence. But even in games with simple looping cues such as *Tetris*, the lack of transitions and repetitiveness of the music play an important role in our perception of a gameplay arc (Kamp 2014, 245–46). This structuring of a game's affordances echoes the functions of moods and atmospheres that I outlined in the previous section. We do not interact with an affordance structure itself, but it forms the basis on which we experience the possibilities for action within our environment; similarly, when we are in a certain mood, we do not experience that mood, but experience the world around us in terms of it. Initially I characterized affordances as the result of a 'tuning' between organisms and environment, and if we consider that German word for both 'tuning' and 'mood' is *Stimmung*, the close relation between Heidegger's and Gibson's conceptions becomes all the more apparent.

With this in mind, we can now ask how music contributes to the affordance structure of a *StarCraft* match. At first sight, it seems that the music plays no role in our actions: it is merely there, in the background. It has no dynamic transitions to speak of, and unlike the equally nondynamic music in *Tetris*, its loops do not structure the perceived arc of gameplay. If there is any way in which the difference in cues between *StarCraft*'s three factions affords different gameplay, it must be in the background to such an extent that it cannot be discovered by turning the music off or replacing it with a different soundtrack. In the final section of the chapter, I will attempt to answer this question by considering the background music of *StarCraft* in a larger context outside the game.

Background Music as Equipment

The three different conceptions of background music I have sketched out so far—ground, mood, atmosphere, and affordances—each have their own drawbacks. Even though affordances characterize the interactive dimension of video game music best, in the previous section we found that music

often *structures* affordances instead of being part of those affordances. The answer to this problem seems to lie in the relationship between moods and affordances. The difference between music and moods, as mentioned in my discussion of atmosphere, is that music is a series of auditory practices that are out there in the world, and moods are a characterization of behaviour that is a part of us. While this might seem phenomenologically suspect (if moods are a part of us, after all, where do we experience this part to be?), the difference seems to hold if we accept Heidegger's point that a mood is something that we are always *in*. If there is no music around us to be heard ubiquitously, how can we always be *in* background music? Moreover, while moods essentially withdraw from our attention, music—if we are to believe philosophers like Andy Hamilton—is essentially something to be listened to: 'Music is an art with at least lower-case "a"—a practice involving skill or craft whose ends are essentially aesthetic, and that especially rewards aesthetic attention—whose material is sounds exhibiting tonal organization' (2007, 52). Background music, for him, is parasitical on the workings of music, and 'belongs under the heading of sound design, and while sound design can have aesthetic purpose, muzak does not' (2007, 54). Whether we ought to consider background music as music or sound design, it is an artefact with a particular function. And in this capacity, we have access to both its nature as an artefact and its function. Although it ceases to be background hearing, we can turn our attention towards background music at any point in time and hear musical qualities in it—what Hamilton would call its musical essence (no matter how clichéd and boring these qualities might be in the case of Muzak). Depending on our musical training, in a Terran cue in *StarCraft* we might hear anything from '1980s-American-cop-show' to the particular picking patterns that were used in the guitar parts. Even if our knowledge is limited, we acknowledge the possibility of the music having all these features that more musical people might find in it. But in recognizing these features that we might call part of 'the music itself,' we never lose sight of its function, that of acting as a background. In other words, unlike phenomenological moods, part of the essential qualities of music—even if heard as background music—is that we always *could* turn our attention to it and hear it as an auditory process or a series of sounds.[19]

What I am alluding to here is a way of being for music that Heidegger calls 'equipment' (1962, 97). Before we come to know a thing 'in and of itself'— what Heidegger calls being 'present-at-hand'—we always understand it first in terms of its functions: being 'ready-to-hand.' This suggests that music

always has a function too, even if that function is what Hamilton would call 'aesthetic.' Equally importantly, there is no such thing as *an* equipment; whenever we think of something as 'a piece of equipment' (note the grammatical relation to 'a piece of music'), we always have to think of it in its relation to the totality of equipment.

> Equipment... always is *in terms of*... its belonging to other equipment: inkstand, pen, ink, paper, blotting pad, table, lamp, furniture, windows, doors, room. These 'things' never show themselves proximally as they are for themselves, so as to add up to a sum of *realia* and fill up a room. What we encounter as closest to us... is the room; and we encounter it not as something 'between four walls' in a geometrical spatial sense, but as equipment for residing. (Heidegger 1962, 97–98)

Endre Kadar and Judith Effken suggest that for these reasons, Heidegger's equipment 'can be understood as synonymous with Gibson's affordance structure' (1994, 310). Heidegger even goes as far as to say that equipment is constituted in an 'in-order-to structure,' something that echoes the very definition of affordances. This suggests an important oversight in my discussion of video game ecologies in the previous section, namely that the role of music in the affordance structure of a video game depends on its role in a larger, world-encompassing affordance structure, much like equipment. We call this role 'background music,' which amounts to something like background music having the function 'of having a function.' I will attempt to explain this tautological statement in this final section by considering our understanding of background hearing in *StarCraft* beyond the matches—beyond the act of hearing—through a discussion of the discourse surrounding the game.

In September 2010, amidst the various discussions of strategies and game mechanics, a topic appeared on TeamLiquid.net's *StarCraft II: Wings of Liberty* forums claiming that 'Terran music is OP.'[20] As one of the biggest community sites surrounding Blizzard games, its forums were no stranger to these kinds of outcries. The question whether there is an adequate balance among the game's three warring factions, or whether any of them are over-powered or 'OP,' is of central importance to *SC*'s players. *StarCraft*'s sequel had only been out for a month or two and was still in the process of being balanced through patches, so the issue was particularly pressing at the time. Given the heated debates, it is no surprise that it took one or two replies

before the consensus became that the topic was tongue in cheek. In the original post, forum member Ketara compares the music of the game's three factions, referring to YouTube videos of the different musical cues for each:

> This is the Terran music. Listen to it as you read the thread. Does it get you pumped? Does it make you feel like grabbing a flamethrower, smoking a cigar and frying everything that moves around you? Yes, it does. Now that you are reading while listening to music, you cannot help but get your adrenaline pumping, and feel that urge to own noobs [new players].
>
> It is **clear** that this music makes you a better player. Why do you think Terrans can play so effectively with such a low APM [actions per minute]? It is because the music makes their units better. Pure and simple.
>
> ...
>
> In comparison, the Zerg music is slow, low key, and positively dank. There are no impressive guitar solos. There are no adrenaline pumping beats. This kind of music *forces* the Zerg player to play reactively and think inside the box. They are not playing aggressively because the music is not telling them to play aggressive.
>
> The Protoss music is very much holier than thou, and extremely haughty. And it too is slow. This sort of music compels a player to do some specific thing that they think is so smart that it alone will win them the game. This is why we see Protoss players doing so many proxy's [*sic*], and so many sneaky bits ingrained into their tech tree. Is it because their race is designed to work this way? No. It is because of the *music*.
>
> I would like to submit to Team Liquid, that clearly, Terran music needs a nerf [rebalancing]. Every time I hear it I have an impulsive desire to put on cowboy boots, get my six shooter, and fly through the stars with nothing but a brown coat and a handful of Chinese curse words to my name.

When Ketara suggests that music 'makes' or 'tells' you, even 'compels' and 'forces' players to feel or do something, they are invoking the common characterization of background music that I referred to in the introduction to this chapter, in which music acts as a drug, unconsciously influencing the listener. But the tone of Ketara's post and its responses suggest a certain irony underlying the argument, which is aimed both towards this conception of background music and towards the tone of the discussions surrounding *SC*. In order to better understand the role of background music in *StarCraft*, what I want to do here is commit the sin of explaining the joke. At a first glance, the

irony seems to lie in Ketara taking the music seriously, as if it were a gameplay element—like the layout of a map or the firepower of a unit—when conventional wisdom is that music does not play a role in players' strategies and is just ear candy. As I argued in the previous section, music structures the phenomenal, not the objective, affordances of a game. However, the conventional wisdom that music is ineffectual to gameplay mechanics seems to break down in the model of background music that Ketara alludes to, where it acts as a drug. Why can John Sloboda's 'music box of pills' (2008, see my discussion below), for instance, not become another part of the player's arsenal with which to best their opponent? Like unscrupulous athletes and their real box of pills, can *StarCraft* players not use music to enhance their performance?

The ironic tone of Ketara's post suggests that in players' understanding of *StarCraft*, music in particular *is* perceived as irrelevant, as arbitrary with respect to gameplay mechanics. Ketara refers to YouTube videos of *StarCraft*'s cues much as I did in my initial descriptions in this chapter, where I ignored the phenomenal character of the music as a background during a match. When they suggest that forum members 'listen to it as you read the thread,' there is the underlying assumption that what one hears in a YouTube clip is what one 'hears' during a match. But as I argued, as a ground, the music is virtually inaudible, and as part of an affordance structure, the music has no significant affordances itself. So what one hears on YouTube can only be considered as what 'affects one' during a match; the qualities that we hear in the music such as 'holier than thou' and 'positively dank' become qualities that 'make' or 'compel' us to play in a certain way. This is the essential quality of background music as equipment: having a functional aspect. There is however a problem with this way of thinking about music.

One consequence of recording technology, Sloboda argues, is that it is now possible to surround ourselves with 'highly polished professional performances at the press of a button' (2008, 32). This has led to 'less incentive to sing or play' music ourselves, and to an overall loss of confidence in our ability to 'understand music,' in our 'judgments and intuitions about it.' Instead of being an event or activity to participate in, music becomes a black box with effects and uses:

> The musical repertoire is seen as a box of pills, with different pieces having different active properties, such as sedation or aphrodisia. This 'vitamin model' lies behind misleading commercial initiatives that package

selections of music as stress busters, relaxation aids or even music to make your baby more intelligent. (Sloboda 2008, 32)

This prompts Sloboda to a plea for more contextual research into music, something that takes into account that musical understanding, or rather, the effect of music, is predicated on our 'moods, memories, intentions, attitudes, choices and experiences' on the one hand, and the context of the listening moment on the other: 'who else is there, what is going on, and the social or personal significance of the event.' I want to go further than this and argue that from a first-person, phenomenological point of view, saying that music has a certain effect on my actions amounts to a 'pharmaceutical' fallacy.

Whereas it makes sense to say that background music in a game affects or influences *other* players in certain ways, these effects make no sense when considered as strategic options for *me*. If I know that music compels or suggests me to play in a certain way, can I not just adjust my actions to effectively ignore these suggestions? By attributing my decisions to outside forces, I am effectively suspending my agency and freedom of choice. In existentialist terminology, I would be acting on bad faith: 'it wasn't me, the music made me do it!' But while we can say this of psychoactive chemical drugs, it is not generally accepted to say this about music. Music is something we can attend to, turn off, and otherwise interact with if we so choose while it is playing, and in this possibility of choice lies the fundamental difference between music and drugs.[21] In other words, we feel we have plenty of ways of understanding and controlling the music that we experience, whereas a drug continues to be something elusive to consciousness. The pharmaceutical fallacy comes down this: to confuse our understanding of our own behaviour as somehow 'altered by the music' with our understanding of the music as equipment.

The question, then, is not what role background music plays in the decision-making process of players. Such a question can be answered perhaps by psychological or other quantitative, empirical methods. What I want to argue is that Ketara's argument reveals that hearing music in the background depends on the other ways of hearing I will discuss in this book: aesthetic and ludic music. The aesthetic kind of hearing is based in YouTube videos rather than gameplay, with an aim to relive old memories of playing the game (see Chapter 2 on nostalgic hearing) and to enjoy the music on its own. While a few replies to Ketara on the TeamLiquid.net forums take their suggestion about the music's drug-like qualities seriously (including

one person who cites a scientific paper [Brodsky 2001] about the effects of music tempo on driving performance), most replies discuss the aesthetic qualities of the Terran cues in *SC2*. The Terran music is praised for its upbeat nature ('more BPM = more APM,' as one respondent put it),[22] country-and-western influences, tunefulness, and ability to get the player pumped up. In their suggestions that the Terran music is at the same time 'more memorable than the music of the other two factions' and 'supplies a LOT of the mood,'[23] the forum members might as well be responding to Hamilton's arguments against Muzak: mood music *can* be aesthetic and *can* be memorable in a video game like *StarCraft*. Then there is the often-repeated nostalgic sentiment that, although it had a similar musical 'imbalance,' the original *StarCraft: Brood War*'s music is of much better quality than that of *SC2*. Some players reply that they turn the music off altogether. When posters suggest that Terran music gets them 'pumped,' whereas the other factions' music is too 'ambient'[24]—or even echo Hamilton by suggesting that the Zerg and Protoss cues are not really music[25]—they are saying that when they play they hear the Terran music ludically. Poster DTown goes as far as to argue a point that echoes Juul's rules-fiction dichotomy:

> [I]t seems to me Blizzard nailed the music in terms of how each race [colloquial term for faction] should 'feel' given their racial characteristics. Terran is redneck rockin' guitar solos, Zerg is creepy and ominous, and Protoss is heady and confident. However, it just so happens the theme that fits the shoot'em up, fast-paced, adrenaline-filled APM fest that is SC is, by far, Terran's rockin' tunes. Unfortunate.
>
> Blizzard should care less bout [*sic*] racial identity for music (so all races get music that actually gets their blood pumping) and more about racial identity for gameplay (Swarm? What swarm? I see only a modest gathering.)[26]

The discussion on the TeamLiquid forums suggests that the two listening contexts—music as a force or drug while playing the game and as an object when browsing for YouTube videos—are closely intertwined, meeting in what Charles Seeger called a 'musicological juncture' (1977) between speech and music. Comments referring to mood and the music's upbeat nature refer to the experience of playing, but indirectly. While playing the game, the music can be very much in the background, having no significance for any particular event in a match. But looking back to the game, reminiscing

with other players on forums while listening to YouTube videos, the soundtrack gains significance. It is in these discussions that aesthetic qualities of the music ('more memorable,' 'get your adrenaline pumping') are framed and inscribed as effects of background music in the game. Although it might be possible to disentangle the two ways of listening, for example in an experimental setting, this would do injustice to the actual experience of music in *StarCraft*. This involves much more than just a multiplayer match: it is an aggregate of all the ways of listening that are available to players. In this sense, the music of *StarCraft* is a background not just to a particular match, but to 'the Game of *StarCraft*,' akin to 'the Game of football' as a player and supporter culture rather than just the movements on the pitch.

Ketara's joke works because music has a very clearly delineated role in 'the Game of *StarCraft*': for players, it is there for its aesthetic qualities, to be turned off or listened to attentively at any point. In *serious* discussions about balance and strategy about whether something is 'OP,' such an optional element has no place. During a match, however, the music's role is more opaque. The lines between the two ways of listening to the *StarCraft* soundtrack—as background music while playing, and as musical cues on YouTube—are constantly blurred in the discourse that follows on Ketara's post. Perhaps this is not so surprising; after all, how is a player to report on their experience of playing a game, even after the fact, without distorting that experience, especially when confronted with other ways of listening? And this is why it is perhaps inevitable that the two ways of listening are blurred into the kind of music-as-drug accounts that we find in Ketara's post: 'the Zerg music is slow, low key, and positively dank,' and *therefore* Zerg players are not playing aggressively; 'the Protoss music is very much holier than thou, and extremely haughty,' and *therefore* Protoss players are compelled to do 'some specific thing that they think is so smart that it alone will win them the game.' That we find irony in these statement at all, whether as musicologists or as *StarCraft* players, suggests that background music has to be conceived of as much more than what we hear when we play. It depends on its function in the larger web of music as equipment, on the 'in-order-to' structures that it belongs to: listening aesthetically in order to reflect, judge, and reminisce; analysing in order to ascertain psychological effects; and retreating from our attention in order to let us play a match of *StarCraft*.

Conclusions

In the example that I started out with in this chapter, that of Fink's late-night shopper, 'music drifting down from speakers embedded in the ceiling hardly registers on her consciousness.' The setting and tone of Fink's anecdote suggests a mode of attention in which we are on auto-pilot: coming home from a long evening's work (or perhaps stocking up for a night of writing), what is left of our focus is elsewhere, on the more important things in life. The shopper's state of mind echoes Herbert's conception of music listening in everyday life as 'trancing.' Throughout this chapter, however, I have tried to argue that for music to be in the background, we are not necessarily in any kind of trance at all. The video gamer, and perhaps the late-night shopper too, perfectly understands what she is doing, and she 'hears' the music perfectly. Rather, she has a pre-reflective, ready-to-hand grasp of the music that suggests no aesthetic reflection or ludic or semiotic action is necessary in order to understand the music. This is the essence of background hearing: a hearing that is so understanding that no explanation is necessary. And it suggests that *other* kinds of hearing have to follow from a 'necessity of explanation,' a kind of friction in our understanding of the music, or at least a desire to explain or, in the case of ludic music, to act. This is why, in the case of background music, essential features of music such as temporality and feeling or affect reveal themselves in terms of 'timelessness' and 'mood' in phenomenological reduction: in background hearing they are insignificant.

We can now also make an attempt at a phenomenological conception of inattentive or ubiquitous listening. It is possible to see this practice as a kind of deliberate attuning to music—or to a setting in which music is playing—allowing it to recede to our attentional background, to become a ground in gestaltist terms. Moreover, music is not alone in that background. It functions alongside other elements of video games to structure the ways in which we perceive possibilities for action—it structures a game's affordances. Attending to background music while we are playing, we would hear nothing of significance, nothing important to whatever we are doing at the moment. But attending to background music at a later point, we hear its function as background music, its role as equipment both within and beyond the video game.

2
Aesthetic Music

Aesthetic hearing happens in video games when we stop whatever we are doing to attend to and reflect on the music, or on a situation accompanied by music. A moment of aesthetic hearing can happen anywhere at any time, but there are specialized environments, technologies, and situations dedicated to facilitating such a mode of hearing: the concert hall and its conventions, noise-cancelling headphones, or the kind of quiet, reflective scenes in which the soundtrack takes over in Hollywood cinema. Video games too can have these dedicated moments, as I will propose with the help of an example from *Tomb Raider* (2013). But some of the most impressive moments prompting aesthetic reflection happen quite unexpectedly. This dimension of serendipity in aesthetic hearing—stumbling upon a moment of unique significance—is facilitated by the open-ended nature of some video games and their soundtracks. The particular examples of these that I will be discussing in this chapter are *Minecraft* (2009) and *The Elder Scrolls V: Skyrim* (2011). By comparing the music and gameplay of these games to each other and to similar musical situations in other parts of life, I want to come to a general idea of what aesthetic hearing is, and why it is a separate category of hearing in games from ludic, semiotic, and background music. Towards the end of this chapter, I will argue that aesthetic hearing is the basis of interpretation. An extended case study of the use of pre-existing music in *Civilization IV* (2004) will serve as an example of how a moment of friction in the game's soundtrack can invite critical analysis that expands one's understanding of the game, and ultimately its 'meaning.'

I want to start with the suggestion that in aesthetic hearing in video games, we are truly concerned with the music itself. Of course, the concept of 'the music itself' is extremely problematic. The other ways of hearing I discuss in this book rely as much on features of 'the music itself' as any kind of engagement with music: symbols and signals in semiotic hearing, and musical movement in ludic music. But one could say these ways of hearing music appropriate musical features for other purposes (ludic and semiotic pursuits in

this case), and that there is such a thing as listening to music for its own sake in video games. The question is, what *is* listening to music for its own sake, and does it make us hear the music in a significantly different way from other engagements with it? Do we do this in video games, and if so, does the video game context alter these experiences of musical autonomy in any way?

To start with I want to argue that, yes, there is such a thing as listening to music for its own sake, which I will call *aesthetic listening*. I can go to a concert or look up an album on a streaming service and listen to it on the couch at home with the hopes of being moved, thrilled, entertained, or otherwise positively affected by the music. This kind of listening can involve interpretative strategies such as 'structural listening' (Subotnik 1996) comparing other performances of the same piece or song, marvelling at a soloist's virtuosity, seeking emotional gratification, or reflecting on the social, political, and historical context of the piece or performance—not necessarily to subject the performance to scrutiny or a judgment of taste, but rather to 'open up' to the possibility of it doing something to us. Note that this can be multimodal listening: we can mobilize our visual impressions of the string section moving their bows in almost exaggerated unison to emphasize the final chords of a Beethoven symphony, and hearing the final bars of Mahler's Ninth peter out sounding through headphones in a dimly lit, empty study can make them all the more powerful. We can also move along to the music in similar fashion as to ludic music, anything from head-bobbing to jumping or swinging (or even more choreographed dancing) to appreciate the rhythms and changes in musical movement. Other kinds of musical experience can be embraced in aesthetic listening as well. The first sforzando trumpet call in Varèse's *Amériques* can shock an unwitting listener in the same way as a stinger chord in a dark corridor in *Resident Evil 7* (2017), I can hear a familiar melody as a semiotic marker for the recapitulation of a sonata just as I hear a frantic ostinato signify the presence of enemies in *The Legend of Zelda: Ocarina of Time* (1998), and I can be moved by the fast, waltz-like sections of Chopin's G-Minor *Ballade* in the same way as I run through enemies and over small chasms along to the star powerup theme in *Super Mario Bros.* (1985). My attention can even drift away from the finale of Glass' *Satyagraha* to such an extent that it is barely more than background music to my inward ponderings, or studies of the audience and set design. In other words, if aesthetic *listening*, or attempting to listen to the music for its own sake, can engender surprised, semiotic, and ludic musical hearing just as well, what exactly would aesthetic *hearing* be?

In this chapter I will show with the help of a number of case studies—supplemented by arguments from philosophical aesthetics—that aesthetic hearing is always tied up with an aesthetic experience. Aesthetic experiences can come from a number of situations: a moment of musical nostalgia, an encounter with an awe-inspiring scene in nature accompanied by 'fitting' music, or an otherwise particularly meaningful contextualization of one's actions in a video game by its music. What connects these are not just their aesthetic qualities, but also their phenomenal, noetic, qualities, which involve a certain reflectiveness, immersion, and serendipity. I want to start by addressing the phenomenology of aesthetic experiences in general, and how they relate to aesthetic hearing and listening in video games. Many of the examples of aesthetic experiences in this chapter, even some of the references I already made in this introduction, come from the canon of 'classical music', from Beethoven to Varèse. This is not a coincidence, as there are listening practices that have evolved around classical music that are perhaps particularly suited to these kinds of experiences. Even William Gibbons, who critically addresses the dichotomy between classical music as art versus video games as entertainment, references Lawrence Kramer's idea that 'intent listening' is the primary focus of classical music: 'it must be listened to and embraced as art to fully function . . . Playing video games would certainly count as another activity, and one in which listening is most often relegated to a secondary role' (2018, 17). This chapter intends to nuance the latter part of that statement, while at the same time disentangling attentive or focused listening from art music. In spirit with Gibbons' critique of classical music, some of my extended comparisons of aesthetic listening will refer to other music traditions, such as my autobiographical example of M83's 'Intro.' First, however, I want to give an example of aesthetic hearing in the game *Minecraft*.

Case Study: *Minecraft*

Minecraft's is a unique success story in video gaming history. The independently developed game, put together by a team of just twelve people, was first released in beta form in 2009 and by the time of its official release made over $80 million, before being bought by Microsoft for $2.5 billion in 2014 (Reilly 2012; Stuart and Hern 2014). Its simplistic, cheap-to-reproduce-and-generate graphic design—the world is made up of coloured, low-resolution blocks, and the creatures that inhabit it are similarly 'blocky'—and lack of

structured narrative made possible a unique experience that was at the time unprecedented in video games. The player's only real goal in the game is to survive. The randomly generated world, with trees, mountainous areas, deserts, and arctic plains, has a day-night cycle, and at night monsters such as zombies and gigantic spiders are spawned randomly, attacking the player on sight. The player is able to manipulate the blocks of which the game world consists by hacking into them with various tools, shaped from resources that are collected from other blocks. For example, to build a stone house to shelter them from the monsters at night, the player has to mine stone. For this, they will need a wooden pick, which is fashioned from wood, for which the player has to cut down trees in the area. Beyond this basic need for survival, the player is free to do as they wish: they can roam around the world, looking for unique locations to build houses, castles, statues, and other works, or they can mine to great depths to find diamonds and gold ingots.

The game's DIY presentation extends to its soundtrack as well. Lo-fi sound effects accompany most of the game's actions and creatures. Most of them are short, sharply distinguishable sounds that pierce the otherwise silent game world. (*Minecraft*'s total original sound file was less than 10 MB in size.) Even the rare ambient sound effects that one hears in caves are a randomized set of thirteen samples no longer than ten seconds in length each. The onset of the game's musical soundtrack is equally sparse and randomized. Minutes of silence while chopping wood outside, or perhaps exploring a dark cave, are pierced by the slow fading in of one of the game's twenty-two musical cues. These cues vary in length anywhere from forty seconds to nearly five minutes, and they fade out as indifferently to the actions of the player as they faded in.

This indifference is key to the ways in which the player is invited to hear the music of *Minecraft*. Quickly learning that there is no way to interpret the onset of a cue as a sign for anything, and quickly finding out that there is no way of 'playing along' to the music in however abstract a manner, the player can either ignore the music, or listen to it. In the first way of hearing discussed at length in the previous chapter, the music becomes a kind of indifferent background music, a wall of sound with no significance other than 'matching' the situation the player finds themselves in. The second way of hearing is inevitably aesthetic hearing, and this is the kind of hearing I want to describe with regards to **Video 2.1** ⏵. Just having started a new game of *Minecraft*, while building my first house, the cue 'Haggstrom' starts playing. (The game's composer, Daniel 'C418' Rosenfeld, has given the *Minecraft* cues on the soundtrack album enigmatic short titles such as 'Haggstrom,' 'Dry

Hands,' 'Excuse,' and 'Mice on Venus.') At the time, I had no knowledge of this piece of music, not even its name. The soundtrack is readily available on the internet, but my first encounter with it was, as I can only assume is the same for many others, in the game. The music starts at no particularly significant moment. I am rebuilding my roof in stone blocks, as the moderately, regularly paced, C-major metallophone broken chords slowly fade in (0'48" in **Video 2.1**). Like most of the *Minecraft* cues, 'Haggstrom' builds up as slowly and regularly as it dies down. It is average in almost every way: not particularly moody, but not particularly apathetic either; unobtrusive, but not necessarily withdrawn from perception, just like Brian Eno's ambient music.[1]

Noticing the cue, there is nothing in the environment that the music explicitly maps onto: no distant mountainscape, no dark and gloomy cave interior. Is the music commenting on my actions then? Perhaps the simplicity of the tune, the childish glockenspiel-like sounds, reflects the mundaneness of my actions, the back-to-nature ideology.[2] In a way, *Minecraft* and its music could be the twentieth-century counterpart to the Romanticizing of nature of which *Skyrim* could be an example (see below): the Hindemith to its Mendelssohn. The very act of trying to answer the question I just posed can be construed as aesthetic reflection—I am lingering on the piece of music I just heard, listening to its details, considering how its aspects relate to one another and to other parts of the game. The asking of the question itself marks the beginning of an aesthetic experience, the moment where my attention turns towards the music and I hear in it something new and meaningful. The random onset of the music turns the mundane (if slightly frantic—I have to finish before nightfall, after all) activity of building shelter in *Minecraft* into a situation, an experience with qualities like 'mundaneness' that the music reflects and maps onto; the everyday becomes a moment of reflection on everydayness. As I will explain below, *mere* experience is turned into *an* experience through the onset of the music. Everything that follows on from that—the lingering reflection on what the experience means, the looking up of the cue on the internet, learning about its composer, and so on—can be construed as the aesthetic listening that depends on that first moment of aesthetic hearing.

This experience, this moment of aesthetic hearing, has a number of essential characteristics that I will discuss in detail in this chapter, and that will return in various guises in the other case studies. The first is the sudden and random onset of the music. This is a case of serendipity, the happy

accident by which we stumble upon the moment, facilitated by the music. Particularly in the case of video games, serendipity is an interesting element. It prompts questions about authorship: How much of the moment I am encountering was designed or intended by the game's creators? And how much of it is emergent, personal, and unique to my experiences of the game? Secondly there is the arresting, lingering quality of the experience: I am not waiting on something to happen, or trying to decipher something for practical purposes—I am merely reflecting on, mulling over, playing with the concepts that the moment presents to me. Finally, there is the question why I would call this an *aesthetic* experience in the first place. How can video game music be related to elevated concepts like beauty and art, the domain of the aesthetic? This question is the one I will address in this first section.

Having an Aesthetic Experience

(1) 'I love the music of *Peggle*.'
(2) 'I love the comically overblown exuberance in a game of *Peggle* when you finish the level accompanied by the irreverent use of Beethoven's "Ode to Joy" theme as a victory fanfare, fireworks and everything' (0′25″ in **Video 2.2** ▶).
(3) 'I loved that moment in *Peggle* when I finished a level for the first time, and I was blown away by the outrageously inappropriate victory music.'

Of these three statements, only (3) is a description of an aesthetic experience. The first two are subjective aesthetic judgments that might be based on an experience such as (3), but that is not necessarily the case. Saying that I love the music of *Peggle* (2007) can be a statement about the kind of person I am, about what my tastes in video game music are—it is not necessarily a recollection of a certain experience in my past. This goes for (2) as well: we could be having a conversation about the comical use of music in games in which I qualify or categorize a certain aspect of the game's music—it does not depend on me having had exactly the kind of feeling that (3) describes. An aesthetic experience like (3) is not guaranteed by any aesthetic judgments such as (1) and (2), either personal or shared with a community, and has its own unique phenomenal qualities.

In the case of the moment in *Peggle*, the aesthetic experience is humorous in nature. The outrageousness, the irreverence, the inappropriateness of the 'Ode to Joy' in such a simple game, in other words the incongruence between the music and what it accompanies is essential to the experience. But humour is not essential to aesthetic experience as a phenomenon. Other inflections can take its place: Nintendo's thematic nostalgia, for instance (see below), or something more complicated such as 'nuclear war anxiety' in *Civilization IV* (see below as well), or even the 'everydayness' that I reflected on in *Minecraft*. What is common to all these experiences is the suddenness of the realization or the dawning of the emotion, and the way we find the music saying something unexpected and meaningful, however unimportant or mundane we might judge that something to be on reflection.

Ascribing to this definition of aesthetic experience implies an embrace of the possibility of everyday aesthetic experiences. This means that these kinds of experiences are not necessarily life-changing events that we feel should be shared with and by everyone. I can briefly enjoy the way a cloud of milk unfolds in my teacup before proceeding to drink it and getting on with my writing, forgetting all about it; I can also marvel at the majestic beauty of a stormy cloudscape, concluding that the sheer vastness of it puts a new perspective on my place in the world (or my place in nature at least).[3] In the everyday conception, both aesthetic experiences are valid, and differ merely in scope. The more profound experiences still share a basic 'structure' with the everyday, forgettable ones. This common structure has a number of features that I will discuss in more detail in what follows: serendipity, emotional expressiveness, and meaningfulness.

In philosophical aesthetics, there are a number of arguments for and against the possibility of having everyday aesthetic experiences. The debate rests heavily on Kantian terminology, as outlined in the *Critique of Judgment* (2005). For Immanuel Kant, there is a distinction between pleasurable experiences: on the one hand there is the agreeable, on the other the beautiful. The taste of a piece of chocolate can be agreeable, but the shape of a vase can be beautiful. The two important criteria of distinction for Kant are whether the judgment or experience is subjective, and whether it depends on an 'interest' in the existence of the object. We are interested in the piece of chocolate because of the cocoa and sugar in it. Without those substances and their effect on us after ingesting it, the taste of chocolate might not be nearly as positive an experience. In other words, the positive qualities of the chocolate depend on its function—in this case improving our mood and energy

level. While the vase, on the other hand, might serve a practical purpose such as holding up a bouquet of flowers, we can 'disinterestedly' enjoy its shape and appearance. Of course, the question whether we are *really* disinterested when enjoying anything at all is a difficult one. For this reason, Kant is reluctant to rank music among the fine arts, as he feels that the involvement of bodily excitement in our enjoyment of music (a 'movement of the intestines'; 2005, 132–33) functions similarly to the sugar and cocoa in chocolate. For my present phenomenological approach, the question of disinterestedness is easier to put aside: in Kantian terms, if I put on a piece of music because I am feeling bad and want it to comfort me, it is agreeable; if I put on that same piece of music and find something moving in it regardless of the mood I recognize myself to be in, it is beautiful.

The difference between the agreeable and the beautiful is important for the question of everyday aesthetics. For Christopher Dowling (2010), aesthetic experiences like the cloud in the teacup are agreeable, whereas true beauty necessarily extends beyond those mundane moments. Dowling's argument is rooted in the other Kantian criterion for beauty, namely universal subjectiveness or communicability. When we experience something beautiful, this experience has a normative aspect to it in the sense that we feel it can and should be shared by others (Dowling 2010, 228). This puts arguments about taste, criticism, accounts of aesthetic experiences, and descriptions of beauty at the centre of what differentiates an aesthetic experience from *mere* experience. We can hear echoes of John Dewey's (2005) aesthetics here: *an* experience differs from *mere* experience because it has a clearly demarcated and distinctive place in our memory; an experience of a trip to Paris differs from the mere experience of travelling. In fact, we can take Dewey's more general distinction between aesthetic experience and other kinds of experience as an argument against Dowling's criterion of communicability. The experience of my trip to Paris can be important to *me*, and I do not necessarily feel travelling to Paris is important to everyone else. What makes it more than agreeable is that it has a particular place in my memory, in my tastes and personality. But Dewey's conception of an experience also falls short of defining aesthetic experience in two ways. Firstly, it is not necessarily positive, or aesthetic. We can think of other kinds of experience that constitute *an* experience, that are somehow important to us or memorable. Secondly, an experience that is of something as broad as a trip to Paris falls beyond the purview of aesthetic experiences: while it exists as a kind of demarcated whole in memory, it consists of many memories of concrete situations, places, and objects. What

is necessary for an aesthetic experience is a particular moment of noticing something, be it an object, a piece of music, or a cloud of milk in a teacup.

With this in mind we can start further defining aesthetic experience. Aesthetic experience is to some extent always *an* experience. My attention lingers for a moment on a scene, an object, an event, or a musical phrase. In the case of *Peggle*, it is the 'Ode to Joy' victory music. That moment of lingering does not have a necessary particular duration, as there is no particular need coming from the object of my attention to move on with my thoughts or activities. I am not waiting on some cue from the music as I would when listening to the radio, waiting for the news to come on, nor am I interpreting it as I would a railway-station announcement. I am not interested in the music beyond 'what it sounds like' and 'what it relates to in the game,' or as Kant would say, its 'form,' and what that form is defined by my interest in it. In other words, I am a disinterested listener. In the case of *Peggle*, it is its humorous and incongruous qualities. To sum up, aesthetic experience consists of a kind of lingering on the object of attention. It is memorable (to greater and lesser extents), and clearly demarcated—something we reflect on. It by definition does not serve a particular purpose, in the sense that we are not waiting for something to happen, or otherwise using the object. Later in this chapter, I will describe different guises that this disinterested lingering takes in the case of video game music.

So far, I have talked about the general structure and qualities of aesthetic experiences, without even making it clear whether video game music, or indeed any kind of music, is unique in the way it provides these. While it makes sense to talk about events or scenes or objects providing experiences that make one's attention on them linger, such as unfolding clouds in teacups and stormy skies, music is an ongoing process that encompasses many possible 'events,' 'scenes,' and 'objects' in the form of recapitulations, grooves, melodies, and so on, much like the aforementioned trip to Paris. So the possibility of having an experience listening to music can prompt the question when this is exactly happening. This is the question Jeanette Bicknell asks in *Why Music Moves Us* (2009). Referring to a number of psychological experiments in the last thirty years or so, she identifies a number of common phenomena that move people to chills or tears. She notes that in rituals, Gilbert Rouget found that the moment of possession or music-induced or assisted trance usually has two musical features: 'breaks or abrupt changes in rhythm; and passages where the music simultaneously accelerates and grows louder' (Bicknell 2009, 63). John Sloboda (1991, 65–66) identifies three

particular musical features that move people to tears: melodic appogiaturas, melodic or harmonic sequences, and harmonic movements through the cycle of fifths to the tonic. Chills are caused by slightly different features, namely 'new or unprepared harmonies and sudden dynamic of textural change, often occurring together . . . and [again] melodic appogiaturas' (Sloboda 1991, 66). Another common musical feature to induce chills or tears is the sound of a soprano voice, in both classical music (opera arias) and popular music (Whitney Houston's 'I Will Always Love You')—sustained high notes by other instruments (violin, oboe, etc.) work as well (Sloboda 1991, 69).

In the case of video game music, I have already hinted at completely different types of music that move us. This reveals a different kind of attention that we pay to video game music. The aesthetic moments that Bicknell mentions happen during the kind of traditional 'attentive listening' that we do in the concert hall. But in video games we are *not* attentively listening all the time, as I argued in Chapter 1. In fact, most of the aesthetic moments in video games arise out of background hearing/listening, where we are focusing our attention on other parts of the game. The relationship between what happens in the music, then, and our experience should be reconsidered in the case of video game music. While it is useful to categorize these moments of being moved by music, I am discussing an altogether broader type of experience here. Not just the beautiful, but the weird, the humorous, the creepy, the nostalgic are categories of aesthetic hearing as well. In the next sections I will give two examples of these: nostalgia and natural beauty.

Nostalgic Hearing

In her categorization of listening modes I mentioned in my introduction, Milena Droumeva defines nostalgic listening as '[a]n analytical, culturally-critical type of listening that has emerged over time in experienced players who look for iconic game music themes through platforms and generations of a particular game (some notable examples here being the *Final Fantasy*, *Super Mario*, *Zelda* and *Mega Man* series)' (2011, 145). On the one hand, this is a manner of listening clearly concerned with the music itself, for its 'iconic' qualities. Nostalgic listening is best described as a kind of reminiscing. Edward Casey, in his phenomenology of remembering, distinguishes reminiscing from general remembering in that it is rarely undertaken for more practical reasons than to 'relive the past' (2000, 107). It can therefore

be qualified as a type of autonomous, aesthetic engagement with video game music: certain music is 'looked for' because it reminds gamers of positive childhood experiences, often by virtue of idiosyncratic features such as the distinct timbres and tunefulness of old hardware. Indeed, many modern games deliberately adopt scores with these features. Particularly titles with smaller budgets that cannot afford professional session musicians (let alone whole orchestras) build on older electronic timbres, from the 1980s' '8-bit'-era soundtrack to *Shovel Knight* (2014) to the early 1990s MIDI stylings of *Return of the Obra Dinn* (2018). Game companies like Nintendo and Square on the other hand are known for re-orchestrating musical cues from older titles in their long-running franchises such as *Zelda* and *Final Fantasy* (Brame 2011; S. Atkinson 2022). Then there is chiptune or chip music, a musical genre that has nostalgia at its core yet, as authors such as Kenneth McAlpine (2018) and George Reid (2018) argue, has transcended that dimension in many ways.

But Droumeva adopts a very broad definition of listening. She uses the term to encompass numerous activities that precede and succeed what might be termed listening proper, such as searching out the music, perhaps on dedicated websites or YouTube channels—which means that listening, as she uses the term, does not even necessitate playing the games. Perhaps even composing 8-bit soundtracks and performing chiptune concerts would fit into this extended definition of listening as a cultural practice. In fact, Sebastian Diaz-Gasca's idea of 'paraludical consumption' (2022) might fit Droumeva's category better than 'listening.' These activities must, however, be prompted by something: a nostalgic episode or experience or a moment of nostalgic hearing that drives people to search out the video game music of their youth. The question is, then, what is this kind of hearing like? Moreover, if we can hear video game music nostalgically under a range of different circumstances, is there a difference between hearing it in a game, and hearing it on YouTube or at a concert?

As Vincent Rone (2022, 11) argues, it is best to locate nostalgia in video game music in the 'sensuous relief and memory' that the concept began to be associated with at the turn of the twentieth century, particularly through the writing of Marcel Proust. Much work on phenomenology and nostalgia (or memory in particular) also starts with Proust's madeleine episode from the first volume of *In Search of Lost Time* (e.g. J. Hart 1973; Casey 2000), and I want to do the same here. Like the madeleine cake, hearing a familiar theme or even a familiar type of instrumentation can suddenly take one back to

one's youth and a bygone era of video gaming. Proust's protagonist Marcel describes in great detail 'the extraordinary thing that was happening' (1992, 60) as he tastes a spoonful of tea with some crumbs from a madeleine cake soaked in it. We find in the subsequent paragraphs a number of important insights into the experience of nostalgia. Firstly and most importantly, it is an involuntary memory that is triggered serendipitously, and its onset is quite forceful. Secondly, it is not merely accompanied but preceded by a strong sensation of 'all-powerful joy' (Proust 1992, 61). Marcel sets out on a search, first by trying more sips of tea, then through introspection, to find the source of this joy. Thirdly, the triggering phenomenon is experienced as instantaneous, or at the very least momentary: just the one sip of tea. Fourthly and finally, Marcel is completely absorbed in the phenomenon and his subsequent search, although this search involves the quite explicit, embodied activities of sipping more tea.

It is easy to draw some initial parallels to a possible nostalgic hearing in video games: the instantaneous and involuntary recognition of a theme, being absorbed into reminiscing over one's youth and the seamless way in which sensation leads to introspection, or in this case, hearing to listening. This contrast between the minuteness of the madeleine and the vastness of the web of memories and connotations that it triggers has been pointed out in the case of music by de Vries and van Elferen (2010), who compare ringtones in their simplicity and lo-fi qualities to Proust's little cake crumbs. We can extract from the previous observations a list of important aspects of nostalgic hearing. They are involuntary, absorbing, vivid, and joyous, prompting or inviting nostalgic listening, and we encounter them serendipitously. There are a number of questions that these aspects raise. Why can we not intentionally think back to our past to create these madeleine moments? Why are they so much more vivid when they appear serendipitously and involuntarily? And related to that, does nostalgic hearing require an attitude of nostalgic listening? Where does one end and the other begin?

Following Proust's distinction between intellectual and involuntary memory, James Hart locates nostalgia exclusively in the latter. As for Casey, so for Hart the past 'lives' solely in involuntary memory: 'involuntary memory is always in play at the magic instigation of some physical thing which is able to explode into the past world, so that in some way it is present to us as other than the "dead" past' (1973, 401–2). Merleau-Ponty (2012, 84) is more critical of the sharp distinction between voluntary and intellectual memory that Proust and his followers make. He takes as an example for his attack on

Cartesian dualism the problem of the phantom limb: how can we experience a phantom limb if we *know* there is no real limb there? Rather than merely concluding that these are two kinds of knowledge conflicting—conceptual and procedural, or mind and body—he attempts a more existential answer:

> If memory and emotion can make the phantom limb appear, this is not in the manner that one *cogitatio* [one voluntary thought or remembering] necessitates another *cogitatio*, or as a condition determines its consequence [a subconscious stimulus triggers an involuntary memory]. Nor is it that a causality of the idea here superimposes itself upon a physiological causality. Rather, it is because one existential attitude motivates another and because memory, emotion, and the phantom limb are equivalent with regard to being in the world. (2012, 88)

This means that we cannot just say that an involuntary memory is alive and an intellectual one dead: '[intellectual memory] could not be memory if the object that it constructs was not still held by some intentional threads to the horizon of the lived past, and to this very past such as we would rediscover it by plunging into these horizons and by reopening time' (2012, 88). Merleau-Ponty's move here to reintegrate the two kinds of memory that Proust et al. attempted so carefully to disentangle might seem almost a-phenomenological. But what it actually does is solve the chicken-and-egg problem of a nostalgic attitude (in our case listening) and a nostalgic experience (in our case hearing) and answer the question of what aesthetic listening entails at the same time. In the case of nostalgia, the 'existential attitude' pertaining to it is the one that allows us to open up to the possibility of nostalgic hearing.

In his characterization of memories and emotions in particular, Merleau-Ponty is following Jean-Paul Sartre's *Sketch for a Theory of the Emotions*:

> To be emotional is to find oneself engaged in a situation that one is unable to cope with and yet from which one does not want to escape. Rather than accepting failure or retracing his steps, the subject abolishes the objective world that blocks his path in this existential dilemma and seeks a symbolic satisfaction in magical acts. The ruins of the objective world, the renunciation of genuine action, and the flight into autism are favorable conditions for the illusion that amputees have insofar as it too presupposes the obliteration of reality. (Merleau-Ponty 2012, 88)[4]

For Sartre, both positive and negative emotions have a 'magical' nature, in that they misrepresent the world in some way. For instance, anger makes us feel like we can deal with threatening phenomena, while we actually cannot—think of angrily kicking against a root you just bumped into on a forest path. Similarly, joy makes us falsely feel like we can experience a positive phenomenon at once in its totality:

> A man to whom woman has just said that she loves him may begin to dance and sing. In so doing he turns his mind away from the prudent and difficult behaviour he will have to maintain if he is to deserve this love and increase it, to gain possession of it through countless details (smiles, little attentions, etc.). He turns away even from the woman herself as the living reality representative of all those delicate procedures. Those he will attend to later ... For the moment, he is possessing the object by magic. (2014, 47)

David Weberman (1996) has pointed out the stoic nature of Sartre's theory, as a kind of condemnation of emotions. I want to give a slightly different reading here, one that contrasts it with my consideration of background music as a mood in Chapter 1. Mood for Martin Heidegger does not have the magical quality to it that Sartre finds in emotions: in structuring the affordances of our environment, mood retreats to our experiential background. But for Sartre, the magical quality of emotions comes from the way in which we explicitly experience them as skewing the world. We will only experience an emotion as an emotion when we are able to transcend it, to move beyond the experiential moment and understand in reflection that the emotion was not a neutral way of viewing the world, nor even a quality of the object, but a 'state' in which we found ourselves to be in vis-à-vis the object. We can shout 'stupid tree stump!' as a result of our anger, but when we transcend the angry moment, we come to recognize that stupidity (and the affordance of kickability) is the quality we ascribed to the tree stump because of our anger. So the difference between moods and emotions lies in their temporality and intentionality: moods are able to retreat to the experiential background because we do not transcend them with the same frequency that we transcend emotions, and we do not experience them to relate to objects in our environment in the same way. This essential quality of transcendence or reflection in emotion allows us to reconcile Sartre's magical qualities of emotions in general with Hart's magic of an involuntary episode of nostalgia: my experience of the suddenness and vividness with which an emotion (whether

pleasant or unpleasant) appears to me is the true magic, like a rabbit out of a hat. Nostalgia is an attempt to prolong the qualities of an emotion through reflection.

So we can say that a moment of nostalgic hearing leads to Droumeva's mode of nostalgic listening, which, like Marcel in his search of lost time in Combray, is an activity in its broadest sense that involves both introspection, attention to music that is playing, and the seeking out of new music. As I mentioned, this is a kind of reminiscing, which for Casey is an inherently social activity. It consists of dialogue along the lines of 'do you remember the time that . . .,' 'yes I remember it very well! That reminds me . . .' and so forth. Of course, it is perfectly possible to auto-reminisce as well. For Casey this has similar aspects to reminiscing with other people, with our own memories (in addition to cues in the environment, such as music) being able to act as 'reminiscentia,' or 'madeleines.' Casey poses that in this case we reminisce with ourselves in diaries or inner speech as a kind of 'proto-communal' (2000, 118) discourse.

Again, the seamless way in which inner reflecting turns into bodily, environment-altering activity for Casey is similar to Droumeva's broad conception of listening that involves searching the internet and one's video game collection for familiar tunes. But if my own memories can act as reminiscentia, where does nostalgic hearing—the madeleine moment—end, and nostalgic listening begin? For Proust, does it begin when he asks himself where that joyous feeling came from? Or does it only begin when he starts retracing his thoughts? It seems that with Proust, the experience of nostalgia is a two-step process that involves a serendipitous, involuntary madeleine moment, and an intellectual, absorbed seeking out of the memories that prompted it. For Proust, then, nostalgia would only be complete when hearing is followed by listening. We saw already that for Merleau-Ponty, the two are necessarily intertwined in an existential attitude of nostalgia, which overarches and even precedes the moment of aesthetic hearing. In other words, in order for us to be nostalgic about something, we must already be open to the possibility of this happening—we must already be 'attuned' towards the triggering object in a certain way. The nostalgic listening that happens at the tail end of a moment of nostalgic hearing is our attempt to prolong that feeling of nostalgia, by giving it meaning and context.

Let us imagine then a moment of musical nostalgia while playing a game. I load up the single-player campaign of *Super Smash Bros. Brawl* (2008), a fighting-game series that pits different classic Nintendo characters against

each other, such as Mario and Luigi from *Super Mario Bros.*, Link from *The Legend of Zelda*, and Pit from *Kid Icarus*. Throughout the first moments of the game, I see short cutscenes of Pit forging his weapon, and as he plunges down from his heavenly abode to earth to join the brawl, his classic theme breaks out in the game's lush, synthesized orchestration, which continues playing throughout a short (thirty seconds or so) gameplay interlude. Hearing the *Kid Icarus* theme in this still quite thin-sounding version makes me curious about the original version, which I played many years ago. I load an emulated version of the game up on my laptop, and as I start playing the distinctive, joyous 8-bit sound of the game's theme sends a shiver down my spine for the briefest moment. In this case, the madeleine moment, although nowhere near as powerful as Marcel's in *Swann's Way*, clearly came after a long seeking-out, what Droumeva would call nostalgic listening. Was it this methodical seeking out that detracted from the moment itself—that took away its serendipitous qualities, but retained its involuntary aspects? Or was Marcel's nostalgic attitude somehow existentially deeper—so pervasive that he himself was not aware of it?

Another example that complicates the aspect of serendipity in nostalgic listening comes from *BioShock Infinite* (2013), a game whose soundtrack has been discussed by several scholars (Pozderac-Chenevey 2022; Gibbons 2018; Ivănescu 2019). The game presents an alternative past, the year 1912, in which the player has to battle their way through a floating city called Columbia, a utopian vision of its spiritual leader Comstock, in which the American founding fathers are revered as prophets. Time travel and alternate dimensions play a large role in the story, and one way in which this is presented to the player is through music. Music from different times sometimes seeps in through 'tears' in reality, such as Creedence Clearwater Revival's 'Fortunate Son,' and sometimes it is performed in more contemporary settings to the game's era, such as a barbershop-quartet version of the Beach Boys' 'God Only Knows,' or a ragtime version of Tears for Fears' 'Everybody Wants to Rule the World.' If there is nostalgia in encounters with these songs, it is carefully constructed to be part of the game. They are worked into the game in such a way as to always be heard, discovered through an 'a-ha!' moment, such as when you recognize a ragtime recording that sounds early twentieth century to be a cover of R.E.M.'s 1991 'Shiny Happy People.' The serendipity in these encounters is also built into the game to an extent: the covers are often hidden away on record players in the corner of a room, or sung by characters you pass by on the street on the

way from one location to another. Whether these parts of the games are experienced as nostalgia is dependent on the player. For some, the *Bioshock* games can truly be said to inspire nostalgia; for others, these moments are merely signifiers of nostalgia in the story context of the game. As Andra Ivănescu argues, the critique that these games present 'has turned on nostalgia itself' (2019, 138). The point is not that the experience of nostalgia can be 'induced' through references of a past, but merely afforded by careful placement of the aforementioned elements in a way that resembles a truly serendipitous experience. For Sartre, this would be a kind of 'false nostalgia' (2014, 48–49)—one that does not well up spontaneously, but that is simulated, partially out of duty, partially in the hope of attaining some of the qualities of real nostalgic emotions. We can therefore say that these kinds of games invite or afford a kind of nostalgic listening *for*, or even 'in search of,' to paraphrase Proust. In the next section I want to look at an entirely different encounter with video game music, that of beauty in nature, that nonetheless shares many phenomenal characteristics with nostalgia.

Hearing Beauty in Virtual Nature

Beauty in nature as a paradigmatic example of aesthetic experience is not as popular as it once was. Visions of (male) tenured professors such as Immanuel Kant going on afternoon strolls through a safe, carefully preserved and/or crafted countryside have an air of exclusivity to them that has been carefully exposed and deconstructed in recent years. Even earlier, in the nineteenth century, aestheticians' gazes turned towards art instead of nature as their primary object of enquiry. Let me, however, briefly try to recapture these lines of thought with a series of examples. By no means do I want to deny the situatedness and subjectiveness of experiences of beauty in nature, but I do want to take them seriously in the face of pluralist criticism, just as I feel the positive qualities of nostalgia can be preserved in the face of authenticity debates. The examples I will be using come from various sources. Some are autobiographic examples of listening to music in everyday life, some are examples from concerts, some from painting and some from video games. The idea behind this is not quite to suggest that the experiences share a common phenomenological essence to do with the experience of 'nature.' This of course would not do justice to the medium specificities and idiosyncrasies of each situation. However, I do want to cautiously suggest

that there is a certain underlying structure of perception, or perhaps merely a reference to that structure, that each experience shares.

I want to begin by comparing two experiences of hearing the song 'Intro' by the French band M83. The first occurred during a concert in the early 2010s at Brixton Academy in London. The band's set started out with an otherworldly creature emerging from the darkness, backlit by flashing spotlights and accompanied by dramatic synth strings. It raised its arms wide, and from its fingertips sprang laser beams that extended over our heads to the back of the hall, creating a momentary ceiling of light that darkened abruptly as the creature retreated into the darkness. Then the first synthesizer notes of 'Intro' (2011) started, with which M83's album *Hurry Up, We're Dreaming* opens. Singer Anthony Gonzales takes his place forcefully in the centre of the band: legs wide, arms behind his back. The first sections of the song are accompanied by a myriad of flashing spotlights and rows of LEDs that accentuate the frantically alternating synth notes. Intensity increases with the addition of a steady kick drum, and the synth accompaniment rising in pitch, when finally the song breaks open into a jubilant instrumental section, and hundreds of stars light up on the back wall, stretching towards the ceiling. Standing at the front of the crowd, our gaze was thrown upwards, immediately accompanied by a sense of vast open space. Even as my eyes fixed themselves back down on the band—particularly the drummer who led the section with drum rolls and off-beat crash hits—the sense of verticality, of space stretching out above the stage, was very strong. The descending scales with which the song ends felt like they were cascading down from the heavens, even though they were barely audible in the performance.

My second encounter with this song happened completely in a situation that was quite similar to the first. Walking through Pembroke College in Cambridge, on my way to my department on a cold Tuesday afternoon, I suddenly noticed the music that was coming through my earphones. I had not been paying the song much attention until that point, and there was a very specific way in which it seeped into my consciousness. My gaze drifted upwards to meet the college's skyline, which was immediately 'potentiated' by the music. That is, the view was not so much given a specific context in the sense of a series of associations that the music provoked, but rather the *potential* of such a context. I was struck by the contrast between the dark rooftops and the crisp, steel-grey sky; the sharp, looming outlines of the cross atop the chapel; and the way these impressions seemed to echo through in the

music; the object-like nature of the phenomena—the rooftops and the cross in particular—was suspended as the music subsumed their appearances after my attention had drifted from them to the crashing waves of M83's electronic sounds. The sounds—thick, fuzzy layers upon layers of consonant synthesizer chords driven forward by a regular drum rhythm—in turn blended upwards with the sky only to come down again on the spires in the distance, aided by the reverb of the voices earlier in the song. These impressions were sustained by the repetition of the eight-bar phrase into which 'Intro' culminates, but ultimately cut short when the dark walls of the buildings overtook the skyline and pulled my gaze back down to eye level.

My two accounts have many similarities. Most prominently, both were involved in a sense of space, particularly verticality. Both had an element of involuntariness to them: my gaze was forced upwards, and there was a skyward 'pull' in the concert experience even as I was attending to something else. However, I must emphasize that at the time they felt quite unique and separate from each other. In fact, I cannot recall which came first. The most important difference is the sense of forcefulness with which the objects of perception came to me at the concert, versus the way in which impressions blended and drifted into each during my stroll through Pembroke. Clearly, my engagement with the music was different, even opposed, in both situations: my attention to the way the performers' gestures and movements produced and directed the different sounds on the one hand, and on the other my relative inattention to the music; I could not even recall at which point in the song my gaze met the rooftops, and the song's structure only became meaningful towards the end with my reflecting on the experience itself and the way it was sustained by the eight-bar phrase.

Are these two different ways of listening—the one perhaps ludic, playing along to the concert with my gaze, moving it to different visual aspects of the experience with the structure of the song—the other one aesthetic, marked by a reflective drifting of my gaze and thoughts away from the music? Or are they two related moments of aesthetic hearing, marked by a sensation of space and verticality, and the difference in 'force' only being a difference in the character of the situation that was revealed by my phenomenological reduction? I want to turn to an example from video games that will lean more towards the latter explanation.

Ronald Hepburn has the following remarks comparing the aesthetic experience of nature to that of art:

> Where we confront what we know to be a human artefact—say a painting—we have no special shock of surprise at the mere discovery that there are patterns here which delight perception; we know that they have been put there, though certainly we may be astonished at their particular aesthetic excellences. With a natural object, however, such surprise can figure importantly in our overall response, a surprise that is probably the greater the more remote the object from our everyday environment. (1966, 302)

There are two interesting insights here. The first highlights the importance of 'finding' an aesthetic panorama, of serendipity. It raises the question to what extent our knowledge of intention—of how much the scene has been 'authored'—can diminish the surprise. The second insight suggests that unfamiliarity or in this case 'remoteness' can also be the cause of this diminished surprise. Video games offer unique cases for the idea of both authoredness and remoteness. Player freedom to traverse video game worlds, especially those of open-world games, complicates the question to what extent the 'patterns' that Hepburn talks about have been authored. Games' fantastical stories—science-fiction and fantasy settings are common—as well as the use of nondiegetic music complicate the question of remoteness: how strange is it really to hear music in a deserted tundra? Consider the following example from the open-world game *The Elder Scrolls V: Skyrim* (2011), a role-playing game in a Nordic-themed fantasy setting in which the player is free to explore a large open world.

Walking through the snowy plains of northern Skyrim, reaching a hilltop, and surveying the countryside to get my bearings, I am suddenly struck by the beauty of the distant mountaintops against the tumultuous grey sky (1'10" in **Video 2.3** ▶). The sense of openness and space is accentuated by the soundtrack, which consists of instrument groups playing single notes that alternate so gradually that any sense of time or musical progress is absent. Sustained notes—high-pitched strings and disembodied, wordless soprano voices—seem to 'hang' in the air, even above the wind sounds that remain anchored to the flurries of snow closer to the ground. I know that the music was playing before I got to the hilltop and continues playing for a while afterwards (even as I encounter a group of enemies and it is drowned out by the sounds of swords clashing and men shouting), but it is in the moment I encounter the vista at the top of the hill that the music acquires this significance. It is as if the music was made for the moment.

In this moment, the music has gone from something that was there in the background to quite a clearly distinguishable and definable set of things: sustained notes that ever so gradually changed, had a location in musical space (being quite high in pitch), and stood in a certain relationship to other elements in the diegetic environment. In other words, these elements of the music became more object-like, not in the sense that I could walk around and manipulate them, but in the sense that I could 'think around' them and relate and compare them with other things in the environment, such as the distant mountains, the gushing wind, and the grey sky. While there is movement in the scene, and movement in the music (to a small extent), the moment seems suspended in time: I am not worried about having to move on, or about what comes after this particular experience—I am squarely *in* the moment, unconcerned with time.

This attempt at a close examination of an experience when playing *Skyrim* raises a number of questions. Before I come back to how this particular nature scene relates to Hepburn's aesthetics—authoredness, remoteness, and serendipity—it would be good to more closely examine some of the concepts I applied in my description. The two that I want to focus on are musical objects and musical moments. Particularly in the case of music, the two are interrelated: only in a particular kind of moment can a musical event or process (e.g. a melody, a trill, a phrase, a crescendo, an entire piece) become object-like to the extent that I can reflect on it and relate it to other objects in that moment. This is the kind of suspended moment that I described above, which is essential to aesthetic experience. Because time and objects have been such central themes of phenomenology, occupying everyone from Husserl (1991) at the field's very beginning to Gallagher and Zahavi (2008) in contemporary investigations, I feel I need to limit the scope of my theoretical background somewhat. I will start by building on Thomas Clifton's proposed 'essential background of time' (Clifton 1983, 51) in his phenomenology of music.

For Clifton, musical time, or indeed any experienced time, is not just another object or thing in the world, nor a psychological aspect, but an essential part of any experience. More importantly for my current investigation, Clifton argues that 'time does not flow' (1983, 56). We can experience things (or even ourselves) as flowing *in* time, but time itself only flows as a 'metatime,' such as watching a clock, or reflecting on one's own experience of time passing. The experienced or phenomenal present is defined in terms of horizons, a term Clifton likens to Heidegger's span or *Spanne*. Judy Lochhead

(1986) has pointed out that Clifton confuses the term 'horizon' with 'field,' which is more in line with Don Ihde's phenomenology that I discussed in my introduction. For consistency and clarity, I will refer to what Clifton calls 'horizon' as 'field.' The character and 'width' of a field can vary depending on the experience: '"now"—in the intermission, while one is eating, in the evening, in summer; "then"—at breakfast, when one is taking a climb, and so forth' (Heidegger quoted in Clifton 1983, 58). Similarly, music is not just a series of infinitely small moments of slices of time. Clifton suggests that 'I could not experience a melody if it did not also push back the borders of the present to include itself, as a singular event, in a single present. We say that we are listening to the *Waldstein* Sonata; we do not say that we are listening to this moment then this moment, then this moment, then this moment, etc., of the *Waldstein* Sonata' (1983, 58). For Clifton, temporal fields can overlap, and one can have fields within fields. In the case of listening to music, this means that 'we will have occasion to speak of musical situations in which beginnings sound like endings, endings sound like beginnings, or in which the beginning "begins again" in a manner other than that characterized by simple repetition' (1983, 59).

While much of what Clifton says about fields goes for my characterization of the moment in *Skyrim*, the specific phenomenal character of that moment precludes the possibility of overlap or a moment-within-a-moment. It is a moment that stands out, or as Dewey would say, it is *an* experience that stands out from *mere* experience, and I think this can be said of other moments in music. Some are shared by many and experienced as intended, such as 'that moment in the first movement of Beethoven's Ninth in which the recapitulation comes crashing in in D-Major.' Some are equally 'intended,' but more personal, such as 'that moment when you realise the performers are not actually going to start playing in Cage's 4′33″.' Some are unintended and even more personal, such as the madeleine moment described above, which can perhaps happen in any piece of music at any time. These moments, while they have an indefinite horizon similar to Clifton's fields, can perhaps best be described as a very specific phenomenological subset of time experience: they appear suddenly, even unintentionally, are quite short (measured in 'real time') and happen quite rarely in music. (This is also what distinguishes them from *an* experience in Dewey's aesthetics. Moments are short, while an experience can span any length of time: the experience of hitting a home run in baseball, of reading a great novel, of going to university, etc.)

Of course, any time in music can be a 'moment.' When I ask you, 'What are you listening to right now?,' you might reply, 'Well, at the moment Keith Moon is going through the drum solo of (The Who's) "Won't Get Fooled Again," building up to that moment when Roger Daltrey comes in with this roaring "YEAHHHHHH."' This answer contains two phenomenologically different uses of the concept 'moment.' The first is a period of time reflectively described, and demarcated partially through reference to the second moment. That second moment is more like the examples above: an event in the song that springs out and defines our experience of it as a whole. The first moment best fits an indefinite article ('a moment,' or 'any given moment' in music); the second a definite article ('the moment,' or 'that moment' in music). These latter kinds of moments—definite, defined, or defining moments—are what I want to call aesthetic moments, which form the core of aesthetic experience. They include moments that have become so codified in discourse that they are almost clichés, such as Beethoven's D-Major recapitulation, or Daltrey's scream, which became an internet meme following its use as bumper music for the television series *CSI: Miami* (2002–2012). But they also include personal moments of musical nostalgia, the kind of moments I experienced when listening to M83's 'Intro,' and when playing *Skyrim*. While any temporal field of music can overlap with another, we can think of our listening experiences in terms of a series of aesthetic moments as well, which cannot overlap, but are rather separated from one another by less interesting passages of background music. As Aaron Ridley suggests, musical understanding requires the listener to be aware of passages of music 'that take up time without being meant to be especially noteworthy or striking' so that 'high-interest material stands out more clearly by contrast' (2004, 37).

If I am right, this means that we do not experience non-aesthetic moments in music without some sort of intentional listening act, prompted by an extra-musical source, such as a question along the lines of 'what are you listening to right now?' or something that requires you to wait for a specific musical event to happen (more on this in Chapter 4). This also potentially goes against Jerrold Levinson's idea of musical listening as concatenational, that is, 'the view that what musical apprehension centrally involves is integrating individually perceived phrases, melodies or sequences into a progressively traversed musical totality' (1997, 37). The progressive traversing of musical totality might be something we do in the concert hall, listening to a symphony for example, but it is not what happens in the aesthetic moments I describe above.

While this all suggests that my experience in *Skyrim* can be characterized as an aesthetic moment in the same vein as a moment of nostalgia, or of my experiences listening to M83, it does not say anything about the temporal dimensions of that experience. Clifton suggests that '[t]here is a distinction between the time which a piece *takes* and the time which a piece *presents* or *evokes*' (1983, 81).[5] The *real* time of two of the musical moments I am discussing is actually hard to pin down. While my experience of 'Intro' during the concert was quite clearly delineated—beginning with the 'breaking open' of the song that coincided with the lighting up of the starry wall and lasting all the way to the end of the song—I cannot quite recall at what point in the song my gaze drifted upwards to the skyline of Pembroke during my walk. Similarly, the exact moment in the music at which I started noticing its relation to the distant mountain tops was not significant to my experience in *Skyrim*. Both walking experiences trailed off as I continued on my journey ('getting back to the task at hand'), to the extent that I can only recall when and how they began, not how they ended. In any case though, the moment lasted a particular number of seconds in each case, ranging from very short (perhaps only an instant) in *Skyrim*, to roughly half the song during the concert (about two minutes).

The *musical* time of each moment is completely different. We can say that my experience during the M83 concert—the aesthetic moment—was in musical time: its horizon stretched from a particular event in the song to the song's end, marked by silence and applause. We can even say that the experience *happened* in musical time: its beginning was led up to and defined by an increase in intensity in the music that preceded it. Although my experience in Pembroke College had a similar moderate tempo to it as the concert experience (105 BPM, measured in real, or rather metronome, time), it did not proceed along with the time of the song or happen in the time of the song. Rather, I noticed the song, almost 'stumbled upon it' at a random point, and took in its moderate motion as part of the scene. My experience of the mountain vista in *Skyrim* had a similar musical time to it without *happening* in musical time. The difference here is that it was the static qualities of the music that were echoed by features of the landscape. Another way to distinguish between these two different experiences of musical time is to note the teleological nature of musical time in the concert (my gaze was thrown upwards when the last section kicked in and lasted until the end of the song) and the absence of teleology in Pembroke and *Skyrim* (the music was just *there*, unfolding, but not culminating or moving towards an end point).

Before returning to Hepburn's aspects of natural aesthetics, I need to address the idea of musical features becoming object-like in the case of *Skyrim*, or the opposite happening to the skyline in Pembroke whose features became less object-like in my experience. This is very closely related to the nature of the aesthetic moments I discussed. For Clifton, musical objects are the same as any kind of object in that they are determined by continuity. When we walk around a solid object, it presents different perspectives to us, but we do not question whether they are of the same object because of a fundamental continuity in the phenomenon. Similarly, when we listen to a tone we do not hear it as something different now than a fraction of a second ago, but as the same 'object,' because of continuity (Clifton 1983, 97–98). Continuity is also what allows us to hear a melody as a melody, rather than a meaningless succession of notes. But there are two fundamental differences between the way in which we hear sounds extended in time and the way we see objects extended in space. The first is that a sound always has a duration. Even when this duration is very long or potentially infinite, because of the energy it takes to produce a sound, we think of it as something that can potentially cease to be. We think of an object, however, as persistent. The second has to do with the kind of agency we have in perception: we can look around an object at will, whereas we have no such control over a sound (even when we are producing a tone on an instrument, we can only manipulate it, so that it transforms into another object). But objects can acquire sound-like qualities. We cannot look around the trees in a painting, and the landscape that we see outside the window on a train journey 'ceases to be' as we pass it by. On the other hand, a sound can become object-like when we 'think around' it, or in other words reflect on it while it is present to us.[6] I want to argue that these events happen particularly in aesthetic moments: in their durationless temporal character and disinterested nature (in the sense that we do not feel inclined to act during the moment; see my discussion earlier in this chapter), both the sound-like qualities of sounds are suspended, and the object-like qualities of objects are suspended. This means that in the moment I experience the *Skyrim* panorama the strings become something on par with the objects in the environment, and in the moment, I experience the Pembroke panorama, and the objects in the environment become something on par with the sounds in 'Intro.'

I will come back to this description of aesthetic moments in my discussion on the music in *Civilization IV* and the possibility for an account of general aesthetic experience of music in video games. But for now, note the

similarities between a nostalgic moment and the experiences described above: their sudden onset and trailing off, and their durationless qualities. What is particular in the case of an aesthetic experience of nature—or more precisely, of a panorama, vista, or scene—is the way in which both the sound-like qualities of the musical sounds, and the object-like qualities of objects in the scene, are suspended. In the durationless moment we are free to reflect on them separately, to consider their relationships to each other, or in other words, to 'think around them.' The musical elements become part of the scene, on equal terms with elements seen and felt, whereas in a nostalgic moment the music comes to the foreground. This freedom of 'thinking around' that musical moments allow for also offers an audiovisual answer to the question of visual aesthetic contemplation in video games that Paul Atkinson and Farzad Parsayi (2021) address. Asking when players have time to contemplate their virtual, natural environment in the goal-driven medium of games, musical experiences like *Skyrim*'s can offer some kind of reprieve.

This brings us back to Hepburn's description of beauty in nature, and how it relates to nostalgia and other aesthetic experiences. The two examples I have used of hearing M83's 'Intro' present us with two different moments or scenes: the concert is an example of encountering the aesthetic in what Hepburn would call 'art,' the walk through Pembroke an encounter with the aesthetic in 'nature.' Everything I saw and heard in the concert was authored to fit together, whereas the connection between the music and the scene in Pembroke was more or less incidental. Of course, the playlist I was listening to was compiled by me—a list of songs that I was listening to a lot at the time. But the music was chosen to fit my general mood; no particular moment, and definitely not the moment I described. Hepburn notes three main distinctions between the appreciation of beauty in nature and in art:

1. In beauty in nature there is a sense of involvement, whereas in art there is a distancing. Moreover, encountering beauty in nature somehow makes us experience our*selves* in an 'unusual and vivid way . . . and this difference is not merely noted, but dwelt upon aesthetically. (1966, 289)
2. Art is *framed*, in that we can usually see a distinct demarcation from the environment. We can see both the boundaries and what lies beyond the boundaries: the silence before a concert, the white walls of the museum and the applause and frames that separate them. Scenes of nature, however, seem to be pervasive. (1966, 290–91)

3. There is a difference in grasping an art object and a scene of nature as a perceptual whole: in the case of the artwork, it is the delight we find when we see how some aspect of the artwork has been put into place for a purpose, namely achieving the artistic whole. In the case of beauty in nature, we marvel at the fact that nature in general can seem beautiful to us at all: that there is natural beauty and that the present scene is an instance of it. (1966, 291)[7]

Contemporary art raises a number of objections to points 1 and 2. Installation art often involves the spectator by having them reflect upon their spectatorship in new ways, such as Carsten Höller installing giant slides in museums. Hepburn's example of staring at a painting in a gallery is a very dated example of art, although it does also pertain to the classic concert-hall aesthetics many still adhere to nowadays. However, if we take the idea of art as 'framing' and 'distancing' to be the qualities not of an artwork's physical presentation, but of the aesthetic experience that it provides, we can generalize beyond traditional art forms. In this view, both Höller's slide and a beautiful landscape are *about* our involvement: the former about our involvement in the museum and the art world, the latter about our involvement as human beings in the natural world around us. But the experience acquires that 'aboutness' (Danto 1981) by distancing us from the actual situation, from our actual involvement in the scene. Heidegger would say that aesthetic experience discloses involvement; it brings the experience of being involved to our attention. The manner of disclosure is the same kind of framing that the gallery does to a painting. Aesthetic experience can be said to frame a certain scene, to make what we would normally glance over into a particular scene, everyday experience into *an* experience.

This still leaves the question if there is any phenomenal difference between the presence and absence of an author in aesthetic experience. If both art and nature can disclose involvement, what is left to distinguish them? According to Hepburn's third point, while in art we contemplate on a part-whole relationship, in nature we contemplate on the possibility of existence of beauty in nature at all, as there is no intended 'whole.' But this is not a necessary feature of the aesthetic experience of nature. In natural aesthetics, plenty of other examples have been given. Scientific cognitivist accounts, for example, hold that there *is* a kind of part-whole relationship in our appreciation of nature. We can admire the particular intensity of a red sunset for its redness, for instance, but to appreciate the red sunset as a part of *nature* employs scientific

knowledge about the composition of our atmosphere, or the earth's rotation (Parsons 2009, 354). This is no different from admiring the yellow of van Gogh's sunflowers or admiring the way the intense colour distinguishes those paintings from other still lifes. These are all concepts that come into play in the wake of an aesthetic experience, rather than prerequisites for it. The presence or absence of an author, I argue, is no different: it is a question that comes into play upon reflection, *not* an essential difference between aesthetic experiences.

This is also why up until now, I have not made any mention of the identity of the author(s) of the moment in *Skyrim*. At multiple points in my discussion, I have implied however that it is not so much the qualities of the musical cue, but how they related to the moment in the game, that are the focus of the aesthetic experience. This already suggests that authorship is not solely attributable to the composer, but to the development team as a whole. But in the specific case of *Skyrim*, the identity of the composer has come to play an important part in many players' experiences since the game's release in 2011. First, Jeremy Soule was a much-lauded and awarded video game composer for his work on the Harry Potter games and *Skyrim*'s predecessor, *The Elder Scrolls IV: Oblivion* (2006). But later in the decade, his name became synonymous with the #MeToo movement and its relationship to video games after accusations of sexual harassment and rape (Freitas 2022). Regardless of whether Soule can be said to be responsible for aesthetic moments like the one described above, his name, much like a film *auteur*, can be a looming presence in any musical reflections upon *Skyrim*. For those aware of the discourse, it will likely even preclude aesthetic moments altogether.

What the phenomenological presence or absence of an author also involves is the issue of serendipity. I have argued before in the section on nostalgia that stumbling upon the object of an aesthetic experience intensifies the experience, and this is no different with natural beauty. If we go to a museum to look at an artwork, we expect to find objects of aesthetic value. This both allows us to adopt an aesthetic attitude that opens up to the possibility of an experience, and makes it more difficult to have one. When there is a particular thing I am looking for, a feature of a painting for instance, my attention is likely to move on once I have found it—there is no particular incentive for me to linger on the feature. This is what connects Hepburn's conception of beauty in nature with the Kantian conception of aesthetics that I outlined in the first section of this chapter and, as we shall see in the next section, with video game aesthetics as well.

Authored Musical Moments

To come back to my experience in *Skyrim*, I want to briefly compare this moment to what Amy Herzog (2010) would call a 'musical moment' in film. This happens in Hollywood musicals when 'music, typically a popular song, inverts the image-sound hierarchy to occupy a dominant position' (Herzog 2010, 7). During this moment, 'the temporal logic of the film shifts, lingering in a suspended present rather than advancing the action directly'; 'movements within the frame are not oriented toward action but toward visualising the trajectory of the song'; 'space ... is completely reconfigured into a fantastical realm that abandons linear rationality'; and there is a 'dissolution of the space-time continuum that orders the reality of our everyday existence' (2010, 6–7). This might seem much more like a description of ludic music, with its emphasis on the experience of musical time, rhythm, and movement, but there are a number of qualities that fit the moment in *Skyrim* as well. The 'lingering in a suspended present' is something that can be said both about the narrative—my personal narrative in the gameplay session can be described as 'I climbed the hilltop to survey the countryside,' but for as long as I am up there my journey does not continue—and about my gaze (in the most multimodal sense of the word), which lingers on the mountaintops and dwells on the music. Like the characters who break out into song in a musical, I am temporarily suspended in music.

The difference here seems to be that on the hilltop in *Skyrim* I am not *just* suspended in music. The lingering of the notes and my lingering gaze, the distant mountaintops and the airy strings, they all blend into each other, creating a moment in which music is very much a part, but in which the music does not seem to dominate like the song in a musical does. But this is only because the music is more static than a typical Hollywood song. It lacks a pronounced beat and rhythm for things to move to and has no clear sections (such as verse and chorus) to carry the moment forward and create a series of events.[8] This makes it easier to think of the music as being subservient to the logic of the 'image'—or, in this case, of the situation that I find myself in in the game. But that does not make it background music. While during the journey leading up to and away from the hilltop the music may have been in the background, I take note of it on the hilltop because it is an integral part of my experience there. The question whether the music acquires its meaning—in this case lingering, airy qualities—from that moment, or whether the moment acquires its meaning from the music, is not

one that matters. We could also say that the moment is as much suspended in the music as the music is in the moment. The *real* difference between the musical moment that Herzog describes and the one I described is very close to Hepburn's distinction between beauty in art and nature. Whereas the musical moment frames the film, authored by the director and crew, the moment in *Skyrim* frames my experience, and I can only conclude in hindsight that I serendipitously framed it myself, or rather, that my travels and climb up the hill framed it.

This difference exists in video games as well. Consider the opening sequence of the game *Tomb Raider* (2013). A remake of the 1996 game of the same name, *Tomb Raider* features Lara Croft, a young heroine who gets stranded on a mysterious island. In the opening moments, right after a spectacular ship crash that is portrayed in an extended cutscene, Lara is trying to escape the island's hostile population, find shelter, and figure out a way of contacting her crew. These moments act as a kind of tutorial for the player, to familiarize themselves with the game's controls and mechanics. Unlike the game's later areas, in which the player is (to a certain extent) free to roam around and explore, this part of the game is largely linear. The player is guided through a number of challenges in which they have limited control over Lara. Along the way, the more shocking features of the cavernous environment that Lara traverses (mostly mutilated corpses and collapsing ceilings) are highlighted in a traditional film-musical manner with stingers. These help to make up for the lack of camera cuts as a narrative device, as camera control is firmly in the hands of the player, behind and slightly above Lara, in the typical manner of a third-person game. They are supplemented with dissonantly layered drones, nearly inaudible under the noise of cracking rocks and rushing water, which sometimes lead up to 'stinger moments,' and sometimes do not, to give the player a continuous sense of dread and danger. (Both have largely semiotic functions, which I shall elaborate on in Chapter 4.)

After solving their first environmental puzzle, the player has to make their escape from the collapsing cave (0'18" in **Video 2.4** ▶). A danger music cue starts—syncopated drums and low brass with off-beat mid-range brass accents that allude to the earlier stingers—and continues looping with variations until Lara reaches the cave's exit. In this sequence, which is essentially also a tutorial for later action sequences of the same nature, both earlier gameplay and musical elements (both stingers and drones) are recycled, combined, and intensified. The most important intensifier here is time

pressure: if the player dawdles or makes a mistake with their inputs, the cave collapses and Lara dies horribly. As she approaches daylight, a short rising brass motif is added. As soon as she reaches the surface, though, a cutscene starts playing, and the music abruptly cuts out (2′19″). The few seconds of silence make way for a simple, adagio piano melody in the same key, later joined by a small string section. Lara looks up to the cliffs to see the sun break through the stormy clouds over her wrecked ship, and we finally see the game's title card (2′57″).

The way the scene is set up is to maximize the contrast between the frantic climb out of the cave and the tranquillity of the cliff-side vista after the storm. This contrast 'frames' the panorama that accompanies the title card. While the similarities to the mountain vista in *Skyrim* should be apparent, the difference is that it is not my journey through the cave that frames the panorama, but the game's 'author.' Like Herzog's musical moment, the game lingers in a suspended present. But this is not *my* present; it is a depiction of *Lara's* present, represented through a combination of gameplay, music, and graphics. I do not stumble upon the cliff-side vista: Lara does. Of course, this does not necessarily stop me from having an aesthetic experience when confronted with this part of the game. But it would do so in the same way as a Friedrich painting—framed on a museum wall—would not prevent its viewer from having one, despite only being a representation of nature (see also Kamp and Sweeney 2019, 190–4).

One could raise the objection that in the *Tomb Raider* sequence we are not really *playing* the game, as it is a cutscene in which Lara walks up to the cliff edge, and control is taken away from the player. Or that it is actually the game's linearity, rather than an unauthored kind of serendipity, that makes this more like art than nature. More interactive musical moments occur in *Death Stranding* (2019), for instance, a game that has the player deliver packages in a postapocalyptic, barren but lush landscape. At times while the player is traversing the craggy terrain, post-rock tracks by bands such as Low Roar start playing as shown in **Video 2.5** ⓟ. These musical moments are framed almost like music videos, as Lidia López Gómez (2022) contends. While these moments are more interactive than *Tomb Raider*'s, with the player continuing on their journey while the track sounds, their audiovisual framing is explicitly authored, with the (co-)author's signature appearing on screen in the track title that announces the song in the player's interface (1′12″). They are also clearly framed temporally through the pop songs' structure.

And consider the following example of *Assassin's Creed* (*AC*). Most *AC* games are third-person action games, like *Tomb Raider* and *Death Stranding*, set in a number of historic periods from ancient Greece to Victorian London. These periods are linked through an overarching science-fiction narrative, in which the player dives into the 'genetic memory' of a modern-day character's ancestors. This framed narrative, while only overtly addressed in small sections of each game, plays an important part in the presentation of the games' interface elements. While in most games (such as *Tomb Raider* and *Skyrim*) these are nondiegetic, and their look and sound are explained by the games' overall aesthetic, in *AC* they are diegetic in one layer of the narrative, and nondiegetic in the other. This is a point I will come back to later on in my discussion.

Even more so than *Tomb Raider*, the *AC* games feature an open world for the player to explore. This takes the shape of a number of cities that the player can freely roam around in. Roaming around and exploration are essential parts of the game, as the player's character, an Assassin, is apt at climbing and 'free-running' through the environment.[9] The player is encouraged to get their bearings when first exploring a city by climbing towers and tall objects, called 'viewpoints,' and surveying the cities from above (**Videos 2.6**, **2.7**, and **2.8** show examples the first three games in the series ▶). This activity reveals new objectives and points of interaction on the game's mini-map and generally serves as a marker for progress through the game. Climbing a viewpoint consists of three stages: the climb, in which the player finds their way up to the top by looking for a path of handholds along the side of the object; surveying the area, called 'synchronization,' by walking to a particular ledge and pressing a key; and the dive down from the tower, in which the Assassin defies the laws of physics and anatomy by landing safely and unharmed in a pile of hay or leaves. The synchronization stage consists of a small cutscene during which the camera rotates around the Assassin, both showing his climbing prowess and giving a quick overview of the surrounding cityscape.

The music that accompanies these viewpoint sequences has both similarities to *Tomb Raider* and *Skyrim*. Like *Tomb Raider*, there is a deliberate auditory framing going on. This happens most consistently, as one would expect, in the game's diegetic soundscape: as the Assassin climbs higher, busy sounds of the bustling city crowd die away to make way for the airy, long drawn-out sounds of the blowing wind and the high-pitched screeches of birds.[10] Here is the first similarity to the sequence in *Skyrim* as

well, namely the gushing wind. Like *Skyrim*, the music mirrors the contours of some of these sounds as well: long, high-pitched, drawn-out strings blend with the sounds of the wind in *AC1*; in *AC2*, these are lower in register, but similar in length; in *AC3* there is a combination of high-pitched drones (violin harmonics) and even lower brass drones, still similarly lingering and static. But unlike in *Skyrim*, and more like in *Tomb Raider*, there is a clear melodic motif in each viewpoint cue. This has the simplicity of the piano melody in *Tomb Raider*—perhaps even more so, as there is a question-answer structure to the *Tomb Raider* theme (2'32" in **Video 2.4** ▶), whereas the motifs in the *AC* games have a singular structure. There are slight differences in musical design between the *AC* sequences as well. Whereas in *AC1* and *AC3* the music dies away as the player climbs the tower to make way for (or frame) the synchronization cue, in *AC2* the music remains. In this particular sequence in *AC2*, the narrative function is to signify the main character's emotional state: playful and mischievous. We find another difference in the *AC3* music: as the Assassin reaches the top of the tower, the viewpoint cue is anticipated by the high and low drones, which gradually fade in.[11] Then, when he has reached the top and the player presses the synchronization button, the melodic motif starts together with the synchronization cutscene.

The *Assassin's Creed* games are much closer to *Skyrim* in the freedom they offer the player than *Tomb Raider*, and yet I argue that there is the same essential difference in the way we hear the viewpoint cues. The music is very similar in each game: long, high-pitched string drones with very little harmonic change that complement the sounds of the wind. In *AC*, the music is part of a very specific cue that is both a narrative and a gameplay marker: narrative, because it describes the particular achievement of the Assassin; gameplay, because it functions as a signifier for the player's progress. But in *Skyrim*, we stumble upon the music, as if it were just a feature of the landscape, not placed there by an author for a particular purpose. Of course, the nondiegetic music is *not* a feature of the landscape. This is where *AC*'s framed narrative can elucidate matters. Although the game's interface elements (targeting icons, minimap, navigation markers, etc.) can be said to be diegetic at least in one layer of the narrative, the music is *always* nondiegetic. (Or at least we can assume it to be, as its presence is never explained by characters in the game world.) Particularly in **Video 2.6**, but in a more subtle way in **Videos 2.7** and **2.8** as well, we hear a flurry of interface 'earcons' as the Assassin surveys the

landscape: at 0′57″, there is the whooshing sound that accompanies the fade to white, at 1′00″ the high-pitched 'Saving . . .' chimes, followed quickly by the 'mission complete' piano motif, which is accompanied by a number of synthesized background noises that map onto interface elements that appear. Throughout all this, the musical drones slowly fade out, back into the diegetic sounds of wind and birds. The music is subsumed so closely and seamlessly in the various layers of the diegetic interface, that there is no question of its purpose: to signify, rather than to merely be, or linger. Ailbhe Warde-Brown aptly calls this signifying of the 'cultural, historical, and geographical context' in these moments 'spatiotemporal semiosis' (2021, 42).[12] The music in *Skyrim*, on the other hand, blends much more closely in with the ambient sounds of the diegetic environment—sounds that were already there, that the player stumbles upon. By virtue of iconic and indexical relationship to other game elements, then, the music assumes completely different phenomenal roles in both games.

The main point of distinction between the way we experience art and nature is not necessarily the presence or lack of an author, but the serendipitous way in which we encounter the phenomenon. In video games, because of their interactive nature, this distinction can be found to a certain extent as well: aesthetic experiences of virtual nature in video games happen because of their nonlinear nature. So encountering a beautiful mountainscape in *Skyrim*, in which the music seems to blend with the mountains in the distance, is not necessarily any different from the aesthetic sensations that M83's 'Intro' aroused in me on a walk through Pembroke College. That is not to say that the only possibility for aesthetic experiences in games lies in the kind of unauthored serendipity we find in natural beauty. On the contrary, the same kind of 'forcefulness' that I experienced during M83's concert could perhaps be found in the uses of music in *Tomb Raider* and *Assassin's Creed*. I do not wish to deny the possible aesthetic qualities of these games. But if they are there, they are fundamentally different from those in *Skyrim*, as they entail a relationship to a perceived author: we stumble upon a particularly well-crafted aspect of the game; perhaps we admire the integration of music and gameplay in *AC*, or the way the music highlights Lara's simultaneous relief and desperation in *Tomb Raider*. In other words, the serendipity is to be found elsewhere. Having discussed the similarities between nostalgia and beauty in nature, in the final section of this chapter I want to generalize aesthetic listening and its characteristics.

Aesthetic Listening as Interpretation

For some it might be quite objectionable to consider *Skyrim*, a video game, as an example of natural beauty. In spite of my arguments, it could be said that *Skyrim* is no closer to providing the experience of natural beauty than a Friedrich painting. What makes it *seem* like natural beauty is the possibility of freely exploring an environment, and we should not forget that this is first and foremost an authored, virtual environment. In this last section I will discuss a final aesthetic experience to address these objections and flesh out the concept of aesthetic listening. This experience is of an entirely different game, *Sid Meier's Civilization IV* (2004), to show both that aesthetic listening is not limited to a particular kind of game or genre, and that there is a similar structure to this way of listening in each situation.

In this final case study, I want to highlight how aspects of aesthetic listening such as serendipity and authoredness translate themselves into a game unlike the third- and first-person games I have discussed before. The music of *Civ4* has already been the subject of academic study and critical acclaim, particularly for the originally composed main menu theme, 'Baba Yetu.'[13] Most of the soundtrack, however, consists of pre-existing musical pieces, but is no less interesting; it includes the musical moment I want to discuss, where the player first hears the music of John Adams. The *Civilization* series is one of the longest-running video game franchises, its first instalment appearing in 1991. Every game in the series features a number of civilizations—such as France, the Celts, or Persia—that the player has to guide through the ages from prehistory to the modern era. It is a strategy game, almost like a traditional board game like *Risk* or *Settlers of Catan*, where players and computer opponents (controlling other civilizations) take turns to explore and settle new lands, wage war, build cities, and conduct diplomacy. Although all civilizations, world wonders, and technologies are designed to resemble their real-world counterparts,[14] their occurrences in the game are historically and geographically incorrect to the point of playfulness: America could be waging desert warfare on the Incas in 200 BCE led by the great general Ivan the Terrible (Carr 2007). In every instalment from 1991 to 2016's *Sid Meier's Civilization VI*, the player is presented with a top-down perspective of a randomized world map, with icons or miniatures of cities, units (armies or army regiments), spies, missionaries, and so on. The games' many menus often have advisor portraits accompanying them, who act as guides to new players and represent the civilization's government.

In spite of the series' many anatopisms and anachronisms, *Civilization* represents advancement—both in the game and in history—most clearly through its different eras: in *Civ4*, these are the Ancient, Medieval, Renaissance, Industrial, and Modern Eras. With each advancement to a new era, the civilization's cities and units will change in appearance (from brick houses to skyscrapers, for instance). It is not these visual changes, however, that most clearly and persistently signify the historical progress from era to era, but the game's musical soundtrack. Because the player's default view (that is, the most effective view for controlling the game) is zoomed out to a point where the changes in appearance of individual units and cities become lost in a clutter of visual information, the music as the only continuous sound in the game takes precedence in conveying the current era.[15] The musical soundtrack too is constantly interrupted by sound effects that accompany the pop-up messages informing the player of completed projects and events that are happening at the beginning of each turn. But when the notifications subside and the player ponders over their next move, the music continues, in a way, to 'suture' (Gorbman 1987) one turn to another.[16]

So how does the music in *Civ4* convey the *zeitgeist* of the different eras? Tim Summers likens it to a kind of musical history lesson:

> Intentionally or otherwise, in drawing on actual world history to create a virtual world, a certain amount of informal education takes place, whereby the virtual world implicitly comments on the actual world. This is particularly significant where the divergences between game world and the actual world are ambiguous for players without prior historical knowledge—such as in the less obvious anachronisms between the music and the designated 'era.' (2016b, 97)

In a way, it is a kind of musical exoticism, where the Ancient Era is characterized by melodically and texturally sparse handclaps, drums, flutes, marimbas, and call-and-response singing, all staples of Hollywood film music characterizations of (African) tribal cultures. Whereas the Ancient Era music was originally composed for *Civ4* by Mark Cromer and Jeff Briggs, the soundtrack for the other eras consists of pre-existing pieces. The music for the Medieval Era consists of a 'greatest hits' of medieval and Renaissance music, from plainchant to Palestrina, in addition to secular polyphony (e.g. Josquin's *El Grillo*) and instrumental dance pieces. The Renaissance anachronistically features Bach, Mozart, and some Beethoven. The Industrial Era

mainly has more Beethoven, Brahms, and Dvořák. The final era, the Modern Era, exclusively features music by John Adams (see **Video 2.9** for a brief example of the use of *Harmonielehre* on the soundtrack ▶). As a trained musicologist, looking at this list of composers I am struck with questions about music historiography: Why would one equate the Renaissance with Baroque and Viennese classics? Are there some Beethovenian myths surrounding his inclusion in two different eras? What does it mean for the characterization of the Industrial Era that almost half the pieces are exotic dances (Brahms' Hungarian and Dvořák's Slavonic dances)? The question that most stands out, though, is why is John Adams the sole representative of the Modern Era in music? I want to address this question above all the others for another reason too: playing the game, the Modern Era music somehow stands out the most, both as the most ear-catching and as creating the most meaningful relationship between gameplay and auditory experience. This has been remarked too by Karen Cook, who suggests that '[t]he repetition of rhythms, the static tonal harmonies, and the relatively quieter mood of the minimalist music in the Modern era are all drastically different form the music that came before it' (2014, 173). While the first problem ('Why John Adams?') arises out of professional curiosity, and the second ('Why does this music stand out?') is of the same aesthetic order as the question 'Is the music commenting on my actions?' that I asked about *Minecraft*; the two are related. In order to provide an answer to both, I will start by discussing the implementation of Adams' music in the game—the poietic side of things—before moving on to a close reading of the aesthesic side of things, or my experience of the gameplay.

John Adams has frequently been called a 'post-minimalist' when compared to composers such as Steve Reich and Philip Glass (Schwarz 1996; 1990; Fink 2005). Instead of strictly obeying a set of procedures throughout the whole compositional process as his predecessors did, Adams adopts a more organic style that is prone to developments and climaxes more reminiscent of an earlier, late nineteenth-century idiom. Indeed, he describes his own music in terms of an 'intuitive sense of balance' (Schwarz 1996, 179), an 'embrace [of] the tragic aspects of life' (Schwarz 1996, 177), and an honest, non-ironic channelling of the sensibilities of composers such as Debussy, Mahler, and Sibelius (Adams 2008, 130–31). In this light, the inclusion of Adams' music for the Modern Era in *Civ4* seems almost like a traditional music-historiographical step from the Brahms and Dvořák of the Industrial Era. As the gameplay of Civ4 demands a teleological view of history (the game has

victory conditions, after all), the music can be expected to reflect a build-up or intensification of certain elements, and what better way than fin du siècle musical modernism and its maximalist tendencies towards bombast?[17]

And emotion and bombast do shine through in Adams' works: the first movement of *Grand Pianola Music* starts out subtly over a steady pulse with instrument groups trading harmonically unthreatening phrases, before halfway through, after building up layers of tension, exploding into E-flat and B-flat major triads hammered out on the piece's two pianos (with a nod to Beethoven's heroic works 'Eroica,' 'Emperor,' and 'Hammerklavier'). The excerpt of this movement in Civ4 cuts out precisely at this point. While the slow middle movement is included, the final movement, perhaps even more harmonically vulgar and insistent than the first, is omitted altogether. Similar operations have been performed on *Harmonielehre*. The first movement is about two minutes shorter in the game than the original recording. The first twenty-eight seconds have been cut, which contain a series of fortissimo E-minor opening chords with prominent roles for brass and timpani. The excerpt instead starts with the (relatively) softer repetition of these chords in the woodwinds and strings, with the block chords smoothed out into faster accompanying patterns. While overall this part of the music is less loud and urgent than the original opening chords, it has less of a sudden 'edge' to it. The final ninety seconds of the movement have also been cut, which represent both a break in the harmonic texture of the rest of the piece and an extreme build-up towards a climax that repeats the opening E-minor chords. In effect, it is as if the edges of the piece have been cut off.

It seems as though the motivation behind the selection and editing of John Adams' pieces is a 'smoothing out' of his music, to make it into more effective background music that has few moments that draw attention to themselves, something minimal music in general is already well suited to. As Andy Hamilton might say, the music is 'anaesthetized' (2007, 54). In this, the selection of pieces for *Civ4*'s Modern Era echoes some of the music for the other eras: slow movements from Beethoven, Mozart, and Brahms symphonies for the Industrial and Renaissance Eras; Palestrina masses for the Medieval Era; Bach's Brandenburg concertos with their seemingly endless interlocking melodic lines; the incidental flutes and drums for the Ancient Era. All this is music that to modern, Hollywood-conditioned ears does not clearly go anywhere, and nothing unexpected happens in it. In many ways, these cues broadly operate according to the rules of ambient music, best put by Victor Szabo as having 'a global sense of stability (through use of a limited range of

melodic gestures, a narrow dynamic range, etc.), while remaining inconstant on the local level (through unpredictable entrances, shifts in color, changes in harmonic quality, and so on)' (2017, 316). But while the background function explains the minimalizing of Adams' maximalist tendencies, it does not explain why it is his music that represents the Modern Era and not, say, a slow movement from a Mahler symphony, Schoenberg's 'Farben' from his Opus 16, or the more subdued sections of the *Rite of Spring*. There is a clear shift in musical tone when one moves from the Industrial to the Modern Era that has to do with Adams' Americanism. Not only is the minimalist soundscape one that is uniquely associated with American composers,[18] Adams in particular both regards himself, and is regarded as, representing American culture beyond the folk roots of Charles Ives and the musical jingoism of Aaron Copland. Citing influences such as the Beatles, Pink Floyd, Marvin Gaye, and the Grateful Dead that signify the unique cross-cultural pollination in which America occupied a central position in the latter half of the twentieth century, Adams stands for an America of rock-and-roll and burgers-and-fries instead of marching bands and the Common Man (Schwarz 1996, 174; Adams 2008, 64). Indeed, the poorly received *Grand Pianola Music* prompted IRCAM, Pierre Boulez' scholarly music institute in Paris, to place Adams in league with 'two other favourite icons of American culture: Disney and McDonald's' (Adams 2008, 118).

It is this kind of Americanism that we should hear in Adams' minimalized, maximalized minimalism in the Modern Era of *Civ4*: America as representing the globalization and commercialization of the twentieth century, versus the nationalism and Eurocentrism from the nineteenth century and *Civ4*'s Industrial Era. In this sense, the fractured view that music histories tend to give of the twentieth century (e.g. N. Cook and Pople 2004), with its multitude of competing forms of modernism and postmodernism, rise of popular music, and jazz and world music, is replaced with a more homogenized music history in *Civ4*, where the German-symphonic nineteenth century (of Beethoven, Dvořák, and Brahms) neatly culminates in an American-symphonic twentieth century. The soundscape of a typical Modern Era turn will have the persistent pulse and interweaving patterns of Adams' *Harmonielehre* that accompany the sounds of tanks rolling across an increasingly urbanized landscape, Leonard Nimoy quoting the Velvet Underground—'. . . then one fine morning she puts on a New York station . . . You know, her life was saved by rock & roll'—when the player discovers the 'radio' technology, and various interface bleeps and sounds

notifying the player of gameplay events. Globalization, Americanization, and modernization are reinforced by Adams' soundtrack and form the background music to gameplay, but not always. There are some moments that do not quite seem to fit this picture, that seem to stick out when playing in the Modern Era, and I will turn to these next.

One Adams piece in particular refuses to stay in the perceptual background. 'The People are the Heroes Now' from the opera *Nixon in China* stands out mainly because of its relatively clearly intelligible vocals in plain English. While any kind of music can potentially be used as background music as Nicholas Cook argues (1990, 12–13), the clarity of the words sung is a strong break with other vocal music on the soundtrack (mainly the medieval choral music). Moreover, on several internet forums players have asked questions about the original 'lyrics' of the 'song' (i.e. the libretto), which further indicates that this particular piece is not merely perceived as background music. But while the piece may stand out in players' auditory perception, it still fits the Modern Era perfectly: the title of the opera reflects globalization and Americanization, and the libretto refers to communism, one of the most significant socio-political forces in the twentieth century.

Some moments in other pieces also stand out because of their 'friction' with the rest of the game's soundtrack.[19] The steady pulses of some of the longer Adams pieces (e.g. *Harmonielehre*, *Common Tones in Simple Time*, and *The Chairman Dances*) are contrasted with some slow, reflective movements and pieces. Unlike the slower pieces in the previous eras, which tend to be modal (in the case of the medieval pieces) and reflective, or in a major key and having a pastoral quality about them (the slow movements of Beethoven's Fifth and Sixth, Brahms' Third, and Dvořák's Ninth), there is a general feeling of unease about these pieces of Adams. The slow string melody of 'The Anfortas wound,' the second movement of *Harmonielehre*, has a degree of pessimism that is unlike anything the player has heard before in a game of *Civilization*. The broken trumpet melody halfway through the movement has a particular quality of powerlessness to it, just as the player reaches the final stages of the game. The chaconne from the violin concerto has an even eerier quality to it, mainly supplied by the dissonant interplay between the violin and the high-pitched string accompaniment that seems to slowly creep forwards, but never quite go anywhere.

These moments of unease come through even more strikingly in the two faster movements of *Harmonielehre* that have a clear pulse, where they are primarily provided by long, drawn-out string melodies that slowly come

into the foreground. The first movement slows down halfway through for the strings to start a never-ending melody similar to the violin in the concerto, described by Adams himself as being 'full of *Sehnsucht*' (Steinberg 2006, 104). The strings come in relatively early in the last movement, but play a similar role. Unlike the German late nineteenth-century repertoire that *Harmonielehre* refers to (Wagner, Mahler, and Schönberg in particular), the melodies' accompaniments have less of a harmonic drive behind them, suggesting a similar powerlessness and lack of direction to the trumpet in 'The Anfortas Wound.'[20] This combination of strong, dissonant lyric melodies inspired by Schönberg et al. with the minimalist characteristics of pulse and repetition is amplified by the cuts that have been made to the pieces for *Civ4*. Whereas these help the more diatonic and consonant Adams pieces to function more as background music, *Harmonielehre* and the violin concerto stand out to give a feeling of unease to what otherwise should be a climactic moment in the game.

But what is it then that these musical moments bring out? When playing the game, it is important to note that the tracks are played in a random order, but given the average duration of a game of *Civ4*, and the fact that the Modern Era is usually the era a player spends the most time in, one is likely to hear one of the *Harmonielehre* or violin concerto movements at some point. The few seconds of silence in between every track give even more of a sense that one is listening to various 'plateaus' of intensity, evoked by the (lack of) pulse and dissonance in the Adams pieces. Moreover, unlike all other *Civilization* games since the third instalment, the music in *Civ4* does not change states whether the player is at war or peace. Even though the player might be trying to achieve a diplomatic or cultural victory without ever fighting another civilization, the first movement of *Harmonielehre* might still come on, signifying some deep sense of tragedy or drama that the player has no control over: it is like there is something wrong with the world that came about with progress. If we look at the various impersonal horrors of the twentieth century—the world wars, climate change—and the technologies associated with them, one can see why Civ4 would be making such a 'point': nuclear fission and fascism are all technologies that help the player progress through the game and achieve their goals.

It is for this reason that players commenting on some of Adams' pieces on YouTube use words like 'apocalyptic,' 'melancholy,' and 'nuclear holocaust' (Michael LeMieux 2010a; 2010b). Karen Cook suggests that the music perhaps signifies 'both the very technologies that the game values and the kind

of empty, vast landscape of outer space that he rush to build a colonizing spaceship (one of the victory conditions) implies—or the emptiness created within players upon finishing play and returning to reality outside the computer screen' (2014, 173). A game of *Civ4* becomes something you need to see through to the end, regardless of what your strategies or goals are in the game, as the music is random and relentlessly nondynamic, refusing to take the side of the player and their actions (as it does in *Civilization V* and *VI*), but rather making a statement about the Modern Era as a whole. The moment the music begins to stand out in the Modern Era, the moment the player starts *listening* to it, it becomes subsumed in a semiotic web of multimedial relationships that involve *Civ4*'s mechanics, the player's actions, and the relation of the music to the rest of the soundtrack. The question 'Why John Adams?,' born from the same kind of experience that I described in *Minecraft*, and essentially a similar one to the feelings of nostalgia and nature I described earlier in this chapter, leads one to what essentially becomes art criticism, or hermeneutics. For that reason, the music historian's question and the player's question are aligned: while both stem from different sources of 'friction,' both lead to the same end point, namely an attempt to better understand the game.

Conclusions

I began my discussion of aesthetic music by considering it as a way of hearing 'the music itself.' It has become clear, however, that I consider musical meaning-making in video games as always multimodal and multimedial. What grants the music autonomy in aesthetic hearing, nonetheless, is its status as a medium standing in equal relation to the media it is encountered with. I want to be careful, however, to suggest that a moment of aesthetic hearing in which music is the sole significant medium (such as it is often heard in classic concert-hall listening) is impossible in video games. I can think of myself playing a game so mundane, so in the background, that I do not even consider its relationship to the music; my case study of *Minecraft* got very close to this hypothetical experience. And perhaps my intermedial interpretations of the case studies in this chapter betray my particular background in music and audiovisual media. Moreover, we can think of the different categories of aesthetic hearing—nostalgia, beauty in nature, and so on—as ways in which 'the music itself' is embedded in a larger cultural background. The point is that the moment of friction comes from a particular

situation in which music is heard, not merely from the music itself. But it is through our engagement with that friction, through aesthetic listening and reflecting, that the music gains the autonomous kind of significance that I described in this chapter.

Two aspects of aesthetic music have come forward most clearly in my account: serendipity and lingering. Most of the experiences I have outlined have had some element of the accidental to them. They revolve around a moment in which we stumble upon something, in which we hear something unexpectedly meaningful in the music that accompanies the game we play. In these moments the music ceases to be background music and becomes an integral part of an experience. While the aesthetic experience of the music remains confined to the moment, its meaning extends beyond that to make up the experience: in *Skyrim* this becomes a timeless experience of a scene, a mountainscape; in *Minecraft* the experience of building my house, which the music only partially covers; in *Civilization* the moment of friction frames the experience of playing the game as a whole. While we can open ourselves up to these moments by adopting an aesthetic attitude, this does not guarantee having the experience.

As I have also tried to show, it is through lingering on an aesthetic phenomenon that a moment of aesthetic hearing is transformed into a sustained act of aesthetic listening. There is something that catches our attention and holds it. With nostalgia, this comes in the form of reminiscing: either sharing with others or contemplating for ourselves the meaning the phenomenon has for us and our shared histories. In this case, aesthetic listening becomes a kind of historiography or autobiography. With natural beauty, or its approximation in a game, we linger because we are awestruck. We contemplate the harmony of the scene, between the music and the panorama it accompanies, before we move on with our activities. If we consider this kind of listening from an even broader, paraludical perspective following Droumeva and Diaz-Gasca, even the 'immersive' *Skyrim* modding practices that Joana Freitas (2021) investigates are a kind of extended lingering. Other aesthetically heard music might move us to interpret different things: mundaneness in the case of *Minecraft*, the apocalyptic anxieties of the twentieth century in *Civilization IV*. All are cases of meaning-making. Whatever the particulars of the aesthetic experience may be, lingering and reflection halt play. Alfred Schutz argues regarding music analysis (itself often an activity based on aesthetic appreciation),

In performing . . . analysis, we are no longer dedicated to the listening to music as an ongoing flux. We are, as it is frequently said, no longer living *in* our acts of listening directed toward the object of such listening, namely the music as it goes on to build itself up within the stream of our consciousness. We have brought this flux to a seeming standstill. (1976, 58)

In the next chapter I will discuss a way of hearing that does not bring the 'flux' of game music to a standstill, in which we consider ourselves to be playing along rather than interpreting. This is ludic music.

3
Ludic Music

One of the essential aspects of aesthetic hearing I identified in the previous chapter was that of lingering on an object—of stopping in our tracks, halting play, and of reflecting and interpreting the phenomenon instead. I want to characterize our relationship to ludic music in opposition to this—in terms of moments that invite us to act, move, or play in some relation to the musical soundtrack. Picking up a star power-up in *Super Mario Bros.* (1985), for instance, triggers a transition to the Starman theme, an up-tempo, frantic cue that invites players to speed up their actions. Rushing through the level, my right thumb pressing down on the controller's B-button (the 'sprint' button), I bowl over Koopas and Goombas and leap over pits, partially with a kind of power-mad glee, partially with a rational determinacy to get as much advantage out of the power-up as I can, before its effects run out (see **Video 3.1** ▶). Most importantly, I do all this somehow to the music. The Starman theme leads me along, and my movements make sense in light of its frantic qualities. I feel I am both invited and allowed to 'lean into' the music, like leaning into the wind in a heavy storm. In this analogy, while the wind is keeping me upright and acting as a crutch, my remaining upright also comes with a sense of agency and empowerment: I am weathering the storm.[1] But is ludic hearing always this kind of 'leaning into?' And where in games can we find ludic music?

The commonalities of music making and video gaming have started to attract significant attention over the past decade, and several studies have emerged that centre around 'play' as an experience that relates both activities. It is in fact possibly within the broadest definition of ludomusicology to study the relationship of music and play, although video games continue to be at the centre of this new subdiscipline. Three studies that are central to this chapter are Isabella van Elferen's introduction of the concept of 'ludic music' (2011), Kiri Miller's 'playing along' (2012), and William Cheng's approaches in *Sound Play* (2014). All of these studies in some way address

the agency of the player in the rule-bound system of a video game, and the role music plays in this agency: either as a means of transgressing a game's boundaries, or as providing its own, less visible, boundaries. From agency, two additional concepts emerge that move the discussion of play from a psychological or phenomenological issue to a cultural critique: freedom and responsibility. On the one hand, the phenomenon of play is a possible site of freedom and resistance to the hegemonic structure of our everyday lives. Miller, for instance, argues that '[b]y encouraging players to experiment with the possibilities and the confining borders of [their avatar's] world, [*Grand Theft Auto*] *San Andreas* invites them to interpret its controversial content on their own terms and to investigate their own complicity with the stereotypes that govern much of the social life of the game world' (2012, 82). On the other hand, there is a tension between the 'magic circle' (Huizinga 1949; Salen and Zimmerman 2003)—the boundary the player draws between the game and the real—and the material consequences of play. Roger Moseley (2013, 279) points to the 'mountains of undersized plastic guitars,' perfectly preserved on a landfill somewhere, as an ecological consequence of the *Guitar Hero* fad. Cheng recounts a moment of playing along to the soundtrack of *Fallout 3* (2008):

> What never fails to strike me is how I pressed the detonator button at almost the exact same moment Sousa's march came to a close . . . Although I was playing a video game, I may have ended up pressing the button when I did because, curiously, it was the *theatrical* or *cinematic* thing to do. It was also the obedient thing to do. (2014, 47)

A recording of himself playing the game reveals the ideological workings of the music and the magic circle it helped construct, and it reminds Cheng of the (albeit virtual) consequences of his actions.

But Miller's, Moseley's, and Cheng's interpretations of play are of a different phenomenological category from what I want to attempt in this chapter. As interpretations they are an instance of aesthetic experience, aesthetic rather than ludic listening. All three are a reflection after the moment of playing, the kind of listening or interpreting I described in Chapter 2. They do, however, give some insights into that moment of playing: for Cheng, it was 'theatrical' or 'cinematic'; for Miller it was a kind of experimenting with and exploring the borders of CJ's world, recognized as such. These are two

different kinds of play. Cheng's is a 'playing to' salient aspects of the game, in this case the perceived affective qualities of the music. Miller's, on the other hand, is a 'playing with' salient aspects of the game, in this case the relationship between the musical soundtrack (in the form of radio stations the player can choose from) and the cultural connotations of the player's avatar CJ. While the first seems to be a kind of wilful subjugation to the fictional world of a game and the second an intentional subversion of that fictional world, 'playing to' and 'playing with' are not clear-cut categories of obedience and freedom, respectively. Wilful subjugation requires a recognition of power (here, it is the theatrical or cinematic power of *Fallout 3*'s musical soundtrack), and, in this case, it means entering into a kind of contract with that power: doing what the music asks in exchange for a more fun or satisfying experience. Deliberate subversion, on the other hand, identifies an object of subversion, but can only do so in the light of (or in service of) an outside power that allows for this identification to happen. In the case of *San Andreas*, these are the game's creators, Rockstar. As Miller reminds us, '[c]ultivating this sense of in-the-know interpretive freedom has been good for business at Rockstar Games' (2012, 82). In other words: are we not always playing to something, whether we are deliberately doing so or not?

Ludic hearing, I want to argue, is in the first place a deliberate and knowing 'playing to' of the kind Cheng describes (albeit in retrospect in his case study): both a recognition and an acceptance of an invitation to do something—be it moving faster in *Super Mario Bros.* or pushing a button in *Fallout 3*—rather than an absorbed coping with the affordances of something such as changing radio channels and relating this to one's avatar in *San Andreas*. And what Cheng calls the 'power' of the music is the same as the 'force' I described in the case of *Super Mario Bros.*: something to lean into. This conception of music stands in direct opposition to aesthetic hearing's conception of music as an object that can be considered, looked or 'heard' around, and reflected upon (see Chapter 2).[2] It also means that ludic music, as the noematic object of ludic hearing, is resistant to interpretation: interpretation after all is the site of aesthetic hearing. Moreover, the temporality of ludic hearing is incompatible with the abstraction from time inherent in interpretation. But it is not impossible altogether to talk about the experience of ludic music, as it is in the case of background music. Considered as a kind of force, we can still talk about how it affects us, just like how a storm affects us.

Affect, or 'Doing This Really Fast Is Fun'

Considering ludic music as a force also helps us to unpack van Elferen's concept of ludic music. Her categorization of video game music roughly corresponds to Jesper Juul's distinction between ludic and narrative aspects of video games, as I mentioned in my introduction, but it is helpful to look at their relationship in more detail here:

> Cinematic game music gives the game hyperreality a personalized coloring and underlines its narrative; ludic game sound further increases the immersion into this hyperreality through the intensification of the gameplay. Together they establish what can be called a musical gaming positioning system through the intermedial virtuality of the computer game, enhancing the game flow by way of music's performative strength. Just like the GPS system in a car, the musical GPS addresses itself directly to players and gives them directions—only this GPS is affective as well as navigational, which makes the game's magic circle expand itself and stretches the borders of hyperreality right into the player's lived space. (2011, 34)

It is these two aspects of the musical 'GPS'—affectivity and navigation—that reveal the difference between ludic hearing as I want to characterize it, and van Elferen's ludic music. A car's GPS provides drivers with a discrete set of instructions that are to be followed: 'turn left at the next intersection,' 'follow this road for the next five miles,' and so on. Musical signals can call out to players in much the same way, as I will elaborate on in Chapter 4 on semiotic hearing. This is different from ludic hearing in that it requires only an infinitesimally short amount of attention, and the sound of the musical signal is arbitrary: when I know that the Starman theme indicates that I am invulnerable for a time in *Super Mario Bros.*, it can be replaced with any other sound or musical cue with any kind of tempo (or melody, etc.), as long as it indicates when and for how long the power-up lasts. We can think of the 'navigational' aspects of ludic music as a kind of 'following,' or perhaps a kind of 'reverse Mickey-Mousing': I hear the music as doing something, such as going up or down, or going faster, and I match my movements to do the same. But this, I want to show, is different from leaning into music. The music becomes an object (albeit a dynamic object) over there, whereas I am imitating its movements over here, and I can think of myself as quite independent of it. In

other words, we can hear movement in music without the music necessarily moving us, affecting us.

The key notion for van Elferen that allows us to lean into music, or play to it as a force, rather than follow it as an object or a set of instructions, is affectivity. She relates this to Mihály Csíkszentmihályi's concept of flow, and music's tendency to always be meaningful, but never quite mean something specific—in Jean-Luc Nancy's terms, to always be 'on the edge of meaning' (quoted in van Elferen 2011, 31–32). In this connection between the spatiality of the GPS and affectivity, van Elferen's ideas are remarkably similar to Julianne Grasso's concept of 'affective zones' that I mentioned in Chapter 1. Grasso builds this concept on interdisciplinary affect theory that combines ideas from the cognitive sciences and humanities, also coming to the idea that affects are always a precursor to meaning (2020, 62). It might be useful to try to commensurate these ideas about affect with the first-person perspective of phenomenology. Beyond Edmund Husserl's term 'affection' and Sara Ahmed's conception of mood as orientation, it is difficult to find extensive phenomenological accounts of affect as a concept separate from moods (cf. Heidegger 1962) or emotions (Sartre 2014), since the term lends itself naturally to third-person accounts.[3] Spinoza (2000) spoke of affectations in terms of constraints on the body, and for Deleuze and Guattari (1987) affect is an impersonal force that shapes interactions, with an ontological status similar to that of Gibson's (1979) affordances. Affects are traditionally seen as different from emotions, and to an extent from feelings as well, in that they do not necessarily have intentional content—they are not directed towards an object. When I am angry, for instance, I am angry at someone or something; an anger-like affect can be an undirected welling up of sudden rage as well.

Daniel Stern's 'vitality forms' (2004) closely approximate this non-intentional definition of affects. They are features of experience that are 'modality non-specific,' and they are forms distinguished from content, which can be an emotion, for instance: '[a]nger can appear on the scene explosively, or build progressively, or arrive sneakily, or coldly, and so on' (2004, 23). Here, the verbs constitute vitality forms or affects, the shapes in which an emotion is experienced. But we can easily substitute anger with a musical object, such as a motif that can 'appear explosively, build progressively,' and so on. Note the similarity to Husserl's idea that an affection is the 'peculiar pull that an object given to consciousness exercises on the ego' (2001a, 196): musical objects can appear to us affectively, demanding we take a certain stance towards them so that their affective tension could be resolved. Stern's characterization

is a good place to start with a phenomenological description of affect, due to its implications of force and movement. But it is also useful in establishing the limits of ludic music. Stern distinguishes vitality forms from signs: 'As a piece of communication to others, a smile or baring the teeth, if performed without a vitality form, would only be a conventional sign. It would lack the full signature of its force and nuanced temporal enactment for it to be a real-life communicative act fashioned for that moment and containing aliveness' (2004, 28). For the concept to be useful for a phenomenology of ludic music, we need to be careful about attributing affective qualities to all (musical) experience. What Stern describes is essentially what distinguishes ludic music from the signs we encounter in semiotic music.

Another scholar who draws attention to these affective dimensions of music is Carolyn Abbate (2004). In her and Vladimir Jankélévitch's words, we should study music as a 'drastic,' rather than a 'gnostic,' phenomenon. In performance, Abbate argues, music cannot be so easily analysed and interpreted as a text. She gives the example of attempting to formulate her thoughts while playing the bravura aria 'Non temer, amato bene' from Mozart's *Idomeneo* on the piano:

> Clearing my mind, I realized that words connected to what was going on did flow in, albeit rarely, but these words had nothing to do with signification, being instead *doing this really fast is fun* or *here comes a big jump*. (2004, 511)

While Abbate is talking about musical performance, 'Doing this really fast is fun' and 'here comes a big jump' sound suspiciously like playing *Super Mario Bros.*—perhaps alluding to what Roger Moseley would call 'ludomusicality' (2016). Both are statements about musical movement experienced as an affective force. Here, the music is meaningful, has significance, but explicitly not a significance that leads to the hermeneutic kind of interpretation we are moved to when we hear aesthetically:

> Turning towards performance means scrutinizing the clandestine mysticism involved in musical hermeneutics . . . because clandestine mysticism could itself be seen as a reaction to forces in play during musical performance. That, at least, is Jankelevitch's diagnosis. Music's effects upon performers and listeners can be devastating, physically brutal, mysterious, erotic, moving, boring, pleasing, enervating, or uncomfortable,

generally embarrassing, subjective, and resistant to the gnostic. (Abbate 2004, 513–14)

Abbate's characterization of drastic experience is strongly reminiscent of Stern's vitality forms: it consists of 'forces in play' that are described in terms of (deverbal) adjectives.

Like Karol Berger (2005), I question the pervasiveness of drastic experiences in music. But unlike Berger, I do not believe that there is no such thing as Abbate's drastic, or what they call 'unmediated musical experience.' Berger argues that we always interpret, that '[i]n any experience of a temporal object the imaginary future and past invade the real present, contaminating the immediacy of presence with interpreted meaning.' But what about the simple, unreflective experience of 'doing this really fast is fun?'

> [I]n this kind of listening, passive and absorbed in the moment, the absent (image, concept) may and does intrude upon the present (sensation), and also in this case, far from obliterating the actual experience, it enriches it, provides it with additional depth, makes it the experience that it is: Temporal or not, the experience is always an experience of something, always a relation of a particular to a universal. (Berger 2005, 498–99)

While I agree with the latter part of Berger's argument, the former, that 'the absent... may and does intrude upon the present,' is a mischaracterization of Abbate's experience. We should not think of the images and concepts Berger speaks of as intruding, but rather forming a ground or background for the ludic experience of 'doing this really fast is fun.' It is an aesthetic interpretation of the musical phenomenon beyond its token performance after the fact that suggests a different way of hearing, the aesthetic hearing discussed in Chapter 2.

I propose a middle ground between Abbate and Berger: sometimes our experience is drastic, or ludic, inviting us to play along, sometimes it is gnostic, or aesthetic, inviting us to stop and reflect. But in which cases? 'Doing this really fast is fun' and 'here comes a big leap' denote dynamic, positive experiences. But what about 'doing this really slow,' for example? Some time ago, I had the experience of hearing Glenn Gould's rendition of Brahms' D-minor Ballade (opus 10 no. 1) in a café. Initially I put on my headphones with the piece just to drown out the sounds of the café: people talking, shuffling their newspapers, the hiss of the espresso machine, and the

faintly audible music of James Morrison coming through tinny-sounding speakers in the corner of the room. Gould and Brahms formed a kind of 'wall of sound,' of background music. But the exceptionally slow tempo of Gould's performance (1982) worked its way into my attention. The recording is almost three minutes longer than Arthur Rubinstein's 1970 recording, which I was most familiar with at the time. The result was that I was hearing the oncoming chords with almost anxious impatience at first. The pauses between and even *during* the melodic phrases negated the point of my putting headphones on, letting in impressions of the various people talking, shuffling their newspapers, and so on with an intensity possibly even stronger than before I started listening.[4] It was only during the middle section's gradual building up to a climax (mm. 41–44) that this impatience or anxiety fell away. One could say that it was 'hammered out' by the section's incessant triplets, but this is a 'gnostic,' aesthetic interpretation after the fact. At the time, my experience of this section did not need this kind of interpretation—it was quite 'drastic,' in Abbate's terms, albeit neither fast nor fun. If there was anything, it was a kind of welling-up, exactly the kind of vitality form Stern describes. But in what ways could I have interacted with it? In the next section, I will discuss a similar example drawn from video games.

Case Study: *Proteus*

The free exploration of a 3D environment that open-world games like *Minecraft* and *Skyrim* offer almost inevitably leads to the serendipitous, reflective encounters of natural aesthetics. Their loosely structured gameplay allows for wandering around without time pressure or the constant threat of danger. In other words, aesthetic music lends itself naturally to the kind of openness in these games.[5] To distinguish ludic hearing from aesthetic hearing, then, it would be helpful to start with a case study of another open-world game. The low-budget independently developed game *Proteus* (2013; its development 'team' consisted of a designer, artist, and programmer, Ed Key, as well as a composer, David Kanaga) offers a prime example of a freely explorable open world. In the game, the player starts off the coast of a randomly generated island, with no clear goals or instructions about what to do. The warm, synthesized sounds of the menu screen make way for the sounds of calmly rippling waves—visually low-fi, pixelated white lines on a blue surface, but quite lifelike in sound.[6] The equally pixelated distant island amidst

the empty sea *invites* exploration, or at least moving towards it. Setting foot on its shores, suddenly a plethora of warm, synthesized sounds flood back in. More careful listening would reveal higher-pitched, moderately fast changing pitches against lower, longer pitches that fade in and out more gradually, all diatonic in the key of E-flat major. However, when one first sets foot on the island, these distinctions hide themselves in favour of a general warmth and weirdness that makes sense given the lo-fi graphics.[7]

As the player moves around the island, these warm tones change ever so gradually, almost inaudibly. More immediately apparent musical events happen when the player approaches objects that stand out—not so much the omnipresent trees, whose flat-textured foliage forms a visual background together with the ground and sky, but monoliths, small animals, strange circles of pixelated statues, and so on. A monolith, for instance, will utter a satisfying low 'thwomp' sounding a bit like a note plucked on a double bass. When the player enters a circle of statues, synthesized, airy soprano voices sound in a never-ending rising fourth loop. In a way, we could consider these sounds as little rewards for the exploring player: a curious shape on the horizon draws my eye, I walk over and hear a sound signifying my having found something worthwhile. Daniel Golding (2013) stresses the contemplative aspects of the experiences *Proteus* offers. But this kind of aesthetic listening is not necessarily the only way in which a player is invited to care about the sounds in *Proteus*. While there is a sense in which I start parsing the soundscape, identifying timbres and pitches as symbols for objects on the island—a kind of semiotic hearing (see Chapter 4)—the music actively plays another part in exploration as well. We can think of free exploration as identifying locations to navigate to: stopping around to get one's bearings, such as my example of climbing the hilltop in *Skyrim* (see Chapter 2), spotting a place of interest on the horizon, and then moving there. On the way, we can admire the sights aesthetically. But we can also shift our attention towards our movements. For *Skyrim*, the climb became a framing device in my memory for the panoramic musical moment. But what could musically frame the climb itself, so that my movements become significant to me? *Proteus*' soundtrack offers several examples of this.

In **Video 3.2** ▶, Stumbling upon a rabbit, only a few pixels of grey on the green sheet of ground, it suddenly leaps up and hops away from me. Each exaggerated 'hop' is accompanied by a staccato acciaccatura, forming a galloping melodic line as I follow it. But why would I follow a rabbit that is neither late, nor carrying a large pocket watch? Is the melodic line a kind

of musical representation of Alice's curiosity? Similar lines are traced by the monoliths that dot the island—large, irregularly shaped, brown stones that are encountered either on their own or in linear formations. So unlike the rabbit, the monoliths are static, and their trajectory is laid out before me visually. The low-pitched 'thwomps' the monoliths emit when approached do not form a melody as neat as the rabbit's, but a more random sequence of notes. The directionality they acquire is 'mapped onto them,' in William O'Hara's (2020) conception, partly by the visual line that stretches out away from me into the distance, and partly by another sound that gradually introduces itself as I start following that line. High-pitched, wind-chime-like tones start ringing as white spots float through the air, and the tones the monoliths emit start vibrating through the landscape, shaking the trees and grass around them in a manner reminiscent of the monolith-shaped creature from *My Neighbour Totoro* (1988). This is the first time a clear teleological directionality appears in my experience of *Proteus*, and it leads towards a large circle in the centre of the island. The white spots come together in a vortex in the middle of the circle (0′28″ in **Video 3.3** ⓘ), and approaching it continuously increases the intensity of the wind-chime sounds. Entering the vortex causes a fade-to-white accompanied by a high synthesizer chord, after which I find myself in the same location, but in a differently coloured landscape: I have moved on to summer on the island (0′46″). What is most striking in this new season, however, is not its colours, but the addition of a beat to the soundtrack of the island. It is not a steady or heavy beat by any means, but rather a jittery, erratic rhythm of woodblock-like sounds.

Critical reception of *Proteus* has frequently concerned itself with the question whether it is a game at all.[8] Co-creator Ed Key at some point described the experience as an 'anti-game' (Rose 2013). And if we take a game to be the system defined by Jesper Juul (2005, 6–7), one with different potential outcomes (positive and negative) and challenging players, *Proteus* is surely not a game: there is no real challenge, and you cannot lose. But this does not mean that we cannot play in *Proteus*. As Miguel Sicart (2014) reminds us, play and playfulness are much broader phenomena than games. The activities that I described in the preceding paragraphs involved me setting my own goals, such as following rabbits and walking towards objects. Perhaps these were not very challenging, but they required effort and had an outcome nonetheless. Moreover, through this kind of play, a progression in the game revealed itself in terms of the change of seasons. And, following this progression, the game turned out to have an ending: in the final season, winter, my

avatar started to slowly float upwards. At first this happened unnoticeably (since there were no sounds of footsteps to anchor my virtual body to the ground), but then, ever more gradually, I was carried towards a chorus of light that extended into the night sky—kind of final reward sequence for 'finishing' the game.

So we could say that there is an equally gradual move in *Proteus* from autotelic activities—setting one's own goals and challenges—to the game revealing its own progressive nature. And the music is instrumental to this by moving from a 'static' or 'spatial' state to a more 'dynamic,' 'linear' one. In an interview with Jon Mitchell at the Daily Portal, composer David Kanaga mentions the spatial aspects of musical composition:

> [W]hen I make music objects, fixed 'lines' of music-information, I'm typically trying to open it up, to liquefy it as much as possible, to play it as one possible flow of a virtual space which sort of extends outside the piece itself. So, I'm trying to find how music spaces are objects, and how the objects are spaces, and to explore the flows, the play, of all of this ... I think the trick [to composing video game music] is to come to terms with thinking these things 'interactive music' and 'fixed music' as the same thing, because all interactive music even is 'fixed' as a line of information when it has been played, and all fixed music creates a virtual music space in us, a sense of possibility that extends beyond the particulars of the piece. (Mitchell 2013)

What Kanaga means when he mentions the possibility of traditional, 'linear' music having a virtual space that 'extends outside the piece itself' is the world of musical possibilities that a piece brings about. He mentions, for instance, David Cope's EMI software that analyses Bach chorales and creates a 'possibility space' for new chorales. Even when we listen to one chorale, our musical understanding of it includes the possibility of the piece sounding different within the 'world of Bach chorales.' But, I argue, this is to an extent still a linear kind of thinking: as the piece unfolds we think of all the ways that it might go. For instance, we might expect a melodic line to go up, or we might expect a full cadence, or more appropriately, we expect a range of melodic possibilities and a range of cadences. To move from this kind of linear prediction (or what David Huron [2006] might call anticipation) to a kind of space in which we have no expectations about anything at any given time requires a different kind of listening. Playing *Proteus*, we experience a move in the opposite direction: from a static, spatial set of musical loops and drones to

a more linear, directional way of experiencing the music. We start hearing melodic lines when following rabbits, intensification of figures when moving along lines of monoliths and eventually a beat when entering a new season.

At this point, I want to take the step from linearity (the 'fixed "lines" of musical information' Kanaga talks about) to movement. Can we say that hearing linearity in music—either a melodic directionality, an increase or decrease in intensity, or a metric regularity—is always a kind of following, or moving along to music? And is there a difference between hearing movement and moving along? In order to provide some possible answers to these questions, I will describe two aspects of the experience of *Proteus* in more detail: ergodic playing along and following musical structure.

In his book *Cybertext*, Espen Aarseth introduces the concept of 'ergodic literature,' which he defines as texts (such as adventure games, hypertexts, and multi-user dungeons) that require a nontrivial, physical effort to read. Nonergodic literature on the other hand places no 'extranoematic responsibilities . . . on the reader except (for example) the periodic or arbitrary turning of pages' (1997, 1–2). The linearity in my two examples requires explicit effort from the player to maintain: if I stop following the rabbit, it stops hopping away from me; if I stop following the line of monoliths, the intensity of the wind chimes stays the same. For these reasons, we can consider these as moments of ergodic playing along to interactive musical elements (using Collins' terminology): to the individual acciaccaturas that make up the rabbit's melody, and to the 'thwomps' that make up the monoliths.' Compare this to the loop of rising fourths that the aforementioned circle of statues emits. While the continuation of the loop as a whole is dependent on my presence in the circle and therefore ergodic, its individual elements are nonergodic: I am not playing along to them.

The summer beat, on the other hand, seems completely nonergodic, being present regardless of my geographical location. It exemplifies linearity independent of me with its continuous presence in the summer season. This is one way in which music reveals the progressive nature of *Proteus*: from musical linearity that requires effort to a continuous kind of nonergodic linearity in the form of a regular beat. There is, however, something particular about hearing a beat that means that we potentially *always* hear it as ludic, as if we were following it, and this is entrainment. The phenomenological features of entrainment are made clear in a discussion between Christopher Hasty and Justin London (Hasty 1997; Hasty 1999; London 1999) about metre and rhythm that ran in the late 1990s. In a review article of Hasty's *Meter*

as Rhythm, London distinguishes metre from rhythm as an active 'mode of attending,' rather than a focus of attention:

> Meter and rhythm remain separate and separable aspects of musical structure. On this view meter involves a very general and very basic perceptual ability, the ability to entrain or attune our attention to temporally invariant aspects of our environment. Entrainment is the regularized ebb and flow of attention over time. (1999, 270)

As 'the regularized ebb and flow of attention over time,' we could only talk about it through an act of phenomenological reflection—by looking back on our experience and realizing it 'ebbed and flowed.' For Hasty, however, it can in a way be both an active mode of attending and focus of attention. As a focus, metre is duration. In his response to London, Hasty goes to great lengths to reclaim the possibility that hearing metre (as opposed to something like 'metric hearing') involves a 'projection' of a duration of a certain musical event: a beat, a tone, or even a rest. In other words, hearing metre is not the anticipation of a second event at a certain point in time, but of a duration of a first event, or quantity:

> [M]eter (or 'projection') concerns the reproduction of durational quantity as an active attunement to musical events as they emerge for our attention (and as our attention is engaged in their construction). This attunement is an ongoing achievement, it is highly context-sensitive, and it operates on many levels 'simultaneously.' (1999, 280)

This conception of metre as 'active attunement' can start giving us some indication of how attending to a beat involves a kind of moving along, however 'inwardly' this might happen. But Hasty's theory of metre cannot answer *why* it is we start attending to the summer beat in *Proteus* in the first place—why I consider myself as moving along to it, rather than just hearing it as background music, like the rest of the omnipresent island sounds. For this, we need to start thinking of its appearance in a larger linear structure.

To answer the question what makes the summer beat significant, we could say that first off, simply put, its appearance is something new. This implies a kind of 'friction,' however, something to be interpreted or explained, and not necessarily followed, and therefore an instance of aesthetic hearing (see Chapter 2). We can think of it more as a cross-domain mapping of continuous

movement in music onto our continuous movements exploring the island.[9] But my movements do not change per se: I cannot start moving faster to the beat, nor synchronize my footsteps to it, as there is no visual or auditory indication of me having any footsteps in the first place—let alone footsteps whose pace I have control over. Something *has* changed in my hearing so that I hear myself as moving along instead of my environment and its flora and fauna, which is static, or at least no more dynamic than in spring. In the case of the summer beat in *Proteus*, I argue, it is our place in the game's recently revealed progression that we hear as inviting us to move along. Musically, this means that we start hearing a linear, progressive structure as soon as we hear the beat. While we did not hear it as such in spring, the static soundscape of the island retroactively becomes somewhat of an introduction.

Musical structures like the one I hear in *Proteus* can be found in examples from Western art music, such as the metrically indistinct opening measures of Bruckner's Seventh Symphony, or in more muddled performances of Beethoven's Ninth and Wagner's *Rheingold* prelude. There is a structural similarity between on the one hand the spatial string nebulae out of which a melody appears in Bruckner's Seventh (m. 3) and the *Ruhig* section (m. 51) with its clearer metre, spelled out by the brass quavers, and on the other the *Proteus* island's spatial music, the melodies that appear by following its fauna, and finally the summer beat. More appropriate to the characterization of 'following' is perhaps the structure of dances. In art music, we can think of Offenbach's barcarolle from *The Tales of Hoffman*, and its introduction with a similar string nebula out of which melodic direction gradually appears; or we can think of various waltzes and their introductions. In modern popular dance music, we find examples of this in trance tracks such as Chicane's 'Saltwater' in which synth pads form the 'nebulae' from out of which Máire Brennan's vocals form melodic fragments, before a more metrically distinct pulse comes in; in rock music, we find something very similar in longer songs, such in as Dire Straits' 'Money for Nothing,' where Sting takes Brennan's part. The main difference between all these examples and *Proteus* lies in the way in which we start to hear structure. In clubs or in the concert hall, we hear the nebulae as an introduction from the very beginning—we expect a beat to come in, or at least something more metrically distinct (perhaps in the form of the contrasting theme in Bruckner). In classic dance forms, introductions are the time in which we invite our partners onto the dance floor and take positions; in modern dance, particularly live performances and EDM sets, we physically embody the anticipation of

the beat by raising our arms, perhaps trying to find it by clapping along to each other, cheering at the performers. In *Proteus*, however, there is no such anticipation. I realize this structure as soon as I enter summer, and in hearing in the beat an invitation to move along to it, I take on the role of a listener or dancer, retrospectively hearing the soundscape of spring as an introduction to the 'summer dance.'

Inward Dancing and Embodied Listening

In *Proteus*, we can identify two ways in which we play to the music: on the one hand we follow directions in which the music takes us or entrain our movements to a beat or metre, and on the other hand we experience ourselves and our actions in musical time, in a musical structure that spans the game. Both ways of hearing involve a kind of movement and a suspension of reflective activity. But is this specific to a ludic way of hearing? Thomas Clifton argues that music, when it works correctly, *always* draws one in. Only bad music does not: '[b]ad music is an expression which really means that the world of music is largely ineffective in its attempt to emerge from its earthly sound source' (1983, 283). But Clifton does not consider the possibility of different ways of hearing music. He does not distinguish between different ways of being drawn in, such as being-in background music or aesthetically reflecting on musical friction, and ludic music.

Ludic music and its relation to movement inevitably bring us to the issue of dance. Dance, of course, denotes a number of specific, culturally conditioned ways of moving to music—usually using one's entire body, therefore excluding such things as swaying or head-bobbing. Video games, too, have capitalized on the explicit forms of embodiment that dance engages us with. Kiri Miller (2017) has argued extensively how dance games involve questions of intimacy, embarrassment, surveillance, and control that this kind of embodiment reveals. A number of scholars, however, have generalized dancing to be involved in all musical experience, and it is this line of argument that I want to follow in characterizing ludic music phenomenologically—keeping in mind the important distinction between this kind of 'inward dancing' the actual dancing that Miller discusses. Don Ihde, for instance, associates all concentrated listening with a 'call to dance.' This includes everything from 'actual dancing, as in dance music or in the spontaneous dances found in rock festivals or religious revivals, to the "internal" dance of rhythms and

movements felt bodily while quietly listening to baroque music' (2007, 156). Roger Scruton describes our engagement with music as a kind of 'sympathetic response . . . to human life, imagined in the sounds we hear' (1997, 355). This sympathy does not include just feeling things, but also sympathetic actions and gestures, of which dancing is the most remarkable:

> In dancing I respond to another's gestures, move with him, or in harmony with him, without seeking to change his predicament or to share his burden... [A]lthough there are forms of dancing which break free from the bounds of aesthetic experience—which by losing all restraint, spill over into erotic or violent action—there is a kind of dancing which parallels acting or singing, in being the producer and the product of an aesthetic response. This kind of dancing resembles our experience in the concert hall, which is itself a kind of truncated dance. When we listen we may tap our feet and sway subliminally; our whole being is absorbed by the movement of music, and moves with it, compelled by incipient gestures of imitation. The object of this imitation is life—life imagined in the form of music. (Scruton 1997, 355–56)

So for Scruton, listening to music—even while sitting still in a concert hall—involves a kind of sympathetic movement, albeit 'truncated,' 'incipient,' and 'subliminal.' Jerrold Levinson takes up Scruton's idea of listening as 'inward dancing' and questions its metaphorical nature. For him, it is no more than an 'extravagant metaphor for the familiar perceptual-cum-imaginative activity often called *following* music' (2009, 425). But he admits that even the idea that musical listening is a kind of following is a metaphor, a potentially inescapable one, because where the philosophy of music tries to explain one metaphor, another metaphor seems to take its place.

There are two things that spring to mind when thinking of dancing as an inescapable metaphor for listening to music. First, we could be dealing with some of the constraints of linguistic meaning itself here: Jacques Derrida's (2011) concept of *différance*, which suggests that words and concepts can always and only be defined through other words and concepts ad infinitum. This casts some doubt on the philosophical project of understanding music through definition (something Jean-Luc Nancy [2007] also alluded to in his plea for philosophers to learn how to 'listen' instead of 'hear'). Second, there is the idea from embodied cognition that there are such things as primal or conceptual metaphors that govern our thinking. George Lakoff and Mark

Johnson have proposed a few of these, such as 'life is a journey' and 'love is war' (1980). These might not be genetically imposed on us, but they certainly pervade culture: the idea that our future lies ahead of us and that we travel into it is central in our understanding of everyday life.[10] In music, the idea that a melody 'goes up' and 'down' is metaphorical, but there is no more literal understanding that we could have of it. In more recent work, Lakoff and Johnson have gone a step further and suggested that these conceptual metaphors are comprised of *image schemata*. These are non- or pre-linguistic structures in our cognitive processes, such as *verticality* or *containment*, that underlie metaphors and meaning in general. In *The Meaning of the Body* (2007), Johnson makes a link between these schemas and bodily motion. Thus, when we hear 'movement' in a melody, the same image schemata are activated as in our proprioception of moving up and down. Marc Leman, for example, further suggests that the perception of intentions in music is always multimodal, even if the music is perceived as 'audio only,' as on a radio: 'music moves the body, evokes emotional responses, and generates associations with spaces and textures' (2008, 139). This means that, for Leman, reactions like unconscious swaying with the music are not a consequence of our perceiving music, but the process of perception itself. This prompts Leman to conclude that we do not just learn, but understand, through imitation. In this regard, he echoes Scruton's idea of 'sympathizing' with music, and Ihde's call to dance.

While these cognitive theories of embodied listening might suggest that movement or sensory-motor image schemata lie at the basis of our engagement with music, this does not mean that we phenomenologically always hear this 'call to dance,' and even if we do, we do not necessarily act on it. Moreover, video games complicate the question of acting *on it*, of answering the call, of entering the ludic-musical space—we might after all just be acting independently of it. Scruton argues that '[s]omeone might be "set in motion" by subdued music, or driven to a frenzy by corybantic noise. But he would be dancing *to* the music only if his movements express his attention to the music. "Dancing to," in the sense that I am considering, is the name of an aesthetic response' (1997, 35). Scruton here circumvents the question of whether dancing is always a deliberate act or whether it can be an involuntary response through his use of the term 'aesthetic response.' I take this to mean something very similar to my interpretation of 'playing to' as opposed to 'playing with,' explained earlier in this chapter. An aesthetic response means that the dancer both understands the aesthetic meaning of the music,

and is acting aesthetically him or herself. So, to give an example of an almost trivial instance, when I follow a rabbit in *Proteus*, I both (pre-reflectively) understand the aesthetic potential of the rabbit in relation to its melody, and I complete this situation through my own movements.

Moving to music in a video game also raises the problem of physical embodiment, of how far our body 'extends' into the game world. For Ihde, when listening to music, '[i]t is my subject-body, my experiencing body, which is engaged, and no longer is it a case of a deistic distance of "mind" to "body." The call to dance is such that *involvement* and *participation* become the mode of being-in the musical situation' (2007, 156). Moreover, Joel Krueger argues that

> bodily movements modulate the listener's relation to different features of the piece (e.g. metre and melody); dancing experientially foregrounds these features and shapes the way that these features stand out against the background of the piece's other sound features. The temporal predictability and consistency of sonic patterns afford this sort of bodily engagement. Sonic Patterns therefore afford an entering into the inner recesses of sonic space, a point of access for losing ourselves, experientially within the piece via the immersive 'deep listening' that often occurs whilst dancing. (2011, 18–19)

But, to go back to my very first example of *Super Mario Bros.*, my bodily movement most significant in playing to the Starman theme was my right thumb pressing down on the B button. To be sure, there was a certain playful exaggeration in that movement: I pressed down slightly harder than necessary to successfully input the sprint command. My thumb was leaning into the NES controller metonymically to my leaning into the music. But can we say that this is the same experience as full-bodied dancing? Not to mention the emotional and social implications of dance games that Miller discusses in *Playable Bodies* (2017), there is at least an important kinetic difference to perceiving movement on a screen and pressing one's thumb into a controller button and moving one's hips, legs, and arms to music. In dance, there is a certain extent to which we can give our movements over to physics: gravity and momentum take over some of the 'work' for us, and in swaying there is a give and take in terms of effort we put in. The broader concept of proprioception that Miller connects to this is, for her, the key to the unique kind of interactivity that dance games like *Just Dance* and particularly *Dance Central* provide: 'the perceptible effects [of the music play out] through players'

bodies' (2017, 102). In video games with more traditional controllers, this give and take is not necessarily present. When we 'fall' or 'lock' into a rhythm (i.e. lean into the music) we do this with only the comparatively slightest of bodily movements: minute movements of the wrist when moving the mouse or the thumb when pressing buttons or moving a stick on a controller. Moreover, I do not *think* in terms of these movements; I think in terms of the movements of my avatar, or the objects that I manipulate on the screen. So at least physically, video gaming is less like actual dancing, and more like the 'inward dancing' that embodied theorists like Scruton and Krueger find to be happening in the concert hall. But the question is whether this is also the case in phenomenological terms, in the way we experience these physical movements.

In video games, we also can find moments in which we give our movements over to physics, albeit the virtual physics engine of the game. Take the game *Journey* (2012), for instance. The most common gameplay form in *Journey* involves the open world exploration we have seen in *Skyrim*, *Minecraft*, and *Proteus*. From the start, the player's nameless avatar finds themselves in a giant desert, freely explorable, with nothing to guide them but a huge mountain far away on the horizon. At some point, they land at the top of a sandy slope, from which they start to slide down automatically (see **Video 3.4** ▶). The short cutscene that introduces this sequence is accompanied by a melodic motif, which cadences into an allegro-paced section that has somewhat of a clear (albeit syncopated) beat. Composer Austin Wintory's cue is carried forward by the melismatic interplay between cello and various background instruments, most prominently a flute. The end of the gameplay sequence segues into another cutscene with the player's avatar flying through a sandfall, in which the light percussion accompaniment, and with it the beat, cut out once again.

In this short one-minute sequence, the player's movement choices are constrained from free exploration in all directions to sliding left and right, and jumping, to avoid the various obstacles on the slope, and guide their avatar over little ramps. As soon as I land, my movement down the slope is inevitable, but the obstacle course presents not so much hazards as opportunities—opportunities to slide through archways and jump off little ramps through sand trickling down the cliff sides. I lean into gravity guiding me down, but in the choices involved in playing around on the slope I can also lean into the music's features. I can jump off ramps on the accented first beats in which a new instrument comes in, and even if my jump does not exactly

synchronize with the beat, it is as if either I or the music is responding—much in the same way the various instruments are responding to one another melodically. This once again highlights the metaphor of dance in my engagement with *Journey* and its music.

However, if we want the metaphor of dance for ludic experience in video games to be more than a metaphor, to be the kind of indivisible metaphor for which no literal description is possible, we have to accept that there is a certain reduction in our experience that takes place, in which there is no difference between full body movements and slight movements of the thumb and the wrist, there is no difference between my avatar and myself, and there is no difference between my movements and movements in the music; this reduction is, in a way, an involuntary version of the phenomenological reduction or épochè. The characterization of ludic hearing as 'leaning into' the music will have to become the kind of a-modal vitality form that Stern describes, whereby my muscles leaning into gravity, my thumb leaning into the controller, my pursuit of a rabbit leaning into the unfolding of a melody, and the press of a button leaning into the coda of a Sousa march are all equivalent in experience. Moreover, I am interested in this experience as just one of four possible ways of hearing music. In order to differentiate ludic hearing from aesthetic, background, and semiotic hearing, then, there has to be something specific in what we hear in ludic music. In this characterization of music as the reduction of mind and body (following Ihde), in which the difference between our own movements and that of the music disappears, a certain theme has started to develop. Similar to Abbate's experiences, all of my examples so far—of *Super Mario Bros.*, *Proteus*, and *Journey*—exhibit a certain joyfulness and playfulness in the music. In the next section, I want to develop the significance and idiosyncrasy of these particular emotional valences further by looking at how music games present their musicality.

Music Games, Synaesthesia, and Glee

A historical overview of musical gameplay in video games would no doubt feature the *Guitar Hero* and *Rock Band* series most prominently. But these series were neither the first nor, since their decline in the early 2010s, the last that can be branded music games. As Michael Austin (2016, 2) argues, there are certain fuzzy boundaries in the question of what constitutes a music game. We can first try to approach the matter somewhat historically.

Original *Guitar Hero* developer Harmonix' early games *Frequency* (2001) and *Amplitude* (2003) both have the player race down a track, picking up coloured dots to the beat of the music, in a very similar graphical interface to their later guitar games. But the basic gameplay rules—pressing a particular button, or combination of buttons in time with predetermined musical moments or beats—were already laid out in 1996 by *PaRappa the Rapper*, and the idiosyncratic controllers, designed to emulate the physical aspects of music making, were first introduced in Japanese arcades through *Beatmania* (1997, mimicking DJ equipment) and *Dance Dance Revolution* (1998, having the player mimic dance steps). The gameplay mechanic common to all these games is pressing buttons in time with a beat, what is essentially entrainment. Examples of this mechanic can also be found in games in which the main purpose is not to 'make music'—that is, to play the role of a musician, or to play along in an abstract manner with music tracks and their visual representation. *Bit.Trip Runner* (2010) and *Rayman Origins* (2011) both feature gameplay in which the player has an avatar 'run' along with the music, jumping over obstacles that are timed and placed with musically significant moments and beats; here, the track or highway from *Frequency* and *Guitar Hero* is moved to the 2D environment of a side-scrolling platform game, and the coloured notes or buttons become pits and obstacles (see Reale 2014).

Another way in which players are asked to interact with music in games is by repeating a series of notes that are played to them. These are in essence musical memory puzzles, and their basic gameplay mechanic can be traced back to the electronic game *Simon* (1978) (Moseley and Saiki 2014, 55; Knoblauch 2016). But there is an important difference between musical puzzles and the musical gameplay that I am exploring in this chapter, namely that we are not playing along to music that we hear, but rather re-creating or repeating music that we have heard before. Even if I have to perform a series of notes in a specific rhythm and/or tempo (which, more often than not, is not required with these kinds of games), I am not synchronizing my inputs with a beat I am hearing. But regardless of this central importance of a beat as a guiding principle in the aforementioned music games, my case study of *Proteus* suggests other ways of playing along in the form of a more general kind of movement and directionality. Are we, even in those 'musical entrainment' games, really purely playing along to a beat? Miller's (2012) research on the *Guitar Hero* series suggests not. She distinguishes between competitive players who go for the highest score and performing players who try to put on the most exciting performance in front of their friends and YouTube audiences. Perhaps we

can say that on a 'basic' level, *Guitar Hero* allows us to play along to melodic contour through the patterns of the dots on the highway—as long as we can think of melodies as going up and down, and are able to translate that to left and right, respectively, on the screen; and to harmonic thickness through the number of dots we have to hit at the same time—as long as we can roughly identify the number of notes in a chord. So rather than a 'basic' level, perhaps I am being invited to play along by virtue of my being an (amateur) musician, who recognizes such things in the patterns. By virtue of my experience of going to concerts, then, I am being invited to play along to the cheers of the crowd and their clapping along to the beat when I activate 'star power,' a power-up state in which I can score extra points. But am I, for instance, also being invited to play along to the Kiss-like makeup of Lars Ümlaüt (or, for that matter, to his name, which is a reference to both Motörhead's band name and Lars Ulrich, drummer of Metallica—what Melanie Fritsch might call a 'culture-based gameplay gestalt' [2014, 173]) as a metal lover? And am I invited by the colourful physical and digital interface of *Taiko no Tatsuijn* by virtue of my literacy in 'geemu ongaku,' which Costantino Oliva (2021, 143) argues reaches well beyond the confines of the game or the arcade? How much further can we take this ability to play along to the music? In phenomenological terms, how does something reveal itself as musical, and when does it ask us to 'join in' rather than merely identify it as musical or hear it aesthetically? And can we perhaps extract an essence of these phenomena other than mere entrainment, which clearly does not cover the breadth of playing along?

A good place to start would be those games whose rules do not require a player to play along, but which are nonetheless considered to be music games, or at least musically 'themed' games. Coming back to Aarseth's distinction between ergodic and nonergodic, *Guitar Hero* is an ergodic music game, in that without the player's physical input, the music stops. But so is *Bit.Trip Runner*, because it punishes the player who does not input their moves at musically significant points in time. A nonergodic music game, on the other hand, provides the experience of playing along to the music, without any consequences for not playing along in a manner determined by the game rules. *Rez* (2001), for instance, has a unique control method that has the player target a series of enemies and then release the trigger, after which the game fires *for* them to the beat of the music. Entraining one's shots to the beat of the music is not required, but shooting in *Rez* evokes the sense that one's avatar is entraining *for* them. While musical actions are not demanded

of the player, the game 'feels' musical nonetheless. Henry Adam Svec even argues that the musicality of *Rez* lies in the freedom of not being demanded to play along:

> *Rez* is a musical-aesthetic machine that allows the player—and audience, who can 'listen' along via an adaptor-vibrator—to behold the processual activity of rhythm ... Although not to the same degree as *Guitar Hero*, this game, too, foregrounds performativity by urging one to play music in front of, and along with, others. Yet, it does so without quantifying the experience, which consequently becomes purely virtuosic: a melding of poesis and praxis less the structure of exchange. (2008)

In this instance, Svec is talking about the 'traveling' mode of play, in which there is no fail state, and the player is 'free to experience the game's visual and sonic virtual-landscapes.' In *Rez*'s standard mode, the game has the player fly and shoot their way through a series of levels, limited in their choice of direction and forced to constantly move forward. In many ways this makes the game similar to older arcade shooters such as *Panzer Dragoon* (1995). The game's visuals, however, feature colourful neon lines and flashes on dark backgrounds that take the place of traditional video game enemies such as monsters, spaceships, or robots (**see** Figure 3.1 on the companion website ⓟ). This has prompted McKenzie Wark to say, '[t]he whole thing is meant to simulate the experience of a night club more than a war. This, together with the curious trigger action, highlights the *act* of targeting rather than the target itself' (2007, §127). But we can turn this around just as easily and say that it is the highlighting of the act of targeting as rhythmical (through the 'entrained feedback' the player gets from releasing the trigger) in conjunction with the neon imagery that simulates a night-club experience, and that is what makes *Rez*'s gameplay musical.

This reversibility of causal terms in *Rez*—does the 'night-club-like experience' highlight the rhythmic qualities of targeting, or does the rhythmic targeting highlight the 'night-club-like experience?'—is a similar reduction of bodily and musical experience as the one I mentioned earlier, with the addition of a visual dimension to that reduction. The import of this visual dimension becomes apparent when one considers the game's dedication 'to the incredible creative soul of Kandinsky' (shown after the game's end credits). The painter's name is frequently mentioned in literature on synaesthesia (Ione and Tyler 2003; N. Cook 1998), and Wark mentions the term in

relation to the game as well: '[c]olors, brightness, shape, movement, beats, notes, sounds, even the pulsating vibrations of the controller in hand come together in *Rez* in a veritable synaesthesia, a blending of the senses intent on melding the gamer with the game' (2007, §128). The specific form of synaesthesia that *Rez* and Kandinsky refer to is chromaesthesia, or the experience of particular colours when hearing particular tones. What is interesting and pertinent here is this particularity of the experience. While Wark might refer to it as 'blending,' the chromaesthetic experience that *Rez* alludes to seems rather to lift individual tones and colours out of their natural context. In our normal perception of objects, colours are intimately tied up with other aspects of the objects: the redness of the chair next to me is a soft-fabric-like redness, whereas that of the wall behind it is a rough, solid kind of red. We have to imagine even a 'pure' kind of red in terms of objects that are coloured a 'more pure' kind of red. Merleau-Ponty speaks of colours as a 'concretion of visibility . . . not an atom': we think of the red of a chair as a 'punctuation in the field of red *things*' (1968, 132). The same goes for the tones that evoke experiences of colour in chromaesthesia. In their case study of D, a chromaesthetic middle-aged woman, Paul Haack and Rudolf Radocy cite one of her problems with attending concerts: 'It is a handicap when I listen to music because I constantly listen for the individual tones themselves. Rather than listening to the overall thing, I dissect it . . . into notes and colors' (1981, 89). *Rez* (and Kandinsky, for that matter) represent synaesthetic experience in similar ways, by 'emancipating' colours from their concretion in visibility, in objects. Kandinsky does this through bright, colourful shapes juxtaposed against each other on canvas; *Rez* does this through bright, colourful geometric shapes and wireframes that flash and move around in a black space.

The use of 'disembodied' colours (particularly against a dark background) as a manner of representing chromaesthesia is not limited to *Rez* in music-themed video games. Other examples include its spiritual successor *Child of Eden* (2011) and *Dyad* (2012); *Audiosurf* (2008), *The Polynomial: Space of the Music* (2009), and *Symphony* (2012), all of which generate levels, tracks, challenges and obstacles from the player's own imported music tracks; VR experience *Beat Saber* (2019); and puzzle game *Auditorium* (2009), in which layers of a music cue are added as the player comes closer to completing a puzzle. We can explain the similarities in visual style in each of these games by tracing it not just back to *Rez*, but also to the music-visualization software first popularized in the late 1990s through media players such as Winamp (1997) and later iTunes (2001). And Ian Bogost traces music visualization,

and its relation to video games, back even further to the Atari Video Music (1976), which connected one's hifi system to a television: 'push buttons and potentiometers allowed the operator to modify the output by changing the pattern, colors, and shapes' (2011, 32). Moreover, he relates the idea for the system to late 1960s and early 1970s psychedelia, whose experience the Atari developers wanted to capture for the living room. We can perhaps draw a parallel here with 1990s rave culture and its colourful glow sticks and strobe lights—after all, its relationship to 1960s psychedelic music has been noted before, among others by Simon Reynolds, for whom it corresponded to his 'vision of a resurrected psychedelia, a Dionysian cult of oblivion' (1998, 3). Winamp's visualizer was a way to bring the flashing lights and neon of the dark rave clubs to one's personal computer at home.

If the use of bright colours and allusions to chromaesthesia are common to music games like *Rez*, music visualizers, rave clubs, psychedelic rock, and Kandinsky's abstract expressionism, then the emotional state that describes the commonality of their experience best is a kind of childlike glee. This term might meet with some resistance. After all, the overt sexual nature of *Rez*'s vibrating peripheral and its washable sleeve, dehydration after taking ecstasy in clubs, bad acid trips at festivals, and Kandinsky's spiritualism all seem to contradict the idea that there is anything childlike or gleeful about these experiences. But I want to argue that what is an essential aspect of all these experiences is the fact that they hide their nature and consequences while we participate in them (successfully). The examples of drugs are the clearest cases of this: dehydration (as a result of hyperthermia) is not solely a physical effect of MDMA, but rather the euphoria makes one forget to drink; adverse reactions to recreational use of hallucinogenics can be mitigated by ensuring a 'set and setting' that is not conducive to worry or anxiety about the consequences (Lucas 2008, 26; Lee and Shlain 1985, 57).[11] For Kandinsky, who collected children's drawings, the child's view of the world has access to a universal purity that is lost in adulthood, a purity that can be expressed by abstracting colours and forms from their association with external objects, by separating them from nature (Wörwag 1998, 86; Kandinsky 1997, 50). It is this 'bracketing' of 'nature,' of the material consequences and meanings of what is depicted, that I call 'childlike' in our experiencing Kandinsky. Finally, to associate childlike glee, or anything childlike for that matter, with a video game with a sex toy peripheral might seem almost obscene. Designer Tetsuya Mizuguchi, however, has denied any sexual meaning behind the Trance

Vibrator (Bramwell 2006). This is expressive of a childlike innocence on the part of *Rez*'s creators that they intend their audience to share in—particularly given the sexual experiences some users report.[12]

In the glee part of 'childlike glee,' we find the particular musicality of these experiences. The word 'glee' itself is closely related to music, denoting a particular type of simple harmonized homophonic vocal composition originating in England in the seventeenth century. The glee lent its name to 'glee clubs,' all-male singing societies that became popular in the towns and colleges of nineteenth-century America. This tradition extends all the way to the modern-day glee clubs portrayed in television series such as *Glee* (2009). As a non-musical term, glee denotes merriment or joy, but the word is often used to describe the kind of joy one takes where it is not wholly appropriate. An adult is not *supposed* to behave in a childlike manner, and one is not *supposed* to express joy in too overt a manner, or take any pleasure at all in destruction or the suffering of others. When we react to something with childlike glee, we momentarily forget our responsibilities and our place in society—a transitory state akin to a 'Dionysian cult of oblivion,' to recall Reynolds' words describing rave culture. In a gleeful moment, I am not constrained in my movements by the unwritten laws of the sensible. I can flail my arms wildly, laugh out loud, shout and sing. Moments of ludic music in games offer this kind of freedom as well: a space to move in that I retrospectively—after the moment has passed—come to describe as unconstrained, or as constrained only by the laws of musical movement, tempo, rhythm, and directionality. When we experience the musicality of these games, we are being drawn in in a manner we can describe as childlike glee.

One might wonder why I refer to the experience of music games, and the way they 'bracket out,' in terms of a very particular emotion, and not in terms of the aforementioned concept of the 'magic circle' (which asks us to ignore the consequences of play in a similar manner to what I just described). But just as critics of the magic circle argument contend that there is really no such thing as 'pure play' (e.g. Consalvo 2009), so have I tried to embed the 'bracketing' of music games in their particular fictional (cf. Juul 2005) elements: an audiovisual way of representing chromaesthesia in a colourful aesthetic that is experienced in a childlike glee. So in other words, there can be an experience of 'pure play' only in a particular emotional state. At the same time, I want to suggest that there can equally be an experience of 'pure music' only in a particular emotional state. Hanslick's

(1986) account of music as purely 'tonally moving forms' and the reduction of music to pure motion that we find in energeticists such as August Halm and Ernst Kurth (described by Lee Rothfarb [2002, 928] as formalistic, antihistoricist, and phenomenological) require a particular way of listening, couched in a particular emotional state. And following on from that, playing along to 'pure musical movement' is moving along in a particular way that I call gleeful.

This idea of gleeful musical movement can be connected to my discussion in the previous sections of *Proteus* and *Journey*. But ludic musical moments like these occur in other non-music games as well, even, significantly so, in games' menus at the very moment we start playing. *Vampire Survivors* (2021) has an audiovisual style reminiscent of games from the early 1990s, and concordantly the start buttons in its menus chime with the timbres of sound chips from that era. As players navigate the various menus to start their gameplay session—pressing start, confirming their character selection and their stage selection—the chimes slowly rise in pitch not unlike the rabbits in *Proteus*. The start menu of *Mass Effect: Andromeda* (2017) opens with a shot of a start appearing from behind a planet (see **Video 3.5** ▶), hearkening back to the openings of science-fiction films such as *2001: A Space Odyssey* (1968) and series such as *Star Trek: Voyager* (1995–2001). 'Press [Space] to start' blinks invitingly in the bottom right corner. We hear a piano playing a rising fifth (much like the opening intervals to *2001* and *Voyager*), A-E, which is repeated with a suspension on G in the bass, then a G-D, before returning to the A. When the player lingers in the menu, a slow horn melody starts playing in D major (0′39″), opening with a rising fifth D-A that echoes the piano opening. In a way, the solo horn acts as a tentative resolution to the opening piano motif. But when the player instead accepts the visual invitation to play and presses space to start, a high D sounds as well, this time in the piano, accompanied by a low drone on D (0′46″): an even clearer harmonic resolution to the piano motif. This interactive cadence retroactively frames the opening piano motif as a musical invitation to play as well. These ergodic musical moments—melodic in *Vampire Survivors*, harmonic in *Mass Effect: Andromeda*—operate very much like the moments of musical anticipation in dance music that I mentioned earlier. As part of the games' start menus, they too can be said to constitute a kind of gleeful 'diving in.' But we may ask if the vast difference between these situations do not stretch the idea of ludic hearing as gleeful to its limits. The final section of this chapter will consider whether it is possible to play along to music in other ways.

Musical Movement and Emotional Context

In the previous section, I proposed that even though in ludic hearing it might seem that there is a reduction in experience to pure movement—both musical movement and physical movement, or the movements of the player's avatar—this movement can take place only in the emotional state that I describe as glee. The question is if this does not limit the emotional spectrum of ludic hearing. To be sure, glee is a concept that can encompass a number of attitudes: with childlike glee we take pleasure in what is considered unworthy of an adult's exuberant attention; conversely, with spiteful glee we take pleasure in the misfortune of others. This means we play along gleefully to music with very different emotional qualities than the aforementioned upbeat, major tonalities of *Proteus* or the busy, glitchy early 2000s EDM of *Rez*. As Peter Kivy argues (1980), the emotions we hear in music are not necessarily the emotional state in which we engage with it. Take for instance the soundtrack of *Halo: Combat Evolved* (2001). This sci-fi-themed first-person shooter popularized the genre for consoles. Martin O'Donnell and Michael Salvatori's full orchestral score is reminiscent of Hollywood film epics, particularly 1990s action films such as *The Rock* (1996). Tim Summers distinguishes three categories of musical material in the game: 'Gregorian chant (and other Western *religioso* materials), Hollywood-style underscore and action music, and exotic/'alien'-signifying musical elements, which includes a female solo voice singing what sounds like improvised non-Western music' (2016a, 12). He divides the second category into action music with rhythmic propulsion (often jig-like rhythms) and Hollywood underscoring in the form of string drones, gradually built-up chords, and stingers, both of which are interspersed throughout the gameplay sequences. It is the appearance of action music in particular that I want to discuss here.

In the game's second level, having just crash-landed on the Halo, a giant ring-shaped habitat in space, Master Chief, the player's character, is attacked by aliens of the Covenant. A cautious, slow-moving melody of high-pitched strings plays over the first moments on the ground, as drop ships filled with Covenant troops land to attack the player (0′06″ in **Video 3.6** ▶). Then, when Master Chief approaches a structure guarded by other survivors of the crash, a single low string drone sets in (2′28″). Later in the level, as more drop ships start to land around the structure, a martial 'action cue' sets in (called 'Brothers in Arms' on the soundtrack album)—danger-state music (5′43″). The up-tempo march is driven by a snare drum, with layers

of baritone-register strings accenting various beats. Nothing in particular changes in the basic gameplay of the level: Master Chief is attacked by Covenant troops and has to shoot them. But I am now invited to shoot my enemies *to the music*. *Halo*'s invitation to play along is in many ways similar to *Proteus*': the appearance of a clear beat, expressed in the snare drum, gives a directionality to the music that it did not have before; moreover, there is a similar movement from a harmonically and rhythmically static musical space to a linear, directional musical section, thus giving structure to my experience on the Halo. Apart from this structure and directionality, the music of *Halo* has very little in common with that of *Proteus*. The experience, however, is similar: a period of following the music where my actions correspond to it and make sense in its light, but which carries no further significance. Afterwards, I have to conclude that my participation in the music—my playing along to it—was a kind of gleeful 'diving in,' similar to the menu music of *Mass Effect: Andromeda* and *Vampire Survivors*, but on a broader timescale.

Even though glee is a more all-encompassing way of engaging emotionally with music than it might seem, we can think of examples of moving to music for which the term is inappropriate. My example of listening to Brahms' Ballade at the beginning of this chapter, for instance, can hardly be construed as gleeful. And we would like to think of the particular ludic music in *Proteus*, *Rez*, and *Halo* as vastly different experiences as well. In *Proteus*, our playing along is joyful discovery; in *Rez*, it emulates the psychedelic colours of rave parties; in *Halo* it is the thrill of war, a 'battle-trance' (McNeill 1995) state of mind. Can we truly reduce all these to affective intensities expressed in directionality and structure, or does that make us guilty of a kind of phenomenal fallacy—of projecting third-person models of cognitive processes onto first-person experiences? We can think of theories of 'pure affectivity' such as Stern's vitality affects as examples of such third-person models, one-dimensional models of bodily arousal.[13] James Russell's (1980) dimensional model of affect expands this characterization by one dimension to include positive and negative affects, so that arousal and valence can be measured empirically by way of electrodermal activity (EDA) and electromyography (EMG) methods. These are, however, reductions of emotional experience, which seems rich with content and context, and we would like to think that affects are not pure musical motion in experience.[14]

The reason why we would like to distinguish among the different experiences of *Proteus*, *Rez*, and *Halo* is that they are meaningful to us.

But the being-meaningful of experiences is an aspect of aesthetic hearing, whose emotional states move us to reflect, interpret, reminisce, and so on, as I elaborated on in Chapter 2. Ludic music instead moves us to play or move along. To attribute reflective analyses and interpretations (such as my characterization of music games) to ludic music, then, misrepresents the actual experience of ludic hearing: it should be considered a hermeneutic fallacy in giving an accurate phenomenological account. In our attempts to describe the experience of playing along, we need to resort to terminology such as 'leaning into' and 'doing this really fast is fun,' finding a way to avoid both hermeneutic interpretations and third-person models of affect. What made my characterization of ludic hearing as gleeful avoid both these fallacies is that it is not a characterization of the object of hearing, but of the way I heard: it is not a noematic quality of the music, but a noetic aspect of hearing. If we want to allow for the possibility of different emotional ways of playing along, we need to establish that there are alternative ways of entering into ludic hearing. As a very rudimentary characterization, I mentioned that my playing along to *Halo*'s battle music, and to the menu music of *Mass Effect: Andromeda* and *Vampire Survivors*, was a kind of 'diving in.' But can we for instance 'fall into' gleeful playing along, or 'embrace' it?

One way to steer clear of aesthetic interpretation and its arresting qualities in characterizing ludic hearing is to focus on the 'acting' part of playing along. If I am leaning into a musical force, I do this in a particular way—I take on a particular role—even if it is just as the kind of person who would lean into music like that. Not every musical space for movement is shaped in the same way: on a basic level, movements can be fast or slow. But a fast movement can be anxious, disciplined, jubilant, angry, and so on. Roger Caillois' (1961) play category of mimicry can help us here. Mimicry involves imitation, pretending, and playing a part. Caillois argues that our interest in mimicry is at least partially based on the (involuntary) contagion of movements, such as yawning and smiling (1961, 20). But it is equally important that at each step mimicry is deliberate, lest it leads to corruption:

> The corruption of *mimicry* . . . is produced when simulation is no longer accepted as such, when the one who is disguised believes that his role, travesty, or mask is real. He no longer *plays another*. Persuaded that he is the other, he behaves as if he were, forgetting his own self. The loss of his real identity is a punishment for his inability to be content with merely playing a strange personality. It is properly called *alienation*. (Caillois 1961, 49)

This gives credence to the idea that mimicry, or roleplaying, is an indispensable aspect of ludic music. When I follow a rabbit in *Proteus*, run along to the Starman theme in *Super Mario Bros.*, or press a button in *Fallout 3*, I am moving in a way that I would not normally move: I find myself pretending, mimicking—not mimicking anything or anyone in particular, but explicitly something other than my own bodily movements. Here, again, we see the importance of serendipity, akin to aesthetic hearing. So where aesthetic listening is an attempt to prolong the significance of the moment of aesthetic hearing through interpretation and reflection, ludic listening attempts to prolong ludic hearing through acting. One can lean into the force of ludic music, jumping in or letting oneself fall into it, embracing it. This involves some kind of movement in the game, such as following the rabbit in *Proteus*, or shooting to the beat of the music in *Rez*. It also explains Cheng's characterization of his experience in *Fallout 3* as theatrical or cinematic, not just in the sense that he was acting, but acting out movements connoting theatrical and cinematic performances.

We can characterize this move from finding oneself playing along (ludic hearing) to prolonging play through mimicry (ludic listening) as a 'gleeful diving in,' but do we have to? Consider, for instance, the possibility of playing along to a sad moment in a video game. A number of narrative games have emotionally charged moments pertaining to the loss of a companion, usually towards the end of the game: *The Legend of Zelda: Twilight Princess* (2006), *Final Fantasy X* (2001), *The Last of Us* (2013), and *Brothers: A Tale of Two Sons* (2013), to name a few.[15] The music in these sequences varies from slow, rubato piano solo melodies (e.g. *Final Fantasy X*) or full orchestral melodies (e.g. *The Last of Us*) to almost complete silence (*Brothers*). The gameplay invariably involves moving one's character from point A to B, much like the games' regular gameplay, but instead with very few obstacles or dangers. We could argue that the lack of danger and the long, drawn-out melodies and silence provide space for aesthetic reflection. But at the same time, one could argue that if I reflect, I do not necessarily reflect aesthetically. I move through the level to this silence, or these long, slow melodies, and take on a sad, reflective persona who has just experienced loss—a persona corresponding to my avatar. The music in conjunction with the gameplay of these sequences invites such a reflective way of playing along. We can characterize 'ludic sadness' in Sartre's account of emotions as a magical way of misrepresenting the world (see also Chapter 2). For him, 'sadness is a magical play-acting of impotence' (2014, 45). When we lose something (or in the case of these games,

a virtual someone) important to us, we have to change the way we deal with the world:

> Most of the potentialities of our world (work *to be* done, people *to see*, duties of the daily round to be accomplished) remain the same. Only the means for realizing them . . . have changed. If, for example, I have just learned that I am ruined, I no longer dispose of the same means (a private car, etc.) to accomplish them. I shall have to substitute means new to me (taking the motor-bus, etc.), which is precisely what I do not want to do. My melancholy is a method of suppressing the obligation to look for these new ways, by transforming the present structure of the world, replacing it with a totally undifferentiated structure. (Sartre 2014, 44)

Similarly, our 'duties' in the game remain the same: moving our character from point A to B. But in moving to the music, we act out the reflective stance of sadness that is involved in this sadness. To summarize, in these sequences we hear the music as inviting a way of playing along expressive of sadness, and we embrace it.

Conclusions

In this chapter I have attempted to come to a description of what it is like to play along to music in video games, or rather to consider oneself playing along to music in video games. I have argued that on the one hand, it involves experiencing a kind of isolation of one's movements and musical movement, which we 'lean into.' On the other hand, our movements are always embedded in a particular context, even if that context is one of music and play as 'pure motion.' This particular context of playing along—one that is presented by music games such as *Rez*, but also in musical moments in games such as *Proteus* or battle sequences in *Halo*—is best described as a kind of gleeful diving into play. Towards the end of this chapter, I considered the possibility of other, non-gleeful, ways of playing along to music, such as in moments of sadness in the narrative of games. Here, we are not so much playing along to musical movement, but rather to the reflective context that the music affords. In these last examples, there is a clear and close relationship to aesthetic music, the sole difference being that we do not reflect *on* the game and its music, but *in* the game and *to* its music. In this case, reflecting

becomes a kind of acting. However, the possibility of 'reflective ludic hearing' reveals the porous boundary between ludic and aesthetic music, and this is no accident. In both ways of hearing, the music attains a significance that is absent in background music. In the next chapter, I will discuss the possibility of a fourth way of attending to video game music, one that complicates the question of significance further.

4
Semiotic Music

In the first decade or so of video game music research, the kind of hearing that most often has been regarded as idiosyncratic to the medium is a kind of semiotic hearing, whereby we hear music as communicating something about the game. Tim Summers identifies this category most explicitly in *Understanding Video Game Music*, where he links it first and foremost to gameplay: 'music that provides gameplay-relevant information which players may use to enhance their chances of winning or achieving a better score' (2016b, 117). An earlier, founding concept in this discussion is Zach Whalen's 'safety and danger state' music (2004; 2007) that I discussed in the introduction. By changing from a 'safe' sounding cue (often exhibiting idyllic or pastoral qualities, major tonalities, light-hearted melodies, and moderate tempos) to a contrasting 'dangerous'-sounding one (aggressive, up-tempo, military instruments, distorted guitars, dissonance, increased dynamic range), the music indicates the presence of danger in the form of enemies or other threatening obstacles. Whalen himself gives examples of two avatar-based third-person games: the action-adventure *Legend of Zelda: Ocarina of Time* (1998) and the survival horror *Silent Hill* (1999). In the first game, a cheerful melody that accompanies the player while they are exploring a certain area fades out to have a more ominous, fast ostinato in the bass register take its place. *Silent Hill*, on the other hand, communicates safety/danger states diegetically, through the use of a radio that emits static as monsters approach the player. Of course, in the latter case we can ask the question whether this is music at all and argue that instead the diegetic soundtrack is mobilized to perform what are traditionally musical functions. It is this interchangeability of sounds that perform the poietic safety/danger functions that I take to be the main characteristic and the main problematic of semiotic hearing. Simply put, if any sound can communicate information about states of the game, what is the significance of the music used in these particular situations? Is this a unique kind of hearing that we do not find anywhere else outside video games? Or do we hear signs in music elsewhere as well?

This final chapter will start with an extended case study of the game *Left 4 Dead* (2008) in which I will introduce several important aspects of semiotic hearing, such as the question of familiarity or experience with the sign that is heard, and the arbitrariness of the musical signifier. In the rest of this chapter, I will theorize these aspects further, while also introducing a categorization of musical signs into symbols and signals—categories through which we can potentially relate the experience of video game music to semiotic attention in other musical situations such as traditional concert-hall listening, and while watching television. Towards the end of the chapter, I will address possible exceptions to the aspect of arbitrariness in the form of anticipated and 'broken' signals, which reveal the dimension of affect in semiotic hearing. The phenomenological qualities of these broken signals also reveal the relation of semiotic music to background music on the one hand, and aesthetic and ludic music on the other.

Case Study: *Left 4 Dead*

As an example of music that communicates information to the player through its musical soundtrack, I want to start with a case study of *Left 4 Dead*. This is a cooperative multiplayer first-person shooter in which four players must fight their way through hordes of cannibalistic, zombie-like infected to reach safety. The appearances of so-called special infected in this game—such as the bloated, bile-filled Boomer or the athletic, leaping Hunter—are signalled by short piano motifs unique to each type of infected. These motifs overlap whatever musical cue is playing and are sometimes obscured in the soundscape of gun shots, infected screams, and survivor shouts to the point of inaudibility. There are two types of special infected whose appearance is accompanied by a more drastic change in musical cue: the Tank, a monstrosity that deals massive damage to the survivors and takes many bullets to kill; and the Witch, a small, long-haired girl, reminiscent of the *Onryo* ghosts from Japanese (popular) culture, who, when startled, screams and charges at one of the players (see Figure 4.1 on the companion website ▶). In each of these situations, the musical cue or motif is usually the first indication a player has of the presence of the infected, as the infected are spawned outside the players' field of vision by design. A way of listening to the *Left 4 Dead* soundtrack could therefore be for this kind of information: music as a sign or signal of the presence of a particular enemy.[1]

The Tank and the Witch's cues are audibly distinct from each other, and again from the various other cues that play during the game. The Tank cue starts with a sudden timpani hit accompanied by a foreboding chromatic bass-register horn motif (0'05" in **Video 4.1** ▶). After repeating a semitone higher, then lower again, the game's main title theme takes over in the same instrumentation and accompanied by the same syncopated timpani rhythms. This loops until the Tank is defeated. The cue's instrumentation, register, and rhythms sound martial, warlike even—a connotation tracing back to Carl Orff's 'O Fortuna' (particularly the low brass and heavy timpani hits on the first beat of the measure), which has become the musical blueprint for much of modern Hollywood film scoring when it comes to dramatic battles. This connotation in turn relates both to the character of the Tank and to the gameplay situation the monster facilitates: a head-on battle, rather than stealthily sneaking around it. Stealthily sneaking is what the Witch requires: when the players startle her, for instance by shining flashlights in her eyes or making loud noises, she charges the nearest player and starts mauling them with her claws (0'14" in **Video 4.2** ▶). For this reason, the cue is divided up into three loops:

a. An eerie, revolving, triplet-heavy melody featuring high soprano voices that plays when the players encounter an unstartled, quietly sobbing Witch (barely audible from around 0'03").
b. Then, when a player startles her, the melody is accompanied by percussion and low brass similar to the Tank's theme, and the melody is repeated a semitone higher, gradually going up in register (0'10").
c. Finally, when the Witch charges a player, this accompaniment disappears again, the voices become more dissonant, and an incessant hammering of high-pitched piano cluster chords comes to the foreground (from 0'14").

If I listen to these two cues for information, what is it that I hear? The war-like sound of the Tank cue can help me adjust my attitude towards the coming situation. If, as a novice player, I have never seen a Tank before, I could decide that the best tactic would be to open fire on the monster, rather than carefully avoid it. Similarly, the eerie qualities of the Witch's melody could suggest that something is about to happen, which I have no way to properly prepare for or deal with, and that the only course of action is caution. More concretely, I could be reminded of the nursery-rhyme-like melodies so often

used in horror games and films, such as *Dead Space* (2008), or the American remake of *The Ring* (2002), which features a ghost closely resembling *Left 4 Dead*'s Witch. These two kinds of associations that the Witch cue brings up—a specific reference to *The Ring* and a general eeriness—might seem to suggest two very different ways of listening: a very knowledgeable and analytic kind of relating the music that I hear to music that I have heard before, and a very broad and associative kind of listening that only takes into account the very broadest impressions from the cue. But in fact, these ways of hearing the cue essentially amount to the same thing: information that guides my actions, based on a knowledge of tropes and conventions in contemporary audiovisual culture, or what Isabella van Elferen would call 'ludoliteracy' (2016, 36) following José Zagal. We should therefore not interpret 'hearing eeriness' as a kind of experiencing being affected by mood music (which is either ludic or aesthetic hearing), but as a recognizing of mood or affect, much like Peter Kivy (1980) argues that we hear sadness in music as we would see sadness in a Saint Bernard dog. This is the difference between expression and arousal in music psychology (Juslin and Sloboda 2010, 29). In other words, recognizing a Saint Bernard as a Saint Bernard and recognizing its face as sad-looking are analogous to recognising the Witch's cue as an instance of *The Ring*'s nursery-rhyme horror trope and recognizing its eerie qualities.[2]

But what if I am an experienced player who has dealt with Witches and Tanks dozens of times—who knows how to 'crown' Witches and 'kite' Tanks, the locations in which they are likely to 'spawn' (some of the terms used in player discourse), and the best tricks to avoid them? Listening for the presence of a Witch, I am no longer interested in her cue's relationship to *The Ring*'s soundtrack, or its eeriness—all I care about is that it is the Witch's cue, which I will recognize almost instantly when I hear it. What is relevant to me as an experienced listener is that the cue sounds different from the other cues in the game, and identical to the cue that I have learned to associate with the Witch. In the process of becoming experienced at playing *Left 4 Dead*, I have learned to ignore certain 'cosmetic' features of the game's locations, infected, and musical soundtrack, in favour of those features that help me most effectively progress through the game. But what exactly are these cosmetic features? And what do I mean by 'ignoring them'?

In *Half-Real* (2005), Jesper Juul argues that video games present the player with both a system of rules and goals, and a fictional world in which these are embedded, or that represents these rules. For instance, a Tank in *Left 4*

Dead has a certain number of 'hit points' that determine how much damage it can take before it dies, which is part of its rules; it also has two giant lumbering arms and a tiny head, which are part of its fictional representation (see Figure 4.2 ▶). According to Juul, statements about video games can pertain to both their fictional world, and their real rules. He gives the following example from the game *Tekken 3* (1997):

> Looking at *Tekken 3*, a game that is not abstract, consider the statement: 'Eddy Gordo is Brazilian and fights using the martial art of capoeira.' Is this true? In this case we have to combine the question about Hamlet with the question about the rules of tennis:
>
> 1. There is no real-world person called *Eddy Gordo*, but in the *fictional world* of *Tekken 3*, there is a person by the name of Eddy Gordo who fights using the martial art of capoeira.
> 2. *And:* In the real world, it is factually true that you can choose Eddy in *Tekken 3*, and that you can control the character of Eddy so that he attacks his opponent using capoeira moves.
>
> The first point looks at *Tekken 3 as fiction*; the second point looks at *Tekken 3 as real activity*. The description of the fictional character of Eddy *also* describes the real-world fact that having selected that character in *Tekken 3* gives the player the option of performing a number of special moves. *That Eddy Gordo fights using capoeira moves describes the fictional world of the game, and it describes the real rules of the game.* (2005, 167–68)

But it could be said that 'Eddy Gordo fights using capoeira moves' is too vague to be a statement about the game's rules. It does not help the player better understand the particular inputs or even general strategies required to use the character successfully in *Tekken 3*. Rather, a statement such as 'Eddy has many hard to predict button executions for some of his moves, that's why players intended to mash buttons instead' (Easternborder 2003), taken from an old player-penned character guide, is a more accurate description of Eddy's 'rules.'

But let us for a moment bracket out this theoretical distinguishing between rules and fiction and ask what I am really doing when I deem certain features of a game 'fictional.' As Juul argues, 'the fictional world of a video game can

cue the player into making assumptions about the game rules' (2005, 177). Similarly, Karen Collins argues that '[s]ymbols and *leitmotifs* are often used to assist the player in identifying other characters, moods, environments, and objects, to help the game become more comprehensible and to decrease the learning curve for new players' (2008). Thus, when we become more experienced at playing the game, the fiction becomes optional: cosmetic features that are no longer relevant to my successfully traversing a game's challenges. Juul (2005, 12) invokes a concept first introduced by Erving Goffman, called 'rules of irrelevance,' to describe this process. Goffman (1972) introduces the idea of rules of irrelevance to describe what happens in social encounters. He uses the example of games, in which we learn to ignore certain aspects in favour of others, such as the way in which we ignore the shape and size of chess pieces in favour of their rules for movement on the board.

Summers (2016b, 123) uses J. L. Austin's speech-act theory to describe how game music communicates with the player, and his ideas can help understand the process of learning the rules of irrelevance in more detail. He looks specifically at examples of stealth and survival horror games, games in which the player's attention to the music is often rewarded, or even required, such as *Tom Clancy's Splinter Cell* (2002). The music in these games communicates important information about game-state events: most importantly the presence of enemies, and their awareness of the player's avatar.[3] Summers categorizes the different levels of understanding of the music in a game according to Austin's different kinds of speech acts. Initially, the player merely hears the music's locutionary force. This is for Austin the act of uttering a sentence, for instance a warning like 'the bull is going to charge'; for Summers, the locutionary musical act consists of 'specific semiotic references' in addition to 'significant musical changes,' and/or 'musical techniques that aim to invoke an emotional response' (2016b, 125–26). These are different from illocutionary force, which is the actual warning conveyed by the sentence or music. Then, 'after spending time with the game, the gamer will come to additionally recognize the cues as single semiotic units' (2016b, 125), which are the music's perlocutionary force, or in other words the outcome of the musical speech act, its effect on the player. In Juul's terms, we can equate the music's locutionary force with its conveying of fiction, and its perlocutionary force with its conveying of rules. What is important here is that this is all given in a single 'music act,' which consists of three layers, locutionary, illocutionary, and perlocutionary, the latter two of which can differ for novice and experienced players. Consider three examples:

1. The novice player who notes the hairs on the back of her neck standing up at hearing the eerie Witch's cue, remarking to her fellow players how creepy the situation is;
2. the intermediate player who notes the creepiness of the music, suggesting that his fellow players look around for the source of this sudden change in music;
3. the expert player who messages 'Witch!' to her fellow players at the first sounds of the Witch's cue, reminding them to turn off their flashlights and hold their fire.

For (1), (2), and (3), the locutionary act of the music is roughly the same: the transition into an eerie musical cue. The illocutionary force for (1) is to creep the players out, whereas for (2) and (3) it is to warn them of something. The perlocutionary force of the music is different for all three: (1) searches her emotions and describes the situation, (2) looks around for the source of the warning, (3) performs the actions she is accustomed to performing upon hearing the cue.

The most important similarity among Summers', Juul's, Goffman's, and Collins' account of this kind of encountering rules or games is the distinction they make between the novice and the experienced participant/player. It presents the important question in what ways the novice and the experienced player hear the music in a game differently. What is it to hear purely 'fiction' in a musical cue, and what is it to hear just 'rules?' My two descriptions of the Witch's cue in *Left 4 Dead* and an analysis according to Summers'/Austin's speech-act theory gave some indication as to what the novice player would hear: a series of connotations, either general eeriness or specific cultural references, possibly providing clues on how to act in the game. As for the experienced player, it might be helpful to turn to Summers' characterization of the music in terms of 'single semiotic units.'

Musical Signs

The reason why I have chosen to call the mode of hearing discussed in this chapter semiotic and not for instance signpost music (alluding to Adorno and Eisler 2005 and their discussion of leitmotivic film soundtracks) is because of its resemblance to the workings of signs in Saussurian semiotics (2011). What distinguishes the semiotics of Ferdinand de Saussure from those of the

other forefather of semiotics, Charles Sanders Peirce, is the arbitrary relationship of signifier to signified in a sign (de Saussure 2011, 67). Although there are conventional reasons why the word 'flower' refers to the plant, in its ability to signify, 'flower' does not have to have a specific relationship of resemblance (what Peirce would call iconicity) or proximity (indexicality for Peirce) to the plant in order to work; it signifies purely by virtue of its difference from other signifiers (in this case other words).

To an experienced player, a change in musical state refers to a change in the game much like a Saussurian signifier refers to its signified. It is transparent in that this kind of player is not interested in its salient features for any other reason than their difference from other musical states. In this sense it, like a Saussurian signifier, can even be described as arbitrary, even though it might have some sort of resemblance to the game state it is referring to. A peaceful melody might iconically or indexically (now using Peircean terminology) refer to a peaceful game state: iconically, music can resemble the calm and serene movements of a person in a peaceful mindset (Kivy 1980; Levinson 1996); indexically, the music can resemble the music played at peaceful occasions such as meditation or prayer and signify peacefulness based on that correlation. As far as our semiotic hearing goes, however, it is only important that it sounds different from a danger-state melody. So semiotic hearing is hearing difference in the music in order to ascertain or confirm something outside the signifying event. This means that phenomenally, a semiotic event could be infinitesimally small. It is merely the recognition of a change in cue that we need to know there is danger, after which the music no longer requires our (semiotic) attention. To summarize, semiotic music has two characteristics: it is unimportant what it sounds like apart from the fact that it sounds different from its context, and it requires only the smallest moment of attention.

This describes the experience of music that informs the player of events in the game for the experienced player. (There are exceptions, to which I will turn in my final two case studies.) For the novice player, such as the *Left 4 Dead* player I described above in my example of speech acts, it is important that the music 'sounds creepy'—that it resembles creepy music in the Kivian way I mentioned earlier; for the intermediate player there is a period of searching for the particular meaning of the music in which musical characteristics are considered in terms of their relationship to the music. This has some resemblance to aesthetic hearing, whose attention is stretched out in time. But for both the novice and the intermediate player, consideration of the

music only requires a moment's attention to the soundtrack after which there is a definite teleological searching out of the environment: unlike aesthetic listening, which is an open-ended process of interpretation (see Chapter 2), our semiotic attention to the music ends as soon as we have deciphered what the music is telling us. Thus the main difference between aesthetic and semiotic listening is between open-ended, continuous interpretation, and teleological deciphering. Repetition—playing the game over and over again and coming across the same musical situation multiple times—is the factor that is responsible for the eventual arbitrariness of the musical signifier that I will be discussing here.

The two characteristics central to the semiotic hearing of the experienced player, arbitrariness and transitoriness, warrant some further description and argumentation. After all, if our attention to the music is infinitesimally short, and indiscriminate as to the characteristics of the music, what is it like to hear it? In phenomenological terms, how does our experience of musical signs differ from other musical phenomena (such as movement, melody, or emotion), and how does it differ from our experience of other, non-musical signs (traffic lights, fire alarms, or vibrating mobile phones, for instance)?

The question is if it is at all possible to provide a general phenomenological account of musical signs. Göran Sonesson invokes Saint Augustine, who defines a sign as 'a thing which, over and above the impression it makes on the senses, causes something else to come into thought as a consequence' (2007, 93) and notes the difference between the directly perceived signifier, which is not in our 'focus,' and the signified, which is not directly perceived but *is* in our focus. This raises the question what exactly that 'focus' is like. Martin Heidegger warns us that for phenomenological description there is no such thing as a sign in general: 'Among signs there are symptoms, warning signals, signs of things that have happened already, signs to mark something, signs by which things are recognized; these have different ways of indicating, regardless of what may be serving as such a sign' (1962, 108).[4] In other words, even if we disregard the particular 'cosmetic' features of a signifier (what it looks or sounds like), even the manner of signification is not generalizable.

Consider some examples of musical signs functioning: the flute embellishments at the end of the second movement of Beethoven's Sixth Symphony *remind* me of bird calls; a short slap-bass lick *warns* me that the commercials are over and *Seinfeld* (1989) is back on;[5] gentle piano music *suggests* to me that I have entered a classy cocktail bar. All of these pieces of music are construed as signs—they all stand for something else. But the

manner in which they do it is experienced in completely different ways. What is needed, even before addressing the specifics of musical signs, is a characterization that is more sensitive to the way we experience them in daily life. We might find, then, that musical signs are not all that different from non-musical or even non-auditory signs, which offers a good start for looking at signs in video game music. Instead of going into the minute and perhaps impossible-to-define distinctions between being 'reminded,' 'warned,' or 'suggested,' let us ask *when* we encounter each of these signs: at the end of a symphony movement in a concert hall, while watching—probably with divided attention—TV in the living room, and while walking into a cocktail bar for the first time. What seems to be an important distinguishing factor is the urgency with which these signs speak to us, which will form the basis of my approach in the rest of this chapter.

One way of categorizing the situations in which we encounter signs is in terms of their availability to us. Hieroglyphs and coats of arms are signs that persist in our perceptual environment, whereas fire alarms and traffic lights have a temporary presence and derive their signifying qualities from that temporality. The former can be defined as symbols, whereas the latter are signals—both refer to something outside themselves, but they make different demands of their interpreters. (Note that with the term 'symbol' I am not referring to Peirce's use of the word, by which he means a specific relationship between a sign and its referent, namely a conventional one. Symbols, in the way I define them, can be symbolic signs, but they can be iconic or indexical signs as well.) In a way, I have already discussed musical signals in-depth through my examples of the Tank and Witch from *Left 4 Dead*. I hear both cues as a warning signal much like a fire alarm or a traffic light, calling me to action. The possibility of musical symbols will need more explanation, and for this reason, I will start there.

Musical Symbols

My examples of hieroglyphs and coats of arms might seem to suggest that symbols are primarily visual signs, and signals primarily auditory signs (or visual signs that at least involve some kind of motion or change in state, such as in the case of traffic lights), but this is not necessarily the case. Suppose I am listening to a concert performance of the second movement of Beethoven's Sixth Symphony, possibly adopting an aesthetic listening

attitude (see Chapter 2) in which I alternately follow where the unfolding symphonic movement takes me, and open up to the possible meanings that it might present to me. This might require a certain minimum listening expertise, as I am not struggling to understand every single note or musical event as it appears to me.[6] Towards the end of the movement, I encounter something odd, deviating from the rest of the movement's thematic texture: the interplay of woodwinds sounds remarkably like bird calls (mm. 129–36 in the score). Their presence has no particularly pressing concerns for me, as I am not warned of any particular events about to unfold in the symphony, and of course neither am I called to act upon them. My deciphering of the bird calls is allowed to proceed at its own pace, perhaps even after they have ended. (And depending on my knowledge of birds, figuring out which species they belong to without peeking in the score can take a while.) Apart from their non-urgency, they have a definite meaning: my deciphering the sounds presupposes an end, whether this is being content with the fact that they are 'bird calls,' or discerning the sound of the cuckoo, quail, and nightingale. While the teleological nature of my encounter with this phenomenon makes it semiotic rather than aesthetic,[7] its non-urgent nature means that the bird calls are symbols rather than signals.

It can be argued that tone paintings in general are heard as musical symbols: the xylophone in Saint-Saens' *Danse Macabre* that represents the rattling bones of animated skeletons, the speeding up of the train at the start of Honegger's *Pacific 231*, and so on. Their meanings, whether instantly grasped or deciphered by an interested listener, are not pertinent to the moment in which they are heard, but rather contribute to the meaning of the piece—or of a section of the piece—as a whole. Beethoven's bird calls do not signal the start of an event in the piece; the dancing skeletons in the *Danse Macabre* are just part of a larger *bacchanalia* that is being portrayed; even in the case of *Pacific 231*, in which the train sets off at the start of the piece (signified by the gradual speeding up of the low strings), the logical inference that the piece therefore represents a journey is not dependent on a particular moment of inference—rather than a musical signal, this *Tonmalerei* is a symbol with a certain 'temporal location' in the piece's structure.

The essential difference between a symbol and a signal in concert-hall listening, then, is that a symbol is not pertinent *right now*, at the moment when it is heard. A signal in concert music would be something like a marker of structure, as is the return to the head in a jazz piece, which signals its coming to a close. Similarly, in a Mozart opera, a large ensemble typically signals the

finale of an act. All these examples have in common that they signify an event about to unfold. They require of the listener an ongoing interest in the immediate future of the music as it unfolds: an interest in the structure of the piece, or in the narrative of its programme. When we hear musical symbols, this urgency is lacking.

We find the same manner of signification in video game music, but perhaps not in a game like *Left 4 Dead*. There, the constant threat of danger means that all musical signs are heard as signals for one thing or another—usually the presence of infected about to pounce on the player. Rather, the kinds of games in which we hear musical symbols have non-urgent threats to the player's progress. These are predominantly turn-based games, in which the opponent cannot make their move until the player ends their turn, or puzzle games, in which the player has an unlimited amount of time to solve a series of challenges or puzzles.

Sid Meier's Civilization V (2010) is an instance of a turn-based strategy game with musical symbols. *Civ5* forgoes *Civilization IV*'s musical characterization of the games' different technological eras in favour of music that both reflects the civilization that is chosen, and the state this civilization finds itself in: either war or peace. In Chapter 2, I discussed a way of hearing its predecessor's music aesthetically, as inviting a kind of critical, interpretative listening. There is no reason why one should not be able to hear *Civ5*'s music aesthetically. There is, for instance, pre-existing music, which consists of familiar melodies that are woven together with newly composed music into the game's cues. This means that moments of recognition can carry a certain nostalgia with them: encountering Fauré's Berceuse, Op. 16, took me back to performing it some years ago. For me, however, the music never quite stood out in the way that certain pieces on *Civ4*'s soundtrack did. An explanation for this could be *Civ5*'s original soundtrack and the 'smooth' way in which it includes the pre-existing pieces, to use Elizabeth Medina-Gray's (2019) terminology. Even when they stand on their own as separate cues, the pieces are new recordings in versions with similar instrumentation to the rest of the soundtrack. Fauré's Berceuse is performed by an orchestra, rather than solo piano, for instance, creating a kind of timbral homogeneity.

This does not mean that, turning my attention to the music during gameplay, I find no significance. *Civ5*'s soundtrack is not exclusively heard as background music, telling me something 'I already know.' Consider the situation of hearing war music while playing. Going to war consists of attacking another civilization, being attacked by another civilization, or declaring war

on them formally through diplomacy. This changes the state of the game to war, which is accompanied by a dynamic change in musical cues. Even if the player is at war with only one other civilization, the 'war state' music plays. This state of war lasts until either the opposing civilization is completely destroyed, or a peace treaty is being agreed upon diplomatically, whereupon the music changes back to peace-state cues. The player's actions will obviously differ while at war from while at peace: they will be attacking opposing cities and units, spending much time moving troops around the map. Battles between units are represented through short animations in which the units attack, accompanied by the sounds of gunfire, clashing swords, and so on. One can imagine the marked difference in soundscape between peace and war states: musical cues that are dominated by low strings and (male) choirs, march tempos, brass, and timpani, punctuated by the shouts of units acknowledging attack commands, and the martial sounds accompanying their battle animations. In both peace and war states, the music is likely to be heard as a background befitting the gameplay situation.

But like in real life, wars in *Civ5* can be long, protracted affairs. The player is not constantly defending their borders or besieging enemy cities. Sometimes, a peace state cannot diplomatically be reached with the computer opponent, or it can be strategically advantageous to remain at war. For instance, playing as France one night, after having my overseas city of Orleans invaded by the Huns (a civilization with a notoriously aggressive computer A.I.), I lost my footing on their continent to the west. While neither of us had any interest in building fleets and taking the war across the ocean, I was not content to let Attila occupy my city without consequences. I therefore opted to stay in a state of war, so that my allies on the Huns' continent were more likely to join, or freeze their trade relations. Meanwhile I turned my attention to my own continent, continuing the building projects and planning of infrastructure that I started during peacetime. For all intents and purposes, I was playing as if I was at peace. Several turns and hours of gameplay later, having taken a break from the game and continued it the following evening,[8] intending to move one of my Great Musician units across the ocean to the west, I double checked whether it was safe to cross (1'12" in **Video 4.3** ▶). Noticing the male-voice choir of the musical soundtrack reciting a very ominous-sounding melodic trace of Offenbach's famous 'Infernal Galop' from *Orpheus in the Underworld*, I was reminded that I was still at war with the Huns, and about to send my musician in their direction. I quickly changed my mind and started negotiating a peace treaty.

What mattered to me in this situation was not so much the musical reference to Offenbach. Of course, the can-can stands as a musical symbol for French culture, with its connotations to the Moulin Rouge and fin-du-siècle Paris. But this is not the symbol I was interested in: I was more interested in the ominous, martial qualities of the music—in fact I was only interested in the music as a cue that plays during a war state, one I had heard countless times before. So when I am describing a seven-note Offenbach citation, this is merely a metonym for 'war-state music.' What I hear in the music is a symbol for war. Compare this with my example of tone painting in concert music. In the light of my project in a game of *Civilization*, namely winning, or on a more local level keeping my units safe, I find symbols in the music that help me complete this project; in the light of my project in attending a performance of *Pacific 231*, namely understanding the piece as a symphonic poem, I find symbols of a different kind. Hearing the 'Infernal Galop' as a symbol of French musical culture would involve a project more like the latter. Both projects are a form of semiotic hearing, because they presuppose an end to the project: keeping my units safe, and understanding *Pacific 231* as tone painting a train (journey). Neither situation requires a particular moment of the music that signals me—both allow for me to attend to an indefinite stretch of music in my own time, and still accomplish the same semiotic project.

We can find musical symbols in other places than non-time-pressured safety/danger-state music as well. Many games add gameplay variety by incorporating puzzles: short self-contained challenges that are encountered either once, or sporadically. Like puzzles outside video games, such as jigsaws and crosswords, they are structured as a single problem that requires knowledge or logical reasoning to solve. And like other puzzles, the player is often given unlimited time to solve them. There are quite a few instances of musical puzzles in video game history—puzzles that require musical skills or knowledge to solve them, such as pitch recognition and memory, memorizing and reproducing melodies, and manipulating musical phrases. The classic adventure game *Loom* (1990) is an important example of the latter. Rather than the usual adventure-game manner of collecting and combining items and applying these to objects in the environment, the game has you solve puzzles by playing four-note motifs on a 'distaff,' a music staff-like interface, which has magical effects on the environment. Summers (2016b, 82) describes the motifs as Wagnerian in nature, with some of them requiring tone-painting techniques on behalf of the player, turning leitmotifs into symbols.

While *Loom*'s puzzles work this way throughout, these kinds of musical puzzles can be encountered incidentally in other games as well. *Fallout 3*, for instance, has a sequence in which the player has to escape a virtual reality set in a 1950s suburban cul-de-sac called 'Tranquility Lane.' While the VR-simulation is set up like *The Matrix* (1999), the atmosphere painted therein is more reminiscent of David Lynch's *Twin Peaks* (1990) and *Blue Velvet* (1986), with a threatening undertone that becomes gradually more overt as the player is tasked to perform ever-more-gruesome deeds by a little girl called Betty in a playground. The only way out of the simulation for players who refuse to partake in the slaughter of every single one of Tranquility Lane's residents (with a 'Pint-Sized Slasher Knife') requires picking up on a hidden musical 'symbol' that forms the clue to a hidden puzzle. In an inconspicuous abandoned house on the lane, there are a number of out-of-place-looking objects such as a garden gnome and a large concrete brick that emit a musical note when interacted with. When the player 'plays' the objects in the right order, a Failsafe Terminal is revealed—much like a console on *Star Trek*'s Holodeck—which can be used to exit the simulation. The right order is suggested by a musical melody that the player hears around Tranquility Lane: it is both whistled by Betty on occasion *and* heard in the nondiegetic musical cue that loops in the background of this section. For me, this diegetic to nondiegetic relationship and the repetitiveness of the music were what clued me in on the melody. Here, again, like in *Civ5*, there was no exact musical moment that signalled the solution to the puzzle (or the actual nature of the puzzle, which was revealed to me at the same time). Rather, the clue was around in the sonic environment, like a symbol to be picked up.

The two characteristics of musical signs, their arbitrary nature and the transitory attention they demand of us, should apply to musical symbols as well. And indeed, it does not really matter what the melody in Tranquillity Lane sounds like to us. Of course, it has to have certain functional qualities: it has to stand out enough from the sonic environment in order to be heard, it has to be short enough that it can be repeated in its various diegetic and nondiegetic guises, and it has to be able to be whistled by Betty while still being recognizable. But attending to it as a symbol, we are not interested in any of these qualities: we are purely interested in the similarities between the melody's pitches and the 'musical' items in the abandoned house. In *Civ5*, we are purely interested in the music sounding like a war state cue—not even necessarily in its connotations with other martial music, but in our memory of that particular cue being used in the game's states of war.

Musical Signals and Anticipation

I mentioned before that signals are different from symbols in that there is a certain urgency to their meaning. The meaning we attribute to the music in the case of Honegger's *Pacific 231*, which I previously discussed, is linked to its specific temporal location, but in the case of signals there is more to it. Their meaning is discharged instantaneously, in the infinitesimal moment of their appearance. A fire alarm is important when it sounds, and a traffic light is important when it changes colour. Similarly, as I mentioned above, the moment when we recognize the reappearance of the head in a jazz performance is important as a signal that the piece is about to come to an end. In video games, the examples of the Tank and Witch cues from *Left 4 Dead* are musical signals: their appearance signals the presence of the infected and calls upon the player to change their behaviour appropriately. As with musical symbols, so with signals we can ask how much we as players care about what these cues sound like, what kind of attention they demand of us. Signals' 'outward appearances' are sometimes designed much like fire alarms to attract the attention. Iain Hart points out that *The Elder Scrolls V: Skyrim*'s combat cues or danger-state music have 'an abrupt start that is, in most cases, louder than the ensuing music' (2020, 234). But these outward appearances, qualities of the signifiers—the loudness of the fire alarm, the redness of the traffic light, the eeriness of the Witch cue, the abruptness of the *Skyrim* cues, or the melody in the jazz standard—seem to matter only to the novice listener, whereas to the experienced listener they have been subjected to the rules of irrelevance.

We may ask of the particular case of musical signals to what extent we anticipate such signs. To some extent, we can say that we anticipate *all* signs—both symbols and signals—since we need to be aware of their signifying function in order to recognise them as signs. In other words, in every situation we anticipate the possibility of certain things being signs: driving down a street, we anticipate the possibility of red and green lights being signs for when to stop and when to drive; listening to a Beethoven symphony, we anticipate the possibility for woodwind embellishments being signs for bird calls. In the case of signals, Karen Collins mentions this quite explicitly:

> Signal listening might also be referred to as anticipatory listening or, according to [David] Huron, 'listening in readiness.' With signal listening, we listen for a particular cue or auditory sign post: the player is anticipating a signal to action. For example, in the video game *New Super Mario Bros.*

(2006), the player sometimes must listen to the music to time Mario's attack, since enemy Goombas jump in time to the beat. (2013, 5)

But this kind of listening does not only anticipate *what* signs will appear, but also *when* they will appear. The particular kind of anticipation *NSMB* asks of us involves entrainment to the beat of the music, which I described as a form of ludic hearing in Chapter 3. Similar rhythmic gameplay can be found more pervasively in other titles, most famously *Crypt of the NecroDancer* (2015). Here, too, the player has to move their avatar around an environment to the beat of the music. Michelle Grosser (2020, 7–9) notes how the tempo and clarity of the beat in different cues and levels allow the game to vary the difficulty level. In my discussion I will focus on the earlier and more obscure mobile game *Beat Sneak Bandit* (2012) that features similar gameplay to *NecroDancer*, requiring players tap along to a beat to move a burglar around a house. The Bandit has to avoid guards and traps, all of which move to the beat as well in differing rhythms (see **Video 4.4** ▶).

Collins' example raises a number of questions about musical signals. Firstly, we can ask whether we anticipate *all* musical signals, or whether there is room for signals to come out of nowhere and surprise us. And if there is, can we still call this anticipatory listening—because we interpret the phenomenon as a signal—or is this an entirely different way of listening? We can start by saying that, like with other musical signs, there must be a first moment of recognition in which a sign is established. This moment naturally has to be unanticipated. In the case of *Beat Sneak Bandit*, these would be the multiple musical as well as non-musical signs that establish its beats as having semiotic significance. There are the verbal instructions, the multimodal synchronization of visual movement and beat, and even an icon at the top of the screen that indicates the beat; then there are the negative clues—the player is punished with 'cuckoo' earcons and the inaction of the bandit if their tapping does not coincide with the beat (0′47″ in **Video 4.4**). All these features act as the affordance structure of the game environment (see Chapter 1) in order for the signals to be heard as signals, much like the driving situation structures the affordances of the traffic lights. We see a parallel here with aesthetic hearing as well: in order to first hear something as a signal, we perhaps do not *actively* anticipate it (the kind of listening that Collins talks about), but we do have to be open in some way to the possibility of hearing something as a signal for action—in terms of background hearing, the background of the situation 'attunes' us to this. But there is a phenomenological

difference between being 'open to' or 'attuned to' the possibility of something happening, and actively anticipating a moment of something happening, whether we know roughly when in the future this moment is going to happen ('I will be able to pass through the yellow beam a number of beats from now,' 0'05"), or whether we have some vague sense ('the Witch in *Left 4 Dead* can appear at any moment now'). Rather than an 'openness to,' this temporal anticipation is a 'directedness towards' a future signal.

So there are two kinds of musical 'directedness towards' states when it comes to musical signals: entrained and non-entrained anticipation. In both cases we can now ask a second question: if at some point I start anticipating a particular musical signal, was there no sign (symbol or signal) that prompted this anticipatory state? In the case of non-entrained anticipation the answer is no, not necessarily: a situation can afford anticipation, a kind of awareness that is not necessarily semiotic. In the case of entrained anticipation, however, there are a number of possibilities for there to be an anticipatory and an anticipated signal. Consider the aforementioned moment in *Beat Sneak Bandit* in which I time my movements to cross through the yellow beam (0'05" in **Video 4.4**). I know from experience that the beams filling up are preceded by a shifting sound on the upbeat, so I count 'a-one, a-two, a-three, a-four' where on the 'a' I raise my head and finger to this shifting sound, and on the count I drop it to the appearance of the beams—not yet on the screen, but hovering just above it, to 'practice' my future taps.[9] Then, when there is no light beam on 'five,' I take this as a signal to move on the next beat (tapping in 'double tempo'). Admittedly the absence of the light beam is a visual signal, but since it happens on the beat and its filling up is accompanied by a sound effect, it is *listened* for nonetheless. So if 'five' is the anticipated signal, are there anticipatory signals? Consider the following possibilities:

1. 'A' is the anticipatory signal for 'five';
2. 'a-one' through 'a-four' are anticipatory signals for 'a-five';
3. there is no anticipatory signal—rather the sequence 'a-one' through 'a-four' structures the temporal affordance of anticipating 'five' in the unit 'a-five.'

My point will be that entrained anticipation is best described as (3), but this will require some explanation.

Elizabeth Hellmuth Margulis notes a phenomenological difference between the expectation of some distant repeated event such as an unentrained

anticipated signal, and the experience of repetition on smaller time scales, such as a beat or rhythm: '[r]epetition makes it possible for us to experience a sense of expanded present characterized not by the explicit knowledge that x will occur at time point y, but rather by a heightened sense of orientation and involvement' (2014, 9). In other words, expecting another beat to follow 0.6 seconds after the one I hear in a 100 bpm piece is not a kind of explicit knowledge of events following one after another, but a knowledge of an 'expanded present' having a certain shape. More generally, she argues that

> [R]epeated exposures [to musical passages] trigger an attentional shift from more local to more global levels of musical organization. Repetition, thus, can be understood to affect a listener's orientation towards the music; the horizon of involvement widens with additional exposures, so that the music doesn't seem to be coming at the listener in small bits, but rather laying out broader spans for consideration.[10] (2014, 9)

This suggests that our experience of entrained anticipation is definitely not like (1), in which the upbeat is an anticipatory signal for the downbeat. It also suggests, however, that 'a-one' through 'a-four' might be part of that expanded present that structures the anticipation of 'a-five,' something like (3).

One could argue for (2), however, on the basis that there is a phenomenological difference between the temporal *gestalts* 'a-one' through 'a-five' and the succession of these *gestalts* in the unit 'a-one through a-four.' What happens is that we find ourselves already entrained to the beat of *Beat Sneak Bandit* so that we hear 'a-one' as a temporal *gestalt*, part of the shape of our present. Much as I argued in Chapter 3 on ludic music, through its audiovisual presentation, the game invites us to 'lean into' the beat from the moment I start the level (four seconds earlier than my example). Everything in my movements is following the music as I count, but this counting could be seen as my entrainment to a higher level of musical organization, attempting to find regularity on the level of four-count sequences (or two-measure units). In Hellmuth Margulis' words, I am attempting to broaden my temporal horizon. But one could also say that I have not yet reached that level of entrainment: in my counting, every appearance of a new yellow beam becomes an anticipatory signal for the fifth beam, which will confirm or deny the beams as a four-count sequence. But what is important here is that because of my entrainment to the beat, the appearance of *something* at counts

one through four does not signify anything anymore. In other words, the temporality of 'a-one' through 'a-five' does not matter in my entrainment. This makes at least 'a-one' through 'a-four' musical *symbols* rather than signals. Only 'five' could be considered a musical signal, since it calls for action at a particular point in time.

So to summarize, the sequence 'a-one' through 'a-four' structures the temporal affordance of anticipating 'five' in the unit 'a-five.' In Edmund Husserl's (1991) terms, the experience of this 'expanded present' *protends* the signalling beat and *retends* the periodicity of the beats leading up to it. But while this might suggest that the absence of the light beam is a signal against a musical background, we actively employ beats in order to synchronize the timing of our actions to a signalling beat. We hear them as leading up to that beat, their tempo indicating the distance of the beat in time. More than just hearing these beats in such a way, we *use* them, actively. In the case of *New Super Mario Bros.* we use the 'leading up to' moment to perhaps move Mario into a more advantageous position to attack the Goombas; in the case of *Beat Sneak Bandit*, we lift our finger (saying 'a' to ourselves) to tap down on the screen at the right moment counting 'five,' leaning into the movement from the upbeat to the downbeat. We could say that actively playing along to the beat in these cases is a kind of ludic listening, a kind of playing along to the soundtrack. But in this case, it is a very rigidly structured kind of play, one that is teleologically directed towards a certain moment, only for the music to sink back into our perceptual background again. Still, there is a kind of semiotic hearing present in these cases. This involves the recognition of the music as a tool for overcoming the obstacles. But as I said, this does not necessarily happen at any one moment, and for this reason, we can consider entrained anticipation as hearing a series of musical symbols, followed by a musical signal that is no less arbitrary or transitory than the signs I discussed before.

This still leaves the question of unentrained anticipation: expecting a musical signal 'any moment now' and not on a regular beat. As I mentioned, as regards 'signal listening,' Collins refers to David Huron's psychological account of anticipation. *Sweet Anticipation* outlines his 'ITPRA model' (2006, 15), standing for the five different biological emotion response systems (imagination, tension, prediction, reaction, and appraisal) that are involved in any kind of encounter with an event. Huron is mainly interested in evolutionary theories of expectation and surprise in music, and this model should

therefore not be seen as a phenomenological description of what it is like to be surprised or to anticipate something, but rather as an explanation of *how* we have come to feel in these ways.[11] That said, Huron does extensively remark on the duration of anticipation, and its general relationship to time. The different response systems, for instance, are activated at different temporal distances to the event: the imagination response, for instance, involves imagining a future event and feeling 'vicarious pleasure (or displeasure)— as though that outcome already happened' (Huron 2006, 8); the tension response, on the other hand, concerns the second or two leading up to an event during which there is an increase in arousal, in order to be better prepared for the outcome. More concretely in the case of music, Huron mentions that listeners are more accurate in predicting periodically occurring events if they happen at certain speeds (2006, 175–76). But these are cases of entrainment, or tapping along to a beat, most successfully predicted between 80 and 100 beats per minute; they do not describe expectation of irregular, distant events. As Huron's distinction between the different kinds of anticipation indicates, there is at least a biological difference between the kinds of expectations involved in these.

And there is a difference in experience as well. Take for instance my example of the Witch's music in *Left 4 Dead* from Section 2. The first state, indicating her presence (0'03" in **Video 4.2** ▶), is usually an unanticipated signal, as she can appear at any point in a stage. This situation then becomes an anticipatory signal for the next state, in which I might startle her (0'10"), which in turn becomes an anticipatory signal for the final state, in which she charges me (0'15"). This can happen at any moment, which means I can in no way entrain to the revolving, triplet-heavy melody of (a). In the case of the Witch's situation, of course, I am trying to avoid startling her at all costs, since that will lead to my death, as shown in the recording. Consequently, there is a sense of fear and being alarmed that accompanies the anticipatory signal (a), which is resolved as soon as I hear the anticipated signal (b). While there is no information about the onset of (b) in the music of (a), the state of fear that (a) put me in has me anxiously searching the auditory environment for (b)— 'searching,' as Don Ihde would say, 'the futural "edge" of the temporal span' (2007, 93). After all, when startling the Witch at 0'10" in **Video 4.2**, the music was the first sign of this event. This gives any change or directionality in (a), such as the half-step modulation or the off-beat accents in the piano clusters, a significance that (a) would not have without its signifying role, what is best

described as an 'eerie quality.' It is an open question whether this is truly part of semiotic hearing. I can describe this significance as a kind of ludic invitation as well: 'lean into these rhythms and patterns and you might learn when (b) will occur.' The difference is that whereas there can be a quality of anticipation in semiotic hearing, even in the absence of entrainment, semiotic listening involves ignoring such qualities. It is focused purely on the signals that help one to progress through the game.

Broken and Unestablished Signs

Having dealt with the question of anticipation, I want to consider two processes via which we can come to hear music as a signal, or as a sign in general for that matter. First, we can conclude that something is a signal for something else from experience. The repeated coincidence of a musical transition with the appearance of enemies, for instance, can clue us into the fact that the music signals danger. In this case, a musical signal is *established*. These ways of establishing proceed along Peirce's classic semiotic categories: coincidence as indexical, resemblance as iconic (the Tank's combative attitude resembles the martial qualities of the Tank cue in *Left 4 Dead*), and experience as symbolic (we recognize the sounds of a lounge piano as indicating an expensive cocktail bar, because we have heard it before in other bars and films). But, secondly, a signal can also be heard as such because it *announces* itself as a signal. A loud, unexpected sound can startle us, suggesting that something is going on that demands our attention. While this is of course dependent on the relative noise level of the auditory environment—just as a visual sign depends on its relative difference from a background to stand out—there is something universal about the signalling qualities of a sudden, loud noise: think of fire alarms, sforzandi, and stinger chords in films.

We can also consider these signal-like qualities that allow musical signs to establish themselves in terms of the gestaltist figure-ground relationship that I discussed in Chapter 1. A sonic figure has some sort of difference from a ground that allows it to be distinguished as a figure, for instance in terms of timbre, pitch, harmony, or volume (ignoring for a moment directionality, which would be lacking in most cases of nondiegetic game music). A good example of this is one of the primary game mechanics in *Immortality* (2022). In this game, the player is asked to scrub through live-action footage of three fictional unreleased films starring the missing actress Marissa Marcel in

order to find clues to her whereabouts. As the footage mostly consists of raw takes of different scenes, there is no in-fiction film score yet present. Instead, the player encounters musical cues that appear intermittently, overlapping both the menus with the film clips and the clips themselves when the player accesses these. In other words, these cues fit into the background of the game itself, not the fictional films that it features. At times, a low, rumbling drone can be heard in addition to these cues (0′42″ in **Video 4.5** ▶). Like many drones in cinematic music, particularly horror, it timbrally occupies a territory somewhere between sound and music. This makes it stand out all the more from *Immortality*'s cues, which rely on a full symphonic twentieth-century Hollywood-style orchestra, with exclusively recognizable acoustic instruments. But it also does not quite fit with the rest of the music rhythmically. The generally upbeat cues have a strong sense of pulse, and the drone does not seem to come in on particularly strong beats or starts of phrases. By virtue of these parameters, the drone can become a signal for the player to stop the clip and start exploring for possible signifieds. This 'exploring' means scrubbing back and forth through the clip to ascertain to what extent the drone is a kind of gameplay symbol, which in turn triggers a crossfade to an entirely different, hidden clip (0′51″). It is this revelation that propels the game's story forwards.

Immortality is a game that at its core functions like a puzzle to be solved, and the drones function much like the melodies in Tranquillity Lane in *Fallout 3*. And like all puzzles, they only hold their ludic value for a new player: once solved, they are of no interest. But let us consider the establishment of musical signals with regards to the experienced player as well. As I have argued, a musical signal such as the Witch's cue in *Left 4 Dead* alarms the novice player, just as a loud fire alarm startles the new office worker. As the player becomes more experienced at playing the game, the eerie qualities of the cue become irrelevant—they are no longer disturbed. In a similar manner, the office worker can become accustomed to a weekly 9.30 a.m. fire drill. But at the same time, an unscheduled fire alarm is still startling, and even a planned fire drill can still give one a slight jolt. There are physical reasons for this. Huron suggests that an auditory stimulus triggers two independent neurophysiological pathways: 'one pathway represents a "quick and dirty" reaction, while the other pathway represents a slow and careful appraisal of the same stimulus' (2006, 226). Huron's assertion is that the quick reaction is never quite suppressed by the slow appraisal, allowing us to be startled even by signals we are familiar with.

I want to illustrate this with the following example from the game *Diablo III* (2012). It, like its predecessor in 1997, is a so-called Action RPG (Role-Playing Game), a streamlined version of classic RPGs. The long, narrative-driven gameplay of those RPGs—in which the player explores worlds, encounters both friends and foes, and develops their character through mechanics and story interactions—has been abandoned in favour of pure mechanical character development ('levelling up' and collecting better equipment or 'loot') and fast-paced combat. And like its predecessor, it has 'highly polished gameplay, attractive audiovisuals, and a highly intuitive interface . . . [and is] easy enough for even total novices to learn, but certainly challenging enough to keep from getting boring' (Loguidice and Barton 2009, 48). In fact, it has all the aspects of what Juul (2010) would call a casual game, save for its 'fiction': an epic dark fantasy tale that has the player combatting the lords of hell, Diablo, Azmodan, and Belial, and slashing their way through thousands of their demonic minions. But even though this makes for an extremely bloody and gruesome ordeal, the game's exaggeration of these aspects means the emphasis is on spectacle rather than realism or horror, and to commit to the game's literally endless gameplay progression of collecting better loot to be able to defeat tougher demons that leave behind even better loot (etc.) is to relegate those story elements to the background of one's experience. What counts as a signal in such an experience? And more specifically, what counts as a musical signal?

Summers has noted the 'state-based approach' (2012, 294) of the original *Diablo*'s soundtrack: musical cues are attached to and characterize areas in the game world, not events and characters in the game's plot. One can imagine that this makes for a soundtrack that is easily exclusively heard as background music. *Diablo III*, however, takes a more story-centred approach than its predecessor, which has garnered some criticism, not so much for its incongruency with the action- and progression-driven gameplay, but rather for its clichés and tendency to be irrelevant to the satisfaction the gameplay provides.[12] The music's dynamic transitions, accordingly, are not just tied to areas anymore, but accompany story events too, both cutscenes and in-gameplay occurrences.

My particular experience of a musical signal involved one such 'irrelevant' musical story element. Clearing the Gardens of Hope in the last act of the game of demons—labelled 'trash mobs' by experienced players for the lack of danger they pose or reward they provide[13]—for what felt like it must have

been the hundredth time, I heard that familiar part of the musical soundtrack again: two inappropriately 'epic'-sounding *tutti* chords that musically trail off with two-note motifs into my perceptual background (0'24" in **Video 4.6** ▶; the two-note motifs occur in the lower brass and strings from 0'36" to the end of the recording).[14] I never took them to mean or indicate anything in particular, but they sounded portentous. In that sense there was the kind of friction between the music and the situation that occurs in aesthetic hearing, but unlike in aesthetic hearing, which invites an interpretative kind of aesthetic listening (see Chapter 2), I concluded that the two chords were merely undirected signals: they sounded like signals, and that is all that they meant to me; they stood out in my perceptual environment in a signal-like manner. Just like the bright yellow-golden glow of gold and the blue glow of magic items shining through the splashes of blood and demon innards signalling the possibility of improving my character (more specifically, signalling something to click on), the chords 'shone' through the screams and explosions, my companion's repetitive outcries, and the otherwise unobtrusive music—but in this case, they did not tell me to *do* anything.

It was only when I decided to record the event as a case study that I realized the chords were part of a dynamic transition that occurs when the player's character crosses a bridge in the Gardens of Hope.[15] Their narrative function becomes apparent on this closer kind of inspection: the narrow bridge provides a larger space on the screen for the backdrop of the High Heavens, where demons and angels are fighting out battles on the distant lower spires and bridges. In their narrative effect, these chords are a kind of musical 'zooming out,' alluding to the broader struggle taking place around the player through the almost monumental instrumentation and open qualities of the half cadence (D-flat minor to E-flat major, iv-V, in the key of A-flat minor).[16] These narrative functions, however, went unnoticed in my apathetic, engrossed slaughtering of enemies for better loot. At the same time, the chords did *sound* like a signal.

What are we to make of this way of hearing? Is 'sounding like a signal' brought forth by semiotic hearing, or is it another kind of hearing altogether? I want to propose that in Heideggerean terms, my becoming aware of the chords is like the breaking down of equipment that makes it 'un-ready-to-hand' (1962, 103). The un-ready-to-hand has certain properties of what Heidegger calls the 'present-at-hand'—it too casts something as a 'thing in itself'—but it is not just an unfamiliar thing that we encounter somewhere

and feel the need to explain in some way: we are aware of it in terms of what it *should* be doing. This conception works fine for Heidegger's archetypal example of the hammer as equipment (1962, 98): when we are working effectively with a hammer, its presence withdraws from our attention, it is ready-to-hand. But a sign is a special kind of equipment that we *do* pay attention to when we use it, when it works effectively (1962, 107–8). So it is not enough to just say that a 'broken sign,' such as the chords in *Diablo III*, becomes conspicuous through its un-readiness-to-hand: it has to be a different kind of conspicuousness than a normal sign. This is what I meant by a signal announcing itself as a sign: a normal, 'working' signal announces its referent; a broken signal only announces that it is a signal. But how do we know something is a broken sign if we did not know how to 'use' it, did not recognize it as equipment, in the first place? There is no real difference between a broken sign and a newly encountered sign that has not yet established its referent: both are heard as referring to *something*, but we do not (yet) know what.

The aspects through which an unfamiliar or a 'broken' sign announces itself are its affective qualities: *Diablo III*'s chords do not merely portent, but they *sound* portentous (much like anticipating signals reveals their affective qualities). Having our attention drawn to a sound's affective qualities is different from 'being affected by' a sound. Going back to Huron's terminology, we are always affected by sounds through their activation of our brains' 'fast-track' response, whether we are aware of it or not. But we become aware of those affects—in other words, these affects become phenomena—in broken or unestablished signs. The primary affect through which an unestablished or broken signal announces itself is surprise or shock. A signal that surprises or startles does not need to be established through a conscious act of identification of the sounds as a sign, but it already sounds like a signal upon first hearing. Sara Ahmed (2006, 2) argues that affects are not only directed towards objects, but they also orient us in a certain way vis-à-vis that object. Fear, for instance, turns us away from an object, or attempts to, as is the case in the Witch's music in *Left 4 Dead*. Shock, or surprise, in this instance, turns us away from the signal, but towards its referent.

Ahmed's conception of the phenomenology of affects is quite similar to Husserl's term 'affections.' Victor Biceaga warns us that 'Husserl's use of the notion of "affection" is idiosyncratic' (2010, 31n) not referring to feelings,

desires, or emotions (he uses the term *Gemüt* for these), but to a sense in which we feel drawn to something. In Husserl's own words:

> By affection we understand the allure given to consciousness, the peculiar pull that an object given to consciousness exercises on the ego; it is a pull that is relaxed when the ego turns toward it attentively, and progresses from here, striving toward self-giving intuition, disclosing more and more of the self of the object, thus, striving toward an acquisition of knowledge, toward a more precise view of the object. (2001a, 196)

In the case of broken signs or signals, the 'object' is the referent. We can strive to 'repair' the signal by turning towards it, releasing its affective tension while assimilating it into our equipmental dealings with the game. (Here we also see a difference between affections and affordances. Going back to my discussion of Dreyfus and Kelly's discussion of affordances in Chapter 1, they understand affordances more as affections, of a pull that one senses and that is relaxed once the affordance has been 'grasped.')

In my gameplay experience of *Diablo III*, however, I chose not to act on this broken signal, not to 'repair it' by tracing its referent as I did when I recorded the videos of my playing. In semiotic terms, my hearing the portentous chords in *Diablo III* is a case of two separate semiotic systems clashing: the music-signified story elements, or narrative events in the game world, whereas I was operating in the narrow search-for-more-loot system, predominated by the blue glows of magic weapons and the jingling of gold pieces. We can call this a case of musical 'ludonarrative dissonance,' a term coined by Clint Hocking (2007) that has found popularity in both academic and popular discourse on video games.[17] Hocking speaks of games in terms of what goals or 'contracts' they offer the player: a ludic contract could be something like 'seek power and you will progress,' which can be contradicted by a moral of a game's story along the lines of 'power corrupts.' In the case of *Diablo III*, the music does not evince a particular moral contract, but it does gesture towards a story that the experienced, loot-collecting player has very little investment in. Phenomenologically, our awareness of the chords is a manner of semiotic hearing, albeit an incomplete one: we hear the signs as unready-to-hand, but as signs nonetheless. This also means that the chords lose their arbitrary and transitory nature as signs. Rather, their affective qualities, portentousness in this case, become conspicuous.

Conclusions

In this final chapter I have outlined a phenomenology of semiotic hearing in video games. Hearing a musical sign is different from aesthetic or ludic attention in that we are not interested in the outward features of that sign, unless those features provide clues as to what the sign denotes. This actually aligns semiotic hearing much more with background music, a relationship I alluded to in my discussion of broken signals. We hear signs first of all in terms of their function, as equipment, much like we hear background music. But directly opposed to background music, signs 'work' *because* we notice them. Heidegger describes the relationship of signs to equipment as follows:

> The sign itself gets its conspicuousness from the inconspicuousness of the equipmental totality, which is ready-to-hand and 'obvious' in its everydayness. The knot which one ties in a handkerchief . . . as a sign to mark something is an example of this. What such a sign is to indicate is always something with which one has to concern oneself in one's everyday circumspection. (1962, 112)

As I argued in Chapter 1, the 'equipmental totality' is essentially the affordance structure of a video game. But it also extends beyond that affordance structure: signs in games first establish themselves by virtue of the equipmental totality in which they are embedded outside the game, what comes down to Juul's 'fiction.' This is part of van Elferen's ludo-musical 'literacy' that players develop. But even further than that, signs also get their semiotic functions from the way we 'concern ourselves' in a game: through the projects that we engage in in order to achieve its goals and overcome its challenges.

There are different ways in which we encounter musical signs in games. The main categories I introduced here were symbols and signals, distinguished along the lines of what kind of attention they demand from us. Musical symbols ask to be deciphered if they are not immediately understood, but they do not require our immediate attention. Signals on the other hand are immediate warning signs, commanding us to act in a certain way upon hearing them. In video game music we normally tend to hear signals in dynamic musical transitions, such as my examples from *Left 4 Dead*, and

even the chords in *Diablo III* that belonged to a dynamic transition although I did not understand them as such. Symbols on the other hand, because of our freedom to interpret them whenever we want, can be heard at any point in a musical cue, as was the case for *Civilization V*.

The various case studies in this chapter have also suggested that semiotic hearing is not unique to video games, even though it seems to be particularly suited to the medium. We hear signs in music in everyday life, in the concert hall, and on the television. To conclude, I want to stress once more the difference between hearing and listening. Semiotic listening, or listening *for* signs, is different from hearing a sign in something. Particularly with this kind of listening, to which there is an actual subdiscipline of musicology devoted (i.e. musical semiotics), it is easy to confuse the encountering of signs in a non-semiotic attitude with the semiotic attitude that takes everything to be a sign. The gamer does not generally adopt a semiotic attitude, nor does the concert goer, or the television audience. Iain Hart puts this perfectly in his overview of the semiotics of video game music: 'Semiotics is rather like mathematics: it describes the world rather well, and while you can live most of your life without it, it can give you a different, different, clearer, more precise, and rather exciting perspective on the things that you see every day' (2020, 237). In Husserl's terminology, doing semiotics is stepping out of the natural attitude that a phenomenology of signs tries to capture. This is why I suggested that those phenomena that semioticians take to be signs, but that might affect listeners 'subconsciously,' are better classified as affordances. Semiotic hearing, for all its tendencies to ignore the salient aspects of a sign (i.e. the 'signifier'), has to attend to that sign nonetheless—semiotic hearing does not involve 'unheard melodies' or subliminal messages as background hearing does.

In the distinction between hearing and listening we can also find a difference between semiotic and aesthetic hearing: as I suggested, aesthetic hearing inevitably leads to an aesthetic kind of listening. Semiotic hearing and semiotic listening on the other hand are not related in the same way: when we hear a sign we do not look for other signs, *unless* we are trying to decipher that sign. This means that the experienced *Left 4 Dead* player can hear signs, but does not necessarily listen for signs. But there are exceptions. The musical puzzle in *Fallout 3* involves hearing a musical symbol and looking for other symbols in the environment: semiotic hearing that leads to semiotic

listening to 'complete' the act of hearing. *Diablo III* was another case of semiotic hearing, but there I was not sufficiently committed to the project of which the chords on the bridge were a part for it to lead to a listening for other signs—this only happened when I recorded my playing and noticed the indexical relationship of the chords to the bridge.

Conclusion

Having illustrated and developed the four ways of hearing video game music in the preceding chapters with a variety of case studies, I now want to come back to my very first example, the beginning of *Hades*. How was I hearing the music in the opening sequence in the two gameplay recordings ▶? One moment where I could have heard something semiotic was in the dynamic transition that occurred in the first recording, after clearing the second room of enemies when the consistent beat of the ostinato dropped out and the drone on G remained (1′34″ in **Video I.1**)—a signal that I had reached a moment of respite, with the shield icon of Athena beckoning non-threateningly. Or I could have heard the resolution of the D drone to G and the entrance of the ostinato as a signal that the game had begun (0′27″). But in truth, these musical developments were buried under a host of other signs, both visual and auditory, with the music providing no additional information that I was looking for. I could alternatively have played along to the musical structure of the ostinato pattern when its percussive beat entered after the rising fourth, much like the spring-to-summer transition in *Proteus* (see Chapter 3). But there was nothing ludically significant in the music in relation to my actions. The syncopated percussion rhythms were no force for me to 'lean into.' I could also have noticed the friction between the driving ostinato and the sober, slight movements of Tartarus' denizens as I explored the room more in the second recording. The fragmented melodic lines of the bouzouki expressed both the aimlessness of their afterlife existence and my own uncertainty of what to do in the room. But in reality, I heard the music in none of these ways. Instead, the music was no more than a background to my traversing the initial stages of the game for the umpteenth time. It is important to note that the music *could* have been significant in all these ways: nothing poietic in *Hades*—not the place of the musical cue in the sound mix, its instrumentation, harmonies, or melodies, nor the rules and goals of the game and the stringency with which they are enforced, not even the ever-present snarky comments from Zagreus—determined that the opening ostinato had to be heard as background music. Rather, the ways in which we hear music in

Four Ways of Hearing Video Game Music. Michiel Kamp, Oxford University Press. © Oxford University Press 2024.
DOI: 10.1093/oso/9780197651216.003.0006

games depend on our individual relationship to them: our experience with games, our level of musicianship, our moods, our place in the world.

Hearing Video Game Music in Context

There are a number of reasons why this book has centred on highlighting the multitude of ways in which we engage with music in video games. For instance, video games are a unique audiovisual medium that offers rule-bound and goal-oriented interactions. By virtue of this, games can represent real-world systems, can have branching and nonlinear storylines, or can present virtual worlds that allow players to live through and experience their own stories—or, of course, present no narrative at all, but instead a series of abstract challenges and puzzles that must be overcome with quick movements or reasoning. This makes games particularly conducive to a variety of musical engagements. At the same time, video games' unique modes of representation relate these engagements to the different ways in which we experience music in other parts of life. As discussed in Chapter 1, music can retreat to our attentional background in a game and still affect our understanding of the game, affording ways to experience the diegetic environment or the flow or structure of gameplay, as in *StarCraft*. A video game's background music can be tailored very closely to a game's narrative structure through dynamic transitions and looping—the ostinato dropping away for a moment of respite in *Hades* is a good example of this. But is this really so different from the music that is tailored to the late-night shopper, to recall Robert Fink's (2005) example, or that we tailor to ourselves through headphones as we work or travel? Background music both in games and elsewhere requires us to be so attuned to it that it offers no experiential friction in need of interpreting, and through this it has the capacity to attune us to our environment, be it a mythical underworld full of dangers or a convenience store full of groceries.

Similarly, in games we hear music aesthetically—as something in need of interpretation or reflecting upon—in ways that closely resemble non-game situations: on a walk mediated by the pop songs coming through our headphones, or in a moment of nostalgia on the radio, for instance. While in a game such as *Skyrim* or *Death Stranding* we might hear the voice of an author (the game's developers, or sometimes just the game director or composer, for better or for worse) behind the aesthetic moments the music helps construct, the serendipitous nature of the encounter and its nondynamic

music mean these experiences are very similar to such real-life situations. And just as we might hear music aesthetically in these instances, so we might hear it ludically as well, finding ourselves moving along to it, synchronizing our footsteps, or being invited to sing along to a well-known song—what, in a video game, we would call *playing along*. Whereas climbing up a hill to get our bearings in *Skyrim* might frame an aesthetic moment involving the music and the distant mountaintops, sliding down a sand dune in *Journey* offers a ludic experience in itself, bringing to attention one's own movements (as experienced through one's avatar) and their relationship to the playful flute and cello ornamentations. Playing along to music in a game and reflecting on it are closely related: both experiences offer a kind of significance that lifts music out of its background everydayness. However, they differ in what the music 'asks' us to do with it: aesthetic music wants to be understood and gives the game a meaningfulness in our lives and life-world; ludic music wants to be played along with, offering a moment of extension or transgression beyond our life-world.

Finally, we interpret musical signs in terms of a particular project that they might be pertinent to. In a video game, this project (progressing through the game) is often clearly related to the music: we can attend to the music to encounter symbols that help us along the way, or signals that warn us of the presence of monsters or of our imminent deaths. But we can also engage semiotically with music in the concert hall, hearing symbols of musical tone painting, or on the TV, hearing the end of the commercials in a short 'bumper' cue. All these ways of hearing might be exemplified by video games, brought out by the various ways in which we are invited to play and interact with them, but they are by no means unique to games. In order to update existing phenomenologies of music, then, we must consider the multiple ways of engaging with the same music in different contexts.

Another reason why I chose to describe in detail the different ways in which we hear video game music is to further existing game scholarship through a new, aesthesic perspective. Although I have used detailed case studies, I have deliberately avoided (as much as possible) taxonomies in terms of video game genres or narrative themes. I have also avoided discussing one particular theme or aspect of game music. The result is not so much a discussion of what makes video game music and our engagement with it unique, but of how it intersects with and exemplifies the ways in which any music may be heard. Video games offer not only musical play, but also musical beauty, musical signs, and musical backgrounds. This opens up new

opportunities for existing approaches to the field. Ethnographic research, for instance, can consider the multitude of relationships among individual players, gaming groups, and gaming cultures, and music. Kiri Miller's (2012) research on music games such as the *Guitar Hero* series and radio stations in *Grand Theft Auto* describes ludic ways of hearing. But one can also consider the role of music as a background in gaming, something I touched on in my discussion of *StarCraft II*. Empirical research could reveal aspects that lie beyond the scope of my phenomenological approach, such as the differences between North American and Japanese gaming cultures and their relationship to ways of hearing, such as Jordan Stokes' (2021) work on the *mono no aware* aesthetic in the soundtrack to *The Legend of Zelda: Breath of the Wild* (2017). My differentiation between ways of hearing also poses challenges for hermeneutic approaches to video game music: as I argued in my discussion of aesthetic music (see Chapter 2), interpretation is just one way of understanding or hearing a game's musical soundtrack. Finally, one could develop this phenomenology of hearing the same pieces of music in multiple ways, either by comparing our engagement with music in video games to music in other parts of life, as I have attempted at various points in my analysis, or by considering the possibility of additional ways of hearing beyond the four outlined here. In the next section, I will briefly discuss a few candidates, before concluding with a few remarks on the hermeneutic nature of my approach in the last section.

Other Ways of Hearing

Initially, I distinguished the four ways of hearing through the ways in which they are significant to the player, at the same time distinguishing hearing from listening. Aesthetic and ludic music have a significance that is 'dealt with' by the player in opposite ways. Ludic hearing involves hearing oneself play along to the music, while ludic listening involves acting out these movements. Aesthetic hearing on the other hand is arresting, while aesthetic listening is the kind of reflection that leads away from the gameplay situation to a broader hermeneutic context. By contrast, if semiotic music has significance, it is only an extrinsic kind of significance: hearing a sign, the player is immediately directed away from the music they attend to, either to another sign, or to perform a certain action. In other words, semiotic music

attributes significance to its signified. Finally, background music has no such informative function, so that if the player were to turn their attention to it while playing, they would hear nothing of relevance in the music beyond the fact that it matches the situation they find themselves in. But there are a number of other, special cases of musical phenomena that warrant discussion in terms of significance. While I am certainly not excluding the possibility of others, the three I will discuss here are hearing bad music, hearing an 'author,' and hearing voice—cases whose particular phenomenology I have largely ignored in this book.

I have mentioned the concept of bad music in two separate contexts. It first came up in my references to Thomas Clifton's idea that when music works correctly, it always draws one in, whereas '[b]ad music is an expression which really means that the world of music is largely ineffective in its attempt to emerge from its earthly sound source' (1983, 283). This earthly sound source is the world of noise: 'an involuntary proximity of sounds ... felt as closing in—a condition we wish to be free of by fleeing from it, putting it at a distance. This can be done literally or figuratively; even ignoring a sound event is fleeing from it, in a sense' (1983, 279). Although this might seem very similar to my account of fear and tension created by scary video game music (see Chapter 4), it is different in one key way. As exemplified by the Witch's music in *Left 4 Dead*, we *need* scary music: we want to turn away and flee from it, but, as we struggle to progress through the game, we cannot. By contrast, bad music in video games not only asks us to ignore it, but also *allows* us to ignore it in our gaming pursuits. At the same time, hearing bad music is not at all like hearing background music. Following Clifton's account of 'fleeing from' bad music, we do not 'ignore' background music at all, since this would require a moment of significance in which the music is heard as noise, after which one makes a conscious effort to turn away from it.

My second reference to bad music was the example I gave in Chapter 4, when discussing broken signals in *Diablo III*. Many more examples can be found in Sander Huiberts' PhD dissertation (2010). Of course, I did not really hear the music as noise. I heard the signal first as a conspicuous set of stinger-like chords. While I could find no purpose for their conspicuousness, I immediately heard a purpose in their stinger-like quality—their 'equipmental' nature in Heideggerean terms—through its reference to a century of film and other audiovisual music. This makes it a different kind of 'bad music' from either the responses Clifton alludes to ('this is not real music, it is noise!')

or the responses that Andy Hamilton discusses ('this is not real music, it is Muzak!'). In my case, I heard it as bad *background* music, as it sounded conspicuous when it should not have, given the gameplay context. The fact that these examples are heard as 'bad music' raises the question of whether it is possible for a player to hear bad ludic or aesthetic music. Thinking back to my examples of *Tomb Raider*, *Death Stranding*, and *Assassin's Creed* in Chapter 2, I can perhaps feel that the music merely signified natural beauty, whereas I would have liked it to have the arresting qualities that beautiful scenes in nature have. As such, it was a moment of semiotic hearing instead of aesthetic hearing. Similarly, I can find myself wanting to play or move along to music in a game because the situation seems to call for it, but being unable to. Having to complete a song in *Guitar Hero* that I particularly dislike to get to play the songs that I appreciate more can seem like going through the motions, hitting the buttons as they come down the highway, rather than performing the music.

An issue similar to hearing bad music came up briefly in my discussion of hearing an author in *The Elder Scrolls V: Skyrim* in Chapter 2. For many, the game's music is now synonymous with the controversy surrounding its composer, Jeremy Soule, who was accused of sexual harassment and rape in 2019. As I suggested, this might make any kind of aesthetic hearing in *Skyrim* impossible altogether for many. Although to some extent we can think of this in terms of Clifton's idea of 'fleeing from' bad music, we could also say that the accusations for some make its soundtrack appear more as semiotic music, a tainted symbol for its composer that makes impossible other ways of hearing, certainly the serendipity of aesthetic music. At the same time, Joana Freitas' (2022) investigation of the reception of the accusations against Soule amongst the *Skyrim* modding community suggests that many expressed sympathy for the composer or were unwilling to believe the accusations altogether. In *Loving Music Till It Hurts* (2019), William Cheng addresses these issues in music more broadly. Suggesting that '[i]ntentionally or not, we sometimes mysticize music as a humanizing force' (2019, 15), Cheng considers that the cases of allegations against superstar conductors James Levine and Charles Dutoit were only really taken seriously when the #MeToo movement took off. For years, the ugliness of their transgressions had been downplayed because of the beauty of their musical performances: 'When the superhuman Levine is conducting, the audience has to hush; a maestro's hands command music and silence alike' (2019, 18). With these cases in mind, it seems as

though aesthetic hearing and listening are very much at fault for enabling the transgressions of the likes of Soule and Levine, a focus on musical aspects to the detriment of moral issues. But perhaps we can also find in the lingering qualities of aesthetic listening some room for moral contemplation in the right circumstances.

As a final example I want to consider the question of the voice. Don Ihde (2007) has argued that the voice has a particularly prominent place in our hearing and that given our nature as 'social animals' this is not biologically or psychologically unexpected. However, in my phenomenology of video game music I have barely mentioned vocals at all. There are a number of reasons for this. First of all, at least until the late 1990s technological limitations prevented sampled hi-fi audio from being used in video game music. Then there is the place of the song in film soundtracks, which has traditionally been very prominent in either musical numbers or 'montage scenes,' neither of which are common plot devices in video games, let alone part of gameplay sequences. There are important and much lauded exceptions, however: *Hades* has several moments in which an originally composed song comes to prominence in the soundtrack and narrative. Voice also stood out in 'The People are the Heroes Now' in my case study of *Civilization IV* in Chapter 2. One can also find pre-existing pop songs in musical karaoke games like *SingStar* (2004), but also in more narrative-driven games' diegeses, such as *Grand Theft Auto*'s radio stations (Miller 2012). It might be argued that the manner in which a game like *Hades* presents its songs mainly elicits aesthetic hearing, affording musical moments of rapt attention. Indeed, Jennifer Smith has argued that female vocals in games can be disruptive both 'to player gameplay and the aural game world' (2020, 94), creating a kind of significance through friction that is central to aesthetic music. But examples like *SingStar* and Kiri Miller's analysis of *GTA* suggest that vocal music can have a strong ludic character as well—what Collins (2013) calls 'singalong' listening. When we hear someone singing a familiar melody we are often drawn to singing along to it, even if we do not fully know the words (as my seven-year-old self could attest to, trying to sing along to a Beach Boys tape without being able to speak English). Hearing voice, we might speculate, has particular noematic qualities: voice has a strong tendency to dominate our soundscape and draw attention to itself, and to invite us to play along. But this does not mean that hearing voice or 'vocal hearing' is a separate noetic category: while vocal hearing has qualities that make it different from other

ways of hearing, we can still hear vocal music ludically, aesthetically, semiotically, or even possibly in the background (see my discussion of singing along to Leonard Cohen in Chapter 1).

A Final Word on Hermeneutics

My project has been a call to be more sensitive towards the multiplicity of ways in which we hear music, presenting playing video games as a particularly revealing case study. It has not been a guide or method for analysing video game music per se. In a way, I am in fact outflanking aesthesic approaches to audiovisual music analysis (such as Nicholas Cook's *Analysing Musical Multimedia*, 1998), or in video game music, say, the approaches of Tim Summers (2016b) or Iain Hart (2020) by relegating these to only one of four ways of engaging with video game music—aesthetic listening. I myself might be outflanked by someone who suggests that this categorization is part of an aesthetic project to highlight a particular set of engagements with games. In a way, they are right: calling attention to the plurality of musical hearing that games exemplify renders them more worthwhile as an object of hermeneutic attention. But this is only a consequence of my actual phenomenological project. By stepping back from the purely aesthetic dimensions of video game music and showing a multiplicity of ways of engaging with it, I hope to have not only drawn music hermeneuticists' attention to games, but also contextualized the practice of musical hermeneutics in general a little.

This brings me to one final phenomenologist, Hans-Georg Gadamer, who sees a distinction between play in art and play in games. Whereas we *play* games, we *see* (or hear) play going on in art—much like witnessing 'a play of light,' or 'a play on words' (2004, 104). More than that, play is art's primary 'mode of being' (2004, 102). But what then of witnessing play in music, obviously a form of art that we can 'play' ourselves? What of playing a video game in which we see and hear something artistic? This problem is encapsulated in the duality between ludic and aesthetic experience—two ways of engaging with both video games and music, but also potentially with the (art) world beyond them. According to Gadamer, in a game 'the structure of play absorbs the player into itself, and thus frees him from the burden of taking the initiative, which constitutes the actual strain of existence' (2004, 104). To some extent, this echoes the magic-circle argument I discussed in Chapter 3. When we play, the existential relevance of game music is revealed

in the ways in which we play: gleefully, theatrically, or cinematically hearing ourselves play along. But as I have shown, we do more than play games and their music: we inhabit them, we interpret them and reflect on them, we decipher them, and we are called to act on them. To say that any one of these ways of engaging is more essential than the other is to diminish the phenomenon of video game music.

Notes

Introduction

1. For a similar case study of *Bastion*, another title by Supergiant Games, see Kamp 2021a.
2. In van Elferen's ALI model (2016), narrative functions are shared by the affective and literacy dimensions, and ludic functions relate to the interactive dimension.
3. Husserl uses the concepts 'stimulus' (sense datum, in our case music) and 'sensation' (experience, in our case hearing): 'The fact that the stimulus endures still does not mean that the sensation is sensed as enduring; it means only that the sensation also endures. The duration of sensation and the sensation of duration are two very different things' (1991, 12). Schutz links these ideas to Bergson's concepts of durée in the case of music, although he prefers the terms 'inner' and 'outer time': 'The inner time, the durée, is the very form of existence of music. Of course, playing an instrument, listening to a record, reading a page of music—all these are events occurring in outer time, the time that can be measured by metronomes and clocks, that is, the time that the musician "counts" in order to assure the correct "tempo"' (1951, 89).
4. Paolo Palmieri reminds us that '[m]elody lasts for a while, but we quickly lose its identity if it lasts for too long. We do not have a capacity for appreciating really long melodies' (2014, 143). Beyond the horizon of our perceptual present, we 'recollect' rather than 'retend' the past. Moreover, hearing a melody is not necessarily one 'moment'—we can easily consider it in terms of multiple moments. I will elaborate on this character of musical moments in Chapter 2.

Chapter 1

1. Regarding acousmatic listening, see Chion 1994; Schaeffer 1966. Philip Tagg (2011, 17) estimates that Westerners hear roughly four hours of music a day in various situations and environments, the vast majority of which is acousmatic, or what he calls 'invisible' in the sense that we cannot see anyone make the sounds we hear.
2. Though often used as a generic term for background music—specifically bland and aesthetically bad music (see for instance the Pipedown movement, Frith 2002)—Muzak was the tradename of Planned Music Inc, which offered originally composed music services ('Stimulus Progressions') for business environments that were designed to optimize productivity. In the 1990s, Muzak started offering pre-existing music programs (often consisting of pop songs) tailored to specific retail outlets (Owen 2006; Lanza 2004).

3. For more on these levels of synchronization, see Donnelly 2021.
4. It has to be said that the game's balance has been a work in progress throughout the game's lifetime, which has spanned more than two decades, achieved by Blizzard's continued support through downloadable patches.
5. Roger Scruton draws upon the concept of musical *gestalts* as well and identifies musical backgrounds separately in different musical parameters: we hear a rhythm against metre as a background, but '[r]hythms are quickly wearisome, unless refreshed by a countervailing foreground which groups the tones against the metre' (1997, 37). Similarly, '[w]e distinguish the voices of an accompaniment from those of the melody, even when the accompanying voices are singing melodically, and make tunes of their own' (1997, 61).
6. For Kurt Koffka, one of the founders of *gestalt* psychology, phenomenology was an essential, but purely functional, part of his approach, going hand in hand with experimentation: 'A good description of a phenomenon may by itself rule out a number of theories and indicate definite features which a true theory must possess. We call this kind of observation "phenomenology" . . . [which] means as naïve and full a description of direct experience as possible' (1935, 73).
7. Something Mel Brooks spoofs in *Blazing Saddles* (1974) through a cameo of Count Basie and his orchestra in the middle of a desert.
8. Ltortoise, http://www.teamliquid.net/forum/viewmessage.php?topic_id=149094¤tpage=4 (accessed 31 January 2023).
9. Similarly, Ola Stockfelt (1997) argues that we should listen to background music in the context of the soundscapes that it occupies.
10. An empirical study (Karageorghis and Priest 2012) and a review thereof (Terry et al. 2012) come to the conclusion that rhythm response, particularly tempo and beat, takes precedence over other musical features in exercise situations.
11. Melanie Fritsch (2014) might consider these musical 'gameplay gestalts,' building on the ideas of Craig Lindley (2002).
12. What I call 'natural' in scare quotes is what Lawrence Kramer more properly considered the 'historical and cultural force of the imagetext, which does enjoy a semantic authority that music is denied, nor again to the deeply felt values, pro and con, that attach to that denial' (2002, 151).
13. Similarly, Kathryn Kalinak compares the music-image relation to 'adjectives and adverbs pin[ing] down the meaning of the nouns and verbs they are attached to' (2010, 18–19).
14. DeNora describes a similar way of hearing music while shopping:

> 'In the retail realm, where music is used to instigate modes of orienting to goods, actors also enter into musical moods and rhythms. In these examples, music is much more than a model, much more than an object upon which to reflect and from which to get ideas or take inspiration. Rather, music can be seen to place in the foreground of perception an ongoing, physical and material "way of happening" into which actors may slip, fall, acquiesce. This passing over into music, this musical mediation of action, is often observable, often known to self as a feeling or energy state' (2000, 160).

The 'placing in the foreground of perception' is like the world-disclosing nature of a mood. When DeNora mentions that this way of hearing is 'often known to self as a feeling or energy state,' however, I would argue that this is an example of ludic music, or a deliberate playing along with the role that we find the music invites us to 'slip' into (see Chapter 3).
15. Böhme calls atmospheres both 'thing-like' and 'subject-like' (2017a, 23).
16. Or, in William James' words, the world as 'one great blooming buzzing confusion' (2007, 488).
17. Compare Windsor and de Bézenac's (2012, 105) examples of intermodal variables with Ihde's (2007, 62–63) description of detecting object shapes through sounds.
18. Melissa Gregg and Gregory Seigworth argue that affect can 'suspend us (as if in neutral) across a barely registering accretion of force-relations and leave us overwhelmed by the world's apparent intractability' and suggest that affect is always present in our dealings with the world even if it does not seem 'especially forceful,' as is the case of perceived tension, ludic glee, or powerful aesthetic emotions such as nostalgia. What I am suggesting here is that affordances (and background music in general) should be considered as a form of the first kind of affects, 'all the miniscule or molecular events of the unnoticed' (2010, 1–2).
19. A parallel to this problem of the essential 'audibility' of music can be found in the discussion around Gorbman's idea of unheard melodies. The idea that film music works because it is 'unheard' or in the background is criticized by Jeff Smith (1996), who argues that Gorbman's suture theory does not account for all the times we can and *do* hear music in films. James Buhler defends Gorbman's suture theory by arguing that 'the figure of inaudibility points not to the fact that music is never consciously heard or attended to but only to the fact that it need not be consciously attended to in order to produce its distinctive effect of clarifying meaning' (2014, 404). Buhler's point is similar to the insignificance of background music and its nature as 'equipment' that I discuss in this section, but put in psychoanalytic terms.
20. http://www.teamliquid.net/forum/starcraft-2/149094-terran-music-is-op (accessed 31 January 2023), emphasis original.
21. If we think of examples from mythology and legend where people were affected by music to the point of performing involuntary actions, such as the tarantella and the Pied Piper of Hamlyn, we find that these are all third-person descriptions of other people who start behaving outside the norm. Ulysses' first-person description of his encounter with the Sirens is of a desire to stay and listen that goes unfulfilled. So we never actually get to hear 'what it is like' to be in a state where music affects us like a drug. If anything, Ulysses' account is reminiscent of a ludic invitation (see Chapter 3). Plus, of course, they *are* myths and legends.
22. Battler, http://www.teamliquid.net/forum/viewmessage.php?topic_id=149094¤tpage=11 (accessed 31 January 2023).
23. TheMarkovian and Jyvblamo respectively, http://www.teamliquid.net/forum/viewmessage.php?topic_id=149094¤tpage=2 (accessed 31 January 2023).

24. For instance: 'Hmm. So true. Terran music gets me pumped up much more than Z or P music' (systemA, http://www.teamliquid.net/forum/starcraft-2/149094-terran-music-is-op?page=14, accessed 31 January 2023);

 'Protoss music is very weak. 90% of the time there's almost no music at all, too ambient. Zerg music has more melodies, still more ambient, but it fits Zerg style, it's dark, insidious and weird. I like it. Terran music kicks ass, because it feels like TERRAN. Rock 'n' roll and big guns hell yeah!' (Bleak, http://www.teamliquid.net/forum/starcraft-2/149094-terran-music-is-op?page=19, accessed 31 January 2023).
25. For instance: 'Please don't refer to that Zerg pile of trash as "Music"; Just dark, ominous tones. I think that even I could compose something as bad as that' (Sicktor http://www.teamliquid.net/forum/starcraft-2/149094-terran-music-is-op?page=19, accessed 31 January 2023).
26. http://www.teamliquid.net/forum/starcraft-2/149094-terran-music-is-op?page=9 (accessed 31 January 2023).

Chapter 2

1. Eno argued that his ambient music 'has widely been misinterpreted by the press (in their infinite unsubtlety) as background music. I mean music that can be background or foreground or anywhere, which is rather a different idea' (quoted in Grant 1982). For more extended discussions of ambient music in video games, see Berndt 2019.
2. Another cue in which this mundaneness shines through is 'Mice on Venus.' The recordings of the various instruments have a particular 'living-room' quality to them that situates the listener anywhere but outdoors or in echo-rich caves. It is not just another expression of *Minecraft*'s DIY aesthetic, but a sharp contrast between the music and what it accompanies.
3. This is an example of the sublime rather than the beautiful, particularly what Kant would call the 'mathematical sublime' (2005, 64). In eighteenth- and nineteenth-century aesthetics, the sublime is frequently distinguished from the beautiful in terms of a mix of terror and awe (Edmund Burke) or a formlessness (Kant). For me, the sublime is a sub-category of aesthetic experience, similar to nostalgia.
4. An earlier edition of *The Phenomenology of Perception* translates Merleau-Ponty's 'la fuite dans l'autisme' more broadly to 'flight into a self-contained realm' (2005, 99).
5. This is essentially analogous to Husserl's distinction between the duration of a sensation and the sensation of a duration.
6. See also Jonathan Kramer's discussion of 'vertical music' (1988, 57)—music that invites hearing akin to looking at a piece of sculpture.
7. A Kantian reading of this aspect would probably employ the word purposiveness, but perhaps also the idea of free play of the senses: we take delight in our *own* free play, but in the case of art we acknowledge that this has been initiated by another person, and in the case of nature we acknowledge that nature has this power over us at all.
8. For a more extensive analysis of these musical cues in *Skyrim*, see Kamp and Sweeney 2019.

9. According to its creative director Patrice Désilets, AC1's 'free-running' traversal mechanics were inspired by the French sport parkour (Howson 2007).
10. Most viewpoint sequences are accompanied by an eagle, who is perched atop the ledge and circles around the top as the Assassin looks around. The eagle is symbolic for the Assassin, swooping down on its prey from high above.
11. For a detailed description of this dynamic transition in *AC3*, see Medina-Gray 2014, 121–26.
12. I would argue that this is one of those moments in AC where spatiotemporal semiosis and Warde-Brown's other category 'spatiotemporal engagement' converge.
13. In 2010, 'Baba Yetu,' composed by Christopher Tin, won the Grammy Award in the category Best Instrumental Arrangement Accompanying Vocalist(s). It was the first Grammy ever awarded to a video game soundtrack. For other academic discussions of the music of *Civilization IV*, see Chan 2007; Summers 2016b; K. Cook 2014.
14. For instance, Arabia receives bonuses on oil production in *Civilization V*, and 'Great Scientist' units like Isaac Newton can help speed up the discovery of new technologies.
15. When zooming in on different cities, the musical soundtrack actually changes to reflect the civilization whose city the player focuses on. There is however very little to be gained from a gameplay perspective by zooming in, which is why I argue that the game's default perspective allows for a continuous musical soundtrack.
16. In Gorbman's psychoanalytic terminology, music in a film can help connect disparate shots and scenes to one another by continuing in the background.
17. I am referring here to Richard Taruskin's (2005c, 352) discussion of minimalism's 'maximalist' tendencies.
18. Not just in the discourse surrounding Western art music, but in popular culture as well. Aaron Copland's score for *Of Mice and Men* (1939) could be described as a more cheerful- and consonant-sounding Stravinsky with its short staccato, angular motifs and heavy reliance on repetition, but it also sounds remarkably similar to Adams' musical idiom. Virgil Thomson described the score as 'the most distinguished populist music style yet created in America' (Pollack 2000, 343), and Richard Taruskin dubbed Copland's style 'prairie neonationalism' (2005b, 662–73).
19. My notion of friction leading to aesthetic reflection and interpretation is very similar to Lawrence Kramer's hermeneutic 'breaking points,' from which '[i]nterpretation takes flight' (1993, 12–13).
20. Adams says the following about the final movement of *Harmonielehre*, which corroborates the lack of drive or direction: 'There's an extended passage during which a tremendous harmonic struggle takes place with the different tonalities vying for dominance. Now, in a more traditionally worked-out tonal piece, there would be a modulatory sequence that would present the outcome in a rather dialectal way. But in this case, I simply place the keys together, as if in a mixer, and let them battle it out' (Steinberg 2006, 105). Similarly, Catherine Pellegrino (2002) mentions the lack of a sense of closure that many Adams pieces give, even though they may employ long, drawn-out climaxes and V-I cadences.

Chapter 3

1. Of course, running to music in *Super Mario Bros.* involves movement, whereas leaning into the storm results in a lack of movement, a kind of dynamic equilibrium. But it is the dynamism of the analogy that matters in this case.
2. This is echoed by Karen Collins, who argues that 'we move to the music, and the music moves us, which changes the way that we hear this music. If we extend this to all sound, then our movement influences the ways in which we hear and interpret that sound. Sitting still and listening are not perceptually the same experience as actively engaging in that sound' (2013, 63).
3. Heidegger does not make a sharp distinction between 'feelings' and 'affects' and 'states-of-mind' and 'moods' (1962, 178).
4. Don Ihde (2007, 221–22) argues that the intrusiveness of other noises while trying to listen to music indicates the fragility of music as a phenomenon. However, his example comes from a phenomenological agenda, and mine from a self-therapeutic agenda, i.e. reorganizing my personal 'soundscape.' On a more in-depth discussion of these kind of practices, see Bull 2007. Moreover, this 'intrusiveness' works the other way around as well, where music can intrude on someone's non-musical soundscape. The film *Punch Drunk Love* (2002) uses this phenomenon to great effect by having nondiegetic music intrude in the filmgoers' ears, to represent the anxiety of the main character, Barry.
5. See also Kate Galloway's (2019) discussion of 'soundwalking' in *Stardew Valley* (2016), or Elizabeth Hambleton's (2020) discussion of walking simulators such as *Leaving Lyndow* (2017). Both point to the significance of attending to and reflecting on these games' soundscapes.
6. Other lifelike sounds in the game are the wind and the rain, and the sounds of crickets to indicate night time.
7. Rockpapershotgun's Nathan Grayson mentions that '[b]asically, it's what I imagine nature lovers believe the outdoors to be' (2013b). But the game's colours and soundscape are much more saturated than *Skyrim*'s Friedrich-like panoramas and airy string sonorities, or even *Minecraft*'s minimalist surroundings and lo-fi music.
8. The IGN review asks 'Is [*Proteus*] a game? By some definitions, sure . . . Is it something else entirely? Maybe . . . But really, here's the short answer to both questions: who cares?' (Grayson 2013a). Gamespot suggests that 'you're left with the feeling that you've walked through an art installation rather than played a game' (Gamespot Staff 2013).
9. See Nicholas Cook's (1998) discussion of cross-domain or cross-sensory mapping in music-image relationships.
10. Rafael Núñez and Eve Sweetser (2006) discuss the exception of the Aymara language in which the future is considered as behind one and the future in front of one. This suggests that embodied metaphors are cultural constructs rather than physically determined.
11. What is also interesting here is that in non-recreational instances such as rituals and psychiatry there are few adverse reactions to hallucinogenics. The difference here

lies in the purposeful nature of these experiences, which provides comfort (Merkur 1998, 171).
12. One reviewer argues that 'it seems to have *no other purpose* than to act as a masturbatory aid. Its shape is pretty nice, it can slip easily under your skirt or in your panties, it comes with a protective "glove" which you can wash, and it emits a regular pulsating rhythm that gets ever more intense and thrilling the deeper you go into the game. Damn, by the end I was writhing on the floor! Synesthesia indeed' (Pinckard 2002).
13. For a graphical representation of affective 'intensities,' see Stern 2004, 15. John Rink (1999) similarly draws 'intensity curves' of musical performances.
14. Rothfarb mentions that the energeticists already made this distinction between motion and affect in the early twentieth century: 'if authors had long recognized the primacy of motion and tonal flux in music, they did not thematize motion to the same degree as did the energeticists, or isolate it from music's affects' (2002, p. 927).
15. Thanks to Floris Schuiling, John Morgan and William Gibbons, Krit Sitathani and James Barnaby, and Elizabeth Medina-Gray, respectively, for these examples.

Chapter 4

1. The game has various other cues that can be listened to for information. 'Skin on Our Teeth,' for example, is a cue that plays when a rescue vehicle has arrived. Its playing indicates that players have to rush towards the vehicle, lest they be overwhelmed by hordes of infected.
2. There is a third way of finding out the 'meaning' of the Witch's cue that *does* involve being affected by the music: we can introspectively note ourselves feeling unsettled or even scared—a form of ludic hearing—and take that as a sign of what is about to come.
3. It needs to be said, however, that in most survival horror games, the musical signs are doubled by visual elements in the interface and environment. This means the music could be switched off, and the player would receive the same information.
4. Following on that, Heidegger seems to make an implicit critical comment on semiotics as a methodology: 'We find it especially tempting nowadays to take [the formal relational character of phenomena] as a clue for subjecting every entity to a kind of "Interpretation" which always "fits" because at the bottom it says nothing, no more than the facile schema of content and form' (1962, 108). While he does not develop this criticism any further, it does stress the importance to distinguish a phenomenology of signs with a semiotics of phenomena: in a phenomenological framework, a semiotic approach distorts the idiosyncrasies of phenomena.
5. *Seinfeld*'s distinctive synthesized slap bass can be heard over the beginning of an episode, as well as at the beginning and end of an 'act,' and as bumpers during the commercial breaks. Ronald Rodman argues that the 'bumper tells the audience to stay tuned (to this network and view its revenue-producing advertisements' (2010, 56), acting in both the story space of the television episode and the flow space (R. Williams 1974) of an evening's television programming. More concretely, if I am changing

channels and come across the commercials during a *Seinfeld* episode, hearing the bumper music can signal me to keep watching.

6. Struggling to understand is another way of listening, one that anxiously searches out familiar musical phenomena: markers of structure such as a repeated phrase or a strong cadence, or recognizable elements such as a danceable rhythm or the sonic connotations of a tone painting. Whatever understanding it is I arrive at, the struggle is teleological: it presupposes an end.

7. Richard Taruskin illustrates this difference rather well when he argues that the 'conventionally embodied meanings' of *sinfonia caratteristica* like Beethoven's Sixth 'were always public meanings. No one needs to interpret the "Pastoral" Symphony, just as no one needed to explain to Prince Esterházy what Haydn was getting at with his "Farewell" Symphony' (2005a, 680–2). What Taruskin calls 'interpretation' I would argue is like aesthetic listening; 'conventionally embodied meanings' on the other hand are deciphered, if they are not instantly recognized. For Richard Wagner, tone-painting is similarly 'closed' to interpretation: 'So-called "Tone-Painting" has been the manifest last stage (Ausgang) of our absolute Instrumental-music's evolution; in it this art has sensibly chilled down its own expression, no longer addressing itself to the Feeling, but to the Phantasy' (1995, 332). 'The Feeling,' here, is the kind of aesthetic attention that I talk about; 'The Phantasy' is something akin to the Imagination in Kantian philosophy, the rational faculty that connects definite concepts to sense impressions.

8. This way of playing is quite normal for a game of *Civilization*, which can take over ten hours to complete.

9. One could say that these 'virtual taps' are the kind of 'epistemic actions' that David Kirsh and Paul Maglio (1994) identify in *Tetris* players. Van Elferen might add that this is one way in which 'music supradiegetically expands the gaming magic circle into the real-life surroundings of the player' (2011, 30).

10. This is similar to Roger Scruton's (1997) remarks about the difference between figures and motifs.

11. Giorgio Biancorosso (2008) notes the lack of references to music phenomenology in Huron's work, particularly Husserl, but this is no real surprise given the intent of the book to explain, rather than describe. Still, this does leave room for phenomenological insights to complement Huron's.

12. Gamespot: '*Diablo III*'s story is unremarkable, but it weaves in plenty of references to and appearances by characters from earlier games and enriches the established lore of the series' (Petit 2012); Gamefront: '*Diablo III* doesn't offer Blizzard's best storytelling. While there was a major surprise for me here and there, predictable plot elements and clichés pervade the story. Some lines of dialogue had me cringing—a first for a Blizzard title' (Miozzi 2012); IGN: 'Some people love *Diablo III* for its story, and the third's narrative is stronger than its predecessor, but still filled with clichés and predictable twists. But that doesn't really matter all that much, because the story merely serves as a way to tie together the various dungeons and quests in your hunt for gear . . . Even when the story failed to grab me, the loot system kept me hooked' (Gallegos 2012).

13. This is a term that is normally employed with regards to MMORPGs (Massive Multiplayer Online Role Playing Games), but has been adopted by *Diablo* players as well. See for instance the *Diablo* Wiki ('Trash Mobs' n.d.).
14. See **Videos 4.7** and **4.8** ▶ for two other video examples of my encounter with these chords. Note the randomization in the appearances of demons in contrast to the same appearance of the cue on the bridge in each recording.
15. This realization based on watching recorded gameplay of oneself can also be found in William Cheng's discussion of *Fallout 3* (Cheng 2014, 47). It also shows the importance of avoiding the over-the-shoulder way of interpreting video game music that Zach Whalen (2007) warned about, and that is a central theme of this book as well.
16. I have argued elsewhere (Kamp 2019, 133) that there are also connotations with 'horizon-broadening' through minor-to-major chord common-tone modulation in other works such as *The Matrix* (1999) and the finale of Beethoven's Ninth.
17. For a more in-depth discussion of the topic in relation to video game music, see Grasso 2020; Kamp 2019. The latter also contains a more elaborate discussion of this case study.

Bibliography

Aarseth, Espen. 1997. *Cybertext: Perspectives on Ergodic Literature*. Baltimore, MD: Johns Hopkins University Press.
Abbate, Carolyn. 2004. 'Music: Drastic or Gnostic?' *Critical Inquiry* 30 (3): 505–36.
Adams, John. 2008. *Hallelujah Junction: Composing an American Life*. London: Faber & Faber.
Adorno, Theodor W., and Hanns Eisler. 2005. *Composing for the Films*. London, New York: Continuum.
Ahmed, Sara. 2006. *Queer Phenomenology: Orientations, Objects, Others*. Durham, NC; London: Duke University Press.
Anderson, Paul Allen. 2015. 'Neo-Muzak and the Business of Mood.' *Critical Inquiry* 41 (4): 811–40.
Ashcraft, Brian. 2010. 'Why Is StarCraft So Popular in Korea?' *Kotaku* (blog). https://kotaku.com/why-is-starcraft-so-popular-in-korea-5595262.
Atkinson, Paul, and Farzad Parsayi. 2021. 'Video Games and Aesthetic Contemplation.' *Games and Culture* 16 (5): 519–37. https://doi.org/10.1177/1555412020914726.
Atkinson, Sean. 2022. 'That Tune Really Holds the Game Together: Thematic Families in Final Fantasy IX.' In *The Music of Nobuo Uematsu in the Final Fantasy Series*, edited by Richard Anatone, 130–51. Bristol: Intellect.
Austin, Michael. 2016. 'Introduction: Taking Note of Music Games.' In *Music Video Games: Performance; Politics; and Play*, edited by Michael Austin, 1–22. Approaches to Digital Game Studies. London: Bloomsbury.
Barthes, Roland, and Stephen Heath. 1977. 'Rhetoric of the Image.' In *Image Music Text*, 32–51. London: Fontana.
Berger, Karol. 2005. 'Musicology According to Don Giovanni, or: Should We Get Drastic?' *The Journal of Musicology* 22 (3): 490–501.
Berndt, Axel. 2019. 'Adaptive Game Scoring with Ambient Music.' In *Music Beyond Airports: Appraising Ambient Music*, edited by Monty Adkins and Simon Cummings, 197–226. Huddersfield: University of Huddersfield Press.
Biancorosso, Giorgio. 2008. 'Whose Phenomenology of Music? David Huron's Theory of Expectation.' *Music & Letters* 89 (3): 396–404.
Biceaga, Victor. 2010. *The Concept of Passivity in Husserl's Phenomenology*. Contributions to Phenomenology 60. Dordrecht: Springer.
Bicknell, Jeanette. 2009. *Why Music Moves Us*. New York: Palgrave Macmillan.
Bloom, Harold. 1973. *The Anxiety of Influence*. New York: Oxford University Press.
Bogost, Ian. 2007. *Persuasive Games: The Expressive Power of Videogames*. Cambridge, MA: MIT Press.
Bogost, Ian. 2011. *How to Do Things with Videogames*. Minneapolis: University of Minnesota Press.
Böhme, Gernot. 2017a. *Atmospheric Architectures: The Aesthetics of Felt Spaces*. Edited by A.-Chr. Engels-Schwarzpaul. London: Bloomsbury.

Böhme, Gernot. 2017b. 'On Synaesthesia.' In *The Aesthetics of Atmospheres*, edited by Jean-Paul Thibaud, 66–75. London, New York: Routledge.

Brame, Jason. 2011. 'Thematic Unity Across a Video Game Series.' *ACT*, no. 2. https://www.act.uni-bayreuth.de/de/archiv/2011-02/03_Brame_Thematic_Unity/index.html.

Bramwell, Tom. 2006. '"Non-Sexual" Rez Trance Vibrator Was My Idea—Mizuguchi.' *Eurogamer* (blog). 25 July. https://www.eurogamer.net/articles/news250706mizuguchi.

Brodsky, Warren. 2001. 'The Effects of Music Tempo on Simulated Driving Performance and Vehicular Control.' *Transportation Research Part F: Traffic Psychology and Behaviour* 4 (4): 219–41.

Buhler, James. 2014. 'Psychoanalysis, Apparatus Theory, and Subjectivity.' In *The Oxford Handbook of Film Music Studies*, edited by David Neumeyer, 383–417. Oxford, New York: Oxford University Press.

Bull, Michael. 2007. *Sound Moves: IPod Culture and Urban Experience*. International Library of Sociology. London: Routledge.

Caillois, Roger. 1961. *Man, Play, and Games*. Translated by Meyer Barash. New York: Free Press of Glencoe.

Carr, Diane. 2007. 'The Trouble with Civilization.' In *Videogame, Player, Text*, edited by Barry Atkins and Tanya Krzywinska, 222–36. Manchester: Manchester University Press.

Casey, Edward. 2000. *Remembering: A Phenomenological Study*. 2nd ed. Bloomington: Indiana University Press.

Certeau, Michel de. 1984. *The Practice of Everyday Life*. Translated by Steven Rendall. Berkeley, Los Angeles, London: University of California Press.

Chan, Norman. 2007. 'A Critical Analysis of Modern Day Video Game Audio.' Bachelor thesis, University of Nottingham.

Chanda, Mona Lisa, and Daniel J. Levitin. 2013. 'The Neurochemistry of Music.' *Trends in Cognitive Sciences* 17 (4): 179–93.

Cheng, William. 2013. 'Monstrous Noise: Silent Hill and the Aesthetic Economies of Fear.' In *The Oxford Handbook of Sound and Image in Digital Media*, edited by Carol Vernallis, Amy Herzog, and John Richardson, 173–90. New York: Oxford University Press.

Cheng, William. 2014. *Sound Play: Video Games and the Musical Imagination*. Oxford: Oxford University Press.

Cheng, William. 2019. *Loving Music Till It Hurts*. New York: Oxford University Press.

Chion, Michel. 1994. *Audio-Vision: Sound on Screen*. Translated by Claudia Gorbman. New York: Columbia University Press.

Clarke, Eric. 2005. *Ways of Listening: An Ecological Approach to the Perception of Musical Meaning*. Oxford: Oxford University Press.

Clifton, Thomas. 1983. *Music as Heard: A Study in Applied Phenomenology*. New Haven, CT, London: Yale University Press.

Collins, Karen. 2008. *Game Sound: An Introduction to the History, Theory, and Practice of Video Game Music and Sound Design*. Cambridge, MA: MIT Press.

Collins, Karen. 2013. *Playing with Sound: A Theory of Interacting with Sound and Music in Video Games*. Cambridge, MA: MIT Press.

Consalvo, Mia. 2009. 'There Is No Magic Circle.' *Games and Culture* 4 (4): 408–17.

Cook, Karen. 2014. 'Music, History, and Progress in Sid Meier's Civilization IV.' In *Music in Video Games: Studying Play*, edited by William Gibbons, Neil Lerner, and K. J. Donnelly, 166–82. New York; London: Routledge.

Cook, Nicholas. 1990. *Music, Imagination, and Culture*. Oxford: Clarendon.

Cook, Nicholas. 1998. *Analysing Musical Multimedia*. Oxford, New York: Oxford University Press.

Cook, Nicholas. 2002. 'Epistemologies of Music Theory.' In *The Cambridge History of Western Music Theory*, edited by Thomas Christensen, 78–106. Cambridge: Cambridge University Press.

Cook, Nicholas, and Anthony Pople, eds. 2004. *The Cambridge History of Twentieth-Century Music*. Cambridge: Cambridge University Press.

Copland, Aaron. 2004. 'Tip to Moviegoers: Take off Those Ear-Muffs (1949).' In *Aaron Copland: A Reader: Selected Writings 1923-1972*, 104–11. New York, London: Routledge.

Danto, Arthur C. 1981. *The Transfiguration of the Commonplace: A Philosophy of Art*. Cambridge, MA: Harvard University Press.

Deleuze, Gilles, and Félix Guattari. 1987. *A Thousand Plateaus: Capitalism and Schizophrenia*. Translated by Brian Massumi. Minneapolis: University of Minnesota Press.

Demers, Joanna. 2006. 'Dancing Machines: "Dance Dance Revolution," Cybernetic Dance, and Musical Taste.' *Popular Music* 25 (3): 401–14.

DeNora, Tia. 2000. *Music in Everyday Life*. Cambridge: Cambridge University Press.

Derrida, Jacques. 2011. *Voice and Phenomenon: Introduction to the Problem of the Sign in Husserl's Phenomenology*. Translated by Leonard Lawlor. Evanston, IL: Northwestern University Press.

Dewey, John. 2005. *Art as Experience*. New York: Penguin.

Diaz-Gasca, Sebastian. 2022. 'And the Music Keeps on Playing: Nostalgia in Paraludical Videogame Music Consumption.' In *Nostalgia and Videogame Music*, edited by Can Aksoy, Sarah Pozderac-Chenevey, and Vincent Rone, 46–66. Bristol: Intellect.

Dobbs, Stacey, Adrian Furnham, and Alastair McClelland. 2011. 'The Effect of Background Music and Noise on the Cognitive Test Performance of Introverts and Extraverts.' *Applied Cognitive Psychology* 25 (2): 307–13.

Donnelly, K. J. 2016. 'Emotional Sound Effects and Metal Machine Music: Soundworlds in Silent Hill Games and Films.' In *The Palgrave Handbook of Sound Design and Music in Screen Media: Integrated Soundtracks*, edited by Liz Greene and Danijela Kulezic-Wilson, 73–88. London: Palgrave Macmillan.

Donnelly, K. J. 2021. 'The Triple Lock of Synchronization.' In *The Cambridge Companion to Video Game Music*, edited by Melanie Fritsch and Tim Summers, 94–109. Cambridge: Cambridge University Press.

Dowling, Christopher. 2010. 'The Aesthetics of Daily Life.' *British Journal of Aesthetics* 50 (3): 225–42.

Dreyfus, Hubert, and Sean D. Kelly. 2007. 'Heterophenomenology: Heavy-Handed Sleight-of-Hand.' *Phenomenology and the Cognitive Sciences* 6 (1-2): 45–55.

Droumeva, Milena. 2011. 'An Acoustic Communication Framework for Game Sound: Fidelity, Verisimilitude, Ecology.' In *Game Sound Technology and Player Interaction: Concepts and Developments*, edited by Mark Grimshaw, 131–52. Hershey, PA: Information Science Reference.

Dulin, Ron. 1998. 'Starcraft Review.' *GameSpot* (blog). 15 April. https://www.gamespot.com/reviews/starcraft-review/1900-2533189/.

Easternborder. 2003. 'Tekken 3 Eddy Gordo FAQ—IGN FAQs.' IGN FAQs. 14 April. https://web.archive.org/web/20081009075324/http://uk.faqs.ign.com/articles/401/401749p1.html.

Egenfeldt-Nielsen, Simon, Jonas Heide Smith, and Susana Pajares Tosca. 2008. *Understanding Video Games: The Essential Introduction*. New York: Routledge.

Ekman, Inger, and Petri Lankoski. 2009. 'Hair-Raising Entertainment: Emotions, Sound, and Structure in Silent Hill 2 and Fatal Frame.' In *Horror Video Games: Essays on the Fusion of Fear and Play*, edited by Bernard Perron, 181–99. Jefferson, NC: McFarland.

Elferen, Isabella van. 2011. '¡Un Forastero! Issues of Virtuality and Diegesis in Videogame Music.' *Music and the Moving Image* 4 (2): 30–39.

Elferen, Isabella van. 2016. 'Analysing Game Musical Immersion: The ALI Model.' In *Ludomusicology: Approaches to Video Game Music*, edited by Michiel Kamp, Tim Summers, and Mark Sweeney, 32–52. Sheffield, Bristol, CT: Equinox.

Feld, Steven. 2012. *Sound and Sentiment: Birds, Weeping, Poetics, and Song in Kaluli Expression*. 3rd ed. Durham, NC: Duke University Press.

Ferrara, Lawrence. 1984. 'Phenomenology as a Tool for Musical Analysis.' *Musical Quarterly* 70 (3): 355–73.

Fink, Robert. 2005. *Repeating Ourselves: American Minimal Music as Cultural Practice*. Berkeley, Los Angeles, London: University of California Press.

Freitas, Joana. 2021. 'Kill the Orchestra: On Music, Mods, and Immersion in The Elder Scrolls on the Nexus Mods Platform.' *Journal of Sound and Music in Games* 2 (2): 22–41.

Freitas, Joana. 2022. 'A (Silent) Game of Words: Notes on Jeremy Soule's Accusations and the Elder Scrolls Online Community.' *Journal of Sound and Music in Games* 3 (1): 50–59.

Frith, Simon. 2002. 'Music and Everyday Life.' *Critical Quarterly* 44 (1): 35–48.

Fritsch, Melanie. 2014. 'Worlds of Music: Strategies for Creating Music-Based Experiences in Videogames.' In *The Oxford Handbook of Interactive Audio*, edited by Karen Collins, Bill Kapralos, and Holly Tessler, 167–78. Oxford: Oxford University Press.

Gadamer, Hans-Georg. 2004. *Truth and Method*. Translated by Joel Weinsheimer and Donald G. Marshall. 2nd ed. London, New York: Continuum.

Gallagher, Shaun, and Dan Zahavi. 2008. *The Phenomenology of Mind: An Introduction to Philosophy of Mind and Cognitive Science*. London, New York: Routledge.

Gallegos, Anthony. 2012. 'Diablo III Review.' IGN. 14 May. https://www.ign.com/articles/2012/05/14/diablo-iii-review-in-progress.

Galloway, Kate. 2019. 'Soundwalking and the Aurality of Stardew Valley: An Ethnography of Listening to and Interacting with Environmental Game Audio.' In *Music in the Role-Playing Game: Heroes and Harmonies*, edited by William Gibbons and Steven Reale, 159–78. New York: Routledge.

Gamespot Staff. 2013. 'Proteus Review.' *Gamespot*, 30 January. https://www.gamespot.com/reviews/proteus-review/1900-6403756/.

Gaver, William W. 1993. 'What in the World Do We Hear? An Ecological Approach to Auditory Source Perception.' *Ecological Psychology* 5 (1): 1–29.

Gibbons, William. 2014. 'Wandering Tonalities: Silence, Sound, and Morality in Shadow of the Colossus.' In *Music in Video Games: Studying Play*, edited by K. J. Donnelly and Neil Lerner, 122–37. New York: Routledge.

Gibbons, William. 2018. *Unlimited Replays: Video Games and Classical Music*. New York: Oxford University Press.
Gibson, James J. 1966. *The Senses Considered as Perceptual Systems*. New York: Houghton Mifflin.
Gibson, James J. 1979. *The Ecological Approach to Visual Perception*. Boston: Houghton Mifflin.
Goffman, Erving. 1972. *Encounters: Two Studies in the Sociology of Interaction*. 1st ed. Penguin University Books. Harmondsworth, Middlesex: Penguin Books.
Golding, Daniel. 2013. 'Listening to Proteus.' *Meanjin* 72 (2): 108–15.
Gorbman, Claudia. 1987. *Unheard Melodies: Narrative Film Music*. Bloomington: Indiana University Press.
Grant, Steven. 1982. 'Brian Eno Against Interpretation.' 1982. http://www.moredarkthanshark.org/eno_int_tp-aug82.html.
Grasso, Julianne. 2020. 'Video Game Music, Meaning, and the Possibilities of Play.' PhD dissertation, University of Chicago.
Grayson, Nathan. 2013a. 'Proteus Review: A Virtual Vacation in More Ways than One.' *IGN*. 9 February. https://www.ign.com/articles/2013/02/09/proteus-review.
Grayson, Nathan. 2013b. 'Staying Humble: Proteus' Origins And Ed Key's Next Game.' *Rock, Paper, Shotgun* (blog). 26 June. https://www.rockpapershotgun.com/staying-humble-proteus-origins-and-ed-keys-next-game.
Gregg, Melissa, and Gregory J. Seigworth. 2010. *The Affect Theory Reader*. Durham, NC, London: Duke University Press.
Grimshaw, Mark. 2008. *The Acoustic Ecology of the First-Person Shooter: The Player Experience of Sound in the First-Person Shooter Computer Game*. Saarbrücken: VDM Verlag.
Grosser, Michelle. 2020. 'Avatar/Player SubjectivityAn Agential Analysis of Crypt of the NecroDancer.' *Journal of Sound and Music in Games* 1 (3): 1–14.
Haack, Paul A., and Rudolf E. Radocy. 1981. 'A Case Study of a Chromesthetic.' *Journal of Research in Music Education* 29 (2): 85–90.
Hambleton, Elizabeth. 2020. 'Gray Areas: Analyzing Navigable Narratives in the Not-So-Uncanny Valley Between Soundwalks, Video Games, and Literary Computer Games.' *Journal of Sound and Music in Games* 1 (1): 20–43.
Hamilton, Andy. 2007. *Aesthetics and Music*. London: Continuum.
Hanslick, Eduard. 1986. *On the Musically Beautiful*. Translated by Geoffrey Payzant. Indianapolis, IN: Hackett.
Hart, Iain. 2020. 'Semiotics in Game Music.' In *The Cambridge Companion to Video Game Music*, edited by Melanie Fritsch and Tim Summers, 220–37. Cambridge: Cambridge University Press.
Hart, James. 1973. 'Toward a Phenomenology of Nostalgia.' *Man and World* 6 (4): 397–420.
Hasty, Christopher F. 1997. *Meter as Rhythm*. Oxford: Oxford University Press.
Hasty, Christopher F. 1999. 'Just in Time for More Dichotomies: A Hasty Response.' *Music Theory Spectrum* 21 (2): 275–93.
Heft, Harry. 2001. *Ecological Psychology in Context: James Gibson, Roger Barker, and the Legacy of William James's Radical Empiricism*. London: Lawrence Erlbaum.
Heidegger, Martin. 1962. *Being and Time*. Translated by John Macquarrie and Edward Robinson. Oxford: Blackwell.
Hellmuth Margulis, Elizabeth. 2014. *On Repeat: How Music Plays the Mind*. Oxford, New York: Oxford University Press.

Hepburn, Ronald W. 1966. 'Contemporary Aesthetics and the Neglect of Natural Beauty.' In *British Analytical Philosophy*, edited by Bernard Williams and Alan Montefiore, 285–310. London: Routledge and Keegan Paul.

Herbert, Ruth. 2011. *Everyday Music Listening: Absorption, Dissociation and Trancing*. Farnham, UK: Ashgate.

Herzfeld, Gregor. 2013. 'Atmospheres at Play: Aesthetical Considerations of Game Music.' In *Music and Game: Perspectives on a Popular Alliance*, edited by Peter Moormann, 147–57. Wiesbaden: Springer Fachmedien.

Herzog, Amy. 2010. *Dreams of Difference, Songs of the Same: The Musical Moment in Film*. Minneapolis: University of Minnesota Press.

Hocking, Clint. 2007. 'Ludonarrative Dissonance in Bioshock: The Problem of What the Game Is About.' *Click Nothing* (blog). 7 October. http://clicknothing.typepad.com/click_nothing/2007/10/ludonarrative-d.html.

Howson, Greg. 2007. 'Assassin's Creed Interview.' *The Guardian*, 19 October, sec. Technology. https://www.theguardian.com/technology/gamesblog/2007/oct/19/assassinscreedinterview.

Huiberts, Sander. 2010. 'Captivating Sound: The Role of Audio for Immersion in Computer Games.' PhD dissertation, Utrecht School of the Arts, University of Portsmouth.

Huizinga, Johan. 1949. *Homo Ludens: A Study of the Play-Element in Culture*. London, Boston, Henley: Routledge and Keegan Paul.

Huron, David. 2006. *Sweet Anticipation: Music and the Psychology of Expectation*. Cambridge, MA, London: MIT Press.

Husserl, Edmund. 1991. *On the Phenomenology of the Consciousness of Internal Time (1893–1917)*. Translated by John Barnett Brough. Dordrecht, Boston, London: Kluwer.

Husserl, Edmund. 2001a. *Analyses Concerning Passive and Active Synthesis: Lectures on Transcendental Logic*. Translated by A. J. Steinbock. Dordrecht, London: Kluwer.

Husserl, Edmund. 2001b. *Logical Investigations*, Volume 1. Translated by J. N. Findlay. London, New York: Routledge.

Ihde, Don. 2007. *Listening and Voice: Phenomenologies of Sound*. Albany: State University of New York Press.

Ione, Amy, and Christopher Tyler. 2003. 'Was Kandinsky a Synesthete?' *Journal of the History of the Neurosciences* 12 (July): 223–26.

Ivănescu, Andra. 2019. *Popular Music in the Nostalgia Video Game: The Way It Never Sounded*. Palgrave Studies in Audio-Visual Culture. London: Palgrave Macmillan.

James, William. 2007. *The Principles of Psychology*, Volume 1. New York: Cosimo.

Johnson, Mark. 2007. *The Meaning of the Body: Aesthetics of Human Understanding*. Chicago, London: University of Chicago Press.

Jørgensen, Kristine. 2008. 'Left in the Dark: Playing Computer Games with the Sound Turned Off.' In *From Pack-Man to Pop Music: Interactive Audio in Games and New Media*, edited by Karen Collins, 163–76. Aldershot: Ashgate.

Juslin, Patrick N., and John A. Sloboda. 2010. *Handbook of Music and Emotion: Theory, Research, and Applications*. Oxford: Oxford University Press.

Juul, Jesper. 2005. *Half-Real: Video Games Between Real Rules and Fictional Worlds*. Cambridge, MA: MIT Press.

Juul, Jesper. 2010. *A Casual Revolution: Reinventing Video Games and Their Players*. Cambridge, MA: MIT Press.

Kadar, Andre, and Judith Effken. 1994. 'Heideggerian Meditations on an Alternative Ontology for Ecological Psychology: A Response to Turvey's (1992) Proposal.' *Ecological Psychology* 6 (4): 297–341.

Kalinak, Kathryn. 2010. *Film Music: A Very Short Introduction*. Oxford: Oxford University Press.

Kamp, Michiel. 2014. 'Musical Ecologies in Video Games.' *Philosophy & Technology* 27 (2): 235–49.

Kamp, Michiel. 2016. 'Suture and Peritexts: Music Beyond Gameplay and Diegesis.' In *Ludomusicology: Approaches to Video Game Music*, edited by Michiel Kamp, Tim Summers, and Mark Sweeney, 73–91. Sheffield; Bristol, CT: Equinox.

Kamp, Michiel. 2019. 'Ludomusical Dissonance in Diablo III.' In *Music in the Role-Playing Game: Heroes and Harmonies*, edited by William Gibbons and Steven Reale, 131–45. New York: Routledge.

Kamp, Michiel. 2020. 'Playing along to What? Video Game Music and the Metaphor Model.' In *Remixing Music Studies: Essays in Honour of Nicholas Cook*, edited by Ross Cole, Matthew Pritchard, Ananay Aguilar, and Eric Clarke, 32–46. Abingdon, New York: Routledge.

Kamp, Michiel. 2021a. 'Autoethnography, Phenomenology and Hermeneutics.' In *The Cambridge Companion to Video Game Music*, edited by Melanie Fritsch and Tim Summers, 159–75. Cambridge: Cambridge University Press.

Kamp, Michiel. 2021b. 'Old(Er) Media and New Musical Affordances in Virtual Reality Experiences.' In *The Oxford Handbook of Cinematic Listening*, edited by Carlo Cenciarelli, 712–36. Oxford, New York: Oxford University Press.

Kamp, Michiel, and Mark Sweeney. 2019. 'Musical Landscapes in Skyrim.' In *Music in the Role-Playing Game: Heroes and Harmonies*, edited by William Gibbons and Steven Reale, 179–96. New York: Routledge.

Kandinsky, Wassily. 1997. *Concerning the Spiritual in Art*. Translated by M. T. H. Sadler. New York, London: Dover.

Kane, Brian. 2011. 'Excavating Lewin's "Phenomenology."' *Music Theory Spectrum* 33 (1): 27–36.

Kane, Brian. 2014. *Sound Unseen: Acousmatic Sound in Theory and Practice*. New York: Oxford University Press.

Kant, Immanuel. 2005. *Critique of Judgment*. Translated by J. H. Bernard. Mineola, NY: Dover.

Karageorghis, Costas I., and David-Lee Priest. 2012. 'Music in the Exercise Domain: A Review and Synthesis (Part 1).' *International Review of Sport and Exercise Psychology* 5 (1): 44–66.

Kassabian, Anahid. 2013. *Ubiquitous Listening: Affect, Attention, and Distributed Subjectivity*. Berkeley: University of California Press.

Kirsh, David, and Paul Maglio. 1994. 'On Distinguishing Epistemic from Pragmatic Action.' *Cognitive Science* 18 (4): 513–49.

Kivy, Peter. 1980. *The Corded Shell: Reflections on Musical Expression*. Princeton, NJ, Guildford: Princeton University Press.

Knoblauch, William. 2016. 'SIMON: The Prelude to Modern Music Video Games.' In *Music Video Games: Performance; Politics; and Play*, edited by Michael Austin, 25–42. London: Bloomsbury.

Koffka, Kurt. 1935. *The Principles of Gestalt Psychology*. New York: Harcourt Brace.

Kramer, Jonathan D. 1988. *The Time of Music: New Meanings, New Temporalities, New Listening Strategies*. New York, London: Schirmer Books.

Kramer, Lawrence. 1993. *Music as Cultural Practice 1800-1900*. Berkeley, CA, London: University of California Press.

Kramer, Lawrence. 2002. *Musical Meaning: Toward a Critical History*. Berkeley: University of California Press.

Krueger, Joel W. 2011. 'Doing Things with Music.' *Phenomenology and the Cognitive Sciences* 10 (1): 1-22.

Lakoff, George, and Mark Johnson. 1980. *Metaphors We Live By*. Chicago: University of Chicago Press.

Lanza, Joseph. 2004. *Elevator Music: A Surreal History of Muzak, Easy-Listening, and Other Moodsong*. Revised and Expanded edition. Ann Arbor: University of Michigan Press.

Lee, Martin A., and Bruce Shlain. 1985. *Acid Dreams: The Complete Social History of LSD: The CIA, The Sisties, and Beyond*. New York: Grove Press.

Leman, Marc. 2008. *Embodied Music Cognition and Mediation Technology*. Cambridge, MA, London: MIT Press.

Levinson, Jerrold. 1996. 'Musical Expressiveness.' In *The Pleasures of Aesthetics*, 90-128. Ithaca, NY: Cornell University Press.

Levinson, Jerrold. 1997. *Music in the Moment*. Ithaca, NY: Cornell University Press.

Levinson, Jerrold. 2009. 'The Aesthetics Appreciation of Music.' *British Journal of Aesthetics* 3 (4): 327-92.

Lewin, David. 1986. 'Music Theory, Phenomenology, and Modes of Perception.' *Music Perception: An Interdisciplinary Journal* 3 (4): 327-92.

Lindley, Craig. 2002. 'The Gameplay Gestalt, Narrative, and Interactive Storytelling.' In *Computer Games and Digital Cultures Conference Proceedings*, edited by Frans Mäyrä, 2013-2215. Tampere: Tampere University Press.

Lochhead, Judy. 1986. Review of *Music as Heard: A Study in Applied*, by Thomas Clifton. *Journal of Musicology* 4 (3): 355-64.

Loguidice, Bill, and Matt Barton. 2009. *Vintage Games: An Insider Look at the History of Grand Theft Auto, Super Mario, and the Most Influential Games of All Time*. 1st ed. Amsterdam: Focal Press.

London, Justin. 1999. 'Hasty's Dichotomy.' *Music Theory Spectrum* 21 (2): 260-74.

López Gómez, Lidia. 2022. 'Transmedia Narratives through Music Video's Aesthetics: The Case of Death Stranding.' Paper presented at Ludo 2022 Eleventh European Conference on Video Game Music and Sound, Royal Holloway, University of London, April 2022.

Lucas, Maura. 2008. 'On Not Passing the Acid Test: Bad Trips and Initiation.' *Anthropology of Consciousness* 16 (1): 25-50.

Marshall, Sandra K., and Annabel J. Cohen. 1988. 'Effects of Musical Soundtracks on Attitudes toward Animated Geometric Figures.' *Music Perception* 6 (1): 95-112.

McAlpine, Kenneth B. 2018. *Bits and Pieces: A History of Chiptunes*. Oxford, New York: Oxford University Press.

McClary, Susan. 1991. *Feminine Endings: Music, Gender, and Sexuality*. Minneapolis: University of Minnesota Press.

McNeill, William H. 1995. *Keeping Together in Time: Dance and Drill in Human History*. Cambridge, MA: Harvard University Press.

Medina-Gray, Elizabeth. 2014. 'Modular Structure and Function in Early 21st-Century Video Game Music.' PhD dissertation, Yale University.

Medina-Gray, Elizabeth. 2019. 'Analyzing Modular Smoothness in Video Game Music.' *Music Theory Online* 25 (3). https://www.mtosmt.org/issues/mto.19.25.3/mto.19.25.3.medina.gray.html.

Merkur, Dan. 1998. *The Ecstatic Imagination: Psychedelic Experiences and the Psychoanalysis of Self-Actualization*. Albany: State University of New York Press.

Merleau-Ponty, Maurice. 1968. *The Visible and the Invisible*. Edited by Claude Lefort. Translated by Alfonso Lingis. Evanston, IL: Northwestern University Press.

Merleau-Ponty, Maurice. 2005. *Phenomenology of Perception*. Translated by Colin Smith. London, New York: Routledge.

Merleau-Ponty, Maurice. 2012. *Phenomenology of Perception*. Translated by Donald A. Landes. London: Routledge.

Michael LeMieux, dir. 2010a. *Civilization 4 Soundtrack: Harmonielehre: Part II. The Anfortas Wound*. https://www.youtube.com/watch?v=oH3HQqEEz6U.

Michael LeMieux, dir. 2010b. *Civilization 4 Soundtrack: Violin Concerto: II. Chaconne: Body Through Which The Dream Flows*. https://www.youtube.com/watch?v=Tx1ktwTcPz0.

Miller, Kiri. 2012. *Playing Along: Digital Games, YouTube, and Virtual Performance*. Oxford Music / Media. Oxford, New York: Oxford University Press.

Miller, Kiri. 2017. *Playable Bodies: Dance Games and Intimate Media*. New York: Oxford University Press.

Milliman, Ronald E. 1986. 'The Influence of Background Music on the Behavior of Restaurant Patrons.' *Journal of Consumer Research* 13 (2): 286–89.

Miozzi, CJ. 2012. 'Diablo 3 Review.' GameFront. 23 May. https://www.gamefront.com/games/gamingtoday/article/diablo-3-review.

Miraglia, Roberto. 1998. 'U.S. Phenomenology of Music: A Critical Survey.' *Axiomathes* 9 (1): 235–51.

Mitchell, Jon. 2013. 'Interview: Proteus Composer David Kanaga.' *The Daily Portal*, 14 May.

Mitterschiffthaler, Martina T., Cynthia H. Y. Fu, Jeffrey A. Dalton, Christopher M. Andrew, and Steven C. R. Williams. 2007. 'A Functional MRI Study of Happy and Sad Affective States Induced by Classical Music.' *Human Brain Mapping* 28 (11): 1150–62.

Moran, Dermot. 2013. 'From the Natural Attitude to the Life-World.' In *Husserl's Ideen*, edited by Lester Embree and Thomas Nenon, 105–24. Dordrecht: Springer Netherlands.

Mortensen, Torill Elvira. 2018. 'Anger, Fear, and Games: The Long Event of #GamerGate.' *Games and Culture* 13 (8): 787–806.

Moseley, Roger. 2013. 'Playing Games with Music (and Vice Versa): Ludomusicological Perspectives on Guitar Hero and Rock Band.' In *Taking It to the Bridge: Music as Performance*, edited by Nicholas Cook and Richard Pettengill, 279–318. Ann Arbor: University of Michigan Press.

Moseley, Roger. 2016. 'Key 1. Ludomusicality.' In *Keys to Play: Music as a Ludic Medium from Apollo to Nintendo*, 15–66. Oakland: University of California Press.

Moseley, Roger, and Aya Saiki. 2014. 'Nintendo's Art of Musical Play.' In *Music in Video Games: Studying Play*, edited by K. J. Donnelly, William Gibbons, and Neil Lerner, 51–76. New York: Routledge.

Munday, Rod. 2007. 'Music in Video Games.' In *Music, Sound and Multimedia: From the Live to the Virtual*, edited by Jamie Sexton, 51–67. Edinburgh: Edinburgh University Press.

Nancy, Jean-Luc. 2007. *Listening*. Translated by Charlotte Mandell. New York: Fordham University Press.

Nattiez, Jean-Jacques. 1990. *Music and Discourse: Toward a Semiology of Music*. Translated by Carolyn Abbate. Princeton, NJ: Princeton University Press.

Núñez, Rafael E., and Eve Sweetser. 2006. 'With the Future Behind Them: Convergent Evidence From Aymara Language and Gesture in the Crosslinguistic Comparison of Spatial Construals of Time.' *Cognitive Science* 30: 401–50.

O'Hara, William. 2020. 'Mapping Sound: Play, Performance, and Analysis in Proteus.' *Journal of Sound and Music in Games* 1 (3): 35–67.

Oliva, Costantino. 2021. 'The Musical Ludo Mix of Taiko No Tatsujin.' *Transactions of the Digital Games Research Association* 5 (2): 131–60. http://todigra.org/index.php/todigra/article/view/118.

Owen, David. 2006. 'The Soundtrack of Your Life: Muzak in the Realm of Retail Theatre.' *The New Yorker*, 10 April. https://www.newyorker.com/magazine/2006/04/10/the-soundtrack-of-your-life.

Palmieri, Paolo. 2014. '"The Postilion's Horn Sounds": A Complementarity Approach to the Phenomenology of Sound-Consciousness.' *Husserl Studies* 30 (2): 129–51.

Parsons, Glenn. 2009. 'Science, Nature, and Moore's Syncretic Aesthetic.' *Ethics, Place & Environment* 12 (3): 351–56. https://doi.org/10.1080/13668790903195693.

Pellegrino, Catherine. 2002. 'Aspects of Closure in the Music of John Adams.' *Perspectives of New Music* 40 (1): 147–75.

Petit, Carolyn. 2012. 'Diablo III Review.' GameSpot. 15 May. https://www.gamespot.com/reviews/diablo-iii-review/1900-6378132/.

Phillips, Winifred. 2014. *A Composer's Guide to Game Music*. Cambridge, MA: MIT Press.

Pinckard, Jane. 2002. 'Sex in Games: Rez+Vibrator.' *Game Girl Advance* (blog). https://www.gamegirladvance.com/2002/10/sex-in-games-rezvibrator.html.

Pollack, Howard. 2000. *Aaron Copland: The Life and Work of an Uncommon Man*. London: Faber.

Pozderac-Chenevey, Sarah. 2022. 'Confronting Nostalgia for Racism in American Popular Music via Bioshock: Infinite.' In *Nostalgia and Videogame Music*, edited by Can Aksoy, Sarah Pozderac-Chenevey, and Vincent Rone, 225–45. Bristol: Intellect.

Proust, Marcel. 1992. *In Search of Lost Time*, Volume 1: *Swann's Way*. Translated by C. K. Scott Moncrieff and Terence Kilmartin. New York: Modern Library.

Ratcliffe, Matthew. 2009. 'The Phenomenology of Mood and the Meaning of Life.' In *The Oxford Handbook of Philosophy of Emotion*, edited by Peter Goldie, 349–71. Oxford: Oxford University Press.

Reale, Steven. 2014. 'Transcribing Musical Worlds; or, Is L.A. Noire a Music Game?' In *Music in Video Games: Studying Play*, edited by K. J. Donnelly, William Gibbons, and Neil Lerner, 77–103. New York, Abingdon: Routledge.

Reid, George. 2018. 'Chiptune: The Ludomusical Shaping of Identity.' *The Computer Games Journal* 7 (4): 279–90.

Reilly, Jim. 2012. 'Minecraft Rakes In $80 Million.' Game Informer. 26 March. https://www.gameinformer.com/b/news/archive/2012/03/26/minecraft-downloads-hit-25-million.aspx.

Reynolds, Simon. 1998. *Generation Ecstasy: Into the World of Techno and Rave Culture*. Boston: Little, Brown.

Ridley, Aaron. 2004. *The Philosophy of Music: Theme and Variations*. Edinburgh: Edinburgh University Press.

Riedel, Friedlind. 2020. 'Atmospheric Relations: Theorising Music and Sound as Atmosphere.' In *Music as Atmosphere: Collective Feelings and Affective Sounds*, edited by Friedlind Riedel and Juha Torvinen, 1–42. London, New York: Routledge.

Rink, John. 1999. 'Translating Musical Meaning: The Nineteenth-Century Performer as Narrator.' In *Rethinking Music*, edited by Nicholas Cook and Mark Everist, 217–38. New York, Oxford: Oxford University Press.

Roberts, Rebecca. 2014. 'Fear of the Unknown: Music and Sound Design in Psychological Horror Games.' In *Music in Video Games: Studying Play*, edited by K. J. Donnelly, William Gibbons, and Neil Lerner, 138–50. New York, London: Routledge.

Rodman, Ronald. 2010. *Tuning In: American Narrative Television Music*. New York, Oxford: Oxford University Press.

Roholt, Tiger C. 2014. *Groove: A Phenomenology of Rhythmic Nuance*. New York: Bloomsbury.

Rollings, Andrew, and Ernest Adams. 2003. *Andrew Rollings and Ernest Adams on Game Design*. San Francisco: New Riders.

Rone, Vincent. 2022. 'Introduction.' In *Nostalgia and Videogame Music*, edited by Can Aksoy, Sarah Pozderac-Chenevey, and Vincent Rone, 1–22. Bristol: Intellect.

Rose, Mike. 2013. 'Is Proteus a Game—and If Not, Who Cares?' *Gamasutra* (blog). 30 January. https://www.gamasutra.com/view/news/185645/Is_Proteus_a_game__and_i f_not_who_cares.php.

Rossignol, Jim. 2008. 'Korea.' *Rock, Paper, Shotgun* (blog). http://www.rockpapershotgun.com/2008/12/11/korea/.

Rothfarb, Lee. 2002. 'Energetics.' In *The Cambridge History of Western Music Theory*, edited by Thomas Christensen, 927–55. Cambridge: Cambridge University Press.

Russell, James A. 1980. 'A Circumplex Model of Affect.' *Journal of Personality and Social Psychology* 39 (6): 1161–78.

Salen, Katie, and Eric Zimmerman. 2003. *Rules of Play: Game Design Fundamentals*. Cambridge, MA: MIT Press.

Sartre, Jean-Paul. 2014. *Sketch for a Theory of the Emotions*. Translated by Philip Mairet. London, New York: Routledge.

Saussure, Ferdinand de. 2011. *Course in General Linguistics*. Edited by Perry Meisel and Haun Saussy. Translated by Wade Baskin. New York, Chichester: Columbia University Press.

Schaeffer, Pierre. 1966. *Traité Des Objets Musicaux: Essay Interdisciplines*. Paris: Édition du Seuil.

Schafer, R. Murray. 1980. *The Tuning of the World: Toward a Theory of Soundscape Design*. =. Philadelphia: University of Pennsylvania Press.

Schartmann, Andrew. 2015. *Koji Kondo's Super Mario Bros. Soundtrack*. New York: Bloomsbury.

Schutz, Alfred. 1951. 'Making Music Together: A Study in Social Relationship.' *Social Research* 18 (1): 76–97.

Schutz, Alfred. 1976. 'Fragments on the Phenomenology of Music.' Translated by Fred Kersten. *Music and Man* 2 (1–2): 5–71.

Schwarz, K. Robert. 1990. 'Process vs. Intuition in the Recent Works of Steve Reich and John Adams.' *American Music* 8 (3): 245–73.

Schwarz, K. Robert. 1996. *Minimalists*. London: Phaidon Press.

Scruton, Roger. 1997. *The Aesthetics of Music*. Oxford: Clarendon.

Seeger, Charles. 1977. 'The Musicological Juncture: 1976.' *Ethnomusicology* 21 (2): 179–88.

Sicart, Miguel. 2014. *Play Matters*. Cambridge, MA, London: MIT Press.

Sloboda, John A. 1991. 'Music Structure and Emotional Response: Some Empirical Findings.' *Psychology of Music* 19 (2): 110–20.

Sloboda, John A. 2008. 'Science and Music: The Ear of the Beholder.' *Nature* 454 (7200): 32–33.
Smith, Jeff. 1996. 'Unheard Melodies? A Critique of Psychoanalytic Theories of Film Music.' In *Post-Theory: Reconstructing Film Studies*, edited by David Bordwell and Noel Carroll, 230–47. Madison: University of Wisconsin Press.
Smith, Jennifer. 2020. 'Vocal Disruptions in the Aural Game World: The Female Entertainer in The Witcher 3: Wild Hunt, Transistor and Divinity: Original Sin II.' *The Soundtrack* 11 (1–2): 75–97.
Sonesson, Göran. 2007. 'From the Meaning of Embodiment to the Embodiment of Meaning: A Study in Phenomenological Semiotics.' In *Body, Language, and Mind*, edited by Tom Ziemke, Jordan Zlatev, and Roslyn M. Frank, 85–127. Berlin, New York: Walter de Gruyter.
Spinoza, Baruch. 2000. *Ethics*. Translated by G. H. R. Parkinson. Oxford: Oxford University Press.
Steinberg, Michael. 2006. 'Harmonielehre (1984–5).' In *The John Adams Reader: Essential Writings on an American Composer*, edited by Thomas May, 101–5. Pompton Plains, NJ: Amadeus.
Stern, Daniel N. 2004. *The Present Moment in Psychotherapy and Everyday Life*. New York, London: W. W. Norton.
Stockfelt, Ola. 1997. 'Adequate Modes of Listening.' In *Keeping Score: Music, Disciplinarity, Culture*, edited by David Schwartz, Anahid Kassabian, and Lawrence Siegel, translated by Anahid Kassabian and Leo G. Svendsen, 129–46. Charlottesville, London: University Press of Virginia.
Stokes, Jordan. 2021. 'Mono No Aware and Musical Ruins in The Legend of Zelda: Breath of the Wild.' Paper presented at North American Conference on Video Game Music, Online, June 2021.
Stuart, Keith, and Alex Hern. 2014. 'Minecraft Sold: Microsoft Buys Mojang for $2.5bn.' *The Guardian*, 15 September, sec. Games. https://www.theguardian.com/technology/2014/sep/15/microsoft-buys-minecraft-creator-mojang-for-25bn.
Subotnik, Rose Rosengard. 1996. *Deconstructive Variations: Music and Reasons in Western Society*. Minneapolis: University of Minnesota Press.
Summers, Tim. 2012. 'Video Game Music: History, Form and Genre.' PhD dissertation, University of Bristol.
Summers, Tim. 2016a. 'Analysing Video Game Music.' In *Ludomusicology: Approaches to Video Game Music*, edited by Michiel Kamp, Tim Summers, and Mark Sweeney, 8–31. Sheffield; Bristol, CT: Equinox.
Summers, Tim. 2016b. *Understanding Video Game Music*. Cambridge: Cambridge University Press.
Summers, Tim. 2021. *The Legend of Zelda: Ocarina of Time: A Game Music Companion*. Bristol, Chicago: Intellect.
Svec, Henry Adam. 2008. 'Becoming Machinic Virtuosos: Guitar Hero, Rez, and Multitudinous Aesthetics.' *Loading...* 2 (2). https://journals.sfu.ca/loading/index.php/loading/article/view/30/28.
Szabo, Victor. 2017. 'Unsettling Brian Eno's Music for Airports.' *Twentieth-Century Music* 14 (02): 305–33.
Tagg, Philip. 2011. 'Caught on the Back Foot: Epistemic Inertia and Invisible Music.' *IASPM Journal* 2 (1–2): 3–18.
Tagg, Philip. 2012. *Music's Meanings: A Modern Musicology for Non-Musos*. New York, Huddersfield: Mass Media Music Scholars Press.

Taruskin, Richard. 2005a. *The Oxford History of Western Music: The Seventeenth and Eighteenth Centuries*. Oxford: Oxford University Press.

Taruskin, Richard. 2005b. *The Oxford History of Western Music: The Early Twentieth Century*. Oxford: Oxford University Press.

Taruskin, Richard. 2005c. *The Oxford History of Western Music: The Late Twentieth Century:*. Oxford: Oxford University Press.

Terry, Peter C., Costas I. Karageorghis, Alessandra Mecozzi Saha, and Shaun D'Auria. 2012. 'Effects of Synchronous Music on Treadmill Running among Elite Triathletes.' *Journal of Science and Medicine in Sport* 15 (1): 52-57.

'Trash Mobs.' n.d. Diablo Wiki. Accessed 11 August 2022. https://www.diablowiki.net/Trash_mobs.

Truax, Barry. 2001. *Acoustic Communication*. Westport, CT: Ablex.

Tuuri, Kai, Manne-Sakari Mustonen, and Antti Pirhonen. 2007. 'Same Sound—Different Meanings: A Novel Scheme for Modes of Listening.' In *Proceedings of the Second International AudioMostly Conference 2007*, edited by Katarina Delsing, Holger Grossmann, Stuart Cunningham, Lilian Johansson, Mats Liljedahl, David Moffat, Nigel Papworth, and Niklas Roeber, 13-18. Fraunhofer Institute for Digital Media, Ilmenau.

Verran, Erick. 2021. 'Negative Ecologies, or Silence's Role in Affordance Theory.' *Journal of Sound and Music in Games* 2 (4): 36-54.

Vries, Imar de, and Isabella van Elferen. 2010. 'The Musical Madeleine: Communication, Performance, and Identity in Musical Ringtones.' *Popular Music and Society* 33 (1): 61-74.

Wagner, Richard. 1995. *Opera and Drama*. Translated by William Ashton Ellis. Lincoln, London: University of Nebraska Press.

Warde-Brown, Ailbhe. 2021. 'Waltzing on Rooftops and Cobblestones: Sonic Immersion through Spatiotemporal Involvement in the Assassin's Creed Series.' *Journal of Sound and Music in Games* 2 (3): 34–55.

Wark, McKenzie. 2007. *Gamer Theory*. Cambridge, MA, London: Harvard University Press.

Weberman, David. 1996. 'Sartre, Emotions, and Wallowing.' *American Philosophical Quarterly* 33 (4): 393–407.

Whalen, Zach. 2004. 'Play Along: An Approach to Videogame Music.' *Game Studies* 4 (1). http://www.gamestudies.org/0401/whalen/.

Whalen, Zach. 2007. 'Case Study: Film Music vs. Video-Game Music: The Case of Silent Hill.' In *Music, Sound and Multimedia: From the Live to the Virtual*, edited by Jamie Sexton, 68–81. Edinburgh: Edinburgh University Press.

Wierzbicki, James. 2009. *Film Music: A History*. New York, London: Routledge.

Williams, Raymond. 1974. *Television: Technology and Cultural Form*. New York: Schocken Books.

Windsor, W. Luke, and Christophe de Bézenac. 2012. 'Music and Affordances.' *Musicae Scientiae* 16 (1): 102–20.

Wörwag, Barbara. 1998. 'There Is an Unconscious, Vast Power in the Child': Notes on Kandinsky, Münter and Children's Drawings.' In *Discovering Child Art: Essays on Childhood, Primitivism, and Modernism*, edited by Jonathan Fineberg, 68–94. Princeton, NJ: Princeton University Press.

Yalch, Richard F., and Eric R. Spangenberg. 2000. 'The Effects of Music in a Retail Setting on Real and Perceived Shopping Times.' *Journal of Business Research* 49 (2): 139–47.

Index

For the benefit of digital users, indexed terms that span two pages (e.g., 52–53) may, on occasion, appear on only one of those pages.

2001: A Space Odyssey, 24–25, 136

Aarseth, Espen, 121, 131–32
Abbate, Carolyn, 115–17, 129
absorption. *See* immersion
Adams, John, 101–7
adaptive music. *See* dynamic music
adventure game, 43, 121, 156
aesthesic, 3–7, 14–15, 17–18, 101–2, 175–76, 180. *See also* poietic
aesthetics
 aesthetic experience, 68, 70–75, 82–83, 84, 88, 90–93, 99, 111–12, 125, 180–81
 aesthetics of music, 30–31, 74–75. *See also* Scruton, Roger
 aesthetics of nature, 84–85, 91–93
beauty, 72, 73–74, 82–83, 91–93, 175–76, 177–79
affect, 56, 111–12, 114–16, 138–39, 145–46, 168–69. *See also* emotions
affordance. *See also* mood
 affordance in ecological psychology, 53–55, 114. *See also* Gibson, James J.
 affordance in phenomenology, 55–57, 169
 affordance structure, 56–57, 59, 61, 159–60, 170
agency (player), 62, 110–11
Ahmed, Sara, 26–27, 114, 168
Aliens, 34
ambient music, 69–70, 103–4
Amplitude, 129–30
Anderson, Paul Allen, 30–31
anticipation. *See* psychology
art music. *See* classical music
Assassin's Creed (series), 54, 97–99, 177–78
Atari Video Music, 133–34
atmosphere, 50–51, 157. *See also* mood

attention, 12–16, 32, 38, 84, 150–51. *See also* listening
 and background music, 29–30, 32, 42–43, 51–52, 65
 and rhythm, 40, 121–22
 in phenomenology, 47, 55–56, 167–68
Audiosurf, 133–34
Auditorium, 133–34
Austin, J. L., 148–49
Austin, Michael, 129–30
autonomous music, 15, 66–67, 107–8

Barthes, Roland, 41–42
Beat Saber, 133–34
Beat Sneak Bandit, 159–62
beauty. *See* aesthetics
Beethoven, Ludwig van, 30, 101–2, 103–5, 111
 Symphony No. 6 ("Pastoral"), 105, 151–53
 Symphony No. 9 ("Choral"), 11, 21–22, 71, 87–88, 123–24, 191n.16
Berger, Karol, 116–17
Biancorosso, Giorgio, 190n.11
Bicknell, Jeanette, 74–75
BioShock Infinite, 81–82
Bit.Trip Runner, 129–30, 131–32
Blazing Saddles, 184n.7
Blue Velvet, 157
body. *See* embodiment
Bogost, Ian, 9, 133–34
Böhme, Gernot, 50–51
Brahms, Johannes, 101–5, 116–17, 138
Brothers: A Tale of Two Sons, 140–41
Bruckner, Anton, 123–24
Buhler, James, 185n.19

Cage, John, 87
Caillois, Roger, 139
Casey, Edward, 75–76, 80

Cheng, William, 5, 110–12, 140, 178–79
Chicane, 123–24
Child of Eden, 133–34
Chion, Michel, 2–3, 12, 39–40
chiptune, 75–76
Chopin, Frédéric, 67
cinematic music, 8, 113. *See also* film music
Civilization. See *Sid Meier's Civilization* (series)
Clarke, Eric, 53–54
classical music, 12, 24–25, 68, 75, 123–24. *See also specific composers*
Clifton, Thomas, 17–18, 19–21, 42, 86–87, 89, 90, 124, 177–79
Cohen, Leonard, 42–46
Collins, Karen, 4–5, 121, 147–48, 158–60, 179–80, 188n.2
Cook, Karen, 101–2, 106–7
Cook, Nicholas, 10–12, 20, 41–42, 44–45, 105, 180
Copland, Aaron, 1–2, 103–4
Crypt of the NecroDancer, 159
Csíkszentmihályi, Mihály, 114

dance, 123–25, 127–28
　dance games, 5, 127–28, 129–30
　dance music, 35, 123–24, 136
danger-state music. *See* safety- and danger-state music
Danto, Arthur, 92
de Certeau, Michel, 6–8, 15–16
de Vries, Imar, 77
Death Stranding, 96–97, 174–75
DeNora, Tia, 30–31, 184–85n.14
Derrida, Jacques, 125–26
Dewey, John, 73–74, 87
Diablo (series), 166
　Diablo III, 166–69, 170–71, 177–78
Diaz-Gasca, Sebastian, 76, 108
diegesis, 3–4, 38–39, 42, 86, 174, 179–80
　diegetic music and sound, 54–55, 97–99, 143, 157
　nondiegetic music and sound, 38, 54–55, 56–57, 85, 97–99, 157, 164–65
　transdiegetic music and sound, 15
Dire Straits, 123–24
Disco Elysium, 43
Dowling, Christopher, 73–74
Dreyfus, Hubert, 18–19, 55–57, 169
drone, 1–2, 24–25, 95–96, 97–99, 136, 137–38, 164–65, 173–74

Droumeva, Milena, 12–15, 75–76, 80, 108
drugs, 30–31, 60–61, 62–63, 134–35
Dune 2, 33–34
Dyad, 133–34
dynamic music, 4–5, 31–32, 49–50, 120, 121, 136, 170–71, 174
　loops, 4–5, 39–40, 95–96, 118, 120–21, 145
　transitions, 7, 10–11, 35, 48–51, 56–57, 164, 173–74

earcon, 12–13, 98–99, 159–60
ecological psychology. *See* psychology
eidetic variation. *See* phenomenology
Elder Scrolls V: Skyrim, The, 85–86, 89–90, 93, 94–99, 108, 118
　combat cues, 158
embodied cognition, 124–25, 127
embodiment, 125–26
emotions, 21, 46, 72, 97–98, 135–36, 137–41, 149, 151, 162–63
　emotions vs. affect, 114–15, 169
　Sartre on emotions, 78–80
enabling similarity, 41–42, 44–45
Eno, Brian, 32, 69–70
entrainment, 40, 121–22, 124, 129–32, 159–64. *See also* rhythm
épochè. *See* phenomenology
equipment. *See* Heidegger, Martin
ergodic, 121–22, 131–32, 136. *See also* Aarseth, Espen
ethics, 27–28, 178–79
ethnography, 5
existentialism, 20, 62, 77–78

Fallout 3, 110–11, 140, 157, 171–72
Fauré, Gabriel, 154
Feld, Steven, 39–40
fiction, 9, 34, 62–63, 135–36, 146–48, 166, 170. *See also* Juul, Jesper
film music. *See also* cinematic music
　film music theory, 1–3, 8, 30–31, 41–42, 48–49, 94, 185n.19
　film music vs. video game music, 4–5, 8, 38, 179–80
　Hollywood film music conventions, 22, 95, 101–2, 136, 137, 145–46, 164–65, 177–78
Final Fantasy (series), 12–13, 43, 75–76, 140–41
Fink, Robert, 29–30, 65, 174

INDEX

first-person shooter, 54–55, 137, 144
flow (psychology). *See* Csíkszentmihályi, Mihály
FMOD, 7
FPS. *See* first-person shooter
Freitas, Joanna, 108, 178–79
Frequency, 129–30
Friedrich, Caspar David, 96, 100, 188n.7
Fritsch, Melanie, 130–31, 184n.11

Gadamer, Hans-Georg, 180–81
Gallagher, Shaun, 86
game rules. *See* gameplay
gameplay
 gameplay mechanics, 60–61, 117–18, 128, 129–31, 137–38, 140–41, 159, 166
 game rules, 8, 9, 34, 129–30, 131–32, 146–49
GamerGate, 27–28
genre (video game), 2–3, 17–18, 32–33, 43, 54–55, 100, 137, 175–76. *See also specific genres*
gestalt. *See* psychology
Gibbons, William, 5, 68
Gibson, James J., 53–55
Glass, Philip, 67, 102–3
Glee, 135
glee, 134–39
God of War (2018), 48–51, 56–57
Goethe, Johann Wolfgang von, 45–46
Goffman, Erving, 147–48
Gorbman, Claudia, 30–31, 41–42, 101, 185n.19
Gould, Glenn, 116–17
Grand Theft Auto (series), 56–57, 179–80
 Grand Theft Auto: San Andreas, 110–11, 175–76
Grasso, Julianne, 50–51, 54–55, 56, 114, 191n.17
Gregg, Melissa, 185n.18
Grimshaw, Mark, 54–55
Grosser, Michelle, 159
Guitar Hero (series), 5, 24–25, 110–11, 129–32

Hades, 1–3, 8, 22–25, 173–74
Halm, August, 135–36
Halo: Combat Evolved, 137–39
Hamilton, Andy, 30–31, 57–59, 62–63, 103–4, 177–78

Hanslick, Eduard, 135–36
Hart, Iain, 158, 171, 180
Hart, James, 77–78, 79–80
Hasty, Christopher, 121–22
hearing. *See* listening; phenomenology
Heidegger, Martin, 20, 21, 42–43, 92
 on equipment, 58–59, 167–68, 170, 177–78
 on mood, 25–26, 46–47, 56–57, 79–80, 114
 present-at-hand, 58–59, 167–68
 ready-to-hand, 58–59, 65, 167–68, 169, 170
 on signs, 151, 167–68, 170
 on time, 86–87
 on world, 22, 46
Hepburn, Ronald, 84–85, 86, 91–93
Herbert, Ruth, 30–31
hermeneutics, 5, 10–11, 20, 22–23, 106–7, 115–16, 180–81
Herzfeld, Gregor, 50–51
Herzog, Amy, 94–95, 96
Honegger, Arthur, 153, 156, 158
horizon (phenomenology), 21–22, 31–32, 78, 86–87, 161–62, 183n.4
horror, 3–5, 8, 143, 145–46, 148, 164–65
Huron, David, 56, 120–21, 162–63, 165, 168
Husserl, Edmund, 17–18, 19–20, 22, 27–28, 39–40
 on affections, 114–15, 168–69
 on natural attitude, 26, 41–42, 171
 on time consciousness, 16, 19, 21–22, 25–26, 162

Ihde, Don, 19, 37–38, 46–47, 55, 163–64
 on first and second phenomenology, 21–23
 on music and dance, 124–25, 127
 on voice, 179–80
immersion, 5–6, 21–22, 44–45, 68, 108, 113, 127
 absorption, 76–77, 116
 immersive fallacy, 6
Immortality, 164–65
interactive music. *See* dynamic music
interface, 54, 96, 98–99, 129–31, 156, 166, 189n.3
 interface sounds, 38–39, 54–55, 98–99, 104–5. *See also* earcon
interpretation. 5, 18–19, 66, 100–7, 108, 111–12, 115–16, 138–39, 150–51, 166–67. *See also* hermeneutics
iTunes, 133–34

Ivănescu, Andra, 5, 81–82

James, William, 53, 55
Johnson, Mark, 125–26
Journey, 128–29, 136, 174–75
Juul, Jesper, 8, 9, 34, 113, 119–20, 146–49, 166, 170

Kalinak, Kathryn, 184n.13
Kanaga, David, 117–18, 120–21
Kandinsky, Wassily, 132–35
Kane, Brian, 20, 39–40
Kant, Immanuel, 72–74, 82–83, 186n.3
Kassabian, Anahid, 10–11, 14–15. *See also* listening
Kelly, Sean D., 18–19, 55–57, 169
Key, Ed, 117–18
Kid Icarus, 80–81
Kirsh, David, 190n.9
Kivy, Peter, 137, 145–46
Koffka, Kurt, 184n.6
Kramer, Jonathan, 24–25, 186n.6
Kramer, Lawrence, 68, 184n.12, 187n.19
Krueger, Joel, 127
Kurth, Ernst, 164

Lakoff, George, 125–26
Lanza, Joseph, 37–38
Last of Us, The, 140–41
Left 4 Dead, 144–49, 158, 163–64
Legend of Zelda: Ocarina of Time, The, 3–5, 67, 143
leitmotif, 147–48, 149–50, 156
Leman, Marc, 125–26
Levinson, Jerrold, 88, 125
Lewin, David, 20
listening
 attentive listening, 38, 48, 68, 75, 88, 107–8, 125, 144
 concert-hall listening. *See* attentive listening
 hearing vs. listening, 13–14, 125–26, 171–72, 176–77
 modes of listening, 10–11, 12–15
 nostalgic listening. *See* nostalgia
 reduced listening, 39–40
 ubiquitous listening, 6–7, 65
Lochhead, Judy, 20, 86–87
London, Justin, 121–22
Loom, 156
loop. *See* dynamic music

López Gómez, Lidia, 96
ludoliteracy, 23–24, 145–46
Lynch, David, 157

M83, 83–84, 88–89, 99
magic circle, 110–11, 113, 135–36, 180–81
Maglio, Paul, 190n.9
Mahler, Gustav, 67, 102–4, 105–6
Mass Effect: Andromeda, 136, 138–39
Matrix, The, 157, 191n.14
McAlpine, Kenneth, 75–76
McClary, Susan, 11
Medina-Gray, Elizabeth, 24–25, 48–50, 154
memory, 73–74. *See also* nostalgia
 involuntary memory, 76–78
 remembering vs. reminiscing, 75–76, 80
Merleau-Ponty, Maurice, 18–19, 20, 25–26, 37–38, 132–33
 on phantom limb syndrome, 77–78
metaphor, 41–42, 125–26, 160
metre. *See* rhythm
Miller, Kiri, 5, 110–12, 124–25, 127–28, 130–31, 175–76, 179–80
mimicry, 139–40. *See also* play
Minecraft, 68–71, 101–2, 107–8
Mizuguchi, Tetsuya, 134–35
mood, 42–51. *See also* Heidegger, Martin
 mood vs. affordance, 56–57
 mood vs. atmosphere, 50–51
 mood vs. emotion, 79–80
 mood vs. equipment, 57–58
 mood management, 30–31, 72–73
 mood music, 62–63, 101–2, 145–46
 phenomenology of mood, 25–26, 46–47
Moran, Dermot, 26
Moseley, Roger, 110–11, 115
Munday, Rod, 5–6, 44–45
music game, 5, 129–36, 159
music video, 9, 96
musical moment. *See* temporality
Muzak, 11–12, 14–15, 30–31, 32, 45–46, 57–58, 62–63

Nattiez, Jean-Jacques, 3. *See also* poietic; aesthesic
natural attitude. *See* Husserl, Edmund
New Super Mario Bros., 158–59, 162
Nintendo, 75–76, 80–81
nondiegetic music and sound. *See* diegesis

nostalgia. 62–63, 75–82, 88, 154. *See also* memory
 nostalgic listening, 12–13
nostalgic listening. *See* nostalgia

Ocarina of Time. See Legend of Zelda: Ocarina of Time, The.
Offenbach, Jacques, 123–24, 155–56
Oldboy, 1–2
Oliva, Costantino, 130–31

Panzer Dragoon, 132
PaRappa the Rapper, 129–30
Peggle, 71–72, 74
Peirce, Charles Sanders, 149–50, 164
phenomenology. *See also specific phenomenologists*
 époché. *See* reduction
 phenomenologies of music, 19–21
 reduction, 18, 22–25, 39–40, 47, 52–53, 84, 129
 variation, 18, 22–25
Phillips, Winifred, 4–5
Plato, 46
play, 20, 110–12, 180–81. *See also* gameplay
 analytical play, 23
 playfulness, 119–20, 127–28
 pure play, 135–36
 role-playing, 129–30, 139–40, 184–85n.14
poietic, 3–7, 14–16, 48–49, 101–2, 143.
 See also aesthesic
Polynomial: Space of Music, The, 133–34
present-at-hand. *See* Heidegger, Martin
Proteus, 117–24, 126–27, 130–31, 138
protention. *See* Husserl, Edmund
Proust, Marcel, 76–78, 80
psychoanalysis. *See* psychology
psychology, 5–6, 30–31, 62–63, 74–75, 145–46
 of anticipation. *See* Huron, David
 ecological psychology, 53–55. *See also* Gibson, James
 gestalt psychology, 37–38, 48, 53–54, 161–62, 164–65
 psychoanalysis, 30–31, 185n.19, 187n.16
puzzle (musical), 130–31, 133–34, 156–57

Ratcliffe, Matthew, 46–47

rave, 133–35
Rayman Origins, 129–30
ready-to-hand. *See* Heidegger, Martin
real-time strategy game, 32–34, 51–52
Reich, Steve, 102–3
Reid, George, 75–76
retention. *See* Husserl, Edmund
Return of the Obra Dinn, 75–76
Reynolds, Simon, 133–34
Rez, 131–34
rhythm, 24, 35, 40, 132–33, 159–61.
 See also entrainment
 and metre, 121–22
rhythm games. *See* music games
Ridley, Aaron, 48
Riedel, Friedlind, 26
Rock Band. See *Guitar Hero* (series)
rock music, 35, 83–84, 88, 96, 103–4, 123–24, 134–35
Rock, The, 137
Rodman, Ronald, 189–90n.5
roguelike game, 2–3, 23–24, 43–44
role-playing. *See* play
role-playing game, 85, 166
Rone, Vincent, 76–77
RPG. *See* role-playing game
RTS. *See* real-time strategy game
rules of irrelevance, 147–48, 158
rules. *See* gameplay rules
Russell, James, 138

Saint-Saëns, Camille, 153
Salen, Katie, 6
Sartre, Jean-Paul, 18–19, 78–80, 81–82, 140–41
Saussure, Ferdinand de, 149–50
Schaeffer, Pierre, 39–40, 183n.1
Schafer, R. Murray, 39–40
Schmitz, Hermann, 26, 50–51
Schutz, Alfred, 16, 19, 24–25, 108–9
Scruton, Roger, 124–27, 184n.5
Secret of Monkey Island, The, 43
Seeger, Charles, 63–64
Seigworth, Gregory, 185n.18
Seinfeld, 9, 151–52
semiotics, 5–6, 41–42, 98–99, 148, 149–50, 164, 189n.4. *See also* Saussure, Ferdinand de; Peirce, Charles Sanders
serendipity, 70–71, 81–82, 85, 93, 96, 99, 140
Shadow of the Colossus, 5

Shining, The, 1–2
Shovel Knight, 75–76
Sicart, Miguel, 119–20
Sid Meier's Civilization (series)
 Civilization IV, 72, 100–7, 179–80
 Civilization V, 154–56
signal, 153–54, 158–64
 broken signals, 164–69
significance, 11, 15–17, 22, 176–77
Silent Hill, 3–4, 143
SimCity 2000, 9, 43
Simon, 130–31
Skyrim. *See Elder Scrolls V: Skyrim, The*
Slay the Spire. 43–46, 48, 49–51
Sloboda, John, 61–62, 74–75
Smith, Jennifer, 179–80
Sonesson, Göran, 151
Soule, Jeremy, 93, 178–79
soundscape, 12, 39–40, 43–44, 51–52
Star Trek: Voyager, 136
StarCraft (series), 32–36
 identity of musical cues, 44–45, 50–51, 57–58
 StarCraft and background music, 38–40, 42, 47–48
 StarCraft soundtrack and affordances, 57
 reception of *StarCraft II* soundtrack, 59–64
Stern, Daniel, 114–15, 129, 138
stinger, 8, 10–11, 48–49, 67, 95–96, 137, 164, 177–78
Stockfelt, Ola, 10–11, 184n.9
Summers, Tim, 5–6, 23–24, 101, 137, 143, 148–49, 156, 166, 180
Super Mario Bros., 3–4, 12–13, 29, 54–55, 80–81
 Starman theme, 67, 110, 112, 113–14, 115, 127–28, 140
Super Meat Boy, 54–55
Super Smash Bros. Brawl, 80–81
survival horror games. *See* horror
Svec, Henry Adam, 131–32
symbol, 152–57, 161–62, 164–65, 170–71
Symphony, 133–34
synaesthesia, 132–33

synchronization, 22–23, 31–32, 43–44, 49–50, 159–60. *See also* entrainment
Szabo, Victor, 103–4

Taruskin, Richard, 187n.17, 187n.18, 190n.7
temporality, 15–16, 21–22, 40, 112, 152, 161–64. *See also* Husserl, Edmund
 musical moment, 86–91, 94–99, 136, 179–80
 temporal objects, 86, 116
 timelessness, 47–48, 86, 90
Tetris, 4–5, 6, 31–32, 43, 50–51, 56–57
time. *See* temporality
Tom Clancy's Splinter Cell, 148
Tomb Raider (2013), 95–99, 177–78
Tony Hawk's Pro Skater (series), 54, 56–57
transcendental reduction. *See* phenomenology
transdiegetic music and sound. *See* diegesis
transitions. *See* dynamic music
Twin Peaks, 157

ubiquitous listening. *See* listening
Unreal, 54–55

Vampire Survivors, 136
van Elferen, Isabella, 5–6, 8, 77
 on game-musical literacy, 22, 145–46, 170
 on ludic music, 8, 113–14
Verran, Erick, 54–55

Warde-Brown, Ailbhe, 98–99
Wark, McKenzie, 132–33
Whalen, Zach, 3–4, 143, 191n.15, *See also* safety- and danger-state music
Who, The, 88
Winamp, 133–34
Warcraft III: Reign of Chaos, 51–52
Warcraft: Orcs & Humans, 33–34
World of Warcraft, 4–5
WWise, 7

Zahavi, Dan, 86
Zimmerman, Eric, 6